Early Medieval Architecture

AS BEARER OF MEANING

Early Medieval Architecture

AS BEARER OF MEANING

GÜNTER BANDMANN

Translated, with an introduction, by Kendall Wallis
AFTERWORD BY HANS JOSEF BÖKER

COLUMBIA UNIVERSITY PRESS NEW YORK

COLUMBIA UNIVERSITY PRESS
Publishers Since 1893
NEW YORK, CHICHESTER, WEST SUSSEX

Bandmann, Günter:
Mittelalterliche Architektur als Bedeutungsträger
Berlin: Gebrüder Mann Verlag, 1951
Originally published 1951, 11th printing (Mann Studio-Reihe) 1998

Library of Congress Cataloging-in-Publication Data
Bandmann, Günter.
 [Mittelalterliche Architektur als Bedeutungsträger. English]
 Early medieval architecture as bearer of meaning / Günter Bandmann ; translated, with
an introduction, by Kendall Wallis ; afterword by Hans Josef Böker.
 p. cm.
 Translation of: Mittelalterliche Architektur als Bedeutungsträger.
 Includes bibliographical references and index.
 ISBN 0-231-12704-9 (cloth : alk. paper)
 1. Architecture, Medieval. 2. Symbolism in architecture—Europe. 3. Christian art and
symbolism—Medieval, 500–1500. 4. Decoration and ornament, Architectural—Europe. 5.
Decoration and ornament, Medieval. I. Title.

NA350.B3313 2005
720'.94'09021—dc22
 2004059374

Columbia University Press books are printed on permanent and durable acid-free paper
Printed in the United States of America

c 10 9 8 7 6 5 4 3 2 1
Designed by Chang Jae Lee

Πόλλ' οἶς' ἀλώπηξ ἀλλ' ἐχῖνος ἕν μέγα
The fox knows many things,
but the hedgehog knows one big thing.
ARCHILOCHUS

For my wife, Faith,
who has made this possible,
as she does all things.

Contents

Illustrations

Acknowledgments

THE TRANSLATOR WISHES TO EXTEND his deep and heartfelt thanks to Warren and Edith Sanderson, for first nurturing his fascination with westworks and then cultivating it in delightful company; Hans Böker, for first assuring him that the text was impossible to translate and then helping him see it to completion with wisdom and charm; Malcolm Thurlby and Roger Stalley, for encouraging him at the right time; Wendy Lochner of Columbia University Press, for believing in the book; Irene Pavitt, of Columbia University Press, and Almuth Seebohm and Sabine Seiler, for making sure that he wrote what he both wanted and needed to write; Eric Ormsby, Calvin Evans, and Frances Groen of the McGill University Libraries, for believing that this decade-long gestation would bring forth a worthy contribution to scholarship; and his beloved Faith, without whose love, wit, patience, scholarship, gift for the right word at the right time, and tolerance for "Mr. B," this book could never have happened.

Early Medieval Architecture

AS BEARER OF MEANING

Bearing Bandmann's Meaning:
A Translator's Introduction

INNOVATIVE WORKS OF SCHOLARSHIP, especially those with a theoretical orientation, present a special challenge to the translator because new ideas require, and inevitably engender, new terminology. New terms are created in many ways. Scientists, philosophers, and theologians traditionally fashion vocabulary by forcing new shoots from old Greek or Latin roots—everything from "transubstantiation" to "angioplasty." Vernacular neologisms can be created, like "being-in-the-world." Terms can also be carried over unchanged from another language where they were coined and endowed with specific meanings, like *Dasein* and *Zeitgeist*.

But there is another way to describe the hitherto indescribable, and that is through metaphor. When early Christians tried to express a new concept of leadership and authority, they did so by appropriating the terminology of sheep-herding. The familiar relationship of shepherd and sheep, when projected into a different context (e.g., God as Good Shepherd of humanity, the bishop as pastor of the faithful flock), conveyed an entirely novel concept: spiritual authority grounded in service and sacrifice.

Günter Bandmann, perhaps because he was primarily interested in how meanings are conveyed symbolically by the purposeful manipulation of specific architectural forms, relied on metaphorical extensions of preexisting German words rather than on neologisms. From the translator's perspective, the challenge then is to find equivalent English terms that capture Bandmann's special metaphors and at the same time acknowledge the literal meaning of the words

whose significance Bandmann has extended. Sometimes the metaphor has worked, and sometimes it has had to be banalized, ironically, to save the meaning from the image. For the sake of greater clarity for English-speaking readers, the metaphorical or implied meaning was at times made explicit, through repetitions of key terms and concepts or parenthetical clarification.

Bandmann uses some apparently univocal terms, such as "form" and "type," in technical ways that are based on his art historical premises. The following notes will alert the reader to some of these key concepts and metaphorical usages and will attempt to make them more comprehensible. The terms that have proved most difficult to translate are precisely those most intimately connected with acts of transmission and reception of meaning.

Form and Type

In *Early Medieval Architecture as Bearer of Meaning*, Günter Bandmann argues that an architectural form, such as a dome, *considered as an abstraction*, can be used to convey a meaning. The importance Bandmann ascribes to form as abstraction has consequences for the English-speaking reader, who must become accustomed to some unusual precision in the use of definite and indefinite articles. When Bandmann speaks of "the dome," he is referring to the abstract idea of the dome, almost in the Platonic sense. The statement "the dome is a circular vaulted covering of a large space with no interior supports" is applicable to all domes, but refers to no particular dome. "A dome," by contrast, denotes a particular and concrete dome. "A dome may have an opening in the center" is a true statement about some particular and actual domes, but not all. Finally, the term "domes" denotes all particular, actual domes, as they might appear on a poster entitled "Domes of the World." "Domes come in all sizes and shapes" is universally true, but it is true about particular and concrete domes. By contrast, the statement "the dome is an image of the vault of heaven," refers, in Bandmann's way of speaking, to the abstraction or idea of the dome; concrete and particular domes will partake of this idea to a greater or lesser degree, depending on their specific construction and circumstances.

A dome (or a domed building) is the structure's "form." "Formal" is the adjective describing the builder's intention with regard to the "form." "The building's formal design" means the building's design with respect to "forms" in this quasi-Platonic sense. For example, when Bandmann writes that the metaphor of the city has "formal consequences" for the design of the church building, "the city" should be understood as the abstract idea of the city (in this case, the abstract idea held in late Antiquity). Visually it was

marked by circumferential walls, multiple rooflines, and monumental gates. Structurally it was marked by oriented major and minor axes constituting processional ways leading to monumental foci and public gathering places constructed of enduring, often striking materials and endowed with symbolically meaningful works of art in appropriate places. Organizationally its social, political, and cultural activities made it markedly distinct from the surrounding countryside. Taken together, these markers constitute the city's *form*.

In the earliest days of Christianity, "the church"—the *ecclesia*—was the assembly of faithful believers, not a physical structure. But as the Christian community gradually became synonymous with the city-community, and as the notion of the church as universal City of God and counterpart of the Heavenly Jerusalem took root in sermons and theological writings, the physical attributes of the ideal city were applied to the buildings constructed to house the Christian community. The idea of the city affected the idea of the kind of building that ought to be constructed to house the church and which in time came to *be* "the church." The form the church building eventually acquired, which became a recognizable form in its own right, was strongly affected by the form of the city—those visual, structural, and organizational markers that made up the idea of "city." Church buildings acquired monumental entrances modeled on city gates and broad aisles suitable for processions. This is what Bandmann means when he claims that "the metaphor of the city has formal consequences for the design of the church building."

Individual architectural elements can also be "forms." For example, the idea of a column embodies both freestanding support—usually cylindrical—and the possibility of being used singly or in groups or patterns for decorative purposes. These attributes comprise the column's "form." The capitals that often crown columns, in turn, come in various "types." The type of the Corinthian capital, for example, is defined by its acanthus leaves. These acanthus leaves may be realistically carved, as the classical Roman ones; tightly coiled and deeply drilled, as the Byzantine ones; or simplified to the point of a cartoon, as the Merovingian ones. But whatever their particular style, they are all clearly and unambiguously legible as "Corinthian capitals." Forms (e.g., the column) have *ideas* standing behind them ("support"), while *types* (e.g., the Corinthian capital) have *images* standing behind them ("acanthus"). Both forms and types can bear meanings.

The distinction between form and type is crucial to Bandmann's analysis, but it may be unfamiliar to English-speaking readers accustomed to more empirical styles of thinking about architecture. A concrete and familiar example may help to make these highly abstract notions clearer.

Why was the United States Capitol built with a dome?[1] As a particular instance of the form we might call "monumental domed building," the United States Capitol belongs to a venerable class of structures. This class includes Hadrian's Pantheon in Rome, Constantine's Anastasis Rotunda in Jerusalem, Justinian's church of Hagia Sophia in Constantinople, Michelangelo's St. Peter's Basilica in Rome, Wren's St. Paul's Cathedral in London, and Mansart's church of Les Invalides in Paris. The ancient representatives of this class are all structurally daring, visually dramatic, major religious buildings of the highest rank. The dome that is their preeminent characteristic is an image and allegory of heaven. The dome symbolically draws whatever transpires in the microcosm on earth into a relation with the macrocosm in heaven. The distribution of monumental domed religious structures from the great kivas of Chaco Canyon in New Mexico to the Temple of Heaven in Beijing would seem to indicate that this perception is hard-wired in our species.

Charles Bulfinch's plans for the first Capitol in Washington included a prominent dome. This was by no means a self-evident choice. The Capitol might have been rectangular like the British Parliament; it might have had a flat, coffered ceiling like a Roman law court; or it could have been a semicircle like a Roman theater, the form adopted for the French Chambre des Deputés. But the form that was chosen was the dome, hitherto reserved for sacred structures, and that choice consecrated the actions of the young nation's lawmakers. So electrifying and significant was this building's meaning to the newborn United States that the assembly halls of several states were rebuilt to include prominent domes even before the national Capitol dome was completed. Bulfinch's dome was not an exact copy of any of its potential models; instead, it copied an idea. To put it in Bandmann's terms, it copied a form.

This form carried a meaning from the past, but it also developed a new and particular American meaning: union. During the Civil War, President Lincoln insisted that the very expensive construction work on Thomas J. Walter's greatly enlarged new Capitol dome continue throughout the war, so that Americans might know that the Union for which they were fighting was still symbolically being built. After the war was won, a dome became an obligatory feature on all state capitol buildings. The legislature's building had to have this attribute, this visual badge of membership in the American Union, in order to bear the burden that the state's legislative authority demanded. The *form* (the dome) had become a *type* (the American domed legislative building). The dome as *form* rests on the *idea* of "unsupported circular covering." It conveys the meaning of "heaven." The American domed building of the legislature as *type* rests on an *image*: the dome of the Capitol in Washington. It conveys the meaning of "the Union."

In the state capitols, the form of the large domed building was not copied because of any meaning the dome-form might have had, although the cosmic meaning was probably lurking behind its original reception. Rather, the type of the United States Capitol was copied because of its philosophical and political significance. It represented the legislative power of the republic. The power of "we the people" had been sanctified by the domed structure of the original legislature's building.

However, the domed building is still a "form," and as such it continues to bear something of its primitive cosmic meaning and the weight of its history in Western architecture from the Pantheon to the present. Consequently, the state capitol dome is often outfitted with images that connote these distant meanings. Stars—electric or painted—symbolize the dome of heaven; gilded, coffered surfaces emphasize the connections with the democratic and republican virtues of ancient Greece and Rome; allegorical and historical paintings constitute a secular hagiography and a political sermon.

The various state copies were never exact reproductions of the Washington prototype, nor were they intended to be. The presence of a dome on a legislative building sufficed to ensure the transmitted meaning of the type. By copying the type of the dome of the United States Capitol, state lawmakers drew parallels not with heaven, but with Washington. The exception that proves the rule is the Nebraska state capitol, which self-consciously opted for a tower instead of a dome. But enter the tower and look upward, and what do you see? A dome, complete with starry lights. The drive to bind the state capitol to the national capitol was irresistible. Ironically, by becoming a type, the domed legislative building was rendered useless for all practical purposes. The space thus covered became acoustically unusable (and as a hallowed space perhaps morally uncomfortable), and actual debate took place elsewhere.

The importance of Bulfinch's thoroughly secular dome cannot be overemphasized. He took a form laden with symbolic sacred meaning and ascribed a radically secular meaning to it. This is a major plank of Günter Bandmann's argument about early medieval architecture: the meanings conveyed by forms are not immutable. For example, the German emperor Conrad II took the monumental Roman groin vault—the defining architectural characteristic of the Roman bath, a form with a thoroughly secular meaning and the hallmark of monumental secular imperial architecture—and incorporated it into his dynastic burial church in Speyer. By sanctifying the groin vault, Conrad created a new Christian ecclesiastical architecture with an explicitly *imperial* meaning. Bulfinch and Walter likewise secularized the dome of heaven by incorporating it into a thoroughly worldly building, but one designed for a nation with a pronounced sense of its historic vocation "under

God." The meanings of both forms were irrevocably modified by these appropriations: after Conrad II vaulted Speyer, church naves everywhere began adopting groin vaults; America's public landscape is strewn with secular domed structures, from libraries to astrodomes.

Forms can and do become types, but it is important to recall that forms and types are not the same. Meaningful architectural types need not constitute forms. A good case could be made for the American county courthouse as an instantly recognizable type, with its classical pediment, monumental front steps, and imposing columns. "Expect justice within," it seems to say. However, types need not convey meaning. The New York brownstone, the Charleston town house with its piazza, and the Montreal row house with its distinctive external stairs are all identifiable types, but they bear no meanings. Types, in short, are typical: they can typify a meaning or simply be typical of a local building tradition.

Reception

The older positivist approach to art history viewed the transmission of images, forms, ideas, techniques, and styles as a linear and almost mechanical process. The focus was entirely on how the art of the past moved forward in time. However, this is only half of the story. What comes forward in time from the past must also be "received" by the present. The concept of reception has long been familiar in legal history and theory, because while a legal precedent can be imported from an alien tradition, such as from Roman law to English common law, it has to be consciously accepted or rejected. The application of this idea to literature, however, began only in the late 1960s. It entered art history in the 1970s and 1980s and emerged in the history of architecture only in the 1990s.[2]

The concept of architectural reception can be illustrated by the example of the Roman mausoleum. The Roman mausoleum has had an unbroken tradition as a building type that has ramified in several different directions; the Roman bath, by contrast, has no such continuous tradition. One could argue that wealthy people continue to die and wish to be prominently commemorated after death, while bathing practices have changed beyond recognition since Antiquity. This is the older "transmission" perspective: forms persist by inherent momentum or peter out because they lose that momentum. But it could also be said that the wealthy plan their tombs well ahead of time and have a chance to look around. They see buildings they like and want to reproduce them. A mausoleum endures and remains visible as a

mausoleum, possibly because mausolea are not easy to adapt to other purposes. Moreover, they often perpetuate the fame of an important person whose memory and monument some other important person might want to emulate centuries later. This is the perspective adopted by modern reception theory: the mausoleum was deliberately "received" as a form by postclassical builders because it conveyed meanings to which receivers responded and in which they wanted to participate and perpetuate.

Reception theory argues that the act of reception, far from being passive, is a conscious decision about the value of the thing received. As in a relay race, another runner must take the baton and continue. Sometimes there are several runners eager to run with the baton, and sometimes nobody wants to carry it farther. Reception theory therefore concerns itself with the actualization of the text or painting or building in the mind of the reader or beholder. In literary theory, reception is an aspect of reader-response theory that focuses on the reception of a text by readers as historically conditioned actors. Reception aesthetics examines how readers realize the potentials of a text in their own behavior and actions. Reception history examines how readings change over the course of time. Once the teleological view of art history is set aside, it becomes evident that works of art and architecture can be treated as "texts" in the same way.

In *The Selfish Gene*, Richard Dawkins proposed the concept of the meme as a unit of culture, spread by imitation, much as a gene is transmitted in reproduction.[3] Depending on the accessibility of what is received and its medium, the effort required to replicate a meme can range from negligible to prodigious. For example, upon picking up an old book in an ancient tongue, one might simply smile and turn the page or decide to spend a lifetime learning the language. In the case of architecture, the most durable and expensive of arts, that effort can range from glancing appreciatively at a ruin to devoting half the revenue of a kingdom to the reactualization of a centuries-old structure. The grounds for reception might be aesthetic, intellectual, philosophical, political, or any combination of those and a dozen equally valid other motives. If the ideas they represent are desirable, memes can be received across great distances and from alien cultures. The architects of the Capitol clearly saw a reason to put a dome on a legislative building. In *Early Medieval Architecture as Bearer of Meaning*, Günter Bandmann investigates the meanings of some of the architectural forms transmitted by Antiquity and received by the early Middle Ages and finds meanings powerful enough to justify enormous investments of time, energy, and money on the part of ecclesiastical and secular rulers.

Claim

The German *Anspruch* means "claim" or "pretension." In Bandmann's lexicon, it acquires an extended social and cultural meaning. If one moves into the local manor house and starts behaving like the lord of the manor, this entails "claiming" certain rights and privileges, and is best justified by "claiming" descent from some previous squire, however distantly. Such pretension to status will be backed up by actions and signs—for example, serving as justice of the peace, becoming colonel of the local regiment, and sitting in the squire's pew in church. In a society enormously respectful of tradition, such as that of the Middle Ages, legitimacy must be persistently claimed and claimed in traditionally accepted ways. The historic accuracy of such claims is ultimately less important than their acceptance or rejection by those to whom they are directed. Bandmann argues that the actualization of building forms or types endowed with specific meanings constitutes a claim (*Anspruch*) to the social, cultural, political, or religious values attached to those meanings. This claim is quite concrete and literal: to copy forms associated with the Roman emperor is to claim, on some level, the office of emperor itself.

Aufheben

Aufheben is another term with an extended meaning. As a verb in everyday discourse, it has several seemingly contradictory meanings. It means "to pick up or raise," as in "to weigh anchor"; "to suspend or annul" or "to set aside," as a law might be "set aside"; and "to keep, store away, or preserve," as one might "put up vegetables" for the winter. Every German dictionary has many useful illustrations. Although not a Hegelian, Bandmann explicitly uses the term in Hegel's sense, where all these contradictory meanings are combined and reconciled. The Hegelian idea of *Aufhebung* involves the dialectical reconciling of opposing concepts in a way that, by raising the discourse to a higher level, combines the formerly contradictory elements into a greater, encompassing whole. Indeed, it is the dialectical process that actually creates the resulting encompassing whole.

The interaction between apostolic Christianity and imperial Rome offers a case study in *Aufhebung*. In principle, these are irreconcilable opposites. But the dialectic of God's Plan of Salvation[4] allowed patristic Christianity to encompass both the Faith and the Empire, while at the same time transforming both. Some aspects of primitive Christianity and of the imperial idea were inevitably abandoned in the process, but most elements of both were elevated to the new plane of discourse, reconciled, and combined. The

resulting amalgam—the idea of Christendom—was eventually seen by the participants as the goal that everything had been leading to all along. This early medieval alloy was not perceived as a composite of dissociable parts, as we see them today. Hence we find it difficult to comprehend the durability of the medieval worldview—durable until the Renaissance and Reformation began the protracted and traumatic process of teasing those components apart again.

To revert to the earlier example of the United States Capitol, when the dome of heaven (a sacred structure par excellence) was combined with the legislative assembly (a very secular institution)—two well-known but unrelated structures—something new was created that combined the previous elements and elevated them to a higher plane. *Aufhebung* had taken place.

But while it is possible to explain *Aufhebung*, it is impossible to find an English word to translate it. In Bandmann's original German text, the term is placed in quotation marks and identified as used in Hegel's sense. Specialist literature on philosophy usually translates Hegel's *Aufhebung* as "sublation," a term that cannot be said to help the nonspecialist reader, let alone make Bandmann's meaning transparent. Because no satisfactory English equivalent has been found, *Aufheben* and its derivative forms have been left in German. The elements of dialectical engagement, reconciling, encompassing, superseding, and rising above are familiar to us all, as is their sequence in Hegel's act of *Aufhebung*, even if the word remains strange.

Bauherr

Bauherr is another term with no exact or even approximate English equivalent. The person who "awards the building contract" (*Auftrag*) is the *Auftraggeber*, a word we have translated as "patron." The patron pays the bills and has a legal, financial, and social relationship with the building project. But the *Bauherr* (pl. *Bauherren*), literally the "lord of the building," is the person in charge of the building *process*. The *Bauherr* may be the same person as the patron. However, the English "patron" connotes a Maecenas whose involvement is primarily through financial support, exercised remotely. The *Bauherr*, while not actually wearing a hard hat, is inseparable from the *Bau*, or physical building. It is tempting to use a term like "general contractor," but Charlemagne, for example, was the *Bauherr* of the Palatine Chapel in Aachen. He was actively involved with the intellectual, philosophical, artistic, and political planning process, but he could not be called the architect or general contractor. In the period under discussion, the functions of both *Bauherr* and *Auftraggeber* extended to design as well as financing and contracting. As always, such people are

concerned with getting value for their money. The question is: What did they value? Much like the producer of a motion picture, the *Bauherr*, whether a person or an organization, is the one who is *responsible for bringing about the object's physical existence*, and it is no accident that in the film credits, the producer's name always comes first and in the biggest letters. Although the subtle distinction between the *Bauherr* and the *Auftraggeber* (patron) is not always explicit in Bandmann's text, using "patron" to cover *Bauherr* risks suppressing that crucial dimension of active involvement in the building process. For this reason, the German term *Bauherr* has been retained.

Indicating

Hinweisen includes elements of "alluding" and "referring," but it is more concrete than either of those words. A *Hinweis* is an "indicator" in the sense of an economic indicator or a directional sign at the side of the road. While not in itself a command, a *Hinweis* unmistakably "points to," "indicates," or "draws attention to" something else deemed important. The Corinthian capital, for example, pointed directly and unambiguously to Augustan Rome, the culture that created this type. By extension, it "stood for" Rome and all that Rome stood for, just as the economic indicator "stands for" a country's prosperity. The dome on a state capitol likewise points unambiguously to the legislative macrocosm in Washington. *Hinweisen* has usually been translated as "indicate."

Coining

Prägung has been variously translated as "coining," "minting," "impressing," "stamping," and variations of these terms. It connotes embossing, making a physical impression on a material substance that can be eradicated only with difficulty. In the ancient world, many architectural forms were so tightly associated with certain activities that their presence in the context of those activities was obligatory. In Bandmann's terms, the form was "stamped" with a specific meaning, just as a coin is stamped with its distinguishing features that confirm its value. Even though it may remain in circulation for a long time, a coin can still be recognized for what it is. If the authority that issued it is still respected, that coin can still have a certain monetary value, one perhaps even greater than that of coins of more recent issue. The acceptance of the American dollar as hard currency in troubled areas of today's world bears witness to the *value* with which that physical object has been imprinted, even though it may be made of paper.

Imprinting can be both physical and figurative. While the Corinthian capital is literally incised with the lineaments of acanthus leaves, outlines remaining visible even in their worn down, cartoonlike Merovingian manifestation, it is also culturally impressed with the idea of Imperial Rome. The perceived value of the architectural coinages of Antiquity possessed a similar tenacity in the Middle Ages. In the West, Constantine's great flat-roofed Roman basilicas defined the form of the church building for almost a thousand years. The flat roof was thus "imprinted" (*geprägt*) indelibly on the form of the church—at least until the era of Conrad II.

Deputy

Vertreter may be translated as "agent" or "representative," but Bandmann also uses the term *Stellvertreter*, which carries a strong sense of personal "deputy" and even "stand-in" or "proxy." This is another word that Bandmann extends in a metaphorical sense to inanimate, specifically architectural, objects. While the viceroy is not the king, he stands for the king and carries all the king's authority and quasi-sacred prestige. In a similar fashion, Romans saluted the emperor's portrait as if it were his real presence, and the emperor's portrait led his troops into battle. His physical likeness on coins guaranteed their value. Even today in many countries, a photograph of the head of state on the wall of a government office proclaims that the civil servants speak with the state's voice. The deputizing agent need not always be a physical likeness. The throne represents the king's ruling presence even when it is empty; the palace represents the monarch even when unoccupied. Most United States currency bears images of iconic government buildings on the reverse side.

 Stellvertreter in this expanded sense has usually been translated as "deputy." If such personification of an inanimate object as a "stand-in" seems contrived to our modern sensibilities, it is because we have forgotten the force with which inanimate objects can carry meaning. The visceral way in which citizens of the United States react to affronts to their flag should remind us of the strength of meaning with which the inanimate deputy of a greater power can be endowed.

Westbau

Westbau (pl. *Westbauten*) literally means the "structures built at the western end of an edifice." It is best understood as referring to all the architectonic structures that are habitually grouped around the western end of the church

and rarely occur elsewhere. The term "westwork," a loan-translation of the German *Westwerk*, has already found its way into English, but is usually limited to a specific kind of *Westbau*. *Ostbau* (or *Ostwerk*) for the "collectivity of eastern structures" occasionally occurs but usually in a comparison with *Westbau* features. That identifiable groups of structures should be consistently deployed in such a manner is one of the keys to Bandmann's wider argument. The terms *Westbau* and *Ostbau* have therefore been left untranslated.

In its original incarnation, this book looked very different: between one-quarter and one-half of the average page was footnote. It presented a very scholarly visage; one could perhaps say an intimidating one. The current version tries to wear that formidable and extraordinarily wide-ranging scholarship a little more lightly. The pervasive German *apparatus bibliographicus* has been converted into user-friendly parenthetical references. The original bibliographic citations, often in highly telegraphic style, have been silently completed or corrected by the translator wherever possible.

When they sit at the foot of the page, footnotes occupy a different "zone of accessibility" than do backnotes, which obligate the reader to use an auxiliary bookmark. Günter Bandmann's original footnotes played with that antiphonal relationship, indulging in a dialogue with his readers. Often a footnote consisted of only a phrase or a word or two, a gloss on the parent text, not a documentary or bibliographic reference. The backnotes used in this translation, being less accessible, could not sustain this antiphony. Therefore, some of the shorter, gloss-type notes have been silently woven back into the main text. However, in many cases this was not possible, and the reader will find that many of the extensive backnotes are in fact voices in the author's ongoing dialogue with his own text.

The original publication of *Mittelalterliche Architektur als Bedeutungsträger* took place in 1951 in the economically straightened conditions of postwar Germany, and the illustrations were not lavish. The book has remained in print for over fifty years, and the illustrations have never been revised. Given their purpose to illustrate ideas rather than buildings, this is perhaps understandable. For this translation, the original illustrations have been retained, but they have been integrated into the text.

The attentive reader will notice some lapses in Bandmann's editing—for example, repetition of quotations. These, too, have been retained. In the original text, section headings were not treated consistently, some appearing in the table of contents and others not. For the English edition, subheadings have been inserted where logical, and the main headings are listed in the table of contents, as is customary. In the last chapter, "The Decline of Sym-

bolic and Historical Meaning," the subheads after the first heading, "Reform and Secularization" have been inserted at the suggestion of Professor Hans Josef Böker.

The text contains references to literary commonplaces, tags that Bandmann assumed his cultured readers would recognize and thus identified only by a parenthetical name, the way an English writer might write "too, too sullied flesh" (Shakespeare). These have been left in that form, on the assumption that an exact reference was consciously omitted from the original and in any case would not help the author's argument.

Unlike the German colleagues and students for whom Bandmann originally wrote, most readers of this translation will probably not have a long-standing first-hand familiarity with most of the monuments casually referred to in the text. A standard work of architectural history, such as Roger Stalley's *Early Medieval Architecture*, or Richard Krautheimer's *Early Christian and Byzantine Architecture* and Kenneth John Conant's *Carolingian and Romanesque Architecture, 800 to 1200*, will supply most of the visual data necessary to understand Bandmann's allusions.[5]

All quotations originally appearing in Latin have been translated by Faith Wallis, *uxor doctissima*, unless otherwise credited.

Kendall Wallis

I

The Problem of Meaning in Architecture

THE FACT THAT CERTAIN BUILDING FORMS are either present in certain periods or are not is an important aspect of medieval architecture that has not been sufficiently appreciated in art history. Those responsible for the building's existence—whether lords, monastic orders, cities, or other individual or collective patrons—either selected and promoted specific building forms from the repertory of forms transmitted from the past, or they rejected those forms. Art historical research, however, has principally concentrated on detailed observations of phenomena such as the modification of architectural forms within regions or periods and the interrelationships between schools and regions, peoples and eras, and has investigated these down to their tiniest ramifications.

The investigation of a problem such as ours does not begin with some kind of stylistic exploration of building types in order to produce a logical arrangement, either by comparing their variations on the basis of stronger or weaker formal differences or by examining the geographical or chronological coordinates of the works of art. On the contrary, our investigation will take as its object the simple fact that a specific ground plan (or vaulting, column, or gallery) *exists*. No chameleon-like *Kunstwollen*[1] is sufficient to explain the creation, reception, or rejection of a type; such a force is satisfactory only as an incentive for initiating change within the type.[2] Rather, religious, political, sociological, and other such factors operating in the larger history of mankind are decisive for the selection of the type in the first place.

Just as the recognizable concept of *Kunstwollen* might explain the steady development of a type toward a recognizable "coinage" or its modification but cannot explain why a form might be received from the distant past or from an alien cultural context, so also invoking "habit" (the unconscious retention of transmitted forms) is not always sufficient to explain persistence in the use of a specific ground plan or in the shaping of masses.

In order for its phenomena to be understood, medieval architecture must be firmly situated in the context of the period's conscious respect for tradition. As far as works of art are concerned—and more particularly works of architecture—this outlook takes on a much more profound significance as we come to understand the meanings that determined the reception or rejection of forms. Those meanings can be deduced only partially using methods such as the comparison of forms and stylistic criticism, and hence modern tools specific to art history can be applied only peripherally. Nevertheless, the physical relicts that have come down to us, like cast-off shells or broken molds left behind by vanished states of human consciousness or modes of expression, can aid us in our efforts to understand the works of art those states of consciousness produced.

For example, beginning in the middle of the eleventh century, forms can be observed in Speyer Cathedral that are novel in the context of the architecture hitherto typical north of the Alps (some few Merovingian and Carolingian coinages aside). For example, engaged columns are employed as wall articulation in the eastern choir and as a pattern in the nave and the vaulted side aisles. A dwarf gallery runs around the whole building. Freestanding columns in the Chapel of St. Afra, set slightly in from the walls, support the vaults that resemble baldachins, and the columns have finely wrought, classicizing Corinthian capitals, such as had not been seen in the West since the days of the Carolingians.

Art historical research—which has grown up on the methodology of visual comparison—either has ignored these phenomena, since they fall outside the imagined path of development, or has contented itself with pointing to earlier occurrences in different cultural contexts. The label "northern Italian" was believed to fully explain the architectural ornamentation of Speyer Cathedral. Since the appearance of this ornamentation was too abrupt to be comfortably attributed to the malleable *Kunstwollen*, the fact that *comacini*, wandering sculptural workers, can be demonstrated to have been in Speyer and elsewhere seemed sufficient to explain the process of transmission (Kautzsch 1919:77ff., 1921:75ff.).

Hence, Italian scholarship could proclaim Speyer Cathedral an Italian building (Hermanin 1934–1943), while the Germans countered by reducing

the obvious Italian relationships to trivialities and turning the *comacini* into wandering stoneworkers, similar to the itinerant Italian laborers of the nineteenth century.[3] Eventually the question was raised whether Speyer Cathedral might have predated the related northern Italian buildings, and whether, contrary to expectations, the architecture of northern Italy might have been molded by the Salian architecture of the upper Rhine (Pühringer 1931).[4]

Strongly charged with nationalist grudges, scholarly research arrived at this conclusion without ever having shed any light on the historical reasons for the existence of those forms in Speyer. Until recently, the outlook of art history seems to have suffered from a weakness or, more accurately, an inhibition that has prevented it from introducing, alongside an exceptionally well-developed sensitivity to the change and development of forms, a corresponding understanding of the continuity of an imprinted form. In other words, it seems to lack a perception of what remains recognizably constant throughout all the metamorphoses of a form and what, in most cases, was the main reason for the reception of the form in the first place.

The traditional methodology took genetics for its model (Töwe 1939). In recent decades, it has been subjected to criticism that has opened up opportunities for posing new questions (some examples among many: Kitschelt 1938; André 1939; Evers 1939; Krautheimer 1942b; Sedlmayr 1948a, 1950; Smith 1950). Rather than explaining the emergence of architectural components as the result either of *Kunstwollen* or of the changing ways in which shapes or elements of surface relief or decoration are formed—ways perceptible to the eyes alone—this newer criticism considers these components in the context of the forces that compel the meaning within a work of art to manifest itself. In other words, there is an effort to reinstate what was truly characteristic of medieval architecture—that it was not so much the artist, but rather the patron who was of decisive importance. We must also assume, however, that the meaning the architecture held was intended to be transmitted, and that therefore the primary concern of the person responsible for the building, the *Bauherr* or patron, was to imprint the form with meaning and to bring about the perception of that meaning through the instrument of the artist's hands. In the Middle Ages, if received forms laid claim from their earliest occurrence to a symbolic meaning, and if the transmitted configurations of the past could be applied in support of symbolic relationships the patron wished to reassert by means of a similar representation (Krautheimer 1942a:1ff.; Paatz 1950), then those forms were again utilized.[5]

Thus it was the meaning contained within these forms that determined their attractiveness, which meant that tradition limited the selection—and, even more so, the creation—of new types. However, the special relationship

of the Middle Ages to form, together with latent regional and temporal artistic forces, so enlarged the possibilities of variation within the type that formal congruence between copy and type can actually be observed in only very few points even in cases where written records explicitly state the builder's intention to receive the form and copy the content.

Recent research in the area of architectural iconography has arrived at these conclusions, but these findings have not been applied to the larger contexts of architectural history, nor has there been a description of the specific behavior of the Christian Middle Ages vis-à-vis the reception of building forms, and that is what we will attempt here. To what degree did the meanings alluded to earlier change during the Middle Ages? What new meanings were read into the forms? Did the church and the empire behave differently? Were the types already "coined" in Antiquity, or did the forms become types through their reception into the Christian worldview? What was the relationship of the prehistoric architectonic customs of individual peoples to the common international types? To what extent can we understand regional style as the dwindling of codified monumental types into unself-conscious local tradition?

All these questions demand elucidation, which, in turn, requires the discussion of a series of preliminary questions. First of all, we must consider some issues that take us back to the very beginnings of architecture and that, unfortunately, can produce results of only hypothetical nature.

The concept of history underlying this work is characterized by two main propositions. First, in its shift from cult object to autonomous work of art, Mediterranean Antiquity anticipated the developments of the later medieval West. Second, the attitude of the Middle Ages toward the work of art was more intellectualized and less based on the work's innate magic power, the primordial power of the created object, than was the case in Antiquity. Hence, despite the Celtic and Germanic peoples' untamed force and initially primitive condition, the medieval attitude is one step further along on the developmental path of human consciousness. Where the one attitude—the shift from cult object to autonomous work of art—would permit the problem to be considered starting with the Middle Ages, the other—the more intellectualized approach of the Middle Ages—requires consideration of the pre-Christian era for an understanding of the changes in the meanings of forms that occurred in the Middle Ages.

The Essence of Meaning

Various circumstances lead people to accept that "the building" as well as its parts may have specific meanings. These circumstances have had important

consequences for the selection of the components comprising the building as well as for their execution. These meanings are not concerned with static performance in the building's tectonic relationships, nor do they relate to the artistic merit or significance of the building, for that arises anew in each actualization of a form. The meanings are very much of an a priori nature in that they point toward a higher content, toward a specific contextualized association of ideas.

In the Middle Ages, meaning participated in the making of a work of art to an extent we no longer experience today. To make the "quality of reality" of a building (Dagobert Frey's *Realitätscharakter*) from that time come alive for us today, we must reconstruct this meaning for ourselves with the help of contemporary sources. But even if the material and methodological means for this undertaking are at hand, some general reflections on the different character of meaning in the Middle Ages and some discussion of the fundamental attitude of the Middle Ages toward the work of art are needed. Only then can we evaluate the broader implications of that use of meaning for the history of art.

To say that a work of art has a meaning is to point to something, to some arrangement within a wider nexus of ideas that transcends the material and formal organization of the work of art. The realm of the artistic is transcended in that the work of art comes to be understood as a metaphor, as a representative, as the material emanation of something else. This allusion is always present if the work of art portrays, represents, or "indicates" something. "A symbol does not have to be a work of art; indeed a work of art can, by means of the context of its meaning, have a symbolic effect that is not at all (or not exclusively) due to its nature as artistic object" (Frey 1946d:21). This symbolic character is not just some special form of art, however; it is the precondition that constitutes art. It is neither an accidental nor a background phenomenon but the property that integrates the whole.

The importance of this symbolic character of art lies in the varying degrees of intensity with which, at different times, the work of art engages with a higher meaning and the varying degrees to which the power of this higher meaning can be present in the work of art. The possibilities range from identity of the meaning with the object that embodies it to purely speculative and dialectically based associations applied to it by the beholder. In earlier times, the varying degrees to which the work of art partook of the spell-binding, magical essence of its model defined the necessity for the work of art and laid the foundation for, in C. F. von Rumohr's phrase, "the position of art in the spiritual economy of man." "The sociological function of art is based in the symbolic" (Frey 1946d:21).

A work of art has the capacity of "pointing toward" or "being indicative of" something—a capacity of being the spellbinding or enchanting embodiment of something. This capacity depends on the extent to which the work of art "denotes" and is equipped with specific formal characteristics—even inscriptions—that ensure instrumental efficacy and establish the connections with that to which the work of art points.

As the anthropological context in which the work of art served as an instrument for enchanting and "binding" a higher idea to physical matter altered over time, that higher meaning, and eventually its very existence, fell into oblivion. In this process, the work of art freed itself from the goal and object of its former context and became an objective creation, an aesthetically enduring composition. The reconstruction of that former context should become the primary concern of art history. Even if the elucidation of the primordial meaning of the work of art does not seem to say much about its individual constituent qualities, it nevertheless provides information of the highest importance for understanding why this form or that form is present in its typical—as opposed to individual—manifestation and why it was selected from the transmitted repertory of forms and was emphasized in particular ways.

The point is now to limit the problem of meaning to a specific subject and period: to architecture, because architecture differs in certain ways from all the other arts. And here we also come to the Middle Ages, to the extent that they can be distinguished from Antiquity and the Modern period, always bearing in mind that the Middle Ages "*aufheben*" Antiquity, in the Hegelian sense.

Because our own "mythic" commitment toward the now profaned objects is attenuated, we have nowadays only a very inadequate sense of the symbolic, and we understand it in an abstractly intellectual sense as mere allegory.[6] It is only through the study of primitive (prehistoric) and archaic (early historic) conditions that we can understand the growth and existence of the symbolic and its particular relationship to the architecture of the Middle Ages.

For early cultures, the act of designating a particular form to reify a given meaning, which was then embodied in that thing or shape, and then imprinting this form on physical material (together with accompanying artistic elements), represented something quite extraordinary. To borrow a term from Rudolf Otto, the act of depicting means putting a spell on something "numinous." In the process of re-creating and conserving that numinous something, a deflecting of its power, indeed a disempowering of what is depicted, happens in the here and now. These are the tools and instruments of primeval people who thought only in images and responded through images.[7]

The reality of the world of images created by man is contrasted to the menace and uncontrollable reality of nature. It is only in our day that it is no longer necessary to acquire power over the world of nature by rendering the ineffable visible. More suitable, more "expedient" practices are now available, ones that no longer partake of the sphere of the artistic.[8]

Because of the instrumental character of these "signifying" and "meaning" forms, the interaction of the beholder with the work of art was hardly a naive one. Rather, the observer originally engaged in an activity representing a very high achievement of the intellect since the higher concepts—the ideas—had to be present in the observer so he could identify the visual representation, decode it, and classify it intellectually.[9]

Until now, our discussion has focused on things and concepts of things, prototypes, and copies. However—and this primarily concerns higher cultures with their differentiated, transcendental religiosity, less fixated on the physical object—it is also possible for the work of art to be an instrument that illustrates and indicates something nonobjective, a comprehensive concept of an order that is not bound to objects, such as the kingdom of a formless godhead, for example.[10] Since in this case the image does not express the whole meaning but rather points toward it and alludes to it, the metaphoric character of the meaning comes to the fore all the more clearly. The work of art becomes the "metaphorical circumlocution of a taboo" (Werner 1919).[11] For the Middle Ages, the concept that "an idea takes precedence over the concrete character of a visual representation" (Hegel) was still charged with efficacy and power. Today, our senses have grown too dull to perceive this sort of thing. St. Augustine believed art had the power "to bind invisible spirits to the corporeal material of visible objects." Works of art thus became "like the bodies of idols; certain seductive spirits dwell in these images that are not without power to either injure or to grant certain wishes to those who show them divine honors" (Borinski 1914–1924:15ff.).[12]

The Medieval Work of Art

There is a primary, preinstrumental, nonfigurative aspect to the work of art that owes nothing to its specifically artistic dimensions. It is the power-filled object that we still know—in an "embalmed" form—as an amulet. The latter's efficacy resides solely in its existence and not in any pleasure of the senses that can be derived from it. It is the object's very existence that inspires reverence through its unusual appearance and material composition. There is no difference between image and ornament, content and form; the thing is effective in and of itself. The cult image developed out of this concept (Leeuw

1933; Löwy 1930; Kaschnitz-Weinberg 1944; Schlosser 1927f:219; Bullough 1914:63; Rapp 1950).

In a second stage, the work loses its essential immediacy and becomes related to the tribe or to an anthropomorphically conceived deity. It is no longer an idol that can act autonomously. Instead, through the medium of its form the work of art stands for something, it points toward something. It becomes efficacious through this signifying, through carrying meaning. At the same time, these images also become satellites of a greater, formless sacredness and are provided with forms to which meaning is ascribed. "In contrast to the fetish, the work of art is only the vehicle of artistic meaning; in reality what it means and what it is are *not* one and the same" (Frey 1946a:88). We can really speak of a "work of art" only when naturalistic forms are applied to an unrealistic setting or surroundings for an object (or to a support placed underneath an object) (Kaschnitz-Weinberg 1943:178)[13]—that is, when their goal is "to indicate the reciprocal activity of the subject perceiving the object as a work of art" (Hartmann 1933:97).[14] In other words, the object at the center of attention strikes the beholder's senses more vividly because its environment is self-evidently artificial—that is, artistically created. The form thus becomes the vehicle of the content.

Through its meaning—the meaning that the work of art both symbolically indicated and represented—the medieval work of art was filled with power and concrete reality and was more intensely effective than an object intended merely as metaphor. "In the mythic mode of thinking, when meaning is given to an object, that object in reality becomes identical with what it means. . . . Through the inscription of the name, the consecrated statue thus becomes the person himself. . . . It not only represents the person but partakes of him" (Frey 1946a:88).

> Nothing of the merely mediating comparison, of the metaphor or "emblem," adheres to the symbol; it stands before us as an unmediated reality. . . . However, as soon as we glance from the sphere of the religious over into the aesthetic sphere, the symbol moves immediately to a different meaning. Its actuality, its objective reality, seems to fade more and more, and a new element, the properly ideal, now comes all the more unequivocally to the fore. (Cassirer 1927:295)[15]

It is typical of the Middle Ages and demonstrates the concrete power of symbolic forms that these images not only served for the instruction of the people, but had an unforeseen justification for their existence in the fact that they were also satellites of the sacred and do not owe their origin to, for instance,

didactic intentions.[16] The figures placed far from human eyes in the towers of a cathedral, for example, though not cult images themselves, still share with the pre-Christian cult image that stood hidden in the *cella* of the temple this quality of being satellites of the sacred (Behne 1942).[17] "That the work of art should be positioned where it is not visible involves no rarified concept of higher religiosity (which would correspond, on the whole, to an advanced logical-causal way of thinking). Rather, it has more to do with the workings of an old-fashioned, magical attitude and belief" (Hartlaub 1938:2). The status of the physical form—that is, the work of art as object—rose to the degree that the statement contained within the form, its content or meaning, declined in power, might, and ineffableness. The emphasis on the act of artistic interpretation drains away what was formerly the vital essence. Increasingly, this vitality is ascribed to the power of human creativity. Because we have forgotten the meanings of the forms—or no longer recognize their specific powers—nowadays all works of art appear to us univocal. This is because only the medium of the forms of previous epochs is present to us, and we mistake it for the essence (Technau 1939).[18] We are therefore inclined to postulate a unified concept of art that becomes increasingly inappropriate the farther we go back into the past.[19] It is only when artists strive to produce the artwork's effect primarily by means of visual media that a concept of art can develop that later gradually becomes autonomous. At the beginning of the history of this concept, we find that the formal shaping of the work of art has only a lesser meaning, one of simple craftsmanlike competence in contrast with higher, cultic requirements. Later we see a concept of art developing in which the possibilities of the form outweigh everything else, and the achievement of the artist is likened to the divine act of creation.

This novel concept of art did not actually become dominant until the last years of late Antiquity (e.g., Pliny the Elder, *Naturalis historia* 34.52) and, after the numinous content had been dismantled, among the theorists of the Renaissance as well, with Ghiberti being the first. The precondition for such a concept of art is the separation of purpose from aesthetic pleasure. This pleasure in the work of art as a formal structure is made possible by separating the formal and aesthetically objectified character of the artwork from its instrumental aspect.[20] This development was probably first introduced by the practicing craftsmen—those who would later become artists and geniuses (Schlosser 1914, 1:9)[21]—when they compared the execution of their work with its traditional content. The creation of the object and the enduring nature of the purpose thus encourage the recognition of artistic expression as something apart from the rest of human activity. Form and content at first are one,[22] then they stand alongside each other, and eventually form becomes

the determining criterion of the work of art: pantonomy—heteronomy—autonomy (Bullough 1914). This process typifies the transition from the communally promoted purpose of the work of art to the individually conditioned experience of art as an "end in itself." Art thus acquires the property of being worthy of contemplation (Frey 1946b). This process, in which educated people came to feel only an aesthetic relationship with the images of the gods, had also taken place in late Antiquity, where any real devotion to the statues themselves was left to the masses (Schrade 1939–1940b:204ff.). Here the split between the artist—rich in fantasy, honored as a creator—and the lowbrow craftsman who is merely carrying out a commission was already evident. Christians criticized this new aesthetic interpretation of the work of art and the emergence of a new sense of the cult as early as the second century (Schrade 1939–1940b:210ff.).

Bernard of Clairvaux saw a danger in valuing what is edifying and beautiful in the work of art: "What is beautiful is more admired than what is holy" (Magis mirantur pulchra quam sacra).[23] This opinion would soon be on the rise again and gain predominance in the view of the Scholastics that Truth revealed itself in the Beautiful. It was not until this phase in the history of art that the work of art began taking the human eye into consideration and paying particular attention to its physiology. Perspective and calculation of the angle of vision from below are important symptoms (Panofsky 1927:258ff.) and characterize an "atrophy of the meaning ascribed to the artwork" (Lützeler 1934:14). Architecture remained excluded from the form-focused concept of art, strictly speaking, longer than any other art, and already in Antiquity it had been considered the farthest removed from "pure art" (Schlosser 1914, 1:57).

In keeping with the fundamentally symbolic character of medieval expression, the possibilities of understanding art both in the formal, late-classical sense and in the archaic-magical sense—the formal pleasure in artistically shaped objects and the worship of holy things in connection with the cult—were simultaneously present in the early Middle Ages (Elliger 1930, 1934; Ladner 1931:1ff.)[24] and also in the time of Charlemagne (Bastgen 1911:63ff.; Delius 1928) and in the time of Bernard of Clairvaux (Weisbach 1945:77). Reformers of all periods did not actually turn against art as such, but against both extremes: against the purely sensual pleasure in all things—even in those connected with worship—and against the liturgical worship of images that bore nothing holy within themselves.[25] On the one hand, the more the symbolic, indicating sense dissipated, the more latitude was given to the play of fantasy within the form. On the other, as the symbol grew into an increasingly concrete object, the form's "sphere of action" simultaneously

became restricted, and the intangible value of its aesthetic effect was considered less important (Schrade 1939–1940b:210).[26]

In its characteristic manifestations, medieval art came to be delimited by these two extreme possibilities, which have historical, religious, and anthropological significance. Repeatedly, medieval art seems to be pulled across the border between the two by historical events and developments, either back to the magic, object-bound art by newly arriving peoples (mainly by the Germanic peoples)[27] or forward through secularization to an aesthetically based nonobjective art. However, as long as art's sphere of action was primarily determined by the fundamental principles of Christianity, medieval art retained its specific character. Art did not qualify as an objective realm because of any legitimacy of its own; rather—based on Plotinus—it was seen as superior to the natural world, as presenting a visible, purified reflection of the heavenly order (Koch 1917:23–24; Elliger 1930:76). If we are willing to allow that divine power can descend into human bodies, where it can then be profaned by human weaknesses, why should we not believe that it can join itself to something, like a work of art, that is flawless by its very nature (Callistratus, quoted in Borinski 1914–1924:7)? The "images" (likenesses) stem from God's hand and point to him. He is the "primal image of all images" (Origen, Contra Celsum, 8.17–19, quoted in Koch 1917:20). Any image created by man, however, is inferior to the primal spiritual image, because it is made out of perishable material. Christianity first had to reject the possibility that created images themselves could contain magical qualities, that images arose out of themselves and could be revered in themselves, not just as vehicles or bridges, as likeness or indication.[28] The nature of art as representation completely determined its possibilities in Christianity. At the same time, this "serviceable" nature of art justified its status. That this understanding of art was frequently abandoned from the fourth century on is connected with subsequent historical factors that shook the spiritual foundations of art's position—a position that in many points is like that of the late Middle Ages.[29] Nevertheless, in order to preserve the spiritual nature of Christianity from recrudescent animism, magic, and the cult of objects, the original conception was repeatedly held up to notice by that element of Christian Antiquity that took refuge in the monasteries.

A characteristic feature of medieval art that grows out of this tension thus becomes understandable: art always appears in connection with the word—with interpretation—and this is the only way art is possible. The symbolic compactness of the compositions as well as the congealing of the classical naturalistic formal elements into signs and archetypal expressions support the argument that the nature of writing and the word, as something that

records and binds the spirit, affected art and left its stamp upon it.[30] As a result of this way of thinking, the work of art could become cleansed of the deficiency inherent in its materiality and of its sensual power of distraction.[31]

This extreme spiritualism becomes the conviction held by Christian intellectual leaders in their confrontation with those unconscious animistic currents that continually arise and from which life draws its sustenance. The compromise between these two—extreme spiritualism and unconscious animism—is medieval symbolism because it includes both the magical and the rational, each in its own way. The Catholic Church had emerged triumphant from the original differentiation of the spiritual and the physical world and held itself aloof from the dissension that was subsequently renewed. It did hold firm on one decisive point, however: the substantial presence of Christ in the sacrament of communion. If it had adopted an exclusively spiritual interpretation, the core of the cultic experience—the mysterious sharing—would, over the course of time, have been destroyed and would have become a mere symbol, very much like the fleeting memorial sign some see in the Eucharist today.

Berengar's conception of the Eucharist (mid-eleventh century) is characteristic of the symbolic structure of medieval thought (Ladner 1936:15ff.) and therefore also of the medieval conception of art. He held that the bread and wine were solely sacramental, not the material substance of the body and blood of Christ. "Sacramental" here means something like "analogous to," "a trope for," or "functioning like a sign" or "signifying."[32] Due to its spiritual character, the symbolic—the sign-like—came to be much more highly valued than the physical presence of the material. Berengar justified his opinion with dialectic and grammatical explanations. This extraordinarily high esteem for the word as a medium capable of representing and realizing matter without the flaws of real existence can be traced back to the assumption that language can exclude evil—the satanic element inherent in all earthly existence. The thing is purified in the symbol.[33]

Thus, in the Christian concept of art, the achievement of the symbol is twofold. When taking the divine, the spiritual, as its model, the symbol is inferior to the model, merely indicating and serving it. When the symbol portrays material, earthly things, however, it places them in contact with the divine, thus cleansing and purifying the subject and making it part of the divine order.[34]

Aesthetic Meaning

What kinds of meanings adhere to the work of art, and what consequences for the architecture of the Middle Ages are to be investigated? One thing all the

meanings have in common is that they indicate or point to something. What they point to, however, belongs to widely different realms that can be roughly classified as aesthetic, symbolic, and historical. The character of the individual meanings will be treated extensively in the sections that follow. Here we will simply trace the modern manner of perceiving architecture and lay the foundation for a scientific methodology to be nuanced and elaborated later.

The "indicating meaning" presses its stamp, so to speak, into the artistic form like a die so that something outside the artwork can be grasped and become visible. Today, this meaning is no longer a category of prime importance in our judgment of buildings as works of art. The concept of aesthetic meaning, where the individual forms are judged in terms of their contribution to the organism of the artwork as a whole, acknowledges none of this. In judging works of art in this manner, the realization of the work of art, in isolation from everything else, is taken as the ultimate goal.

Today, our aesthetic categories for judging buildings are based on perceptions and requirements that only in modern times—mainly since the Renaissance, the Romantic period, and *Jugendstil*—have become the wholly dominant categories. For example, we evaluate the work of art as an organism, as the result of a construction process, as an instance of the proper use of materials, and so on.[35] The dominant view holds that after satisfying its practical requirements—as dwelling, church, factory—the highest accomplishment a building can attain is to represent itself and its material justly, without false pretenses. In modern and in older buildings, we enjoy the harmony of the proportions, the freshness of the spatial composition, the appropriateness of the coloration, the solidity of the materials. These ideals no longer include any claims to a formulated meaning. There is nothing that is not grounded in the building itself. In addition, even the generally elevated feeling that comes from lingering in a monumental building is traced to the enjoyment of its rhythmic patterns. These categories were cultivated chiefly in the struggle against the historicism of the nineteenth century and its Second Baroque, characterized by the unconsidered use of elements chosen from diverse stylistic realms that were applied like masks with no consideration of any indicating meanings they may once have borne. There was, indeed, no concept of an encompassing order of which an entire building could be an analog (Sedlmayr 1948b:15ff.). Where man once trembled before the divinity, now he and his perceptions became the highest authority and a goal in themselves.[36] Since the nineteenth century, all sensitivity for architectural elements conditioned by purpose and endowed with the power to indicate—for "meaningful forms" to be more important than architectural utility—has been lost. "One should not mask the blank walls, which

are there for architectural purposes, with contrived constructions" (Hübsch 1828). Since the beginning of the nineteenth century, the tendency has been to eliminate such criteria as color, ornamentation, and column patterns in order to obtain a "pure" building.

As ethically and artistically clean as this rejection of false pretensions may be in contemporary architecture,[37] it is wrong to apply the standards derived from it without modification to a historical presentation of the architecture of the past. How, then, should the historian of architecture evaluate the styles of the past, buildings from which, without prejudicing their static stability, we could knock away engaged columns and blind arcades (as in the Romanesque) or ribs from the vaults (as in Norman architecture prior to the Gothic period), to say nothing of the monumental facings of the baths in late Roman architecture?

These modern parameters have been determined by the artistic implications of the concept of the organism, which has been applied to architecture after the fact. The purpose of the building and its static requirements provide the limits within which a free, artistically conceived form can be expressed.[38] In painting and sculpture, an emphasis on the unique and unchangeable, purified from every extra-artistic consideration, can go to such lengths that the task of illustration disappears completely, and every relationship that partakes of comparison, even meaning itself, is excluded from the work of art.[39] The work of art as organism declares itself in colors, masses, lines, and surfaces alone. The individual creative genius—artistic causality, so to speak—gives birth to the relations of the parts of the picture to one another. The observer experiences the picture not through the logic of comparison with a model but through the picture's immediate address to his "inner self," which responds to colors and shapes, not to a rational superstructure measured by meaning (Rothacker 1948).

We delight in the stoniness of the material and let ourselves be moved by the naiveté and freshness of the spatial compositions, but in the Middle Ages the sublimation of the material—the intellectual process of integrating the elements into the speculative structure of meaning—evoked the transposition and taming of the primitive. It was "honey from the rock, and oil from the hardest stone" (see p. 60). This speculative and intellectual content, which has also been transmitted in written allegorical interpretations, instructed the onlooker in how to understand the building.[40] The later medieval drive toward allegorization gave the medieval church its sublime and transcendental character, which is made manifest in incomparable manner in the Gothic structures of the thirteenth and fourteenth centuries (see figure 2.3). The natural weight of the stone, the harmony of the static relations, the solid, substantial

appeal of the colors—all of these became saturated with the symbolic inter-connectedness and the functionality of the meanings, whereby the directly perceptible appeal inherent in the material became transposed and elevated to a higher plane.[41] Through an ever-increasing control and domination over the material—material that had originally been impregnated with magic powers—meaning was allowed to shine forth, and physical substance was allowed to be forgotten. While medieval people experienced this process with pleasure and delight, we moderns, on the contrary, allow ourselves to be attracted to the physical elements of art again, which in turn leads us back to the more primitive relationships. We "experience enjoyment" in art—even the phrase is significant and shows the need to address the inner self in the context of our thoroughly rationalized existence.[42] In contrast, in the Middle Ages, the work of art made its claims chiefly on the rational super-structure, a flash of the intellect in a life still permeated with magic. It is in this way that the transmitted allegorical interpretations should be under-stood as true instructions and the formal shaping as didactic. All that we are capable of appreciating in medieval architecture is its formal and technical functionalism, but this is no more than its shell, so to speak, the fossilized im-print and empty mold discarded and bequeathed to us by that long-gone hu-man condition.[43]

In the visual arts, it is primarily the Baroque that turns away from this al-legorical encoding and descends to the primitive strata. For example, in the early Middle Ages all naively physical expression—like the Old Testament, particularly the Song of Songs—became detached from its immediate effect, because every visual image, every poetic account once sufficient in itself, now became the basis for a superstructure of metaphor and intellectual rationali-zation (Overbeck 1919:75–93; Dobschütz 1921:1ff.; Vollmer 1907). However, Rembrandt again sought out the immediate impact of the biblical texts and dissolved the encrustation of symbolism that had carried the traditional me-dieval way of thinking into modern times (Einem 1950).

Although the forces of the new emotional sensuality—with its religious roots in Protestantism—can already be observed in Dürer, it is only since the seventeenth century that this new personal *mentalité* has permeated the visu-al arts. Luther (*Tischreden,* nos. 2560–68) said: "When I was a monk, I was master of all spiritual meanings, I allegorized everything; afterward, howev-er, I saw that with allegory and spiritual meanings, nothing was anything. . . . St. Jerome and Origen helped one to allegorize things so. May God forgive them" (see also Jedin 1935). Goethe also had no sympathy for medieval alle-gory and the hierarchy of meanings connected with it. In relation to the Gothic he writes in *Elective Affinities*:

So far as I am concerned, I do not in the least like this assimilation of the sacred and the sensual, this compounding of them together. Nor do I like it that certain particular rooms have to be set aside, consecrated and adorned for the preservation and enjoyment of pious feelings. The sense of the divine ought to be accessible to us everywhere, even in the most commonplace surroundings, accompany us wherever we are and hallow every place into a temple. (Goethe 1971:206)[44]

According to this view, appreciating the work of art as such no longer requires knowing what the architectural sign means. Aesthetics and art history, to the extent they grew out of the way the modern artwork functions, developed criteria that were adapted to the totality of a building's effect and left the individual meanings unaccounted for.[45] It was mainly Carl Schnaase and August Schmarsow who through the elaboration of a more nuanced concept of space created a formal category that is eminently suited for identifying buildings as original or individual entities and to classify them methodically according to specific periods, styles, and regions. With all due respect for the achievements arising from this concept, it is necessary to point out that it forcibly excluded any integrating, instrumental character from the building. The building comes to be seen as a goal in itself. For a modern architect, "space" may well be a conscious aesthetic starting point, but in the Middle Ages "space" in this sense was not a conscious quality and therefore not one to be striven for. In the written sources, we read only of the higher meaning of both the building as a whole and the individual components composing it. The concept of space in modern art history, by contrast, presupposes the aesthetic concept of the building as an organism.

To begin with, we can say that the aesthetic meaning of forms has become increasingly important since the Renaissance, and in our day it is wholly dominant. When forms of the past are still used, it is mainly because of their aesthetic qualities. We no longer have the sensibilities to perceive that not every place has a status worthy of being distinguished by a column or a pediment. Today, building forms are deployed for their aesthetic contribution to the organism of the artwork as a whole. These forms have become the tools of artistic genius. This aesthetic meaning has also taken on various different colorations and cannot always be defined clearly and unambiguously. If early Christian or early Romanesque forms are conspicuously adopted in contemporary church architecture, this is not just because they correspond to our aesthetic preconceptions (the sense of surfaces and clear arrangement of spatial relationships) but also because they are conducive to contemplation. The virtues of their atmosphere speak to our contemporary spirituality. We could

say that the nonmystic, soul-cleansing, or purgative function of religion seems to be best expressed in these simple, clear constructions. For all that, historical meaning plays no role in this example, and Christian allegory scarcely figures in it either. At best, these forms echo a primal-symbolic meaning (in Semper's sense) (Schwarz 1947), one that is not brought about by the reception of ancient forms, however, but sought by the artist in new forms resembling the old. The new materials (iron, glass, concrete) and the modern concept of the honest, completely unique work of art are incompatible with a search for historical meaning.

This does not rule out projects occasionally being planned in other areas of modern architecture with a meaning in the old sense—that is, when the building is intended to serve a specific purpose. On May 29, 1948, the *Rheinische Merkur* reported that President Truman said an exact copy of the White House should be built in every capital in the world as the American embassy, so that when an American citizen visited his ambassador, he would feel that he was in the house of the president. This idea is an example par excellence of historical meaning: these buildings were not intended as works of art; rather, as copies they were to "express" the same meaning as the original.

The concept of the building as organism on which the aesthetic judgment of architecture is based has a precedent in an ancient architectural theory developed by Vitruvius. This "organic" concept has survived as an interpretive approach down to the present day. According to this way of interpretation, the work of art is generally understood as an organism, similar to the human being, or a living unity, the living, unified whole of the artwork in general (Brzóska 1931).[46] This also constitutes a "meaning," something that points toward an all-encompassing order. However, this order is no longer defined in terms of religion but is related to the highest authority of modern times—that is, nature. It is significant that—primarily in the Renaissance, but also in the nineteenth century—this organic order was not meant as a comprehensive one but was seen mostly in the exterior surface of the building, on the visibly articulated structure. Both Alberti and Winckelmann were of the opinion that the "substance" of the building—its unformed nucleus—was determined by the building's purpose and requirements and therefore did not belong to the realm of "art." The visible exterior skin, however, was the clothing "that serves to cover its nakedness" (Lotze 1868:515). Stone is dead matter whose value is exclusively utilitarian; organic life takes place on the stone's outer surfaces;[47] hence it makes perfect sense to conceal the materials of which the building was constructed. The "clothing-symbolism" or "symbolism of disguise"—Gottfried Semper's *Verkleidungssymbolik*—prevailed until the twentieth century. It is this clothing that is subject to the test of taste,

of *goût*; it is here that specific national and individual artistic principles can be recognized.[48]

Despite the classicizing slant of the concept of art-as-organism, understood in aesthetic terms, this separation of the "meaning"—in the sense of the building as visually experienced—from the dead matter belonging to the building's physical requirements is still medieval. With Schnaase's (1866–1879, 4:80ff.) interpretation began a methodological separation into spatial qualities and a concept of individual style. Only then did the building become understandable in and through itself; it no longer had to be explained as "deriving" from something else. Individuality became part of the building's essence and was no longer merely the modification of an ideal concept.[49] Although Schnaase's observations first paved the way for scientifically differentiated judgment and formed the foundation for later discussions from Georg Dehio to Werner Gross, his concept and method represented progress only when it dealt with questions of the originality of individual works. When it came to the architecture of the past, however, it relegated phenomena of the highest importance to the margins.

The Current State of Research on Symbolic and Historical Meaning in Architecture

Except for some recent research mentioned in the introduction, since Schnaase and his followers, theories concerning the problems of classicizing form in medieval architecture have disappeared from the literature of art history as an independent discipline focusing on questions of form. Shortly before and after Schnaase, however, there were two men whose efforts are being taken up again today.

The first is Friedrich Schlegel; after a journey from Paris to Cologne in 1804/1805, he recorded his views in the *Grundzüge der gotischen Baukunst* (1846b). For the first time since the Middle Ages, we find there a conception of the meaning of medieval architecture that, following a general Romantic tendency, was markedly Christian. The "idea" of the building revealed itself to him, for "the meaning was the primary goal of those ancient artists" who wanted to represent "the church itself, in the spiritual sense, in the visible building." The building should also "present in miniature, a copy of the eternal structure of heaven." "The divine meaning is the essential, which alone makes the beautiful beautiful and the ideal ideal. Without this relationship of beauty and ideal, one's discourse is idle chatter without content" (Schlegel 1846b:182ff.).

These thoughts are dependent on medieval sources, even in the way they are formulated. Schlegel saw this shift in the intrinsic meaning of Christian

architecture as resulting primarily from Germanic inventiveness, which had caused the Germanic concept of the infinite to be integrated into its reflection of nature in the building. In this way, the modern religious notion of nature-as-divine-revelation was inserted into the interpretation; at the same time, the required trope of the imitation of nature prevalent in Antiquity and the Renaissance became Christianized. It is understandable that Schlegel (like all Romantics) preferred Gothic architecture to Romanesque because of its greater richness of naturalistic forms and its obviously effective artistic fantasy. Here, again, it was only Schnaase's efforts that made a positive judgment of the Romanesque possible (Termehr 1950:86ff.).

The other great architectural theorist who dealt with the problem of meaning was Gottfried Semper (1878). While Schlegel was deeply rooted in the Romantic movement's efforts to recover and preserve the Middle Ages and owed his insights to medieval Christian sources, Semper takes his principal impetus from the materialistic currents of the nineteenth century. Intellectually aligned with Darwin, Comte, Lotze, Schopenhauer, and F. T. Vischer, he based his theories less on Christianity than on more general historical data.

By a strange twist of intellectual history, it was not Semper's pupils who received his inheritance; instead, it was Alois Riegl, a former opponent of Semper, who fruitfully exploited the latter's thoughts and methodically purified them. Riegl refuted the crude technical-materialist interpretations that had been presented chiefly by Viollet-le-Duc (1854–1868) and, with his concept of the *Kunstwollen*, was the first to consider the problem of meaning in a systematic way. Semper was firmly convinced that art evolved according to the principles of nature, but for Riegl "evolution" was inadequate as a means of understanding the architecture of the past. Having a strong aversion to the architecture of the Middle Ages, he took his examples from ancient Near Eastern, classical, and Renaissance architecture. Like Winckelmann, he saw the roots of architecture in the satisfaction of needs, in the response to necessity. The "primal dwelling," the *Urhütte* that also figures in Goethe's hymn of 1772, "On German Architecture" (Beutler 1934:31ff.), and that has its origins in the French architectural theorists of the eighteenth century (e.g., Laugier 1755), is also the starting point for Semper's observations. Like Herder's "primal language" (*Ursprache*), the Darwinian "primal cell" (*Urzelle*), and Goethe's "primal plant" (*Urpflanze*), Semper's *Urhütte* arises from the great ideas of the Enlightenment concerning life's history and prehistory. For him the image of the "primal dwelling" was imbued with the same naked necessity as nature's other raw materials. Having been fixed at the beginning, the formulation of the primal dwelling can be discerned in all subsequent buildings and establishes each building's unconscious symbolism:

For as the roots of speech maintain their validity and continue to pres-
ent their basic forms across all later transformations and through all ex-
tensions of the concepts they acquire, and as it is impossible to find a to-
tally new word for a new concept without losing the primary purpose
of speech, namely, being understood, that is, the new is always de-
scribed by extending the meaning of the old—so one does not dare
spurn this oldest type and root of the symbolism of art in favor of oth-
ers and leave it unaccounted for. (Semper 1878, 1:6)

Meaning here does not refer to the subsequent intellectual interpretations
of the building forms as understood by the Christian Middle Ages, but rather
to the meanings of the primal form that are present from the beginning and
are not susceptible to intellectual formulation or expression. Through exten-
sive documentation, Semper (1878, 1:200–350) demonstrated the survival of
the primal forms in pre-Christian architecture. He showed how building
forms that had been originally constructed in ceramic, textile, or wood were
carried over into stone and so came to compose the *Verkleidungssymbolik*, the
clothing or disguise symbolism of buildings. As a result of this thesis, the way
nineteenth-century architecture picked up elements from the past and wore
them unthinkingly, like carnival masks, is very obvious to us, but the pro-
found revelation of how the old lives on in the new does not have the same
impact. The modern efforts to build further upon these views, therefore, are
all the more important.[50]
 It is by retaining its form while changing its material that the building
first achieves expressive and "indicative" power and becomes understandable
on a rational level. Meaningful form becomes detached from technical, struc-
tural necessity. In essence, architecture is no longer "sophisticated construc-
tion, statics and mechanics equally illustrated and illuminated, pure materi-
al statement" (Stockmeyer 1939:39) but becomes the *image* of the tectonic and
can even become "art" (Kauffmann 1941). The consequence is a sublimation
of the technical and the material, a transformation of the "real" form into a
structure of the "ideal." "The form-motif loses the meaning it had in the
original material context and through the new context acquires a connection
to 'ideal' substance" (Stockmeyer 1939:45). This is Winckelmann's "clothing"
with which the dead material covers itself; "the form as a spiritual cloak,
which is thrown over matter" (Vischer 1898:54). Goethe also saw "seemingly
transferring the quality of one material onto another" as a characteristic of
architecture, and along those same lines Riegl rejected the technical-
materialist interpretation of art and declares that all portrayal is forcibly
achieved by working against the material and that each medium, such as

stone or ivory, has its own ideal *Kunstwollen*, so to speak, just as each mate-rial has an ascertainable coefficient of friction.[51]

Semper saw the retention of these building forms as bound up with the perseverance of the social institutions that had created them. The existence of the social institutions—the nobility, the king, the community, the priest-hood—is by no means exclusively a matter of blood or inheritance; other peo-ples can perpetuate these institutions if they visibly claim such a role—that is, if they seek to legitimize themselves through the reception of the correspon-ding older forms. On this basis alone, it is possible for Semper to connect the Egyptian temple with the Christian basilica, not by direct derivation, but as a spatial type that shows through, linked to a certain group of people and a certain conception of divinity.

According to Semper, the abstraction of the forms from their material confines and their survival in the imagination on the basis of a new connec-tion to meaning had its origins in two phenomena. The first is the applica-tion of the axial principle in architecture, whether in the alignment of the temple or palace in a celestial direction or in the symmetrical arrangement of the building parts. He believed that he saw the imprint of the cosmos in this principle, the satisfaction of a "cosmogonic instinct" in humanity (Semper 1878, prolegomena:xxiff.). Indeed, it can be shown that axiality prevails wherever the city, the palace, or the church is conceived as an image of heav-enly order, wherever earthly events are understood as reproducing cosmic processes (see pp. 147–58).

Semper's second phenomenon is the emergence of ashlar masonry—that is, the fashioning of a natural material in order to achieve its subordination and integration within the building as a whole. "In the Hellenistic *isodomos*, ashlar masonry finally completed the emancipation of the monumental form from the material through the sole, undeniable means of the total technical control over the latter" (Semper 1878, 2:374ff.). If we take the word "monu-mental" in the literal sense here—as relating to a monument, stimulating memory, recalling something—then indeed the meaning of this transition to ashlar masonry becomes extraordinarily important. Semper's ideas about this have been taken up anew in art history (Evers 1939; Kaschnitz-Weinberg 1944:23ff.).

Semper and his successors demonstrated their ideas using pre-Christian architecture and confined themselves mostly to that era. They sought to dis-cover the beginnings of the building forms in the given materials and tech-niques and to trace the imprinted elements of those forms as they lived on in other materials and in other techniques. And—like Walter Andrae and Alexander Scharff (1944–1946)—they tried to find how the house, which had

originally encompassed all human needs, affected tombs, palaces, and tem-
ples as they gradually became independent buildings in their own right, sep-
arate from the house (see pp. 136–43). Hans Sedlmayr (1948b), however, has
shown similar transpositions of a symbolic character in the architecture of the
nineteenth and twentieth centuries. Under the rubric of the *Gesamtkunst-
werk*—that is, the "all-encompassing work of art" and "work encompassing
all the arts"—he collected a series of artistic "coinages" that partake of that
highest status among the concepts of humanity: those in which God (or, more
accurately for the nineteenth century, the divine) was believed to reside. All
these *Gesamtkunstwerke* were conceived to be reflections of the cosmic order,
and all arts were subordinated to and integrated into this overall conceptual
order. These "abodes of the divine" change over time, but each new one first
appears in the form of the preceding one. The retention of the older form in
the new is not due to some inertia or unconscious habit of the craftspeople,
but must be understood as legitimation through long-hallowed coinages.
Thus, for example, house forms appeared in tombs, in temples, and in the
royal palaces of ancient Near Eastern cultures and in the structural arrange-
ment of royal palaces in Hellenistic cities and of the early Christian basilica
in the classical period. Likewise, city elements appeared in the medieval
church; church forms, in the city hall; and temple and church forms, in
nineteenth-century museums and theaters. Since the eighteenth century, a
whole sequence has appeared: the *palais* (the seat of the Sun King), the land-
scaped garden,[52] the museum (art as something holy), the Biedermeier home
(the "inner cathedral"), the theater,[53] the world's fair (excerpt and image of
the "world"), and eventually even the factory.[54] Each of these *Gesamtkunst-
werke* passes on the coinages employed by the previous one, adapting them to
new contexts.

In the work of Schlegel and Semper, both of whom were preoccupied
with symbolic meaning in architecture, the double possibility of symbolism
becomes clear. The immanent symbolic meaning, which Semper drew to our
attention, begins with the very beginnings of architecture. The symbolic
meaning can appear when one building form visually "stands in" for anoth-
er one with which it once was identical—for example, the tomb as symbolic
of the house. In contrast, the allegorical meaning was originally not identical
with the form depicted—for example, the church as allegory of an ark.

In addition to these kinds of meaning, there is yet a third one that has
only more recently become clear as a result of the material collected by art
history, and we may best call this the historical meaning. The historical
meaning became evident when the phenomenon of building forms being re-
ceived over vast spatial and temporal distances, even occasionally from com-

pletely alien cultures, was encountered in historical documents. Concepts had long been available to explain these appearances, largely on aesthetic grounds. One spoke of renaissances—rebirths or revivals of art of the past— in which the observed tendencies of the Italian Renaissance of the fifteenth and sixteenth centuries were transposed to apply to seemingly similar reappearances in earlier times. Renaissances were discovered in Antiquity (Rodenwaldt 1931); one spoke of Carolingian (Patzelt 1924), Ottonian (Naumann 1933), and Hohenstaufen (Hashagen 1937) renaissances. Recently, however, it has been claimed that the model of the Italian Renaissance does not suffice to explain these earlier manifestations (Panofsky 1944; Paatz 1950; Heer 1949). Those earlier receptions and the actual beginnings of the Italian Renaissance are indeed due to the classical forms being received, yet not so much because those forms had taken on a new aesthetic meaning but because of their historical meaning. That is, forms were adopted because of the way they had been employed in the past by patrons into whose line of succession certain new patrons now wished to enter by taking up those forms and employing them in new contexts. This can be illustrated by the partial and fragmentary copies of classical forms that were made during the Middle Ages; in many cases, they were not aesthetically effective at all—for example, Charlemagne's adoption of the Constantinian transept (Krautheimer 1942a). The Italian Renaissance was the first to see the art of Antiquity as a whole and to wish to revive it as a whole.

There is another concept used in the literature of art history to explain the appearance of forms that are similar to those of cultures of the past: that of parallels in growth. The idea of growth implies that the art of a people or a region is an organism that then exhibits a development from bud to blossom and eventually declines to decay. When this model is sweepingly applied to cultures, the implied process finds in the culture under discussion corresponding phases to establish the analogies the model requires. By thus identifying the finest flowers of a culture, one may thus rescue what is "proper" to every culture (the highest authority recognized by modern history and historiography) and may interpret correspondences between cultures as results of parallels in growth. By means of improved visual comparison, art historians could observe logical developments without having to take into account considerable "intrusions," so to speak, of forms that do not belong to the culture under discussion. Striking similarities, such as those of the sculpture of the thirteenth century to Roman or even Greek sculpture (Einem 1948), then reveal themselves as parallels. Without denying the existence of parallel growth in itself (for in painting and sculpture, it is of great importance), it must be said that in architecture this model fails. The continuous Carolingian transept

cannot be explained as an increased enrichment of the eastern end of the church (for the Carolingian transept appears from the beginning as a fully developed re-creation of the Constantinian transept), nor can the dwarf gallery of Salian-Hohenstaufen times be understood as a growing sculptural and spatial development of blind arcades (Kahl 1939), for it appears fully developed on Speyer Cathedral in the eleventh century. We could justly argue that the "preliminary stages" and "fading echoes" found in blind arcades— which are to be found only in regions outside the upper Rhine Valley—are almost randomly selected by the researchers and represent something completely different, perhaps a survival or a stratum received from some other classical building form, such as the blind gallery. As we have noted, the efficacy of parallel growth in architecture should not be completely ruled out, but in every case it requires careful examination to differentiate parallels in growth, which can be established only aesthetically, from true reception motivated by historical claims. The difference is one between unself-conscious habit, in which variations will always occur, and conscious tradition, in which the fully developed type stands at the beginning (see pp. 119–28).

While the concepts of parallels in growth and renaissances have insinuated themselves into our methodology as the result of the observation of the sources as they have come down to us, there is another architectural phenomenon that forbids the application of these concepts and is wholly incomprehensible in formal terms. In certain cases, documentary evidence informs us that one building was intended to copy another, and yet we can observe no formal similarity between the two buildings. Here we are dealing not with an unconscious parallel in growth but with a conscious intention, not with a renaissance recognizable in the forms but with a reception that is not satisfied with aesthetic effect and visual appearance. We must accept that it was truly believed that the copy did indeed reproduce the building on which it was modeled. The notion of a copy, therefore, must have been different from what it is today. That is, copying did not consist in complete formal congruence. The meaning of the forms must have been detachable from them; that is, the particular form must have been only one of several possible vehicles for the meaning that is intended to be conveyed (see pp. 49–51).

Historical meaning has many nuances and borders on the symbolic and aesthetic as well. It is primarily bound up with the official architecture of those people and groups in society that wish to be considered the heirs of earlier communities. It could not appear in human history until the moment when the consciousness of transience awoke and with that the necessity to overcome it.

Sources and Methods: The Sources

The following kinds of sources will be our guides to the meaning of forms:

1. There are the written and visual sources that directly express the symbolic or allegorical meaning. Due to their fundamentally Christian outlook, these sources present a comparatively unified appearance (at least, as far as the Middle Ages are concerned), and so they will be treated separately from those that express the historical meanings. The relationship of the form to the meaning (whether the meaning had always underlain the form or whether it only subsequently came to be perceived as underlying it) underwent a change in the central and later Middle Ages. In the later period, there was an increasing effort to make indicators, which at first had been only intellectual or cultural associations, more and more visually perceptible.

2. There is the selection or rejection of certain forms by the *Bauherr* or commissioning patron. It is here that such meanings as might have accrued to the form through its prior historical application become evident. This meaning does not stand in an allegorical relation to some greater whole, nor can it be expressed metaphorically. Rather it points toward the historical powers the *Bauherr* represents and through which he would legitimize himself: empire, papacy, reformist monastic orders, and cities, to name only the most important. Here, for example, the "Roman-ness" of the manifestation (so often appearing in the written sources as *Romano more*) can include a meaning that is to be made visible through certain forms and whose meaning the *Bauherr* intends to revive.

For example, in the eleventh and twelfth centuries, the double-choir layout becomes connected, for seemingly the first (and only) time, with a specific meaning, one that grew out of the imperial metaphysics of the Ottonians and Hohenstaufen (Unterkirchner 1943:59ff.). Although the type had already been present in Carolingian times and earlier, in those earlier cases it owes its appearance either to coincidence (Kitschelt 1938:80) or to liturgical necessity and thus to the fulfillment of a purpose.

A similar accrual of meaning (one that can be traced only with elucidation of historical connections) may have caused Charlemagne to repeat Constantinian ground-plan types and encouraged Conrad of Hochstaden to receive a building of the Île-de-France in its entirety as a model for his Cathedral of the Three Kings in Cologne. A historical meaning can be supported by a symbolic meaning, but it can also stand in opposition to the symbolic meaning. Thus the reception of the Corinthian capital—so closely

associated with Antiquity—by Charlemagne, Henry IV, Cluny, and the city of Florence is certainly not due to its faded pre-Christian symbolic meaning (the column-as-tree played no role in medieval allegory) (see pp. 74–75). Rather, this reception was due to the capital's historical meaning, one that had accumulated around its past applications. The Corinthian capital was tied to the idea of the authentically Roman and imperial.

The selection or, contrariwise, the rejection of such forms charged with historical meaning can be connected with either of two great groups representing inherent but contrasting tendencies within Christendom. One of them imposes claims upon the earthly world, urges the establishment of the kingdom of God on earth, and rules as deputy for the divine. This tendency can first be observed in the fourth century, and its main driving force is to be found in the delaying of the Second Coming. The second tendency is concerned with the rejection of all earthly pretensions, the conviction that all earthly "coinages" are fleeting, the primacy of humility over power, and the emphasis on spiritual tendencies of Christianity. The first, represented by the emperor and prelates of the church, enters into the succession of the *imperium romanum* (with all the accompanying consequences for art). This group forms the tangible kingdom of God on earth, makes history, and is the actual creator of art. From it proceeds that hierarchical quality so truly characteristic of the Middle Ages—the necessity of legitimization through other established, earthly powers. The representatives of this group, united at first in their common goals, had by the early Middle Ages already become rivals for primacy and true legitimacy, so that despite vehement struggles (with frequent changes of sides) the Western and Byzantine emperors, the pope, monasticism (in part), and even the caliphate attached themselves to a common tradition and selected the same architectonic building types in order to legitimize themselves.

Hence the *imperium* was at pains to sideline the strengthened papacy, embodied in the classical Roman pretensions of the curia, to the exclusively spiritual side. The papacy, though, alluding to the circumstances surrounding the establishment of the Western *imperium* and its dependence on Rome, challenged the emperor's claims transmitted from Antiquity and designated the power of the state as subordinate.

While the first tendency worked to preserve the continuity of the earthly order of power within Christendom and incorporated numerous receptions from Antiquity, the second was specifically Christian and adopted receptions only at a later stage. For this second tendency, the early Christian epoch (i.e., up to the fourth century) is the proper source of prototypes. Its representative is monasticism, a monasticism that opposes every worldly hubris, whether on

the part of the emperor or the pope. Here, latent skepticism toward the typical formations of architecture can first be observed. This skepticism was generated in the pre-Constantinian Christian communities' opposition to pagan rulership and later took root among the Cluniacs, Cistercians, Mendicants, and early Protestants, who initially appeared not as heretics but rather as reformers within this same tradition. It was paralleled later by the Eastern monastic orders in their own relationship to the Byzantine *imperium*. In keeping with this belief in the superiority of spiritual things over earthly ones, types that due to the nature of their meanings must literally make claims are also rejected. Whether the rejection of the hierarchically and symbolically and, indeed, physically "stepped" or gradated church building in which space is arranged in a structural hierarchy—like the rejection of the rich Corinthian capital, of the cult image without relics, or of towers—is to any degree based on a slowly fading consciousness of the symbolic connections of these forms (which would have been understandable, given the increasingly secularized use of these forms by "the opposition"), or whether the "spiritual" position fundamentally places itself in skeptical opposition to *all* formal appearances cannot be determined conclusively. In any event, we can conclude (and this is an indication of the existence of meaning within the form that we are trying to grasp) that these two latent tendencies in Christendom behave differently in relation to architectonic types. The net outcome of all this is that in seeking to legitimize themselves, reform movements eventually fall into line and create types (as did the Cluniacs), bringing themselves to those positions of power that invariably lead to hubris.

As a source, historical meaning is also exceedingly important for the question of the survival of types hitherto touched on only in passing—that is, the merging of types into regional practices and their decline into habit. At the very least, historical meaning gives us a key that can be applied critically to the question of how regional peculiarities of fundamentally contrasting character have developed. This does not refer to the appropriation and transformation of an individual form within the pattern of an established type in a geographically defined context, but rather to the reflection of historical conflicts between different regions.[55] For example, the architecture of Saxony (indeed, of Lower Germany in general) appears in a different light in relation to that of the upper and lower Rhine in Salian and Hohenstaufen times if we consider that the types were fixed according to one tendency in the imperial regions of the upper and lower Rhine, while the Guelphs and regions given to anti-imperial tendencies (e.g., Bavaria) were cultivating buildings of the type favored by reformers. In this connection, the question of the extent to which the indigenous forces of the region were conducive to one tendency or the

other will be left open. This is a question to be resolved based on the trans-formation of types and will not be discussed here.

3. There are sources that register the meanings inherent in specific build-ing elements, consisting of observations about the place in the building where typical forms appear. This is important for the investigation of individual components. Particular attention should be directed to the eastern and west-ern parts of the building. We know that the east is the place of the holy of holies and of the choir; it houses the altar and constitutes the focus of a group of integrated, very specific concepts (Sauer 1924:87ff.; Dölger 1918; Nissen 1906–1910). Likewise, we know that very specific symbolic meanings are connected with the western parts of the building (Kitschelt 1938:79). In themselves, these facts are already quite remarkable and should not simply be taken for granted, for they represent the reception of a specific stock of ideas, and that, in turn, produces numerous forms. It is therefore important to observe which types congregate around the eastern choir and which in the west. All the forms that have an exalted status as types, such as columns, niches, gables, and galleries, can first be observed in these places—initially tacked onto the surface and later integrated into the body of the wall. Partic-ular conclusions can be drawn regarding their intrinsic meaning when they appear not in their wonted place but, for example, in the transept or even in the nave, where they become elements of equal worth within an apparatus of forms that is no longer hierarchically ordered. Thus within the *Ostbau*, there may be places of higher or lower degree, closer to or farther away from the altar, for example, where specific forms are used, but in the vast expanse of the nave, the hierarchies level out. The triforium, the dwarf gallery, and the engaged column appeared first in the choir and in the western complex and only later in the nave.

This change in placement can be interpreted in two ways. It can express the fact that the meaning of the form was gradually being forgotten and that the form's effect was then based only on its appearance; in other words, it became secularized.[56] However, the change in placement of these forms can also mean that the nave, the place of the community, was gradually gaining a higher status; secularization can, therefore, mean not only the lowering of the hitherto holy but also the elevation of what had hitherto been subordinate.

In addition to these observations of the changing use of the forms on the building itself, the question of the origins of those forms accenting the east-ern and western structures of the building is also important. For example, it is particularly significant that in the Hohenstaufen epoch both profane and

sacral buildings can donate forms to each other, with forms from secular classical architecture, such as baths or palaces, appearing on churches and forms from churches occurring on newly constructed palaces.

4. Finally, there is the temporal and geographical distribution of forms, which can provide valuable information about the meaning of forms when a connection to the historical powers prevailing in a particular region or era can be demonstrated.

For example, the concept of the "regional peculiarity"—derived from the Romantic fiction of the genius loci—is invoked to explain the striking spread of the triforium in the period from 1150 to 1250 in the area delimited by Cologne, Basel, Lyons, and Caen (Kubach 1934). Regionalism can no more be denied outright than the factor of stylistic development, but it is of only limited effectiveness if we examine why exactly any particular form was selected in a particular place. The genius loci did not create the triforium; it must even be doubted whether that spirit was responsible for the reception of that particular form from the classical repertory. For then we would have to ask why these forms were not taken up again in the eleventh and twelfth centuries in the other regions of the former Roman *imperium* where blind galleries had proliferated in Antiquity. There was no discernible lack of enthusiasm for building in either northern Italy or Provence, for example. We would also have to ask what common geographic or ethnic foundation in the Basel-Cologne-Caen-Lyons area could support the phenomenon just described. Clearly, historical categories must be applied to arrive at an explanation. Charlemagne's continuation of the *imperium romanum* must play a larger role in the explanation than the tribe of the Franks. This is not to say that the intensity of the reception and the persistence of its application were not strongly supported by the regional idiom. In any event, after the initial reception, "habit" or "custom" must play a role in our evaluation of the situation. If the forms sink into unconscious usage as elements of the local building school's repertory of forms, then this represents a reduction of the capacity for thinking in terms of types. It is "habit" that perpetuates the forms without using them to express something—that is, for more than general decorative purposes. This "habit" represents a latent extra-historical force, one that moves the forms into the sphere of "artistic expression" and thus makes them available as objects to be subjected to an anonymous—or, mainly in later times, an individual—*Kunstwollen*.

It is not easy to separate "habit" from conscious manipulation. Due to the ubiquitous, unconsciously effective nature of visual tradition (and due to the inherent inclinations of the local artisans), habit is manifested in every artis-

tic realization, even in the first reception. But at the same time a meaning, an indication, also inheres in every artistic creation. The proportion of the one to the other is difficult to ascertain unless the written or visual sources enlighten us. These sources do not always refer to the symbolic meaning, the inclinations of the *Bauherr* are not always evident, and their application to the building is not always characteristic. That being the case, and having no further extra-artistic resources at our disposal, we must deal with each problem on an individual basis, returning to two specific methods of art history: morphological and structural analysis.

Sources and Methods: The Methods

1. Morphological analysis follows a specific form through its various transformations across historical epochs. Changes are defined by means of visual comparison and traced to various causative factors. The usefulness of this method emerges when we pose the question of establishing the unchanging meaning that is grounded in the form or of demonstrating those formal peculiarities that belong to a type and cannot be lost as long as it remains a type. With this method, we can track down what the form originally represented or illustrated and what lives on in the form, even if only symbolically or very dimly. Morphological analysis tracks the prehistoric reality that continues to resonate in the inherent meaning. Faced with the task of establishing what allegorical meanings were possible in earlier times, however, such an analysis must admit defeat. It can make the observation that a temple is actually a house and that a church can represent a city, but by itself it cannot conclude that, for example, the cross-shape of a ground plan indicates the four cardinal directions of the heavens, or that a tower "means" the Virgin Mary.

That is, the method breaks down when dealing with all allegorical or metaphoric meanings since these often change within one and the same form and can bring to light the most unexpected beliefs. When we have no literary testimony, we are here faced with riddles (Möbius 1944:264ff.). Methods of morphological analysis can also point out where forms free themselves from their functional constraints and become types by taking on their own, proper imprinted characteristics, ones that cannot be lost; alternatively, the newly independent types may retain only those imprintings that continue to be associated with the original meaning of the form. When morphological analysis ascertains the original form that was rooted in and determined by the building's purpose, it can then trace whether the form disappears or changes as the technical necessity for it decreases or alters. Detached from its

purpose, the form remains, living on independently and in monumentalized form. When it is then received in another cultural context, in a different time, we can assume that, like a parable, the form now stands for something and has taken on a meaning that elevates it into a type. It represents something and points toward some higher concept. Naturally, when considering particular monuments, it is always necessary to reduce the typical forms to their individual meanings for the specific building, to determine their contribution to its artistic substance and their role in ensuring its enduring existence as a work of art. In this book, however, attention will be focused on those remarkable features that are held in common, scattered occurrences of specific types in different times and among different peoples that, in this sharing of chosen types, come together through their points of resemblance and illustrate a commonality of concepts.

Certainly, factors other than meaning play a role in transcending purpose and in reception into another context. For example, in the twelfth century the dwarf gallery was applied to the articulation of the apse on many buildings in Germany, France, and Italy, and it fulfills various functions. Each of these functions has a long series of antecedents that can be traced back to very different realms, but only one function, that of inherent message—the meaning—retains certain basic features of the coinage when viewed in morphological terms. While there is a certain point of view that favors the existence of dwarf galleries, it cannot have been decisive for their reception. We could say that in the twelfth century the bodies of those hitherto decoratively chaste pre-Salian buildings, with their smooth, plane surfaces, came to be invaded with cavities serving as undercut foils setting off the corporeal, sculptured elements that came to envelop the buildings. Our example of the dwarf gallery is one such three-dimensional building element that can be found on the lower Rhine only after 1150—that is, after the beginning of Hohenstaufen architecture. An increasingly thorough articulation, starting from simple *premier art roman* blind galleries and niche galleries on the apse, establishes itself beginning in the eleventh century, at the end of which we find dwarf galleries that one can actually walk through (Kahl 1939).

A logical, understandable sequence is established in this way, one that demonstrates the development from nothing, so to speak, to the finished type. This approach, however, conflicts with some other observations. First, the dwarf gallery appears in Germany on the east choir of Speyer in its fully developed form, without being derived from earlier, less developed, or blind forms in the architecture of the upper Rhine region. Second, if we disregard the dwarf gallery's location on the apse, it can be seen to be related to the passageway that opens outward through a line of columns and follows examples

from ancient architecture—*propugnaculae*, *solaria*—that are far removed from medieval blind arcades but are related to *attika*, ancient galleries for the emperor's ritual appearance (e.g., the Porta Aurea in Split, the Mausoleum of Theodoric and the so-called palace of Theodoric in Ravenna, the Porte Saint-André in Autun, and the Palais Gallien in Bordeaux).

Thus, an approach based on the genetic relationships of forms, working within too small a radius, loses its value, and the morphological method, by surveying a larger context, is seen to be capable of obtaining better results. When seen from the point of view suggested by the forms of the Roman galleries, the receptions in Speyer appear in a very specific light, one heightened by the figure of Emperor Henry IV, who was very concerned to participate as strongly as possible in the tradition of the *imperium romanum*. We should perhaps ask whether it was not the successors of Speyer (successors in the sense of displaying similar pretensions) that subsequently first provoked the formal requirement for a dwarf gallery of similar shape (e.g., Mainz and Schwarzrheindorf). Apart from these connections that flow from Roman architecture, the other functions of the dwarf gallery—the highly debatable lightening of the mass of the apse vault behind it; the possibility of speaking from it on special occasions or exhibiting something[57]—all carry little weight. They have prototypes that are unrelated to the formal appearance of the dwarf gallery as type.[58]

2. While the approach of morphological analysis assumes a more or less typological character—juxtaposing the forms in their changing appearances in order to determine them more closely—structural analysis proceeds from the individual appearance of the specific monument whose structure is first established, and only subsequently is that structure compared with others. Nevertheless, structural analysis cannot track down an allegorical meaning—that is, the particular metaphoric significance of a form. Unlike the morphological approach, it cannot even uncover the symbolic, mythic meaning, the earliest content of the form, but it can clarify the indicative, associative function of the form within the context of the work of art as a whole. By grasping the aesthetic sense, it can help forge links to the religious essence of the work of art.[59]

2

The Symbolic Meaning of Buildings
According to Written and Visual Sources

The Written Sources

The Role of the *Bauherr*

THE WRITTEN DOCUMENTS may be divided into two princi-
pal groups. First, there are documents concerning facts that
relate to the inception of the building process, to con-
secrations, to the *Bauherr* (and occasionally those actually
working on the construction of the building), and to the or-
dering and intended uses of the spaces; these documents sel-
dom deal with the formal design of those spaces. Second,
there are the specific descriptions, mostly later ones, of the
richness of the design[1] or of the allegorical meaning of the in-
dividual parts,[2] but these documents only rarely touch on the
effect of the forms on the viewer.[3] Although earlier research
criticized this documentation for its omissions—unnamed
artists, unacknowledged influences, and unreported techno-
logical advances—it has a positive significance in regard to the
questions we are asking (Krautheimer 1942b; Förster 1943).

Central to all this documentation is the patron (or the
founder), whose agency can penetrate deeply into formal de-
sign. Even consecration inscriptions on Egyptian temples be-
gan with: "He (the king) has built this as his memorial"
(Dworak 1938:53).

The buildings of the Egyptian kings were conceived as
dwellings of divine beings and did not belong to the realm of
the transient, not simply because they were made of unchang-
ing material, but because they proclaimed themselves eternal
testimonies of the ruler's power and might. For the Middle

Ages, such a conception of fame (which would become important again in Renaissance architecture) certainly must be qualified. Of course, the idea of building a monument to oneself could play an important role in the earlier Christian Middle Ages as well, as Ruotger's (1841) statement concerning Bruno, bishop of Cologne, shows: "The memorial these pillars comprise will stand where they were built forever, so that the memory of so great a man will be carried, untroubled by the passage of years, even unto the end of time" (267).

However, the medieval memorial intention is very different from the more modern one. During the Renaissance, for example, the patron showed great concern and haste that the architectural memorial be completed during his lifetime, and he sought in his last will to secure its completion under any circumstances. The Middle Ages showed little of this concern because of the fact that constructing a church as such already meant working on the realization of the kingdom of God. Building a church was in itself a religious act. The glory of the patron was thus associated with the process of building and independent of its completion (Schneider and Schelke 1950:1265ff.).[4] Doubtless, the religious meaning of the act of building accounts for many such projects in the Middle Ages, in terms of both their sheer number and the length of time required to bring them to completion.

"In speaking of a creator of a work of art, the Middle Ages combined the *autor* with the *auctor*, and both meant something slightly different than when we speak of an 'artist.' Even the function of 'founder' or 'patron,' seemingly so unequivocal, leaves open the proportion of intellectual to manual activity in their role, which sounds strange to the modern ear" (Swarzenski 1932:241). The *Bauherr* determined the ground plan—and may even have determined the individual forms—or, by his selection of builders, gave direction regarding his intentions about the prototype to which he wished to relate his building. Medieval sources that refer to the *Bauherren* abbots Ratger and Eigil of Fulda and Anstaeus of Metten and to the bishops Benno of Osnabrück, Bernward of Hildesheim, and Poppo of Trier as "architects" are not mistaken; on the contrary, they are reporting exactly what matters. Since the *Bauherr* is responsible for the selection of the building's type, his responsibility includes the shaping of the building. We know that from Ottonian times on, bishops sought to replicate the buildings of the emperor in their cathedrals as well as in their palaces. We know that the emperors took great care to reproduce the building types of earlier Roman rulers in order to support their aspirations to the same rank and status. We know of Constantine's translation of Hellenistic ideas of kingship into Christendom, and we know how careful various *Bauherren* were to evoke the Church of the Holy Sepul-

chre in Jerusalem (Krautheimer 1942b; Dalman 1922).[5] It is rare for build-
ings of the Middle Ages to reject conscious derivation from an outstanding
model. Only with unimportant construction projects was the decision made
to follow vernacular building practices and traditional craftsmanship. The
master of the works of a great project had to channel his ingenuity into copy-
ing, not into creating "original forms." The perfection of the statement was
valued above all, not the expression of the artist. Here the preeminence of the
patron over the actual craftsmen and his far-reaching participation in the
building process comes to the fore. Hence it is also understandable that the
documentary sources should say that the patron *fecit* or *aedificavit*; translated
literally, this means the patron "caused it to be built."[6] It is true that there are
incidental references to wandering *comacini*, Lombards, and Greeks as
builders in the early and central Middle Ages, but it was only between the
thirteenth and fifteenth centuries that the profession of architect and the au-
tonomous workshop steadily grew in importance while the role of the
Bauherr in the planning process steadily diminished. At the same time, it
should be noted, the building came to constitute itself as a work of art, and
the statement of the building's content became less important than the ex-
pression of the building's form (Pevsner 1942; Jüttner 1933).[7]

It would be misleading to attribute the anonymity of the individual artisans
to the dominant position of a *Bauherr* who gathered all the glory to himself.
Rather, it is a reflection of service in a collective endeavor, not unlike one that
in pre-Christian times might have concentrated on a divine ruler or on the af-
terlife of the dead, but now was devoted to the Christian Plan of Salvation.[8]

The Medieval Copy

These observations on the position of the *Bauherr* already highlight some of
the qualities of the architectural prototype: the meaning that was perceived
to inhere in it and hence its eligibility for reception. These qualities are close-
ly linked, as it is the meaning—whether inherent in the form or subsequent-
ly perceived as underlying it—that first renders the form worthy of being re-
ceived as a prototype. We must now ask how the form must be constituted
and which of its characteristics must be copied in order for the prototype to
be recognized in the copy. When comparing a completed monument with
the documentary evidence, we must bear in mind that the medieval copy
never completely replicates the original but only its most important charac-
teristics—that is, the ones that refer to content. Forms are carried over into
the copy only insofar as they relate to the meaning of the original. Often the
documentary sources proclaim an intention to build a copy of a prototype,

but no copy or even partial copy is in fact ever constructed. Thus, although there is documentary evidence that Germigny-des-Prés was an imitation of the Palatine Chapel in Aachen, Petershausen a copy of St. Peter's in Rome, and the Carolingian palace of Aachen a replica of the Lateran palace in Rome, they are not recognizable as such in their formal aspect. Reception depended not on the splendor of the construction or the beauty of the forms, but on the significance associated with those forms. That is, it was based on the meaning those forms were associated with, both in the prototypes and in the copies, and that they were seen to express. As long as the associations or power of the holy events connected with the prototype could be invoked in the copy, an approximate formal similarity was sufficient. For this correspondence, even such commonplace factors as the number of supports, where the numbers eight and twelve played a particularly important role, were sufficient (Dölger 1934; Sauer 1924:61ff., 387ff.). Symbolic numbers can also be applied to the dimensions of different parts of the building, where they take the place of the classical system of strictly regulated proportions (Krautheimer 1942b; Mortet 1896, 1898). Three or four repeated dimensions in the building and a few copied elements were enough to ensure that the meaning expressed was considered identical. The more unusual the form of the prototype and the more distant the artistic environment from which it derives, the less was a total copy expected or required. A few elements reminiscent of the prototype sufficed. The prototype is broken down into its typical parts—like quotations, these come to stand for the type—and these parts are then regrouped in new ways in the copy. Sometimes the model is called vividly to mind and lives on in spirit simply because the copy was dedicated to the same patron saint.[9] To this primary and most important common feature, the same name in the dedication, a few visual characteristics can then be added.[10] This "naming" of the intended meaning sufficed to establish identity with the prototype.[11] We find formally complete copies only later, in historicizing epochs. Buildings of past epochs became independent as works in their own right and as aesthetic objects only once there was an awareness of temporal distance.[12] This phenomenon can be seen particularly clearly in buildings intentionally imitating Jerusalem's Holy Sepulchre. While the buildings of the eighth through thirteenth centuries differ strongly both from their prototype and from one another and completely adopt the style of their own era, in the sixteenth century we find for the first time imitations of the Holy Sepulchre erected with fabulous and charmingly oriental forms intended to reproduce the original as a visual whole; a good example is the Holy Sepulchre of 1505 in Weilburg (*Bau und Kunstdenkmäler* 1907:4).

Since that time, the historicizing tendencies in all church building have been a noteworthy feature. During the Counter-Reformation, Jesuits in the conflict zone of northern Germany adopted Romanesque and Gothic forms because these were associated with a spirit of universalism. In Bavaria, however, where this defensive stance was not necessary, the Jesuits built in a Baroque style derived from Il Gesù in Rome without historicizing tendencies. Yet, astoundingly, even here they had recourse to very traditional ground plans, including cruciform and double-ended layouts (Reiff 1937).[13]

Historical Consciousness in the Middle Ages

In the Middle Ages, a feeling of historical distance is almost never present. The concepts of "old" and "new" are encountered throughout, but in most things people felt themselves to be on a continuum (Spörl 1930). The people of the ancient world, too, knew full well the difference between their present and the past and understood the concept of progress—and they also had a nostalgia for a better past that they wanted to renew or re-form.[14] Indeed, complex concepts, such as culture, were seen as subject to a general process of growth, flowering, and decay.[15] However, in Antiquity—and in the Middle Ages even less so—people scarcely felt that the bridges to the past had been burned so badly that they could not be repaired. There were no perceived revolutions in the Middle Ages; rather, the Middle Ages held to an essentially traditionalist position.

Those in power derived their legitimization from the past, from the concept of a theocratic state as revealed in the Christian Plan of Salvation, which was so closely tied to the *imperium romanum* and in which all forces of order were implicated. Departure from this structure of universalism grounded in the past was inconceivable: "Nothing should be made anew, save what has been handed down" (Nihil innovetur, nisi quod traditum) (Cyprian, *Epistolae*, 73, 21, quoted in Dölger 1929–1950, 1:79ff.). The fact that modern and medieval perceptions of the assessment of the work of the individual medieval artist differ so vastly is closely tied to this. To hold fast to the old is not impotent and mindless perpetuation; it is the expression of a specific ethos growing out of the desire to be seen as working within the Plan of Salvation. The new, then, is a blemish.[16] This hardly means that one does not rejoice in individual achievement and see each work as unique, but the uniqueness of the artistic achievement lies in the splendor with which it acclaims the fulfillment of the Plan of Salvation, not in the artistic individuality or originality of the forms.[17]

The practice of referring all facts to the Plan of Salvation revealed by Christ—in which all historical changes, all increase of power, were seen as

being in the service of this notion of the kingdom of God—was not conducive to a consideration of real, historical time. In this context, time is only the material prerequisite for progress in the realization of the Plan of Salvation or for the reform of deviations from it. Even the ideas of the Italian *rinascità* (rebirth) in the fifteenth century were originally completely consonant with medieval universalism (Burdach 1926:97; Kauffmann 1941). People wanted only to renew, to revive what had been stifled. Theology, science and scholarship, and even art were all committed to a dogma not susceptible to change. It could be explained, purified, nuanced, and even reformed, but it could not be overturned. This corresponds to the belief in authority and the high value the scholastics placed on patristic proofs. One of these fundamental principles was the promise that the Roman Empire was the last empire on earth and that Judgment Day would follow it.

This picture of history applied by Jerome, Orosius, and Origen to Christianity was founded, in turn, on the Hellenistic principle of the four world-empires expounded by Claudius Ptolemy: the Assyrian-Babylonian, the Medan-Persian, the Greek-Macedonian, and the Roman, the last persisting until Judgment Day, which would signal the beginning of the Heavenly Kingdom (Spangenberg 1923; Spörl 1935:19; Martin 1929:311; Adamek 1939): "Quando cadet Roma, cadet et mundus" (When Rome falls, then falls the world) (Bede 1862:543).[18] In the thirteenth century, people still lived within this continuum—in the fourth world-empire, the Roman[19]—and even as late as the seventeenth and eighteenth centuries we still find evidence of this consciousness (Lauffer 1936:6ff.).

Every subsequent empire wishing to wield power had to enter into this tradition and attempt to legitimize itself in those terms. This constituted the main task of the historiographers of the German emperors.[20] However, non-German historians became more and more aware of their own nationality. Once peoples such as the French, English (Normans), and Italians began to doubt the legitimacy of the empire, they tended to infringe on the concept of universality, for which they were reproached as "innovators." Naturally, they looked to the other legitimate successors of the Roman Empire, especially the papacy and Byzantium.[21]

It is here among the opponents of the concept of empire that the idea of establishing definite historical caesuras first emerges. Whenever the unity of the German *imperium* was threatened, when other nations gained strength, and when rivals to the idea of prolonging the Roman Empire attained power, these opponents proclaimed that "the empires" were at an end and past epochs finished, and that something fundamentally different was being inaugurated. The interregnum between 1250 and 1300 was such a moment.

The nations engaged in establishing their own identities saw the interregnum as a liberation (Schmeidler 1909:56–57); the Germans working within the concept of the universal empire perceived it as ruin (Delbrück 1893; Steinhausen 1923:153ff.).[22]

Orderic Vitalis, William of Malmesbury, and Romoald of Salerno turned their backs on theories of a universal empire (Schunter 1926). They no longer stood within the tradition that believed in the *translatio imperii*, in the transfer of the symbols of the *imperium* that conveyed power from one people to another. Rather, "there are carriers of historical development, at times a whole people, that rise, overshadow others, and then sink, without any deeper historical laws necessarily being in operation" (Spörl 1935:63). Such ideas—that the end of the *imperium* had come—had been favored by West Frankish historians since the tenth century and became common in Germany after the end of the Hohenstaufen dynasty.[23]

This short sketch of the relationship of the Middle Ages to the past explains how the *renovatio imperii Romani* (in its Christian calling) received the great official architectural expressions of its past (Paatz 1950). It also sheds light on the particular elaboration these ideas underwent in the German realms and how their reception could be different there from how they were perceived and expressed by other nations and in other regions. Moreover, the earlier discussion also outlines the context in which those architectural forms were regarded. Although the forms' artistic structure had been largely determined in the past, architectural forms often came to be used in only a partial or fragmentary way—almost as quotations—because no perception of distance from the past had yet developed, which alone would have enabled an artistic form to be perceived in its totality.

This situation is also revealed in the relationship of the Middle Ages to the ruins of Antiquity (Heckscher 1936). Either the ancient buildings were ignored and used as a quarry, or they were turned into Christian churches in the traditional style. Alternatively, sometimes bits of the ancient structure were turned into precious elements within medieval buildings (Deichmann 1940; Weigand 1940:545; see also Bogner 1906). Only occasionally were buildings intentionally preserved for their inherent historic value (Spörl 1930:333n.172), as in Byzantium, where Theodosius I allowed the reopening of the temples that contained images of gods, "which are to be valued more for their artistic worth than their divinity."[24] Since the Renaissance, a very different attitude toward the buildings of Antiquity has taken hold and become the rule, an attitude that regards those buildings in a detached, objective way in their totality as aesthetic objects to be preserved (Schlosser 1914:5; Vasari n.d.:34ff.; Panofsky 1944:223ff.).

The Standards of Medieval Architectural Theorists

Compared with the standards of Antiquity, the particular standards of medieval theorists for judging the visible form of a building were noticeably diminished.[25] Although Vitruvius was known throughout the period, the categories relating to the visual arrangement of the facade of the building, "composition"[26] and "proportion,"[27] were no longer acknowledged as important. The dominating principle was now that of "arrangement of space," which is expressed in the ground plan.[28] Of the Vitruvian categories, only "shaping of space"[29] and "massing"[30] were still recognized as artistic categories. These three—arrangement of space, shaping of space, and massing—were the principles deemed suitable and sufficient for the judgment of medieval architecture (Lehmann 1938).

The Intended Purpose

In the written records of the period, a great deal of space is devoted to the intended uses of individual parts of the building. We learn about the provision and placement of altars; about the preferred locations in the church building for entombments; about sacristies and baptismal chapels; about the intended uses of the atrium, transepts, and pastophories; about the activities taking place in the western parts of the church; and about the functions of towers. There is no doubt that the ground-plan arrangement of the church mirrors the liturgical uses of the spaces, and there are many attempts to explain medieval church architecture in terms of typical solutions to the problems posed by utilitarian considerations (Gause 1901; Delinger 1936; Witting 1902; Liesenberg 1928).

This way of looking at things is certainly more appropriate than a purely stylistic one—to see the ground plan as shape or ornament—or than falling back on the *Kunstwollen* of individuals or whole peoples (Stange 1935).[31] However, it is still open to question whether evidence of the purpose of a particular building type can satisfactorily and fully explain the appearance or selection of that building type. Typical formations, such as the transept, westwork, and double choir, have been extensively investigated in terms of their functions, but the answers have not always been completely satisfactory. The effect of local building traditions or habits on limiting the purpose of the building has also been mentioned, in the sense that the purpose determines the selection from among potential building types. However, a more exact examination of those functional relationships and of the motivations driving the selection of any specific building type is required, since these relationships reveal much about the factors that gave rise to the type.[32]

It must be stated at the outset that in medieval architecture as a whole, the repertoire of individual forms is identical with that of late Antiquity, or at least it can be derived from types that existed then.[33] True, certain forms were particularly cultivated and modified in different regions by age-old local traditions,[34] but in its morphology every medieval building element can be traced back to Antiquity. Thus we can say that the building's purpose did not bring about the creation of new forms; rather, it only prompted the selection and adaptation of specific possible forms from the inherited supply. In the arrangements of the elements, as in the system of the elevation, there are characteristic medieval formulations but no new creations, no new typical arrangements of building elements that became fixed in their interrelationships and that were fundamentally different from those of Antiquity. Even that hallmark of the Middle Ages, the overlapping deployment of double or multiple architectural systems, had certainly already been prepared by Roman architects. This can be seen, for example, in the distinction of load-bearing and -weighting members in front of a continuous wall, in the combination of arch and architrave, in the separation of the continuous supports carrying a vault resembling a baldachin from the wall behind them—as in the Basilica of Maxentius—and in the "Colossal order."[35] If the building's purpose determined the choice of forms, then we must ask how we should understand the concept of purpose. If by "purpose" we mean practical demands and requirements, such as arose from the liturgy, then we must severely restrict its importance, for we can observe that "purpose" in this sense only seldom begets forms appropriate exclusively to itself. However, if by "purpose" we mean all those forces that inspire the reception and determine the use of a specific architectural form and that lie beyond the practical functions of the form itself, then we must ascribe a great power to this concept. Since all the forms used in the Middle Ages could already be found in the architecture of Antiquity, and since the forms' functions in the Christian Middle Ages were different from those they had had in pagan Antiquity, then "purpose" must be neither custom nor *Kunstwollen*, but something *outside* the physical form that allowed it to be received across a great distance of time and space. It must be a specific meaning, a specific intention, that was somehow bound up with the form and transcends the immediate reason for its use.

Even if later modifications were conditioned by liturgy, in early Christian times, cathedrals, parish churches, *memoria*, and baptisteries corresponded to no particular spatial types. Even the momentous invasion of ancient mausoleum types into Christian architecture after the fourth century indicates a reception conditioned by something more than function. In early Christian times, the requirements of liturgical use had a greater effect on church fur-

nishings than on church architecture. An arrangement of furniture and screens could be installed in very different spaces without having any effect on the structural elements (Deichmann 1950a; Xydis 1947) (figure 2.1).[36]

Even concerning the question of spatial organization as expressed in the ground plan, all we can say with certainty in most cases is that the practical purposes or needs availed themselves of forms that were received for other reasons and turned to good account. The practical purposes were common and international, valid in all Christian churches, and yet widely differing building types were used. We know, for example, that in the great Constantinian imperial churches—such as St. John Lateran and St. Peter's in Rome—tables were set in the transepts on which the gifts for the offering, an essential element in the early Christian liturgy, were placed (Klauser 1937:57) (figure 2.2).

The same goals were served, however, by pastophories, chambers on either side of the choir that were accessible from the hall where the community had gathered.[37] Sometimes, particularly in the early Christian architecture of Egypt, the two pastophories were connected by a corridor running around the outside of the main apse (Liesenberg 1928:78, 82).[38] Although the Roman transept at a later stage of development allies itself with a three-celled space that can be compared with pastophories (Lehmann 1938: 83ff.), the two

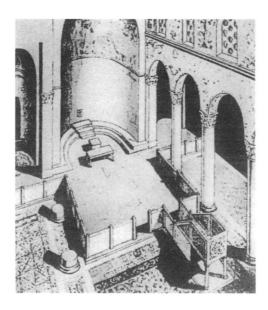

Figure 2.1 Gerasa, St. Peter and St. Paul, mid-fifth century. Reconstruction of the interior. (From Xydis 1947: fig. 29)

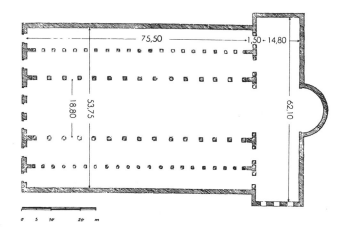

Figure 2.2 Rome, St. John Lateran, 314–320. Floor plan.
(From Deichmann 1948:plan 1)

forms—pastophories and transept—are completely different from each oth-er despite being put to similar uses. It is important to note that these two types exist side by side at the same time and in the same region, but most pastophories are found in the Middle East and Byzantine areas, while in the fourth century the transept is found only in the Constantinian state basilica that spread (despite its obvious Hellenistic origins) from Rome.

If in examining the genesis of the transept, we recognize that as a trans-versally placed space in front of a holy of holies it was already widely diffused in pre-Christian times, in both funerary and palace architecture, and if we admit the supposition that a specific meaning was associated with this arrangement (see pp. 167–79), this evidence of parallels weakens the defini-tion of purpose offered earlier, and the power emanating from it becomes even more questionable. The documented purpose of the offerings table— later the side altar—did not create the type but merely made use of it. How far a new purpose can change and adapt a received type is, of course, anoth-er question. In this case, purpose acts as a moderating factor that changes with the times, much like the regional traditions discussed later and the *Kunstwollen* that changes with the times.

A similar situation is found in the case of the double choir and the west-work, both of which are closely connected with the structure's purpose. While in most cases the documented purposes of these two are identical,[39] the genesis of their forms seems to point in opposite directions, even though the two types can also blend (St. Michael's in Hildesheim, for example).[40] For symbolic and

practical reasons, they are connected with the western part of the church and hence avail themselves of the building types appropriate to that place.[41]

The history of towers in medieval architecture remains obscure, for their documented purpose as structures for hanging bells and as defense works does not suffice to explain either their existence or their absence (Lasteyrie 1912:376ff.). The Cistercians and the Mendicants renounced the erection of towers but never the use of bells (Jüttner 1933:23). It could be said that the meanings connected with towers were not bound up with the intentions of these reform orders, and therefore when the orders were freed from certain earlier reasons for building towers, the towers' other "purposeful" functions (i.e., carrying bells) could be carried out more simply. Only when the deeper symbolic meaning weakens can considerations of purpose come to the fore and prevail without regard to such meanings.[42] Naturally, it cannot be denied that there are elements in medieval church buildings that occur for purely functional reasons (e.g., ridge turrets or buttressing), but these elements should not be considered types, since they have no enduring reference to the purpose of the building. They are present when needed and are absent when not. If specific meanings connect themselves to functional forms, and if those meanings displace the original requirements of the form, perhaps even making the form unfit to fulfill its original functions, only then can we speak of types in the sense we are suggesting. This process is clear in the way purposeful forms become typical forms through the accretion of meaning chiefly in pre-Christian architecture, for the apparatus of forms used in medieval architecture was already prefigured in Antiquity.[43]

In summary, the documentary evidence concerning the purpose of building parts and the arrangement of space tells us that, without exception, the individual building elements are receptions and imitations of ancient forms or follow from them. The building's purpose is not the chief reason for the forms' existence, and the purpose alone does not suffice to explain the appearance of specific and typical building elements. Even when we reflect on their technical and structural uses (e.g., by examining whether elements are necessary in terms of statics, a question to which the written records contribute little), we are continually astonished to learn that any technical advantage derived from an element is mostly secondary and subsequent to its reception as an object or image.[44] Naturally, most of the forms were developed in prehistoric times to satisfy a practical requirement and technical necessity. Their formulation as types, however, took place in Antiquity when they were refined in the transition from wood to stone construction and became traditional in the use of abbreviated symbolic elements stemming from house-building in funerary or temple buildings, thus designating those

buildings as the "house of the dead" or the "house of god" (Kaschnitz-Weinberg 1944:38; Scharff 1944–1946) (see pp. 134–43).

Regarding the typical medieval arrangement of spaces, it must be said that purpose *can* be creative. However, the question is whether a spatial arrangement already common in Antiquity, such as the transept, was received and was then merely used for a particular purpose. Where such retrospective connections are lacking and we see that a purpose has really prompted the creation of an arrangement, we should ask how long the purpose was sufficient to explain the arrangement's appearance. In other words, we must examine whether the same preexistent form was later received without the original purpose causing the reception, and whether the form disappears when the purpose no longer exists. There is not always an unequivocal answer to the question of when and where a meaning may be ascribed to a form over and above its practical purpose. Only when we can do so can we speak of a type in the sense we intend here.

If, however, we take the concept of purpose as having a broader sense and see it as a force that lies outside the form and includes signification and meaning, then its efficacy cannot be overestimated.

Written records are important testimonies to the intended purpose, for they often point in the direction where the meaning lies. As will be shown, such a meaning can be immanent in the form (e.g., the transept), it can grow out of the history of the type (e.g., the westwork), or it can be introduced as an allegorical reflection (e.g., when the cruciform ground plan is interpreted in relation to Christ's death on the Cross).

The Allegorical Meaning

Sources that expound the allegorical interpretation of the church building are another important category of literary record. Joseph Sauer (1924:282ff.) has collected those that have appeared in critical editions, and their relevance to church buildings has been established.

At first glance, these allegorical ruminations would seem to be a major source for the typological consideration of architecture, for they speak of cruciform and circular ground plans, of towers and columns. They refer to the building and its parts exclusively as types. They specify only the name of the genre, say nothing about the configuration of its specific features, and completely ignore style. They see the building as a sum of typical forms. Descriptions relating to color, number, and material composition of constituents are adduced only when these qualities, in turn, have a symbolic meaning. The only information about the buildings worthy of comment is

the meaning associated with the component parts. The fundamental attitude of allegorical interpretation is demonstrated by Durandus (1843) at the beginning of his *Rationale* (Sauer 1924:2ff.) and seems to agree completely with our observations: "All things, as many as pertain to offices and matters ecclesiastical, be full of divine significations and mysteries and overflow with a celestial sweetness, if so be that a man be diligent in his study of them, and know how to draw 'honey from the rock, and oil from the hardest stone' (Deut. 32:13)" (3). Our first line of questioning should be on the basis of the historically developed and recorded meanings of the forms or their immanent force. But notice that Durandus values things only insofar as they are meaningful and inasmuch as they relate to the divine Plan of Salvation—the only way in which it is possible to grasp true significance. Our question is: Which meaning has required the use of these forms in this particular place, at this particular time? Durandus's question is: Through which meaning do the forms, usually already existing, demonstrate the Plan of Salvation?

Sauer (1924), accordingly, comes to the conclusion that "when it comes to specific interior architectural components, thoughts about symbolism have in a great many cases simply been abstracted *post facto* from the given objects" (290).[45] Even in the case of the most common phenomena in church buildings—orientation and cruciform arrangement—Sauer (1924:292n.2, 294) remains skeptical, despite early Christian confirmation, that any early demonstrations of symbolic meaning could have created the arrangements under consideration. In order to put the problem on a solid footing, it is necessary to examine the main thrusts of the basic character of symbolic interpretation as it has come down to us. First, we must free ourselves from the definition of a symbol as "nothing more than an image representing a thought or an object, complete in itself, which evokes the concept in question without anything further being added" (Sauer 1924:2). Such a definition gives rise to often seemingly bewildering interpretations of those symbols that, in fact, will *not* reveal themselves without the addition of something further arising out of the object being interpreted.[46] These interpretations are subjective, speculative allegories that are applied to existing buildings only after they are built. Whether or not such literary allegories were actually intellectual commonplaces, in which case they could have formed the basis for a work of art, will not be investigated here.[47] These allegories represent only one subgroup of symbolic meanings for which generalized relationships were established long ago, in prehistoric times and in pre-Christian Antiquity. In Christian times, these meanings underwent a special and increasingly subjective intellectual and allegorical reformulation that distanced them from their older, inherent meanings. Most interpretations, however, clearly took the form as their point

of departure and therefore provide a good indication of what general meanings of the form prompted its reception.[48] Christendom appropriated forms (columns, apse, arch, tower, vault) associated with specific meanings—albeit meanings that were already fading from consciousness—and then, in their combination in a new structure, gave them a new significance as the New Jerusalem, the City of God, which is a modification of the age-old concept of the house of god. The church fathers Origen and Clement of Alexandria also adopted this transmitted symbolic significance and added a typical Christian meaning to it; they transformed it from a symbol (as the house of God) into a prototype (as the City of God). The church building now became a type and symbol of the Heavenly City, the kingdom of God, in which the faithful participated during worship. The faithful themselves were also an essential part of the church, and they bore the name *ecclesia*, a name that initially signified the spiritual structure whose beginnings reach back to Paradise and whose fulfillment awaits us in eternity (Schlesinger 1910:21ff., 8off.; Sauer 1924:4, 103; Knopf 1914; Sedlmayr 1948a; Dionysius Areopagitica n.d.:119–583).

The Church as Heavenly City

One common factor in all interpretations of individual architectural elements is that they are subordinated to the concept of the church as kingdom of God, both to the image of this concept and to its reality by reason of the real presence of God in the Sacrament and of the saints in the relics. Even the most peculiar interpretations never abandon this basic concept. Its beginnings are in the Apocalypse (Revelation 21:2ff.); it was taken up by the earliest exegetes, Origen and St. Jerome, and received its grandest formulation at the hands of St. Augustine (Sauer 1924:103).[49]

The fundamental concept of the New Jerusalem—a specific variation of the ancient concept of the house of God—developed out of descriptions of the Temple in Jerusalem in the Hebrew Bible and the Apocalypse. In the Christian interpretation, that concept came to be applied not only to the church building but also to the city (Braunfels 1950:39ff.; Kantorowicz 1944), the whole earth, the cosmos, the tower—which, in turn, symbolized the Virgin (Sauer 1924:141ff.)—and even the individual Christian (Sauer 1924:303).[50]

Just as the spiritual structure of the *ecclesia* can metaphorically be represented by different things in Christian allegory, so can the word *templum* refer to various precincts in classical allegory (and, from the fourth century onward, in specifically Christian allegory). Originally, *templum* was like the Greek *temenos*, an "area set apart," and retained this meaning also in later technical texts. (On the sacred meaning of the hallowed area, see pp. 135–36.)

Just as a Christian in the second century would not have understood *ecclesia* to mean a building, so Plautus, for example, would not have understood "temple" to refer to a particular building. *Templum* is first extended to include a religious edifice in Vitruvius and Cicero, and from this we can deduce that a wider-reaching cosmic allegory had come to underlie the house of god as a likeness of the divine order. Similarly, Lucretius could call the vaults of heaven a *templum*—that is, designate them as the locus of the order of the spheres—and Ovid could apply "temple" to the inner person, as Quintilian did to the theater. With Lactantius, Eusebius, and Ambrose, *templum* also became a common word for the Christian house of God (Flasche 1949).

The conception of the church as a likeness and earthly manifestation of the kingdom of God is a genuinely medieval one, and we may assume that it was shared by *Bauherren* and laymen alike. As Suger writes in describing Saint-Denis:

> The midst of the edifice . . . was . . . raised aloft on twelve columns representing the number of the Twelve Apostles and, secondarily, by as many columns in the side aisles, signifying the number of the Prophets, according to the Apostle, who buildeth spiritually, "Now therefore ye are no more strangers and foreigners," says he, "but fellow citizens with the saints, and of the household of God; and are built upon the foundations of the apostles and prophets, Jesus Christ Himself being the chief keystone," which joins one wall to the other, "in whom all the building" whether spiritual or material, "groweth unto one holy temple in the Lord" [Ephesians 2:19–21]. (quoted in Panofsky 1946:104–5)[51]

An examination of Suger's position may shed light on many of our questions. First, some points are to be established from which conclusions can then be drawn.

First, the building symbolizes the Apostle Paul's "word," which "buildeth spiritually." It therefore follows that every building, "whether spiritual or material," can grow into a temple of God, provided that the apostles and prophets lay the groundwork and that Christ is the keystone holding the whole construction together.

Hence the house of God is not in a specific place, but rather God is in every place where a spiritual or material construction illustrates the Plan of Salvation.[52] It is by means of this construction, both material and spiritual, that the house of God is realized. This illustration of the Plan of Salvation can be made manifest in equal measure by every ordering of the state, every building, every city, every individual person. These earthly manifestations

can be compared with one another insofar as they are based to the same degree on the idea of *ordo*, the Plan of Salvation, the kingdom of God. Indeed, the church building has been compared to the heavenly hierarchy, the city, and the form of the human person.[53]

While this indicates the possibility that these things could reciprocally serve as metaphors for one another—that is, building as city, human body as city, city as heavenly hierarchy, and so on—and thus some forms, such as the cruciform ground plan (with its reference to the crucified body of Christ), persist and proliferate, which in turn intensifies their allegorical aspect, it is nevertheless doubtful that either can be said to depict the other.[54] For neither the human body in itself nor the city in itself was something holy; rather, they are holy only insofar as they are susceptible to metaphor, insofar as they illustrate the kingdom of God. As we will explore, the city metaphors have been exceptionally rich in formal consequences for the church building.

Second, the supports of the church personify the apostles and prophets that bear aloft the building, which is the kingdom of God. For Christians, therefore, the building is the likeness of the living *ecclesia*, and the columns accordingly take on anthropomorphic significance. Christ is recognized as the keystone crowning the building and holding it together. The members of the community are "no more strangers and foreigners, but fellow citizens with the saints, and of the household of God."

Hence we deduce that in this way, the kingdom of God reaches into this world as a reality, and the faithful are its citizens. The "Heavenly Jerusalem" is not an apocalyptic historical condition, as current historicist thinking would have it, "but rather the final stage of the current condition" (Herwegen 1932:47). As Photios expressed it, "the believer is immersed in the sanctuary as if he had actually entered into Heaven" (Wulff 1929–1930; Grabar 1947). The church not just is a likeness of the Heavenly Jerusalem, but, because the individual elements of the church translate the sacraments and the relics into reality and make them manifest, becomes the reality of the Heavenly Jerusalem. This interpretation follows not from any formal development of the components but from number in the case of the columns and from position in the case of the keystone.

The idea that the one may be demonstrated through the other, that the one may partake of the reality of the other, permits Gothic panel paintings to depict heaven by means of Gothic architectural fragments, such as the church portal through which the blessed enter or the church interior where the Virgin is enthroned. This idea lives on in secularized form in the Renaissance, for example, when Alberti (1988) writes that "a city, according to the opinion of philosophers, [is] no more than a great house, and, on the other hand, a

house [is] a little city" (23). Before we approach the question of the formal consequences of this allegorical interpretation, a few words are in order about the twelve supports representing the apostles and surrounding the center of the church building, as in Suger's description of Saint-Denis. We can assume that this refers to the pillars of the ambulatory around the choir. That is, these pillars both support the building and stand around the altar, which is the throne and sepulcher of Christ. The columns thus represent an event or, better, a state of conditions in heaven into which people also strive to enter (and figuratively do by joining those pillars/apostles standing around the altar) to become, according to Suger, citizens and fellow residents of the kingdom of God.[55] Hence Constantine has twelve columns symbolizing the apostles standing around his tomb (Koethe 1933). This comparison of the dead to Christ by means of a reflection of the Holy Sepulchre does not necessarily point to a survival of the ancient conception of the god-emperor. Theodoric apparently followed the same pattern, thus presenting himself as the equal of Constantine (Schneider 1941b:404ff.). Bernward's tomb in St. Michael's in Hildesheim recalls probably even in formal details the arrangement of the tomb of St. Martin in Tours (Beseler 1946).

Placing oneself in an analogous situation is not so much hubris as an expression of one's consciousness of being a citizen of the kingdom of God. This also sheds some light on people's insistence on being buried in or near a church—that is, in the fellowship of the saints. It is worth considering whether or not the freestanding supports of an ambulatory around an altar or a tomb—in either a crypt or an upper church—are primarily suggested by the memory of the Holy Sepulchre. In all probability, such an arrangement should not be regarded as a copy in the same sense that the abbess's choir in the Essen Minster is a section copy of the Palatine Chapel in Aachen. Instead, it should be seen as combining the imperatives of the building's structural requirements with a compelling allegorization, one that was established at a very early stage.[56]

These supplementary remarks bring us back to our earlier questions:

1. Can the interpretation of the church building as Heavenly City be seen as generally binding for the Middle Ages?
2. Since the interpretation is an allegorical one, does it indicate a meaning that has subsequently been applied to an already existing form?
3. Can an allegorical interpretation have formal consequences, whether causing specific components of the building to become accentuated and brought to the fore in support of the allegory or resulting in the depiction of something originally introduced into the building as a metaphor?

The answer to these questions should unequivocally clarify our discussion of the symbolic meaning of architectural types.

The answer to the first question must be definitively affirmative. From Eusebius (*Historia Ecclesiastica* 10.4; Sauer 1924:103ff.) on, we find written sources describing the church building—the *ecclesia*—as the kingdom of God (Kitschelt 1938:9ff.). Undeniably, this idea's "degree of reality" has been fading in modern times: the idea of the kingdom's reality and presence has dissipated, and its metaphoric character has come more and more to the fore. Nevertheless, until the end of the early Middle Ages, our interpretation is correct. But by the same token, in early Christian times, up until the second century,[57] this interpretation—based as it is on the Apocalypse of John and the letters of the Apostles (Ephesians 2:19–20; 1 Peter 2:5)—had as yet no formal consequences for church construction. Before there could be a readiness to portray things, to make claims, and to express meaning through architecture,[58] more factors first had to come into play: the internal development of Christendom, the evident delaying of the Second Coming, the importation of relics into the church under the influence of the tombs of martyrs (with the consequent change of the conception of the altar) (Dölger 1930, 2:161ff.), and the official recognition of Christianity (with the accompanying forms of the cult of the ruler that were thereby acquired). When all this had transpired, Christendom would begin to adopt the even earlier concept that the building was not only a meetinghouse for the community of the faithful but also the house of God, which in pre-Christian times had been its primary function. The temple building had already carried meaning in pre-Christian times and had incorporated structural elements of domestic architecture that had originally been developed to meet architectonic requirements, from which those elements were now freed in their new context. When the concept of the house of God was superimposed on the human dwelling, the symbolic resonances—that is, of whose house it was and who the inhabitants were—were intensified. By virtue of its splendor and status, the temple meant more than a dwelling, for it was inhabited by a deity whose kingdom was the universe or, in earlier religions, by one whose realm was as wide as his power could reach. The roof of the building was the heavens; the floor, the earth; the supports, plants or superhuman servants that held up the whole. Such a cosmic interpretation made the point that forms deriving from dwellings were endowed with a significance extending beyond their simple structural functions. This universal meaning of the house of God—found in Hindu and Sumerian temples, in Mayan stepped pyramids, in Egyptian temples, in East Asian pagodas, and in Mycenaean *tholos*-tombs—early on also became connected with the Christian church building, which was able to find correspondence in countless biblical

references (Sedlmayr 1948a; Lehmann 1945; Soper 1947; Smith 1950). From numerous indications, we can conclude that the vault—even a rafter roof—signifies the canopy of heaven (Lehmann 1945; Soper 1947)[59] and that the supports represent the vegetative world or the world of living beings (Curtius 1913:42).[60] Here we are dealing with a godhead claiming universality, not a god merely connected to a spring or confined within a stone. The stage of animist religiosity was left behind. But even a man—king or emperor—who is seen as divine could be surrounded with such forms as these if his power is meant to be universal. Temple and palace can be identical, and the throne hall can be outfitted with a vault of heaven. In addition, the forms expressing these aspirations in the imperial palace can be taken over by foreign religions for their own divine symbolism. Indeed, we can say that it is only due to their potentially universal meanings that forms are translatable and receivable in the first place.

When Christianity wanted to express these same claims in its cult buildings, it turned to these same forms, imprinted with these meanings in Antiquity. Their reception had, in fact, begun in the second century[61] and from the fourth century on can be demonstrated in almost all typical church buildings.[62] However, two characteristic qualities endured from the time before this transition—from the purely functional period, so to speak—and make the Christian church different from the temple of Antiquity. First, although in the final analysis the gathering of the community is not really needed for the existence of the sacraments or the relics, it is necessary for the consummation of the Christian kingdom of God. This kingdom requires the communal celebration of the liturgy, the presence of the community *in* the house of God: "no more strangers and foreigners, but fellow citizens with the saints."

And second, there has never been a single Christian cult image—in the ancient sense of that word—that would have been operative in only one specific geographical location.

We can make the following statements, anticipating later findings: The temple was originally a copy of a dwelling. Its form could be identical with that of the house—but in a more refined formulation (made of finer materials and better workmanship)—or it could refer to the house only symbolically. With the progressive withdrawal of the god from the sphere of everyday life and his elevation to all-powerful, universal ruler, the original sense of the temple-as-house was supplanted by the new allegorical meaning of the temple-as-universe. As we will see, either the new allusions to the temple-as-universe were applied onto the surface for visual effect—that is, they never were structurally necessary—or the traditional forms were transformed.

Although the associations of Christian church architecture with these meanings were prepared in Antiquity, and the meanings of the church as cosmos and as House of God are attested, we must also stress that the meaning of the church as the *City* of God soon came to far outweigh them. In response to our second question of whether an allegorical interpretation indicates a meaning that has subsequently been applied to an already existing form, we can say this much: the meaning of the church as Heavenly City was indeed subsequent and applied retroactively. Nevertheless, despite its literary origins and despite important peculiarities, it did establish a connection to the ancient pre-Christian cult building.

The Visual Sources

The Formal Consequences of Allegorical Meaning

Whether or not an allegorical interpretation can have formal consequences is the most difficult question, and also the most important one. With this in mind, we can compare building forms whose meanings have been established either through inscriptions or through accompanying images, setting aside for the moment the written sources and focusing exclusively on the visual ones.

We begin with two observations: first, many allegorical interpretations of the Christian church building have had no formal consequences, as, for example, the image of the church as the tent of the Ark of the Covenant (Sauer 1924:98ff.)[63] or the widespread interpretation of the church building as an ark (the ark of Noah) or ship—that is, the "nave" of the church, which comes from the Latin *navis* for "ship" (Sauer 1924:100ff.).

Second—and this follows from the preceding observation—while it is evident that some components of pre-Christian cult buildings could have acquired their meanings as images of real things (see pp. 133–35), most elements came originally from the functional dwelling and thus originally had no particular meaning. Only subsequently, because of the meanings that became attached to certain building components, were pictorial forms abstracted from them. Thus in the Egyptian temple with many aisles, the supports surely were not initially intended to be "trees" or "vegetation"; rather, they acquired leafy tops—their capitals—only later. In the same way, the supports of the *megaron*, the Greek dwelling, were originally without formal attributive embellishment, and likewise vaults were surely not originally constructed as images of heaven. Rather, all these structural elements or features originally came from purposeful, customary use and were only subsequently invested with an allegorical or metaphoric sense. This is clear from

the geographical range of the vaulted building, which is found in certain regions in prehistoric times without the meaning of vault of heaven associated with it (Glück 1933). Conversely, in regions where the meaning of the vault of heaven is predominant, that meaning can also be associated with flat-roofed buildings.[64] Therefore, we must admit that an allegorical meaning *can* have formal consequences in that the form can change itself into the image meant;[65] however, the meaning can also remain without formal effect.

Why one component formally changes its sense and another does not is a question that will be touched on only briefly here. The farther back we go in time, the more symbol and allegory blend into each other. In fact, we are dealing with allegory only when there is no mythical reference connecting meaning and its architectural manifestation—that is, when that connection is based largely on speculation, ungrounded in observable reality, or if the form in question was "really" already connected with some other meaning. To change the dominant metaphor of the church building from "house of God" to "ark," for example, would drain the physical value from the building's form, which is already deeply imprinted with that first meaning—that of house of God. Allegorical interpretations can formally affect only those components that either are new or have hitherto been without meaning. Finally and most profoundly, it is a question of either allegory or symbol and thus a question of priority and of consciousness.

How does the influence of a new meaning express itself in Christian architecture? Which forms remain open for a Christian interpretation with formal consequences? At this point, historical evidence should be produced that would demonstrate how the original community room of the classical basilica—doubtless a building of the highest status, but no temple—received the temple-forms appropriate to the house of God. That question will have to be pursued elsewhere. When a building acquires a new meaning, the first formal consequence is that the building receives the forms that have carried or represented that meaning from time immemorial. As a result, building components and arrangements (the cruciform ground plan, for example) are allowed to persist long after they have ceased to serve their purposes. A further consequence of the acquisition of new meaning can be that the meaning empowers forms hitherto unencumbered with meaning and accents them. Indeed, a newly acquired meaning can permeate the whole edifice and suppress all the effects deriving from the physical building material in order to make the new overriding allegorical, meaningful sense clear.[66] The consequences of this last process are not going to be easy to explain.

As mentioned earlier, our present-day categories for judging architecture are essentially determined by aesthetic meaning and the contribution the indi-

vidual elements make to an organic artistic whole. These categories are visual ones. They provide the concrete criteria that make art history a true science, for only with them can we critically and comparatively judge our sources—the works of art. Nevertheless, it is necessary to ask whether these formal criteria suffice to reconstruct the erstwhile reality of the work of art. These criteria both seduce us into detaching the work of art from its historical contingency and lead us into objectifying the realm of art. This is incompatible with the medieval way of thinking, to say the least (Bandmann 1950). However, it is precisely in this frame of mind—that is, detached from historical context and as participant in an objective world called "art"—that the modern concept of "functionalism" (Sedlmayr 1933)—a concept that belongs to the structural analysis of forms—tries to capture the multilayered and interwoven nature of medieval architecture, with its dove-tailing meanings and focus on correspondences. It will not suffice, however, to base such functionalism as we perceive in a medieval building on what is technically and optically demonstrable—that is, on a developmental theory of statics or a physiological mode of seeing. It is only when we return to the documentary sources to broaden our understanding of the reality within which the work of art was created that we realize that this "functionalism" perceived in the forms is really only the by-product of the forms' symbolic references. In other words, the functionalism of the forms that we perceive is only a reflection of the hierarchy of the meanings of the individual forms within the overarching meaning of the whole building.

As far as the particular "spatiality" of the medieval church building is concerned, the concept of space, introduced as a formal criterion into art history by Schnaase and Schmarsow, has been elaborated only within a historical context of formal development. But even here, in the arrangement of space, there are fundamental meanings that cannot be discovered through stylistic criticism alone.[67] More recent research has raised the possibility of a comprehensive understanding of medieval "spatiality." First of all, we must cite "Zuschauer und Bühne" (Spectator and Stage) by Dagobert Frey (1946f), in which Frey suggests that a hallmark of medieval theatrical space is that the place of action encloses the community. In contrast, since then the theatrical "space" of the Renaissance was increasingly placed in juxtaposition to the audience and acquired its own sphere of artistic illusion.

Since this problem cannot be comprehensively treated here, some excerpts from an article by Kuhn (1949) that delve deeper into the metaphysical postulates must suffice:

The visual arts of the Middle Ages are as yet oblivious of the unified concept of space referring to an outside viewer as in the modern age.

Space in medieval art contains time, as it were; it is brought about through action in time. However, it is also the nature of space to be that which cannot be grasped, which is even nonexistent "between" the walls, "between" things, not the air between them but actually a "nothing" that does something. In abstract terms, space, which is itself not-being, is the place of all being; after all, it allots and allows everything to be. God Himself, however . . . is the invisible one, or rather the one who never appears, the one who is never in the process of being: because He is being itself. If God only becomes effective because the more I exercise earthly privation, making a service out of not having Him . . . , then all of medieval space brought about in the same way acquires a direct metaphysical quality; it becomes the place, the bringing about, of God Himself. Hence the spatial quality of the works of architecture and art . . . in the Middle Ages. (114ff.)

THE MEANING OF THE KEYSTONE A building element like the keystone, whose preeminent importance in terms of statics has given rise to the slogan "the Gothic lies in the keystone," owes its importance perhaps less to the structural genius of the builders than to the persistent influence of the meaning that caused them to devote such concern to this element and to bring it to as prominent a position as possible. Suger speaks of the Christ as keystone that unites both sides (Gall 1925:99); those sides can mean Jewry and Christendom, laity and clergy, and so on (Sauer 1924:116). It is interesting that the biblical references this allegory is based on refer not to a keystone, but to the foundation stone and the cornerstone (1 Corinthians 3:10–11; Isaiah 28:16; Psalms 117:22; Matthew 21:42). Suger, however, in his quotation from St. Paul's Letter to the Ephesians (2:20) makes a keystone out of the cornerstone and adds "which joins one wall to another."

Not only is the placement of the keystone connected with the events of Salvation, but what the keystone accomplishes, its strengthening of the tectonic function, is also bound up with the deed of Christ. Ignatius of Antioch writes, "You stopped your ears against the seeds they were sowing. Deaf as stones you were; yes, stones for the Father's Temple, stones trimmed ready for God to build with, hoisted up by the derrick of Jesus Christ (the Cross) with the Holy Spirit for a cable" (quoted in Sauer 1924:103n.2).[68] In the Old English poem "Christ" we find: "Well it befits you that you are the headstone in the glorious hall and that you conjoin the wide walls, the intact flint with a firm-fixed bond" ("Christ I" 1982:205). In his description of the crypt of St. Michael's in Fulda, the monk Candidus (1887) compared the keystone to Christ: "The chief and maker of this roof is Christ Jesus. What this means is

that the perfection of this building is consummated in one single supreme stone" (Cuius tecturae princeps et conditor est Christus Jesus. Quid vero significat hoc, quod in summo uno lapide istius aedificii perfectio consummatur) (230). Reading further in Suger's report, we find the status of the symbolic meaning of the keystone becoming particularly clear from the miraculous way it held the arches of the unfinished church together during a storm. The keystone also represents one of the few places in the Gothic church to which meaningful three-dimensional images have been applied.[69] The depiction of the keystone in the crossing vault as a ring from which the ribs extend and radiate like lines of force is also perhaps not without emblematic relevance (figure 2.3).[70]

Surely, without the allegorical meaning, the keystone would not have been pushed to the level of formulation and achievement it acquired in the heartland of scholasticism, the Île-de-France. Let us pursue this thought— that allegorical interpretation, which reached its height in the twelfth and thirteenth centuries, gradually declined until its radical rejection by Luther. By that time, the intention to address the senses directly—that is, *without* the attribution of an allegorical superstructure—had become predominant. Then some of the appearances of the later Gothic—above all, the German

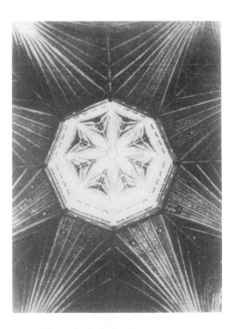

Figure 2.3 Ely, cathedral. Crossing octagon, 1322–1342.
(From Hürlimann 1948:ill. 42)

Sondergotik—take on a new aspect. This can help us to understand the aban-
donment of the keystone and its replacement by net vaulting as well as the de-
functionalization of the rib vaulting. These features thus became elements of
a more emotional arrangement, one more charged with style and part of the
domain of the architect-as-artist. They came to be employed to express a feel-
ing rather than to make a statement. The indoor space, conceived as more
than just a roofed-over enclosed area, became preeminent. This conception
sets its stamp on all the elements of the interior. Hitherto, except for the vault-
ing, all these elements of the interior enclosed space had been identical in
form with comparable elements found on the exterior (figures 2.4 and 2.5).
For example, while an interior engaged column of the twelfth century is in-
distinguishable from an exterior one, by the fifteenth century the two are fun-
damentally different objects. Each has become profoundly marked by the
particular space it occupies in the building and serves the overall atmospher-
ic effect. The sculptural forms growing out of the building element—sculpt-
ed because they were meant to be appealing—became subdued or eliminated
altogether; the room's "impression," the concave, came to dominate. An ap-

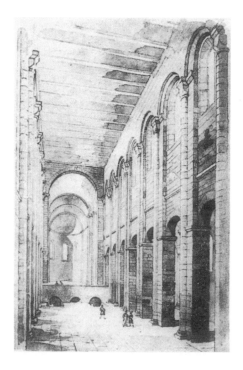

Figure 2.4 Speyer, cathedral. Reconstruction of the interior of the early Salian building.
(From Röttger 1934:241)

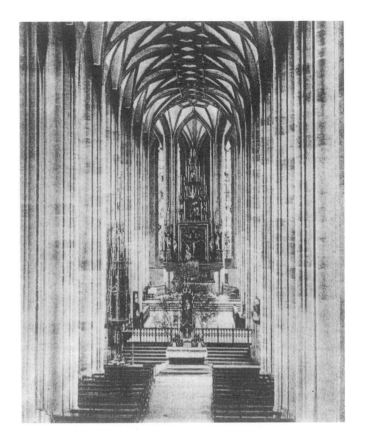

Figure 2.5 Dinkelsbühl, St. Georg, mid-fifteenth century.
(Photo Archives, Kunsthistorisches Institut, Bonn)

proach based on the analysis of styles and psychology of forms confirms this tendency (which is corroborated by the written sources as well)—that the rational superstructure of the allegorical interpretation with its didactic, typological meaning gives way to an arrangement dictated by aesthetic demands.

This observation, to which we will return, answers the question posed earlier about the formal consequences of allegorical interpretation. Indeed, the meaning underlying the forms can motivate the reception of elements and can also initiate a formal transformation by accenting and stressing and articulating those elements.

The last of the questions posed earlier still remains to be answered: Can the allegorical interpretation cause something initially introduced as a metaphor to be depicted? One aspect of the question may be answered in the affirmative straight away; the form that represents the meaning can be

attached to the building element. In this way, the columns of the Gothic portal can carry the figures (e.g., of the saints) that they signify, the keystone can show a symbol of Christ, and columns can sprout representational foliage on their capitals.

The tomb, taken as a whole, copies the house because symbolically it is supposed to stand for the house.[71] The same holds true for the temple, which is supposed to designate primarily the *house* of the god. When a wider sense, something cosmic, enters into this relationship, a new metaphor becomes operative, and elements of the structure that were hitherto unencumbered with meaning and still lacked specific referents can be constrained to indicate the new, wider meaning.[72] As long as the metaphors "house" and "cosmos" still stand in a kindred relationship, the one (the house) in intensified form can be taken for the other (the cosmos). However, other metaphors are beyond all possibility of architectonic representation, especially as long as the building is still subject to practical purposes and structural requirements to which such metaphoric exploitation must be subordinated.[73]

The comparison of the tower with the Virgin Mary—which has caused Marian altars and frescoes with Marian themes to be placed in them—is widely diffused. However, this comparison does not reflect the form of the tower but rather the fact that the tower was already marked as being a replica of the sepulcher of Christ (Forsyth 1950).

THE COLUMN AS TREE Although the speculative character of medieval metaphor, its polyvalency, and its changeability certainly support the general contention that the character of architecture is representational, most new metaphors are not capable of deflecting previously marked forms into new directions. The formal influence of a double metaphor on a single element can be clearly seen in the example of columns in medieval architecture.

Throughout its history and through its different uses, the column had already acquired a variety of different interpretive possibilities even before its reception by Christendom. The column's role in the middle of the dwelling—as a support devoid of representational meaning—surely stands at the beginning of its history. According to records, it was used as the carrier of the ridgepole in the old Nordic wooden dwelling (thus preparing the two-aisled room), as a support for a porch in the original form of the *megaron* (the basic form of the Greek temple) (Durm 1910:1, fig. 5; Schuchardt 1935:229; Kiekebusch 1912:160ff.), and as a stone pillar in the prehistoric Mediterranean stone buildings of Malta, where it broadens toward the top, carrying jutting stone slabs into a vault resembling a cupola (Andrae 1930:54; Schuchardt 1935:46, 79, 214; see also Hoernes and Menghin 1925:603).

We must assume that an emphasis of these tectonic relationships and the ascription of symbolic meaning had already taken place in prehistoric times; hence a symbolic ridge tree was erected in the Irminsul, and the idea was elaborated that the axis of the world resided in that fork that otherwise carried the ridgepole (Trier 1947:9ff.).[74] Numerous written references inform us that although not marked with any special visual metaphors, these tectonic columns had peculiar indwelling powers and were specifically protected by law (Clasen 1943:13ff.; Saeftel 1935).[75] In Egyptian architecture, one formulation of the column developed in a specific direction under the influence of metaphor. In the house of the world-god, it signified a tree or a plant-image that stood beneath a roof symbolizing the heavens. It carried a foliage wreath and was bundled into a shaft to resemble a palm tree and a papyrus plant (Curtius 1913:42). In addition to the nonfigural capitals of the Doric and Ionic columns—more dependent on Indo-European prehistoric wooden building forms—the Greek Corinthian capital, the foliage capital *par excellence*, became dominant in the Hellenic world.[76] The Augustan period preferred it, especially as expressed in the composite capital (Rodenwaldt 1942a:82, 1942b:372), and it became a primary requisite for all movements in the Middle Ages that identified themselves with Roman imperial times (see pp. 222–25). Thus the foliage capital, whose shaft recalled ancient associations with the tree, but whose deeper meanings had long since been forgotten in Antiquity, was adopted by the Middle Ages.[77]

Therefore, we are dealing here with a meaning previously impressed on the form, a meaning that would contradict any other subsequent attempt at allegorization. It is only when the older sense has become completely forgotten that a new meaning can begin to have an effect on the form. This process can be observed in the Middle Ages as the column lost its original meaning of a tree or plant, and another meaning, hardly less venerable, came to the fore. This is the meaning of the column as (human) figure, a meaning that had last borne fruit in classical speculations regarding proportion.

THE COLUMN AS FIGURE In this meaning, the morphology of the column is completely different. It goes back to the idol or to the column that marks a place; from the beginning, it represented something and stood in isolation, rather than as a meaningless component in a tectonic assemblage. Suger's interpretation of the meaning of the columns as apostles standing around the Holy Sepulchre or supporting the Heavenly Jerusalem has already been mentioned (see pp. 62–64). This same thought can be found in slightly altered form in Hrabanus Maurus (1851:403), Sicardus, and Durandus (Sauer 1924:134), for whom the columns could also represent bishops and the doctors of the church as the successors of the apostles. Although

there is a specifically Christian allegorical character of this interpretation based on the New Testament (Galatians 2:9; Revelation 21:14), the meaning of the column-as-person was already common in pre-Christian times.

While the accounts of columns as living beings in Solomon's Temple (Schlesinger 1910:24) and the documented meaning of columns as guardian creatures flanking portals in pre-Christian times (Kiekebusch 1912:165; Jung 1939:96; Kaschnitz-Weinberg 1944:35n.9)[78] and the caryatids of the Erechtheion give the impression that the building's exalted meaning had dictated this specific formulation of these elements,[79] investigations into the meaning of the freestanding column have shown that the root of the column is the cult image—or, more accurately, the cult object—which was only later employed in a tectonic arrangement. When the temple acquires its higher meaning as the house of the supreme god or as image of the cosmos, this process of the incorporation of distinctive columns into a temple can take on a deeper religious sense as the formerly independent, but weaker, divinities become subordinates and servants of the greater and more powerful god.[80]

The roots of this specifically anthropomorphic meaning of the column extend back to the beginnings of animistic religiosity where a specific stone or tree was honored in itself as a divinity (Kaschnitz-Weinberg 1944:34; Jung 1939:103; Mogk 1911–1919).[81]

We are discussing here the simplest form of meaning: identity between meaning and object. No symbolic abbreviation, taken over from another, originally different function, or goal is involved. In a subsequent stage, the stone standing for a tree or divinity is lifted out of its surroundings and endowed with symbolic form, such as foliage or limbs (Bötticher 1856; Kaschnitz-Weinberg 1944:27, 31, 36).[82] When a natural material is given form and thus turned into something that represents a specific meaning and elevated above its material existence, we are witnessing the beginnings of art: an exterior form indicates an indwelling one. The object by that time had already lost its direct magic and become merely the vessel in which the deity was captured.[83]

Forms of this kind long remained commonplace (Haftmann 1939:7; Evans 1901), even when the modeling of the figure took on a resemblance to the human image and the cult image received its own environment. The column remained an anthropomorphic representation of a divine being or an image of a being regarded as alive. Thus we find the image of the dead in the menhir on the barrow grave,[84] in the stele on the Greek tomb (Schuchardt 1935:65, 90; Kaschnitz-Weinberg 1944:36), in the pointed columns standing in the niche-graves of Maltese houses (Evans 1901:154ff.), in the superhuman servants lining the way leading to the shrine, in the colossi of the Egyptian

streets of the gods (Schuchardt 1935:110), and, eventually, in the Christian context, in the columns representing the apostles.

In addition to this persistent meaning of the column as figure, which originally was not connected or developed in connection with a building, there is a group parallel to the cult statues consisting of the column-as-place-marker, as memorial. The members of this group are not endowed with anthropomorphic ideas but indicate the place where the divinity or the dead one dwells. To this category belong funerary columns, triumphal columns, honorific columns, judgment columns, consecrated columns, tomb-towers (Diez 1944:86), Indian *stambhas* (Diez 1944:102), minarets (Reinhardt 1941), and monuments, obelisks, and pyramids in general (Haftmann 1939:7ff.). The column-as-marker and the figural meaning of the column-as-god meet in the fully developed cult image or later in the honorific column carrying a statue of the person being honored. There both meanings are combined into a single type.[85] Here again, however, the column is not attached to the building; it remains an isolated figure or marker.

It is not clear when this primordial meaning first connects itself with the column-as-part-of-a-building. What *is* certain is that such a connection becomes possible only when the building deals with hierarchical relationships that can be expressed metaphorically. The tectonic supports can then be endowed with human form, and, conversely, the solitary marker-column can assume the form of the tectonic column.[86] We can scarcely attempt to determine how much of this primeval mythic sense survives in the medieval interpretation of the column as figure. It cannot have died out completely and everywhere, for it can be seen in buildings that are far removed from the language of forms of classical Mediterranean Antiquity and possess a more naive, archaic relationship with forms. Accordingly, the cultures less fluent in the classical use of building elements reveal the most impressive formulations in this direction—for example, the animal columns of Moissac and Freising and the remarkable figural columns in Jutland (Haupt zu Preetz 1925:23) (figure 2.6).

If the building as a whole comes to be interpreted allegorically as the Heavenly City, then this new meaning of the form must be read into the more or less conventional column in its canonical subdivision into base, shaft, and capital.

In the early eleventh century, it sufficed to write the name of a saint on the column or deposit relics within it in order to emphasize this relationship (e.g., Hildesheim), but in the twelfth and thirteenth centuries, the concrete visual realization of the meaning was insisted on.[87] (This process of making the figurative meaning of the columns visible was perhaps equally due to the

Figure 2.6 Column from a church in Jutland.
(From Løffler 1883:21)

undeniable supporting function of the columns in the interior—that is, the
tree-resonance of the columns—even though this latter sense had been com-
pletely lost.) The simplest solution is to be found on pillars in the interior of
Gothic churches where statues resting on consoles were attached to the
columns (e.g., Cologne Cathedral) (Beissel 1880a:137).

On the Gothic portal flanked by columns, where the structural function
of the columns is less important, a progressive development in the visual as-
pect of the symbolic meaning of the columns can be observed. The Gothic
portal, bedecked with figures, visually recapitulates, so to speak, the mean-
ing of the cathedral as Heavenly City (Frey 1946b; Sauer 1924:47, 308ff.), for
when decoded, it makes the real meaning of the whole building visible to
the senses:[88]

> Whosoever thou art, if thou seekest to extol the glory of these doors,
> marvel not at the gold and the expense but at the craftsmanship of the
> work. Bright is the noble work; but, being nobly bright the work

should brighten the minds, so that they may travel through the true lights, to the True Light where Christ is the true door, *in what manner it be inherent in this world the golden door defines: the dull mind rises to truth through that which is material and, in seeing this light, is resurrected from its former submersion.*[89]

We can observe that at first these columns flanking the doors are decorated and covered with richly textured patterns that visually express their status. In France, a dramatic idea then occurs, and the columns seem to sprout figures. At first the figures appear half asleep, as if still imprisoned within the architectonic requirements of the column (figure 2.7).[90] The elements of the

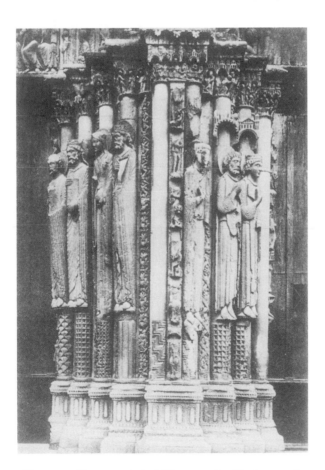

Figure 2.7 Chartres, cathedral. Figures on the pillar between the middle and southern doors of the west portal. (Foto Marburg)

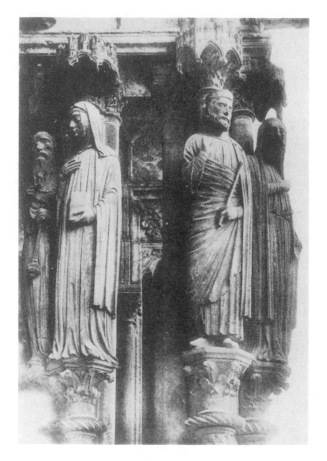

Figure 2.8 Chartres, cathedral. Figures on the north porch.
(Foto Marburg)

familiar column, with its capital and shaft, can still be observed. But in the
north transept portal of Chartres, the figures move more freely and step out
from the columns that appear behind them like a foil (figure 2.8).

It is important to note here that the other, older metaphoric indicator of
the column, the foliage capital, is also diminished. It is reduced to the under-
side of a tiny baldachin above the figure, which now crowns the column as
an attribute of the figure in place of a capital. On the west portal of Chartres,
the baldachins appear tacked onto the columns; their ends portray, in highly
reduced form, a foliage-frieze derived from the original capital. The capitals
in the transept portals have completely lost their expressive power; they have
become decorative forms to set off the figure. The column shaft no longer
appears whole; the lower part, which serves as a console for the figure, now

carries its own capital. Thus we have the impression that the ancient column-as-figure, which can be seen so often in medieval book illustrations and wall paintings in depictions of worship of heathen idols, has been pushed toward the door jambs. This impression is driven home in instances when the figure appears alone as a trumeau figure whether standing, as in the Pórtico de la Gloria of Santiago de Compostela (Hauttmann 1929:fig. 473), or even sitting, as in the portal of the western facade of San Vicente in Ávila (Hauttmann 1929:fig. 474). Eventually, the column—the silent mother of the figure—can vanish completely, and the figures stand arranged in a row against an angled wall, as in the west portal of Strasbourg (figure 2.9).

In the drive toward symbolizing with which the thirteenth century inaugurated an era of sculpture and painting,[91] the symbolic expressive power of

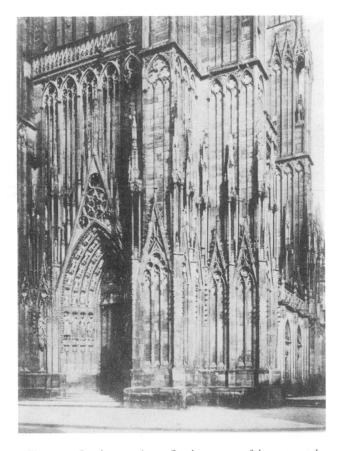

Figure 2.9 Strasbourg, minster. Southern corner of the west portal.
(Photo Archives, Kunsthistorisches Institut, Bonn)

the architectural elements diminished, and the columns of the portal that were not transformed into figures became merely a part of the general scenic background, not much more than a prop. As its implicit meaning as tree or figure diminished, the column was granted correspondingly more liberty in its application. At the same time, the column's aesthetic qualities again became canonized, a fate it had already experienced in Antiquity.

This observation regarding the changing participation of the meanings of the parts of the building *in* the building also explains something else that the history of art forms has remarked on but has never been able to interpret adequately. Paul Frankl (1927:145–50) claimed that every genre—painting, sculpture, architecture—has an inherent drive toward representing a style "purely." In any given setting, therefore, one genre could thus be more advanced in that process than the others. This is supposed to be the reason why the architecture of the cathedral of Reims can be said to be a representation of true Gothic style, while the portal sculpture of the same building still persists in an earthy "Romanesque" corporeality. Apart from its analytic and ahistoric nature—one that would break up a unified creation and perception and a rootedness within a single *Kunstwollen*—this view also embodies a way of thinking that endows style with a self-actualizing evolutionary drive, even though style clearly lacks any biological substance. Frankl posits a conceptual model from the natural sciences that produces some results for the history of art, but only if applied metaphorically. In this materialistic form, such an interpretation is simply impossible. Besides, we could ask whether the sculpture of the west facade of Chartres—which does not have the corporeality and heaviness of the sculpture of Reims and yet is structurally part of the building—should perhaps be seen as anticipating the Gothic.

Based the earlier discussion of the meaning of sculpture within the context of the whole building, we can perhaps arrive at the following explanation of the obvious differences between the sculptural and the architectural organization of the cathedrals of Reims and Strasbourg.

In the architecture of the twelfth century—before the increasing detachment of the figural sculpture mentioned earlier—the building possessed a wealth and density in its material make-up that was perhaps to some extent contingent on the fact that the building as a whole expressed the meaning of the Plan of Salvation and the City of God. This meaning informed the building's entire structure and permeated its substance but had not yet been emphasized pictorially. As soon as a few building parts in Saint-Denis and Chartres had their meaning made graphically real, the architecture whence it was born became but a supporting background and frame for the pictures. In Chartres, the images still dwell within the stone; in Reims and Strasbourg,

the images' drive toward actualization has separated them from the stone and brought them to a real fullness. By concentrating the meaning in the images, the images were given power, while the architecture became a mere container for the idea, now detached and a "poetic" conception that no longer needed material density. The contradiction between corporeal sculpture and spiritualized architecture is not caused by the different tempo in which styles develop but by a shift in the place where meaning was emphasized.[92]

With this discussion, we have answered a part of our question about whether an allegorical interpretation of a building or its parts can have any formal consequences. As we have seen, something introduced as a metaphor can indeed be depicted as a figure. With respect to the column, we can say that the metaphor can work so powerfully on the actualization of the form that its power can suppress the column as an architectural element and eventually cause it to be abandoned, unless it performs some other function and is structurally irreplaceable.[93]

Here we have observed an encounter between two metaphoric interpretations of a single element; one of them had scarcely any life left in it (the column-as-tree), and the other had newly emerged (the column-as-figure) but could also be supported by a much older meaning. That the effects on the column-as-building-element could be so different is due to the separable functions of the column within the whole structure—decorative portal, structural support—so the question still remains to what extent the building as a whole is responsive to an allegorical superstructure.

CITY AND CASTLE AS MODEL OF THE CHURCH As we have established, an allegorical interpretation can have many and complex consequences. It can articulate and highlight an element, like the keystone, that had originally become necessary for technical reasons and had been without any particular symbolic meaning. In the context of the church structure as a whole, we believe that the formal transformation occurring in the sublimation of the physical material—which occurred from the twelfth to thirteenth centuries, when allegorical interpretation reached its high point—can be traced back to this very same allegorical interpretation. In contrast to the ancient law court basilica, which essentially provided a covered area without a strong axial focus, we believe that the pronounced axial and hierarchical arrangement of the spaces in the early Christian, particularly Constantinian, basilica should also be understood as a consequence of the basilica's new meaning as royal hall and throne room, reflecting the arrangements of the pagan temple and, above all, the sacred meanings of palace architecture. Other features of the early Christian basilica also indicate that the royal symbolism being felt in Christendom, and actually predominating from the fourth

century on, thoroughly transformed the transmitted repertory of forms and invested the available elements with specific meanings. In addition, a new store of typical associations that previously had been exclusively royal attributes came to be adopted for the Christian church building (Alföldi 1934; Dyggve 1941). This discussion of the basilica as royal hall really belongs to the next chapter. It will not be pursued further here for examples of visual effect, except to state the following. First, we are dealing with the revival of a meaning already inherent in the basilica. Second, traditional forms already found in Christian church architecture and the new ones to be copied, which were invested with the newly added royal meanings, do not stand in opposition to one another. Thus it should be possible to determine when the copying began. And, finally, it is possible that the early Christian (Constantinian) basilica not only meant or represented the throne hall of Christ but actually *was* the throne hall of the bishop as deputy of the emperor and of Christ.

It is different for the other meanings of the church building as a whole, for they can stand in contrast to the traditional and conventional forms. Our morphological observations of an individual element, the column, have prepared us for these various possibilities. A meaningful form that is to be copied can simply be attached to the building; however, it can also take the place of an existing form if there are no functional grounds for retaining the older one.

In accordance with the Christian idea that God's plan and order can appear in every intellectual or material construction, these realizations, in spite of being completely independent from one another morphologically, can all be brought into relationship and equated with one another. Church, state, palace, city, castle, Christ, monastery, and even an individual person can metaphorically represent one another. In representing one another, they also shape one another as meaning affects form. This reciprocal metaphoric representation is limited only by the practical purpose the building must serve and by the forces of architectonic tradition, which precede the allegorical influence. Because of this essential limitation, the comparison of the human form to the building played a limited role. That the tower might represent the Virgin or the floor the apostles or prophets can be made visible only by labeling them or by attaching pictorial images. The situation is different in the case of reciprocal representation of architectonic structures.

The City—the Heavenly Jerusalem—is the principal literary metaphor for the kingdom of God and the church. Church, city, and kingdom of God, all these appear in literature until well into the thirteenth century under common guises (Lichtenberg 1931:11ff.).

There are three reasons why the city should appear as the primary architectural model for the church and not vice versa—that is, the city as the architectural representation of the church. First, smaller forms, such as the church, as structures less determined by their function and not limited in the variation permitted to their forms by specific requirements, are better suited as representations than bigger, complex structures, such as the city. The bigger structures grow in response to many different needs and other factors; they are not fully planned. Just as a figural baldachin or an altar tabernacle can be a more naturalistic and mimetic representation of a city than of a church building, so the church can much more readily take over the symbolic forms of the city than the city, with its constantly changing components, could ever portray the church. The second reason is based on the status the city held in Mediterranean Antiquity. The state was the city (Tritsch 1928),[94] and the idea of the kingdom of God was necessarily identical with the concept of the City of God. The sensory vividness of the city and the stability of the concept of the *polis* were almost completely lost later in the Middle Ages, corresponding to the completely different social structure north of the Alps. It is significant and a corroboration of the representation argument that some of the symbolic forms standing for the city in its classical sense died out, while new ones, which had been absent in Antiquity, emerged. (This will be explored later.) In the Middle Ages prior to the thirteenth century, the idea of the city was represented in the north by the castle (*Burg*), which was the visible form of the human communal life. Indeed, *Burg* became the term for "city" in Middle High German. The disintegration of the concept of the city as inherited from Antiquity is also shown by the fact that in the Gothic period the Heavenly Jerusalem is no longer illustrated by an architectonic assemblage of individual buildings but by a church. This second reason—that for late Antiquity and early Christian times the concept of the state coincided with that of the city—underwent a change of direction in the Middle Ages. In some cases, the concept disappeared completely and the city lived on through insignia other than those observed in Antiquity. The third reason for the primacy of the concept of the city in allegorical interpretation lies in the fact that the Hellenistic city had already been elevated to a sacred type and held a meaning embodied in the ordering and alignment of the ruler's palace. A glance at the city plan of the palace of Split suffices to reveal a layout with hierarchical gradations of spaces and purposefully imprinted structures within a plan constructed according to some sort of all-encompassing meaning (figure 2.10).[95]

Compared with a structure such as this, the early Christian church, at least in its initial stages, was only minimally developed as a type. Until the fourth

Figure 2.10 Split, Diocletian's palace. Floor plan.
(From Niemann 1910:fig. 4)

century, we know of no hallmark that could essentially differentiate a church from a pagan building, although liturgical forms suggest the first signs of such a differentiation as early as the second century. Liturgical requirements were satisfied, however, with movable furniture within the given space, and whatever structure was at hand sufficed (Kirsch 1933:15ff.). Smaller rooms in private houses, auditoria,[96] two-aisled halls,[97] as well as three-aisled basilicas were used,[98] all without any evident principle governing selection.

Encouraged by the Hellenistic monarchies, particularly the Ptolemies of Alexandria, the three-aisled, oriented basilica, common in the Mediterranean world since the Egyptian throne basilica, spread throughout the northern and western Mediterranean (Langlotz 1950). It flourished in palace basilicas (the Flavian Palace on the Palatine, Hadrian's Villa in Tivoli, Diocletian's Palace in Split), in the *praetorium* of the Roman camp, in the law court basilica, as synagogue, and as assembly place of religious associations. It was also further secularized in the house and market basilicas and was even used for military drill and riding halls. Together with the single-nave solution (the *schola* and *curia*), it was the basic architectural form in which a large community could assemble. We can cite no instances of Christians before the

third century understanding this structure in a higher, allegorical sense or as anything other than an assembly hall devoid of pretensions to representation and meaning. In Christian church architecture—and among medieval reformers, Protestants as well as other modern sects (Marx 1948)—this original idea of the church-as-place-of-assembly was contrasted with allegorizing building types that made claims to a higher meaning. Eventually, the two came to be placed in opposition to each other. Because the church building was rooted in the Christian community, it could never allow itself to go to such extremes as the pagan temple, from which the community could be excluded. This fact is important in understanding the possibility that later arose of making only a partial copy of an entire building. Where the obligation to include the community could not be set aside, the inclination to copy had to make concessions. It is therefore only in exceptional cases that churches take the form of a single tower and that the central space—which could have mirrored the circle or square of the Celestial City much better—never became predominant in the West.[99]

Apart from the far-reaching significance of the fact that the community always belonged to the church building, the preceding observation also makes it understandable that as the church building became allegorized and established, a type of the older city concept, with its already heightened propensity to allusion, became the model, and its features were projected onto the church building. It is very debatable to what extent the early Christian basilica, following its adoption by Constantine, can be taken as an abbreviation of the city. Lothar Kitschelt, in his clever and well-grounded thesis, maintained that the early Christian basilica represented the Heavenly Jerusalem and portrayed the Hellenistic city in that the basic elements—city gate, colonnaded street (*via sacra*), and royal palace—were combined into a unified building. It must be granted that the early Christian basilica is, indeed, built up in this manner (Kitschelt 1938:9ff.). Other architectural historians would agree that the church entrance is related to the city gate, the *presbyterium* to the royal hall (Kollwitz 1943:273), and in form the main nave is also related to the *via sacra,* or processional way (Deichmann 1950a). However, whether this means that these forms were copied from city elements is very doubtful, since they are already found in the same relationship in the pagan basilica, which arose without any connection to such concepts.[100] Whether the interpretation of the building as city became dominant when the basilican type achieved general prominence from the fourth century on remains an open question, for the characteristic formulation of the Constantinian state basilica tends to copy other elements. Here the underlying idea is that of "basilica"—of the royal hall, the royal palace in general. The etymology of "basilica" as royal hall was

still current with Isidore of Seville.[101] The ceremonial, the particular situation of the prototypical Lateran basilica, the history of the reception of this particular type, and the fact that even in the high Middle Ages the Heavenly City could still be poetically represented by means of the architectonic symbol of the royal hall (Lichtenberg 1931:18, 23ff.), all support our conclusion that the predominance of the basilica over all the other architectural possibilities of late Antiquity can be traced to a resurrection of the concept of the throne room basilica (see pp. 168–79) and that the allegorical interpretation as city is a later consequence of this. The formal similarities to the Hellenistic city can be seen as deriving from those same "royal" tendencies, and this renders moot the question whether a construction such as that in Split is a city or a palace.[102]

For these reasons, we would *not* trace the question of the image of the city in the church building to the early Christian basilica—the type created by Constantine—but rather to a later time period when features appeared in the building of churches that did not belong to the early Christian church and that can all be traced to other concepts.

THE TWO-TOWERED CITY GATE On coins, seals, *bullae*, manuscript illuminations, and ivory carvings, we have a shorthand image for the city that despite higher allegorical meanings retained its mimetic tendencies. Because of the accompanying inscriptions and through the depiction's visual connections, we are certain that we are dealing with a city symbol.

The image in question consists primarily of a city gate flanked by paired towers, a niche-portal, a surrounding city wall, and later also a three-tower group with a raised middle tower. The other possible image is a representation of the city by means of a collection of tiny houses; this image survived longest in ivory carvings where it serves as a lifelike backdrop for the dramatic treatment of biblical scenes. That treatment is more an indicator of place than one of higher meaning. Nevertheless, it is important as a source for the abbreviated assemblage of the three-tower group and of the figural baldachin representing a group of houses.

Even if we accept the great antiquity and all-encompassing nature of the equivalence of church and Heavenly City and assume that the city influenced the church (and not vice versa), we begin to discover that there are, however, many aspects of the church building that militate directly against any formal representation of images at all.[103] The more mimetic image of the city—the assemblage of little houses—is almost completely disqualified as a potential model because it would have meant abandoning the essential feature of the Christian church: the space for the cult of the community. The creative powers of the liturgical and symbolic conceptions of Christianity aside (Weigand 1933:458ff.; Schwarz 1913:341; Heisenberg 1908, 1:197ff.), we could still per-

haps see this mimetic image in the arrangement of the many lesser buildings clustered around the church[104] if pre-Christian temple precincts (totally lacking any inclination toward representing a city) were not also so constructed. Indeed, we could also see this pluralistic manifestation of the city in the multitowered Romanesque church building or the assemblage of tabernacles in Gothic churches.

However, we look in vain in Constantinian church buildings for the shorthand abbreviations of the city that we find on coins and seals. Neither niche-portals nor double-tower facades nor three-tower groups nor city walls are to be found. Despite all the allegorical interpretations of the church building as a whole, formal indications are lacking on the outside of the structure. There are several reasons for this. First, most early Christian churches were located within the city, and their exteriors could not easily be perceived in their entirety. That became the rule only with early medieval church building in the North and, above all, with monastic buildings. Early Christian churches were intended to be perceived primarily from inside, from the room where the community assembled and where the representing and indicating forms were what was meant to be seen.[105] Second, since they stood inside the city, early Christian churches in their individual parts did not have to perform civic functions. For example, defensive functions were absent, but in the North and in the missionary regions outside the large cities, the individual parts of the church had already of necessity acquired this similarity with the forms of cities. Thus in the North, the massive, seemingly defensive western parts of the building did not grow to resemble city gates by simply copying their prototypes. This point should not be overstressed, however, for strangely enough, in contrast to the buildings of the more secure twelfth century, the configurations of the early periods in dangerous regions (Fulda, Werden I) seldom show these defensive elements.

We turn now to the influence of this city motif on church buildings. We see this abbreviation of the city already in Antiquity on coins depicting a gate flanked by two towers (figure 2.11).[106] This building motif did not appear in Greco-Roman temple architecture.[107] Originally developed for secular defense purposes, by Roman Imperial times the form had already far surpassed any actual need. This indicates that the form had acquired additional meaning. That is, by virtue of the character of the Hellenistic monarch as savior (*soter*), peace and salvation were brought by the king through the gates to the city that received him, here comparable with and substituting for the whole world (Kantorowicz 1944:212; Alföldi 1934:57). Even in pre-Christian times, the portal with two flanking towers had taken on this higher formulaic meaning (Liegle 1936). Thus fraught with

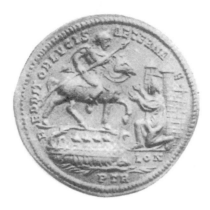

Figure 2.11 Gold medallion of Chlorus receiving the homage of the city of Londinium (London). (From Alföldi 1934:57, fig. 1)

meaning, the motif became detached from its original defensive associations and appeared in other connections, emblematically substituting for the higher meaning, that of the source of salvation. It had become a type. In this sense, it appears frequently on coins, seals, and imperial *bullae*, where in one sense it is Rome that is represented and, in the larger sense, the entire Roman *imperium*. The latter, according to the Plan of Salvation, is called on to bring about the *civitas Dei* (figure 2.12).

It is clear that this motif could also appear on a church building when the building represents such a claim. Strangely enough, we do not find it in the Constantinian basilica. From this we can conclude either that the church building did not yet manifest this sense or that other factors militated against its appearance. Since we know that the church *was* already understood as a city in its higher sense, we have to say that this motif *was not chosen* to symbolize the city. However, what the grounds were for its introduction into northern medieval architecture is difficult to say. We simply cannot say whether this was because the tendency toward allegory became stronger (as it would in the twelfth century), because the drive to symbolize had progressed further or the common identification of the function of the church with the function of the city promoted the copying, because strong Syrian influences (principally in Frankish times) introduced this motif (Schaefer 1945:98),[108] because the later westwork fortuitously emphasized this type (Thümmler 1937; Wersebe 1938:n.157; Fuchs 1929:61),[109] because the idea of the tower-tomb facilitated its introduction (Schaefer 1945:96ff.), because the models of the Cluniacs, particularly on the upper Rhine and in Burgundy and Normandy, promoted the type (Reinhardt 1935:241ff.), or because of the

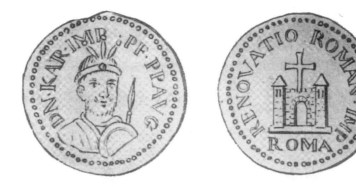

Figure 2.12 Imperial bulla of Charlemagne, 800–814.
(Sketch after Jean Mabillon, 1704. From Schramm 1935–1936:fig. 7d)

continuing influence of the provincial Roman *porticus* villa with corner tur-
rets (Swoboda 1919:188; cf. Weigand 1927:150ff.). What *is* certain is that in
the North in the Middle Ages, at least from Frankish times on, the church
facade with double towers was widespread[110] and that in the *laudes* and
church consecration rituals the entrance to the church was unequivocally re-
ferred to as a city gate (Sauer 1924:104; Kantorowicz 1944).[111] For example,
the doors of Santa Sabina in Rome show that in early Christian times this
motif was already applied in connection with church buildings (Wiegand
1900:52) (figure 2.13). Wiegand's interpretation of this as a representation of
the Christian-Roman *imperium* was refined by Kantorowicz (1944:211) based
on a more exact interpretation of the iconographic traditions. The scene de-
picted represents the *adventus* of the lord (*kyrios*), the appearance of the
bringer of salvation in the form of the emperor; the buildings in front of
which the emperor and the angels stand must belong to them in a way that
refers to them. Any particular identification is difficult. We would misjudge
the early Christian situation if we assumed that this arrangement is like
known medieval examples, where two figures stand before a gatehouse—a
Torhalle in the fashion of Lorsch—behind which rise the towers of a basilica.
Such an arrangement could not have existed at that time—that is, in the mid-
dle of the fifth century. A structural relationship, such as the one that appears
on the imperial *bulla* of Emperor Conrad II, must also be rejected as an ana-
log (figure 2.14). On this *bulla*, a projecting square-cornered building like a
cella is depicted crowned by a cross in the center of the roof. Despite the en-
trance on the narrow side, it is a transversally placed building.[112] The towers
stand in close symmetry to the cross. The figures in the upper portion of the
panel are presented with a severe and hierarchical frontality that relaxes only

Figure 2.13 Rome, Santa Sabina. Wooden doors, mid-fifth century.
(Photo Archives, Kunsthistorisches Institut, Bonn)

in the lower register. By means of the curtains (Alföldi 1934:29ff.) and the
cross[113] and by the transverse arrangement of the building in relation to the
flanking towers of what would seem to be a city gate,[114] we are shown that
this building is not a parish church but is marked as the imperial palace, be-
fore which the emperor appears as *kyrios*.[115] In the shaping of the forms, as in
the meaning of the content, naturalistic forces mix with more general allu-
sions to the sacred. The emperor is present with all the attributes of his office
and his individual countenance, but at the same time, the bodily presence of
angels reveals him in his meta-personal role. While the palace—with its roof
shown in detailed perspective—encompasses the earthly relationships, it is
the cross and framing towers that give it its overall meaning. We are to grasp
the whole architectonic assemblage as an abbreviation for the City of God—
Eternal Rome—characterized by the *aula regia* and the towers of the city

gate.[116] At the same time, we are to see it as an allusion to the everyday city there represented. The *aula regia*—the heart of the imperial palace—lies on an axis with the city gate, shown here in the middle of the city. In similar fashion, the later *aulae regiae* in Lorsch and Mainz would simultaneously be royal chapel and residence, linked by a *via triumphalis* stretching in front of the basilica (symbolizing the city) to the gate.

While we do not know of such an arrangement within an architectural grouping dating from the fifth century, either within a church building or in a larger layout, it is common in the eleventh century. The imperial *bullae* of Conrad II and Henry III, for example, are unambiguously marked with the inscription "Rome, head of the world, holds the reins of governance of the round earth" (Roma caput mundi regit orbis frena rotundi) as a city and also as the City of God (see figure 2.14). Inside the ring formed by the walls, the broad side of a building can be seen in front of a great tower flanked by two smaller ones on the sides. We can no longer say with certainty whether we are dealing here with a palace and gate towers that are still thought of as separate or whether this association relates to the known form of the western complex of contemporary churches (figures 2.15–2.17).

If the latter is the case, it would seem to indicate that the church is no longer represented by means of the city and that instead the city can be represented by the church. However, this assumes that the church has taken on the forms that once served as a shorthand form for the city—that the church not only means the city but also portrays it. That is, while the doors of Santa Sabina reflect a topographical situation typical of cities in late Antiquity—a transversally placed *aula regia* in the axis of the city gate and the main artery—

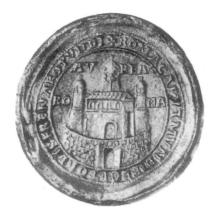

Figure 2.14 Verso of an imperial bulla *of Conrad II and Henry III, 1033–1038. (From Posse 1909–1913, 1:pl. 14.4)*

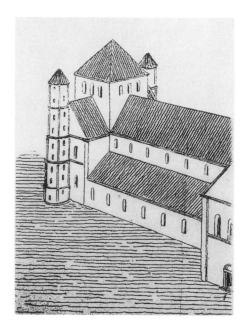

Figure 2.15 Mainz, cathedral. Reconstruction of the eastern parts by Rudolf Kautzsch. (From Frankl 1918:62, ill. 89)

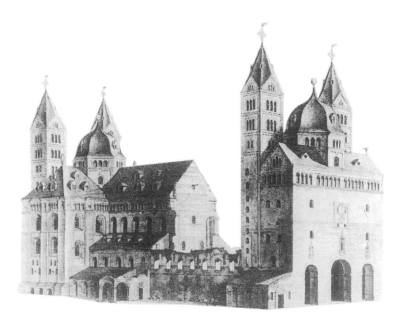

Figure 2.16 Speyer, cathedral. View from the northwest, ca. 1750. (From a watercolor in the Historisches Museum der Pfalz. Photograph, Historisches Museum der Pfalz, Speyer)

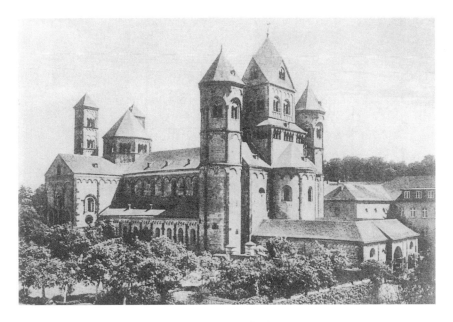

Figure 2.17 Maria Laach, after 1093.
(Photo Archives, Kunsthistorisches Institut, Bonn)

that was not reflected in the church buildings of the time, the city on the *bulla*
of Conrad II is visualized by means of a tightly compressed building resem-
bling a castle surrounded by a city wall. This structure may be taken both as a
recollection of the situation of Santa Sabina and as a recollection of the church
buildings of the time. The question of whether the transverse building in the
foreground is a palace (as in figure 2.18) or the western transept of a church can
be left open. The meaning is identical and, for the medieval observer, clear.[117]

The type of coin represented by Conrad's *bulla*, which has become so im-
portant in the discussion of the spread of the double-tower facade,[118] replaces
the symbol for the City of God common in the Carolingian period with a
classical temple facade (figure 2.19). On both types, the inscription proclaims
"Roma caput mundi," "Aurea Roma," "Renovatio romani imperii," "Xris-
tiana religio," and, if it is a civic or an episcopal seal, "Colonia urbs" or "Ar-
gentina civitas" in addition. The meaning of this representation is thus clear:
the specific city and, as simultaneous allusion, the City of God and the king-
dom of God. With this double sense, *urbs* and *orbis*, it is possible to introduce
realistic, mimetic characteristics and at the same time to subordinate the ac-
cidental and the unique in a hierarchy. Triple construction, symmetry, and
frontality all unite to create an overarching representational diagram.

Figure 2.18 Henry IV transmits the coronation insignia to Henry V, 1099.
(Berlin, Chronicle of Ekkehard von Aura, 1106, fol. 99v. From Schramm 1935–1936, ill. 123a)

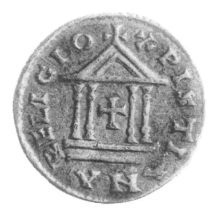

Figure 2.19 Penny of Louis the Pious, 814– 840. (From Lange 1942:53)

THE CITY WALL Groups of buildings are often enclosed by a wall, and
this introduces a new form of symbol for the city. For example, on a penny
minted during the reign of Otto I, margrave of Brandenburg (1170–1184), a
city wall with a classicizing gabled portal surrounds a large transversally placed
building with two flanking towers and a large tower behind it. The legend is
"Brandenburg," and the name "Otto" appears on the building. This is doubt-
less a survival of the palace—the *aula regia*—that appears as symbol of the city
and is possibly the western part of the church (Suhle 1936:88).[119]

The meaning of the city wall would seem to grow in consequence of its increasing significance as fortification; for instance, in the depiction of Ravenna with the palace of Theodoric (figure 2.20), the city gate is the only military defense shown, and the arcaded palace presents itself uncovered to the outside world. But in the resurrection of Lazarus (figure 2.21),[120] for example, or in the Paris Psalter (Paris, B.N. MS grec 139, fol. 431v; Omont

Figure 2.20 Ravenna, Sant' Apollinare Nuovo. Mosaic with the city of Ravenna and palace of Theodoric on the upper wall of the south side of the nave. (From Dyggve 1941:pl. 21)

Figure 2.21 Raising of Lazarus. Ivory from Alexandria, ca. 600.
(London, British Museum. From Goldschmidt 1926, 4:pl. 40, fig. 11)

1929:pl. 12), the wall is already part of the essential depiction. On seals and
coins of the twelfth and thirteenth centuries, a round or polygonal wall fre-
quently encloses a multitowered building complex (figures 2.14 and 2.22),
and the ring of walls in the *bulla* of Henry II can represent the city without
any other additions (figure 2.23).

Along with an increasing push toward stronger fortification, connected
with an allegorical interpretation of the church (Sauer 1924:141), another sit-
uation had arisen that encouraged the development of this symbol and the
frequency with which it appeared among the visual forms. In the Middle
Ages, the concept of the city was no longer characterized by the elements that
had been significant in late Antiquity. The street leading from the city gate
to the royal palace, the axial system, the organized contents inside the walled
enclosure, all had contracted into the small, strongly fortified complex re-
sembling a castle that embodied the concept of city for the Middle Ages. Its
principal distinguishing features are the towers.

The motif of city walls played scarcely any role in church buildings.[121]
We might consider, however, that the early Christian atrium could possibly
have represented a city wall. The arrangement of a western entrance resem-
bling a gate with towers (e.g., Cluny and Hirsau), the right of asylum con-

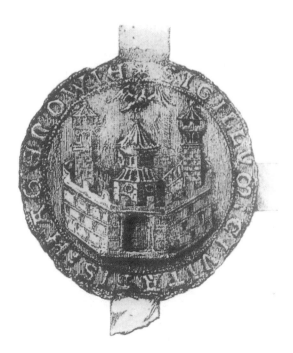

Figure 2.22 City seal of Haguenau. (From Schlag 1943:62)

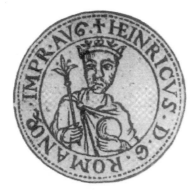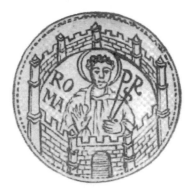

Figure 2.23 Bulla *of Henry II, 1014. (After an engraving of 1749.*
From Schramm 1935–1936:fig. 80b)

nected with the atrium,[122] and the circumambulation of the churchyard dur-
ing the consecration (Sauer 1924:124) are some indications suggesting this.[123]
But the observable diminishing of the role of the atrium in church buildings,
along with a simultaneous increase in the emphasis on the city wall in picto-
rial representations of the city from early Christian times to the Middle Ages,
argues against this interpretation.

THE THREE-TOWER GROUP Another symbol standing for the city,
and perhaps the most fertile one for the Middle Ages, is the three-tower
group. Several different morphological derivations of it are possible, both in
church buildings and in pictorial transmission. One of these could be the in-
tention to represent the two-towered portal of a specific city-gate type that,
although rare in Antiquity, was widespread in the Middle Ages.

A second motivation for this three-towered grouping lies in the out-
standing heraldic quality of the arrangement with a raised middle tower.
The three-tower group is, so to speak, the most impressive abbreviation of
the city with its many towers. We can clearly see why it was chosen over the
jumbled picture of a city with many towers and why it subsequently be-
came prominent.

Obadiah's sermon to the city of Edom (Obadiah 1:3–4) is depicted in the
Bible of Sant Pere de Roda (figure 2.24).[124] Like the Tower of Babel, the tow-
er in the biblical text symbolizes hubris and arrogance; on these grounds,
towers were rejected by the reform orders. The three-tower group—the for-
tified gatehouse—has now become the proxy for the whole city.

The motif appears with a positive meaning in a panel of a casket showing
the Beatitudes (Goldschmidt 1926:pl. 30, fig. 94c; Robb 1945:165ff.) with an-

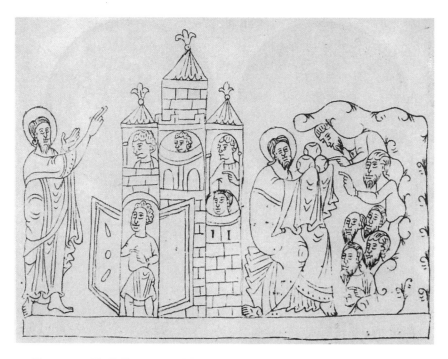

Figure 2.24 Obadiah's sermon at Edom. From the Bible of Sant Pere de Roda, ca. 1000.
(Paris, Bibliothèque Nationale, Cod. lat. 6, fol. 82. Photo Archives, Kunsthistorisches Institut, Bonn)

gels and saints (apostles or personifications) standing under arches bearing
their ascriptions (figure 2.25). While providing a flat frame, these arches serve
as a three-dimensional entry into a building complex whose towers appear
above the arched entrance. The towers to the right are arranged as a three-
tower group; it is uncertain whether the larger middle tower is to be thought
of as behind the flanking smaller towers. The remaining panels show various
other arrangements. The meaning—the Heavenly City—is clear and reflects
the architecture of church and castle construction at the time (figures 2.26 and
2.27). The towers on the casket are the hallmarks of the city: one of a number
of possibilities of arrangement has been selected here, one that combines the
requisite identifiers of centering and crowning with multiple towers. The
composition as a whole is both the scenic depiction of an event—the meeting
of figures before a great gateway leading into the Heavenly City—and the flat
arrangement of forms whose decorative effect and symbolic meaning work to
suppress the illusionistic features—angels and saints beneath an arch carrying
an architectural baldachin. From the second of these conceptual possibilities,
the way leads to pictures in which the figures become monumental ones freed

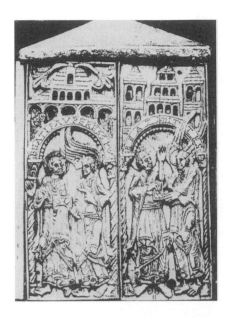

Figure 2.25 Angel with saints (apostles or personifications).
From a casket with the Beatitudes, Spanish, ca. 1063.
(Madrid, Museo Arqueológico, no. 2092. From Goldschmidt
1926, 4:pl. 30, ill. 94c)

Figure 2.26 Cologne, St. Maria im Kapitol. Detail of the church from the panorama by
Anton von Worms, 1531. (From Clemen 1916–1929, 1:184)

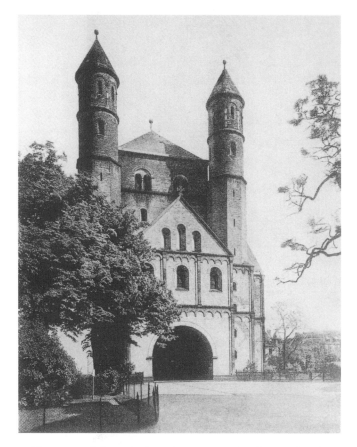

Figure 2.27 Cologne, St. Pantaleon, ca. 1000. Porch restored in the nineteenth century. (Photograph, former Staatliche Bildstelle, Berlin)

from time and place, and the background elements that define the scene are frozen into heraldic attributes.

On the city seal of Strasbourg, the visual organization employs similar elements (figure 2.28). The Madonna is enthroned in the open gate surrounded by architectural forms that are arranged like a baldachin above her. While the outer flanking towers are presented in the manner of a fortress and allow the opening to be perceived as a city gate, they are clearly set apart from the three-tower group—the contemporary church building—that appears above the main arch. The fact that the cathedral of Strasbourg is dedicated to the Mother of God would seem to support the assumption that the outlines of the Romanesque Strasbourg Minster are depicted as in a portrait (Reinhardt 1935). But in spite of this, we have the right, based on the evident mixing of

building elements from the city and church, to make the city of Strasbourg equivalent to the City of God.

The decline of architectural forms is even more clearly visible on a penny of Abbess Adelheid III of Quedlinburg (1161–1184) (figure 2.29). Here the three-tower group is compressed into an architectural throne, the flanking towers have become the wings on the back of the throne, and the middle tower has turned into a baldachin. We are therefore invited to synthesize the meanings of a number of equivalent representations: Heavenly City, abbey, throne hall, and place of ceremonial public appearance or epiphany.[125]

Although compressed into a few signs, the sense of the whole still shines through: divine order—city—abbey church—throne. Even the imperial crown, whose meaning as an image of the Heavenly City is well established, could be inserted into this series of architectonically formulated symbols (Eichmann 1942, 2:69).

This city-symbol is accorded a similar status in two manuscript representations of German emperors. In one, Henry II stands between two bishops (figure 2.30). The three figures stand in front of and within a triple arch that is endowed with a particular meaning. Where the two arches join, there are small towerlike structures, and a small tower with a cross stands on top of the central arch. In this way, despite the flat arrangement and strong emphasis on the frame, the meaning of the architectonic whole is expressed, even if it is not clear whether church, city, or palace is intended.

In the other representation, Henry IV transfers the coronation insignia to his successor, Henry V (1099) (see figure 2.18). Here, due to the compactness

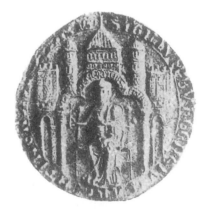

Figure 2.28 City seal of Strasbourg. (From Walter 1918:fig. 50)

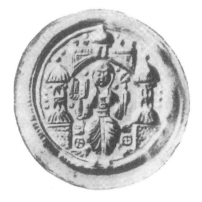

Figure 2.29 Penny of Adelheid III, abbess of Quedlinburg, 1161–1184. (From Lange 1942:78)

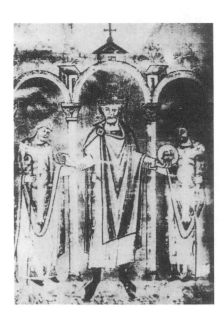

Figure 2.30 Henry II between two bishops, 1002–1014.
(Bamberg, Cod. lit. 53, fol. 2b. From Schramm 1935–1936:ill. 83)

of the architectural parts, the resemblance to a baldachin is even stronger, and so we are not tempted to see the arch in the lower part as a gate in relation to the architecture above. The forms above resembling cities or, more probably, palaces are clearly designated and can no longer be confused with church buildings. The city walls outfitted with battlements terminate in structures extending like wings, and a building clearly recognizable as a palace rises in the center.[126]

The sculptural baldachins built over Gothic freestanding and column figures—not infrequently adopting the formally appropriate solution of a three-tower group—should also be considered in this connection (see figures 2.7 and 2.8).[127]

And, once again, another Gothic solution can be discerned that shows complete and decisive differences in the language of the forms, although it formally follows the same symbolism. Consider the three-tower reliquary from the end of the fourteenth century from Aachen Minster (figure 2.31). Here, in very artistic filigree-work towers, Christ appears in the center tower, with St. John and St. Stephen in the flanking towers. The meaning of the Heavenly City is also expressed through architectural forms that appear as a whole in the three-tower group and that in the details conform to contemporary architectural forms.

Nevertheless, confusion with actual city and church buildings is no longer possible. The fantasy of the architecture has become so free that it is no longer constrained by the visual requirements of commonplace architectural metaphors. The urge to intensify those elements that are susceptible to visual expression has proved irresistible. The other side of the coin, however, is that in its treasury of dedicated forms, the architecture of the earthbound church no longer possesses as strong a power as it did previously to express statements and indications concerning the beyond. Architecture can no longer so self-evidently harbor both the meaning and the existence of the Heavenly Jerusalem within itself if at the same time a conception of the Heavenly City can clothe itself in such a dreamlike expression as this.[128] A progressive separation of the sacral and profane spheres is announcing itself.[129]

The preceding images illuminate the following points: First, until the thirteenth century, visual representations that are unequivocally identified as the Heavenly City through inscriptions or scenic arrangement can display an architecture that coincides with that of palace and church buildings. In the fourteenth century, artistic fantasy creates forms that lie beyond "earthly" possibilities. Second, the narrative representations of the Heavenly City that are still possible in pictures in the eleventh century (and have equal rights with the figures) are reduced to an enumeration of attributes in the twelfth and thirteenth centuries. As the artistic meaning inherent in the building

Figure 2.31 Aachen, minster.
Three-tower reliquary with Christ between St. John and St. Stephen. (Foto Marburg)

grows in importance, the building itself is reduced to a commenting symbol and its role becomes not unlike that of the baldachin over a statue. In the context of art history, this process says something about the pictorial image, hitherto still organized in the fashion of Antiquity, but now developing into individual, representative sculptural figures.

Finally, the three-tower group can be interpreted equally well as a depiction of a Roman and medieval city gate—a fortified gatehouse—and as an abbreviation of the representation of the multitowered city. It can be assumed that these two kinds of sources had an effect on church building and also that church architecture itself might have stimulated representations on coins and in manuscripts, as can be presumed from the city seal of Strasbourg. This identity of meaning—which in a higher sphere reconciles the differences—makes the interchange of symbols possible, symbols we must never interpret as merely mimetic reflections of earthly situations and things but only as indicators pointing to the next world.[130] Thus it is understandable that as the potential and power of the classical view of the city grows dimmer in the course of the Middle Ages and, more important, its chronological precedence in sacral meaning over the church building no longer obtains, the church, having previously incorporated certain impulses from city and castle architecture, replaces the city in visual representations.[131]

Already with the imperial *bulla* of Conrad II (see figure 2.14) we are unsure whether we are dealing with a compression of city symbols (wall, gate, tower, palace, *aula regia*), with a castle and therefore not a compression but a more mimetic reflection in the sense of a contemporary view of the city as a fortified agglomeration, or with the image of a church signifying the city. The representation on the metal *bulla* of Henry IV (1065) also appears very much like a church (figure 2.32). However, the lines leading from the flanking towers to the main tower appear not to denote the gable of a church facade, but to be city walls constructed heraldically and converging in perspective. The lines on the archaizing imperial seal of Charles IV (1346–1378) (figure 2.33)—this time diverging—are to be understood in much the same way.

From the thirteenth century on, the forms begin to take on a more naturalistic character, but initially only on city seals. Just as the artistic fantasy in the Aachen tower-reliquary is aspiring toward becoming an autonomous work of art—that is, being valued in and for itself—so here, as a consequence of the separation of the sacral and profane spheres, artistic perfection orients itself toward the factual denotation of concrete individuality. The magic of objects was diminishing, and the absolute character of artistic creation was increasing.

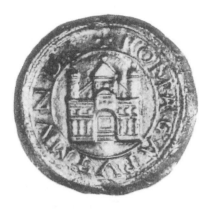 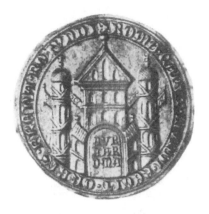

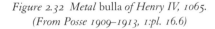

Figure 2.32 Metal bulla of Henry IV, 1065. *Figure 2.33 Imperial seal of Charles IV, 1346–1378.*
(From Posse 1909–1913, 1:pl. 16.6) *(From Posse 1909–1913, 1:pl. 3.7)*

The city seal of Strasbourg, discussed earlier, distinguishes visibly between the crenelated city wall towers and the flanking towers belonging to the church building. The city seal of Haguenau shows the city wall with its square stones and, sharply standing out from this, the detailed construction of the palatine chapel, so clearly that it could serve as the basis of a reconstruction (Schlag 1940:62ff.) (see figure 2.22). Beginning in the later twelfth century, there is an observable tendency to set the specific in the place of the generic. Thus on the coins issued in the course of the twelfth century, the traditional face of the king is replaced by the faces of those who run the mint: the bishop or the local lord (Lange 1942:57).

The three-tower type on coins and seals was introduced at the end of the tenth century through the representation of the transverse building flanked by towers and superseding the Carolingian temple-gable type and was most widespread in the twelfth and thirteenth centuries (see figure 2.14). It was used by emperors, sovereigns, bishops, cities, and abbeys but remained essentially limited to Germany.[132] We find it spreading, probably from Cologne (1023), to Brussels, Antwerp, Liège, Dinant, Münster, Maastricht, Andernach, Trier, Halberstadt, Fritzlar, Bremen, Paderborn, Corvey, Osnabrück, Soest, Speyer, Basel, and Strasbourg. Even the pictures of Rome on papal seals followed this type (Erben 1931).

So, for our question of whether the three-tower layout in church buildings is the picture of a concurrent city symbol, it is decisive that the image on the coins points unequivocally to the city in the form of a castle. Hence the

church building did not provide the prototype for the coin representation.[133] The cultivation of the three-tower group in church buildings before its earliest representations on coins and seals shows only that the coins were not the models for the church buildings; the actual architectonic elements of city building must have influenced church building at an earlier time.[134]

THE NICHE-PORTAL The niche-portal in a gate tower is yet another element of city architecture that emerged in medieval church architecture but was absent in early Christian times and completely lacking in Italian churches. As an abbreviation of the city, we first encounter it in the apse mosaic of Old St. Peter's, which dates from the time of Constantine's son Constans (337–350) and is documented only in a later engraving (Wilpert 1916, 1:362) (figure 2.34).[135] In the lower zone of the picture, sheep file out of city gates designated as Jerusalem and Bethlehem toward the cross standing in the center. As part of the fortifications, the great niche-portal represents the whole city and is identified as such by the inscription.

Two hundred years later, we encounter the same gate—now with the inscription "Ravenna"—on the upper surface of the south wall of the nave of Sant' Apollinare Nuovo in Ravenna (see figure 2.20). The city of Ravenna is represented with its chief building, the palace of Theodoric. To the right rises a great niche-portal with a frieze of crenelations between two tiny flanking stair-towers constructed of a sturdy stonework that contrasts with the expensive masonry of the neighboring palace. In height, the gate rises above a double-storied cloister and the two stories of the palace: the lower portico and

Figure 2.34 Rome, Old St. Peter's. Mosaic in the apse, 337–350.
(From Wilpert 1916:362, fig. 114)

the upper solarium—an earlier form of the solar of the medieval palace. The palace is marked as a royal building both by a large projecting gabled structure opening into a tripartite interior carrying the inscription "palatium" and by the curtains between the columns.

Ejnar Dyggve (1941) has proved convincingly that we are here not dealing with a palace facade built in a straight line but with a typical medieval planimetric representation of a palace atrium or, more probably, a palace basilica. The part crowned by the gable is both the end of the open basilica and the doorway to the inner chambers, the place of the ruler's ceremonial public appearance or epiphany. The three arches on a single level connected on either side are really porticoes diverging at right angles from the gabled *basilica discoperta*. The roofs of the city appear behind the palace grounds; among them two round buildings resembling mausoleums are particularly conspicuous. Starting from the left side of the palace, the city walls enclose the whole arrangement in a rectangle. Due to their crenelations, they appear to be built up in the same fashion as the city gates. The whole layout apparently follows the well-known Roman city type that is attested well into the sixth century—for example, Split (see figure 2.10), Palmyra, and R'safah (Wulff 1914–1918, 1:259ff.). We are told that Theodoric wanted his palace to rival that of Constantine, his great model in Constantinople (Wiegand 1934). The arrangement in a flat plane, which this specific medium required, dictated that the more mimetic qualities be suppressed and the main elements be simply arranged next to one another.[136] This representation makes it clear that at least into the sixth century the ancient concept of the city, with the palace in the middle enclosed by an important building complex of many elements, was still alive. In the Middle Ages, in contrast, a structure resembling a castle with one or two clustered towers gathered around it and the whole enclosed by a fortification wall was central to the idea of the city.

In contrast to the representation from Old St. Peter's, the conspicuously mimetic image in Sant' Apollinare Nuovo perhaps harks back to the fact that the city represented there originally had been part of a larger historical scene, where, with barbarian unself-consciousness, Theodoric glorified his deeds in the manner of famous classical models. With the reconsecration of the church by Bishop Agnellus (d. 589), everything except for the palace was removed from the mosaic in order to make room for more seemly subjects (Wulff 1914–1918, 2:440).[137] The sacral status of this city representation is surely affirmed by Theodoric's dedication of the basilica to Christ, indicating that by being elevated to symbols, the parts of this picture rise above being simple local details in a historical picture.

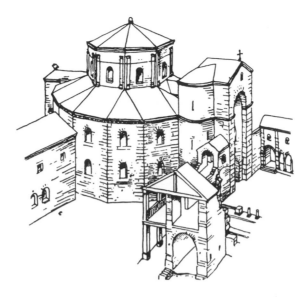

Figure 2.35 Aachen, Charlemagne's Palatine Chapel. Reconstruction of the exterior. (From Buchkremer 1947:2, fig. 17)

The niche-gate, which we also find elsewhere as a visual abbreviation of the city,[138] emerges in Carolingian times in the massive western structures of churches, most splendidly in Aachen (figure 2.35), where, apart from a gable in place of the crenelations, it looks like a reiteration of the example from Ravenna. Buchkremer's (1947) research established that the *Westbau* of Charlemagne's Palatine Chapel in Aachen was already in its foundations conceived separately and placed in front of the actual main building, although it was directly attached to this central-plan (octagonal) building of the chapel proper. In this regard, Aachen does not follow its model of San Vitale in Ravenna, which has a simple narthex and whose small stair-towers are inconsequential. Whether there is a suggestion of the Ravennate city fortifications in Aachen is immaterial, for remains of Roman buildings in the countryside and city fortifications could be seen everywhere by the builders of Aachen: the gate of the precinct of Xanten Minster, for example (Rothkirch 1938b:131, fig. 9).[139] Even an influence from Parthian-Sassanid and Islamic palace architecture cannot be excluded. The great *iwan* has definite similarities to the niche-portal of Aachen.[140]

Other niche-portals can be found in Corvey, Wimpfen, Werden, Regensburg, Hildesheim, and—if we do not place the emphasis on the concave niche, but rather on the wide, blind arcade—in the cathedral of Trier.

The reasons that Charlemagne might have given for this structure in Aachen can only be guessed at. The building had been begun by 796 at the latest, when Charlemagne already felt himself to be the strongest ruler in the West (Faymonville 1909:5), although he was not crowned emperor until the year 800. The building was consecrated in 805 by Pope Leo III. The church was primarily a palace chapel for the emperor and his household, a treasury, and, following an old tradition, a mausoleum built during the ruler's lifetime. Charlemagne legitimized himself by adopting the old Mediterranean tradition suggested by Justinian's court church of Ravenna. It may be imagined that upon his coronation, Charlemagne's gaze focused particularly on Rome, where the conception of the church building was different from that in the Byzantine Empire. In Byzantium, the proprietary church of the ruler still derived part of its meaning from the status of the ruler, who, in the late classical manner, partook of the highest sacral rank. The church—above all, the court church—was his crowning, as it were, and his appropriate environment, and it served as the natural setting for his activities (see pp. 176–79). This claim to status, which Charlemagne shared with the other early Germanic kings in the Roman *imperium*, decreased in importance after his coronation as Roman emperor. On every occasion, the papal powers continued to press for the diminution of the ancient concept of the god-king, a concept that in some ways still nourished the *imperium*, for the emperor was still allowed to remain within in the framework of the Plan of Salvation as protector and advocate of the church. To be sure, the pope conferred on him a series of rights and even let the earthly monarch reserve an area within the church building. At the same time, however, the most prominent part of the church was reserved for Christ as the one true king (Tellenbach 1936:44). Thus we can observe that in Carolingian and early Ottonian architecture, unlike in its Byzantine counterpart, the more worldly activities of the ruler were moved from the church building outward into western annexes or into the atrium. In Werden, for example, the once traditional procedures of the episcopal assizes of the *Sendgericht*[141] were transferred in the eleventh century from the westwork of St. Peter's Church (building begun in 875) into a *parvis* built in the manner of an atrium in front of the church (Effmann 1899:312; Bandmann 1942:41). In the wake of the Cluniac reform, this was a thoroughly understandable "cleansing" of the church, but nonetheless an interference in the complex universal character of the central-plan church, which so long predominated in Byzantium and was long echoed in the westwork of the Carolingian and Ottonian periods.[142]

The niche structure in Aachen provided Charlemagne with a remarkably powerful apparatus for ceremonial representation, for as ruler he could appear

in an upper opening resembling a loggia and at the same level as the imperial gallery within and show himself to the people assembled in the atrium below. In other words, he could show himself in a parallel "secular" apse. This meant, however, that in the actual palace chapel, Christ and the Virgin were the rulers whom Charlemagne served, as did all other faithful believers.[143] A break with the existing church in the East, the *ecclesia triumphans*, was thereby effected when Charlemagne appeared as Protector of the Church in the massive, western structure resembling a bulwark or a city gate, the symbol of the *ecclesia militans*. As stated earlier, the influence of Rome's striving toward autonomy for the true church (Caspar 1935:132ff.) is only possibly the reason for the selection of this niche-form of the *Westbau* and thus for the deviation from San Vitale.[144] This interpretation seems to be confirmed by the fact that in later niche-portals the apsidal form is almost always attested by documentary evidence (Rothkirch 1938b:129ff.; Evers 1939). This character of a "secular apse" is particularly important if the portal is situated in a narthex and no longer obviously functions as a "city gate" due to the change in setting. Hence Henry II had his seat of judgment set up before the niche-portal in the narthex at Regensburg.[145] A classical prototype of this niche-portal can be found in Leptis Magna in the form of the exedra that faced the open forum and led to the basilica proper (figure 2.36). We know nothing about the meaning of this structure. Perhaps it had a meaning similar to that of the large exedra we find closing off the court to the west and looking out over the *porticus* onto the street in Trier. This structure dates from the end of the so called red period (from Diocletian to Constantine) (Krencker 1929:146, fig. 183a–c) (figure 2.37).

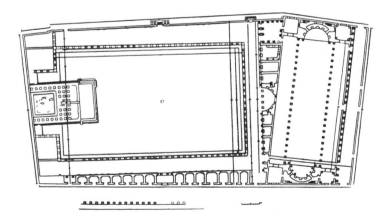

Figure 2.36 Leptis Magna. The niche-portal is between the forum with the temple and the transversally placed basilica. (From Apollonj 1936)

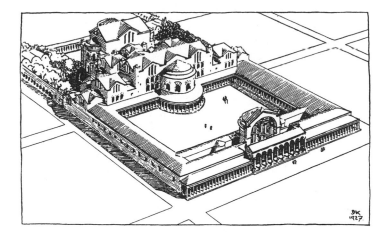

*Figure 2.37 Trier, "Imperial Baths." Reconstruction of the baths in
Constantinian times. (From Krencker 1929:148, ill. 185)*

Krencker (1929:149) interprets it as representing a niche for the imperial
cult, but his argument is not convincing since it is based on the great rectan-
gular imperial hall opening onto the *palaestra* in the Baths of Antoninus Pius
in Ephesus. There, however, the arrangement and form of the space are com-
pletely different (Krencker 1929:287, fig. 426). Moreover, due to the adjacent
roof, the emperor would have been visible from only a limited distance. Con-
sidering the situation depicted in Leptis Magna, it is possible that the niche in
Trier had an opening, and this would not have prevented that particular spot
from having a cultic purpose and meaning of some kind. Indeed, no other
spot would be more suitable as a monumental entrance to the baths.[146] Bra-
mante also seems to have retained an allusion to the great exedra of the classi-
cal Temple of Fortuna—held to be a building of Caesar's—in Palestrina (the
Roman Praeneste) in his great open niches in the Cortile and Prato of the
Belvedere in the Vatican (Huelsen 1933:57ff.). The exedra on the Palatine,
which faced the Circus Maximus, certainly functioned as an imperial loge.

With these observations, we may provide some historical underpinnings
for the reception of the niche-portal of Aachen since the main grounds for its
application were historical ones, although it can also be explained as a sym-
bol. This historical meaning will be discussed in more detail later.

THE THREE-ARCHED OPENING Before the question of the influence
of the idea of the city on medieval church building can be comprehensively
answered based on the foregoing illustrations, one motif remains to be ad-
dressed, a motif that evidently comes from palace architecture but changed

under the influence of the concept of the city. For example, in the representa-
tion of Theodoric's palace in Ravenna, the palace is characterized by different
forms, such as the portico on the lower level with curtains hung between the
columns and the upper story depicted as a solarium. Its principal hallmark is
the gable-crowned middle building, above whose three great arches the word
"palatium" is placed (see figure 2.20). Basically, we are dealing here with the
classical temple pediment, which had evolved into a type of its own and become
invested with its own meanings; it is here affixed to the palace as a mark of sov-
ereignty. Without any other structural context, simply as facade and symbol of
the *religio Christiana*, it later appeared on a penny of Louis the Pious (814–840)
(see figure 2.19).[147] In the palace of Theodoric, the classical temple pediment in-
cludes a group of three arches, an inheritance from the East, that had already
been used in late Hellenistic times in the construction of palaces and city gates
(Weigand 1928:112; Kitschelt 1938:22ff.). The group of three arches was more
suitable than most other formations to emphasize and crown one figure stand-
ing in the middle, accompanied by two minor figures that embrace and exalt
it. For that reason, we also find it on later pictorial representations as a symbol
for palace, church, or city. It appears also without other specifically architec-
tonic elements, apart from the columnar character of the supports that was al-
most never abandoned (figures 2.38, 2.28, and 2.30). It is a very display-orient-
ed structure and usually shelters enthroned figures, epiphanies, and homage
scenes.[148] Unlike other symbols characterizing the city, this motif at first fol-
lowed no specific formula. The three-arch group appears on the Strasbourg
city seal (as a picture frame setting off the figures of Madonna and Child)
propped up in front of the group of individual buildings (see figure 2.28).

Figure 2.38 Coin from Strasbourg, 1249.
(From Schaefer 1945:fig. 5)

This motif occurs frequently in architecture where it marks the boundary between two spaces, serving as the entrance to a sacrally elevated area. For example, the transversally oriented *presbyterium* (*consignatorium*) of the church that Theodorus built in 314 in Aquileia opened out into the adjoining hall by means of such a three-arched opening (Gnirs 1915:166ff.). Similarly, in the fortified camp of M'shatta (built between 527 and 627), the three-aisled nave was joined to the triconch "sanctuary" by a group of three arches (Schulz and Strzygowski 1904:pl. 4), and the square "core-building" of the cathedral of Trier (310–381) was connected through three openings with the adjoining hall (Kempf 1947:129ff.).[149] As a window and gate element, this group can be found everywhere.[150] As a decorative element, it had its greatest diffusion—apart from Byzantine architecture—in the Hohenstaufen architecture of the Rhineland.[151]

On an ivory artifact in the Museo Archeologico in Milan, St. Menas stands in front of such a group of three arches (figure 2.39; compare figure 2.40). The middle arch looks like a scallop shell. The arches to the right and left are capped by two small tower cupolas with crosses. Lamps and knotted curtains hanging below create the spatial impression that the picture shows an epiphany at the entrance to a church, a palace, or, indeed, the Heavenly City.[152] This influence of the idea of the city gate may be observed in intensified form on an ivory belonging to the same group (figure 2.41). Here, in place of the two companion arches, we find two small, functional towers that almost let us forget the old motif of the three arches. The symbolism of the city is thus reflected in the large central structure with flanking towers, as in the niche-portal of Aachen and on the page from the Apocalypse of Urgell dating from the end of the tenth century, to mention just a few pictures of many (figure 2.42). We may say, then, that a motif coming from palace architecture, one that would have great success in the Middle Ages, was modified in the sixth century under the influence of the concept of the City of God.

Summary

By way of summing up the influence of the concept of the city on church architecture, we may assert the following.

First, the early Christian basilica did not represent or reflect the city. Even when considering the fact that the conception and presentation of the city in late Antiquity and early Christian times was different from that in the northern Middle Ages, the concatenated similarities—city gate, colonnaded way, royal palace—were already present in the characteristic form of the basilica of Antiquity. They assuredly were also present in ancient palaces, whose influence

Figure 2.39 St. Menas. Ivory from Alexandria, ca. 600.
(Milan, Museo Archeologico. From Goldschmidt 1926, 4:pl. 40, fig. 120)

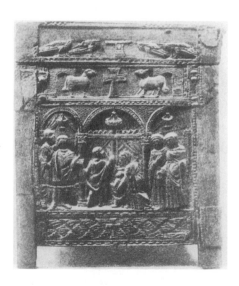

Figure 2.40 Ivory casket. From the Hermagoras in Pola.
(Pola Museum. From Gnirs 1915:169, fig. 131)

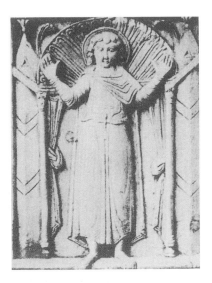

Figure 2.41 Praying saint. Ivory from Alexandria, ca. 600.
(Paris, Musée de Cluny. From Goldschmidt 1926, 4:pl. 40, fig. 121)

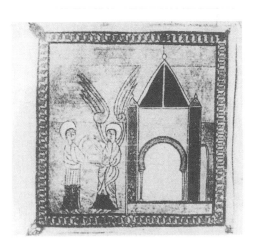

Figure 2.42 Apocalypse of Urgell, fol. 57, tenth century.
(From Neuss 1922:fig. 50)

on the early Christian basilica will be shown elsewhere. It could perhaps be ar-
gued that the ancient city influenced the atrium of the early Christian basilica,
with its gatehouse buildings, but any charge of copying is refuted by the exis-
tence of similar arrangements in pagan temples and palace buildings.

Second, abbreviations of the architecture of the city, such as the double-
tower facade (i.e., city gate) and the niche-portal, had been common in pic-
torial representation since Antiquity and flowered in the architecture of the
northern Middle Ages. The interpretation of the transformation of the com-
mon Italian type of basilica in this manner under the influence of an
allegorical interpretation of the church building (one that reached its high
point in the twelfth century: *ecclesia*, *civitas Dei*, *nova Jerusalem*) is convinc-
ing; nevertheless, other morphological derivations that do not point toward
city architecture are also possible here. Among the three-tower groups, the
castellum, called the westwork, and the fortified gatehouse agree most com-
pletely with the contemporary visual symbols of the city. Thus the westwork
is not only a fortified castle for the basilica to which it is attached, not only a
proprietary church for the local lord, but also, as a symbol for the city, an ab-
breviation of the whole church.[153]

Third, the concept of the *ecclesia militans* points toward castles and forti-
fications, which were representative of city architecture in the Middle
Ages.[154] The allegorical split of *ecclesia militans* and *ecclesia triumphans* in a
single building[155] and the assembly of functional relationships in the *Westbau*
of the church—the place of triumphal entry, locus of imperial activities, seat
of judgment, and so on—make the attachment of city symbols to that specif-
ic location understandable.[156]

And, fourth, at the same time the niche-portal and two- and three-tower
groups are generally present (from the eighth to thirteenth centuries), the
specific formulation of the idea of the city is represented by means of the
transversally placed royal palace and small flanking towers found on coins
and in church buildings primarily in the German parts of the empire in Ot-
tonian, Salian, and Hohenstaufen times (see figures 2.14–2.17).

The importance of the relationship of written and visual sources to the
meaning of typical forms has been shown in these examples. Since these
sources deal with symbolic meanings, the question has been treated, as would
have been appropriate for the Christian Middle Ages, separately from the
historical context. Because of the depicting, deputizing character of symbol-
ic meaning, it has had to be traced by means of morphological investigation.

3

Historical Meaning

Tradition and Habit

WHEN WE SURVEY the prodigious array of architectural monuments that have come down to us from the past, we find that the buildings of each epoch can be grouped according to certain common characteristics of formal organization, however much the ground plans or building types may differ from one another. The buildings of a given people or geographic region will also arrange themselves according to certain common factors that are independent of their types. There would be no great scholarly fascination in these possibilities for arrangement—for the *Bauherren* of most and the locations of all the buildings are known—were it not for the interactions and reciprocal influences of cultural groupings, the developments within the groups, and the gradual changes of geographic arrangement we can observe.

There is, however, a third possibility for arrangement, one that has already been referred to briefly—arrangement by type. The wider the weave of the net of types we throw over the monuments, the more tenuous are the relationships that we can discover between the monuments we find and the stranger the effects of the historical combinations seem to be. Stone buildings gather together and group themselves in contrast to wooden and earthen buildings; oriented arrangements stand apart from unarranged buildings; the Egyptian throne basilica aligns itself with M'shatta, the Church of the Nativity in Bethlehem with St. Maria im Kapitol in Cologne and its imitators; the transversal structure in the palace of

Hatra stands beside the transversal structures of the Salian minsters, the Sassanid *iwan* beside the westwork; and so on.

What are we to make of all these linkages? Do they help our understanding of medieval architecture? Doubtless, various historical facts can be set forth to illuminate these affinities.

One possible interpretation is to assume parallels in growth. Accordingly, the change in the early Middle Ages in northern Europe from building in wood to building in stone, for example, would correspond in some way to the peoples of that region entering into the realm of the historical and showing a new readiness for enduring and monumental forms, a new self-awareness, and a claim on a place in the world, which, although long a feature of the great ancient Mediterranean cultures, were previously unknown to the Germanic peoples. Or one might assume that the way the early Christian basilica orients itself, the way the western structures emerge and the eastern part becomes enriched, can be understood only within the processes of Christianity's own development. In that case, affinities with similar structures in other cultural contexts are merely fortuitous. They are analogues, and even direct relationships and influences must appear secondary and must be understood as arising from a certain inertia in the production of new and different forms.[1]

Another possible interpretation is to assume actual receptions, the unmediated influence on the newer construction by the older. It is not the specific manifestation that is most important but the force that emanates, so to speak, from a typical formulation and that has an effect when it encounters a cognate situation. Historical plausibility can always act as a corrective if in an individual case sources to support such a relationship, other than artistic ones, are lacking.[2]

While the first interpretation can be blind to great historical interconnections and makes little of the traditionalistic convictions of the Middle Ages, the second is too easily satisfied with taking the work of art at face value. It also often underestimates the prominent spiritual meanings that a reception can embody—every bit as much as total copying can—and, in effect, only shifts the emphasis in judgment farther back toward the "genesis" of the type.

Both interpretations or explanations have their justification, but it is necessary to examine how they may be applied to an individual monument or the actual accomplishments of an epoch. The fact that from the eighth century on all large buildings of sacred architecture were erected in stone is, in itself, indeed an accomplishment. At the same time, however, the actual physical presence of Roman architectural monuments in the daily lives of the Carolingians did something to stimulate their conscious or unconscious reception.

In many cases, it is impossible to make distinctions even where the formulations of types are concerned. Is the palace—the Western *palatium*—grounded in prehistoric Germanic tradition or a revival from Mediterranean architecture (Schlag 1940; Swoboda 1919)?[3] Is the wall pattern of the Norman churches a replacement in stone of the timber of prehistoric wooden buildings or of Roman mural columns (Bauch 1939; Strzygowski 1941)? Is the cubic capital a lathe-turned wooden form translated into stone or a Mediterranean creation (Haupt zu Preetz 1925:23)? Is the double-towered facade an indigenous creation or a Syrian legacy (see pp. 88–95)?

These questions cannot be decided here, but a few major points can be illuminated nonetheless. All the relationships based on the material substance of the components and their arrangement—including, for instance, the insertion of the transept in front of the holy of holies and the articulation into forecourt, hall, and shrine—can be demonstrated to be indigenous developments, because the meanings of these things are grounded within the actual building forms themselves, and they would have arranged themselves similarly within any given historical situation. Nevertheless, there are correspondences that can be explained only by means of "influences." In other words, a demonstrable claim put forth by means of these buildings could be expressed only in architectural forms that had, through their historical use, already taken on precisely those meanings. To take an extreme example: if we encounter the Roman triumphal gate well into the Baroque period, we are dealing with a reception of the purest sort; that is, someone wishes to be seen as possessing the qualities of a Roman ruler. These receptions can be fully independent of the more common customary forms; indeed, when they are promulgated by an all-encompassing power and sustained by a meaningful spiritual vision, they rank as a universal style far above the idioms of local and vernacular building traditions. By leaving behind its underlying ideas, however, this universal style can lose its direct ties to its models and—beyond what has been until now the only achievement valued positively by art historians (i.e., documentable transmission or copying)—find itself reduced to the level of traditional local custom.

Approaches to the development of the segregated crossing in the architecture of the Middle Ages may be evoked as an example (Beenken 1930:226ff.; Lehmann 1938; Guyer 1950). In general, the theory runs like this: one assumes a form for the eastern parts of the church common in the Carolingian period (either a continuous transept or a three-chambered area) and then observes the slow change that appears in these types and that would lead to the true "segregated" or partitioned-off crossing: the joining of a forechoir with the nave and transept in a rectangular schema, where the

center of the transept—the crossing—is set off by prominent transversal arches (figures 3.1–3.3).

When seen in retrospect from the true partitioned crossing, the changes brought about in such a linear development appear as preliminary steps; they appear as "not yet" something—that is, as undeveloped or "immature" forms of some later structure. The idea of an inherent development determines where the accents are to be placed in a historical evaluation. When observed historically, however, these relationships present themselves in a completely different light. For example, Hersfeld I, with its continuous Roman transept, represents not an antiquated, unmodern solution but the conscious reception of the Constantinian Roman transept, one that dates from centuries earlier and that, for historical reasons, the Carolingians wanted to make their own (see pp. 218–19). Each change subsequent to the Carolingian reception then can be understood as resulting from a need connected to a purpose (e.g., the adjoining of a forechoir because the number of priests had grown), not as the expression of an immanent developmental drive. The changes to the original building, in fact, signal a departure from the original intention of the reception.

Conscious tradition—that is, the reception of the Constantinian form—had to become unconscious custom, meaning that the choir was perceived as overcrowded, before a new change could take hold, that is, the decision to enlarge the choir. Or, as sometimes also happens, another level of meaning had to come into play (such as the tradition of the mausoleum in the case of the segregated transept) with which the original type could be overlaid (see pp. 179–84). From this point of view, the sequence from Hersfeld I to Hersfeld II to Hildesheim takes on a completely different value. The buildings in the sequence no longer represent preliminary stages of an innate development toward the perfect partitioned crossing but the modification of a type invested with a specific meaning. With a truly innovative building like St. Michael's in Hildesheim, the alteration becomes consolidated into a new ideal.

Types can present their proper, innate meanings as well as meanings acquired through application in historical contexts. A history of types in the architecture of the Middle Ages cannot, therefore, begin by setting up Charlemagne and his creations as receptions that would then have further effects.[4] Rather, the growth of individual building traditions into typical forms must also be investigated, and every nation's, every people's unique prehistoric situation must be elucidated. Even in an exposition of the receptions, the figure of Charlemagne would represent only one important point and would indicate the reiteration of a process that can be observed over centuries.[5] Such an investigation would only demonstrate that, as has happened often before, a ruler deliberately transcended the ordinary architectural forms of his day and

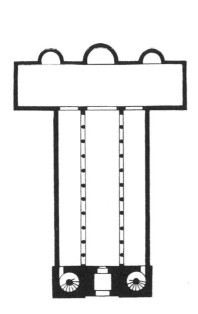

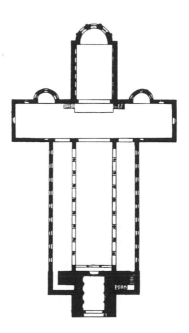

Figure 3.1 Hersfeld, abbey church,
first phase, 831–850. Floor plan.
(From Lehmann 1938: pl. 37, ill. 104)

Figure 3.2 Hersfeld, abbey church,
second phase, after 1037. Floor plan.
(From Lehmann 1938: pl. 47, ill. 177)

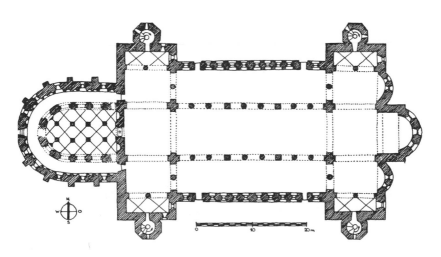

Figure 3.3 Hildesheim, St. Michael, 1001–1033. Floor plan. (Sketch by Dr. Hartwig Beseler)

reached intentionally back to an established "coinage" from the past, to a form whose spirit and meaning he wished to embrace and take for his own. A specific treasury of forms, once minted, tends to reroot itself in unconscious usage—that is, to become part of the vernacular building tradition. When it is then adopted by new powers, it comes to life again, enriched through this distinctive re-imprinting. Not only must Charlemagne, Theodoric, Justinian, and Constantine be taken into consideration along with their buildings, but the pre-Christian rulers Diocletian, Augustus, Alexander, and even the rulers of the great Egyptian, Assyrian, and Persian cultures as well. They gave the impulses that lifted their buildings out of the shackles of mere functional necessity and, by means of their buildings, expressed their claim to rule the world. The types they selected resemble islands that are surrounded by a constricting and anonymous sea of the building habits of tradition.[6]

By definition, habit must have a strong, traditional element in it. In the unconscious transmission of forms, custom and habit are characteristically powerful. Fundamentally, it is an overriding force that can, however, be creative in individual artistic situations. Only a very strong will can free itself from habit. But customs and traditions are also characteristically adaptive and do not depend on the form of the building. They possess no "missionary zeal" but resemble the powers of nature that are continuously effective and all-pervasive. Customs and traditions, too, can be imprinted and to a certain extent suppressed by human will.

When it comes to the treatment of forms, the traditionalist posture of the Middle Ages reveals a double face: unconscious persistence in custom and tradition coexists with taking up received ideas, attributing moral qualities to them, preserving them, and transmitting them onward with conscious care. In the first case, the participants do not oppose an idea; indeed, they cannot oppose it because they do not even notice it, for it is not seen objectively, as one might regard it from the outside. In the second case, the participants are forced to take a stand with regard to an idea and make a decision.

Naturally, both situations tend to flow into each other and merge and to oscillate. Customs can lead to growing consciousness and fixation on an object and can transmute the object or idea handed down into a historical one, thus elevating it and shaping it into an object worthy of care and honor. However, the same process of growing consciousness also creates the possibility of consciously neglecting or denigrating that same object. Once those objects or ideas have been lifted out of unconscious usage and are now having effects of their own, that same conscious transmission admittedly tends to encourage the activity to revert once again into a customary one. Habit as-

sures the continuity of life—by doing what has always been done. Conscious transmission assures the coherence of a culture's interrelationships and underlying ideas—by doing what is valued and important.[7]

Custom knows no types, no formulated and sanctioned "coinages," only those constraints inherent in all unconscious factors. Conscious tradition, however, formulates and must visualize in terms of types so as to transmit the motif-as-object in a specified manner.

Face to face with a work of art, it is difficult to decide which of these two categories, unconscious custom or conscious tradition, takes the upper hand (Brutails 1900:9ff.) and even more difficult to decide which of the two lies at the work's foundation. When appropriated by conscious tradition, a type can have constraints that limit the creative individuality of an artist or people,[8] but the compulsion to employ a type pushes the craft (in this case of building) to rise to those higher levels of imagination that are the basic prerequisite for the creation of monumental works of art.

If a building appears in a form that seems to be a novel one in the context of accepted custom but as a whole adopts a type derived from the past and strives to be representative of that type, then surely we can speak of the effectiveness of conscious tradition. The temporal distance from the model can be an indication, but it is not of great significance in itself. This act of reception marks a consciousness of something that is different; it says that someone wants to make that something his own, something he identifies with, and that that thing will legitimize his specific position. In keeping with the anthropological condition of the Middle Ages, for which many imprinted signs are still full of demons, the imprinted type, depending on its context, can be far more than just reminiscence and attribute. An imprinted type may not simply be an indicator of the sublimity and holiness of the idea or being with which it is associated; rather, through that same association, the building type can actually *establish* that holiness in the mind of the beholder (Burkhardt 1929:74, 78, 81; Semper 1884:419; Spörl 1930).

Before the development of the formal methods of art history, the concept of reception was quite a familiar one. It was used when scholars wished to characterize the reemergence of transmitted forms in a new context. Scholars used this term to establish the historical connections of epochs and cultures, unless—for more complex phenomena—they invoked the concept of a renaissance. In general, the concept was not completely thought through, nor, it would seem, was it assigned a value, except for when it was contrasted with originality and individuality. Georg Dehio brands it as unvalued when he speaks of the various German "receptions" of the French Gothic with regret, a regret mitigated, however, by his insight into the apparent

structural backwardness of German Romanesque architecture and into that higher value that had been placed in the Gothic since the *Sturm und Drang* and the Romantic period, an attitude he still shared. In Wilhelm Pinder, who had abandoned the concept of structural progress and who had, in keeping with the times, placed Romanesque architecture on a higher level, the negative assessment of reception is obvious. Together, the turning away from the historical—from what had conditioned the reception in the first place—and the dominance of the idea of the autonomous development of style made the concept of reception as a conscious act superfluous. Receptions became "influences," tributaries to the unerring flow of the development of styles that were propelled forward through history by their own inherent power. Where true reception was not to be denied, scholars consoled themselves with the thought that only what was appropriate to the style's own character and time would be adopted. This act of the will was based on the perceived congruity of the visual forms. The rediscovery of the culture of Crete was congruent with the period of the *Jugendstil*, for example, and the discovery of Asian pictorial art with the period of impressionism. (We leave the question open whether this idea might suffice to explain the adoption of the Egyptian cult statue by the Greeks, who until then had still been living in the imageless world of the early geometrical style.)

Although it is characteristic that even renaissances have whole clusters of receptions at their core, formal art history concentrates on the unique elements, the renaissance's power to transform all things. Wherever possible, it denies the receptions, speaking instead of "parallel developments." Without being willing to deny the uniqueness of renaissance epochs and the possibility of parallel growth, we must nevertheless acknowledge the many cases of well-known, documented reversion to forms of bygone epochs not as indicating a lack of independence or an insult to one's own time and place. Instead, they must be seen as attempts at legitimization, identification, and appropriation. For in earlier epochs, the reception can even be what lays the foundation for the period to begin with.

Forays in this direction, which in no way contradict the concept of "style" but only its imagined anonymous and autonomous development, are found not only in fields devoted to specific historical data, like architectural history.[9] Clear movements toward a new evaluation of reception are also discernible in the historical sciences (Spörl 1930). The sort of "plagiarism" found in Widukind has been examined in a positive light by Beumann (1948). In the context of a critical attitude toward sources—one dedicated to the concept of "originality"—plagiarism indicates a lack of independence and a secondhand status. If, however, we investigate the author's intentions of reception as

characterized earlier, these plagiarized facts appear in a specific perspective and tendency, one whose investigation is a high priority for the historical sciences. In the Middle Ages, "reiteration" had its own historical reality; it created the perspective from which to see the facts. In any event, in order to be able to evaluate this "reiteration," the researcher must recognize it as such.[10]

The powerful historical complex of the old Mediterranean cultures attracted peoples who, again and again, in order to hold their own ground were obliged to enter into the traditions of those advanced cultures, seize onto typical Mediterranean formations, and augment those cultures' treasury of forms with their own prehistoric ones. Again and again, the incoming Indo-European peoples encountered ancient autochthonous Mediterranean coinages and were obliged to come to terms with them: the Achaeans with respect to the Egyptians and peoples of the Near East, the Romans with respect to the Etruscans and Greeks. Later, as Christianity grew into a significant force, it had to confront the Hellenistic concept of the god-king, just as the Germanic peoples had to confront Mediterranean Christianity. It is these two last processes that gave the Middle Ages and medieval traditions their special coloration. To the extent that their phenomena were adaptable to the inclinations already inherent in Christianity and *germanitas*, the overall tonality of the Middle Ages is that of Antiquity. There were tendencies in Christianity as well as in *germanitas* that were at the same time receptive and hostile to that tradition. The powers intent on the conservation of the *imperium romanum* seized the transmitted types eagerly and en bloc. The groups in Christianity that focused on the purity of teaching in ascetic renunciation and, in the Germanic world, insisted on maintaining the old order that had been customary since prehistoric times—that is, the reformers in the one case and the military leaders in the other—remained reticent in their assimilation of Antiquity.

For the visual arts, entering into the world of Mediterranean tradition held a twofold meaning. In a positive sense, it meant the introduction of numerous new themes and goals—the memorial, the image, building in stone, and interior space—that had been unknown in prehistoric times and now made their influence deeply felt in the shaping of forms.[11] But, in what we today would see as a negative sense, entering into another tradition meant suppressing the inclination of individuals or peoples to freely express themselves as artists or cultures through their own proper coinages. The modern concept of originality stands in complete contrast to the traditionalist mentality; it is precisely in the fact that a building harks back to other buildings and can be compared with them that it reveals its meaning. Hence a building like Charlemagne's Palatine Chapel in Aachen joins a long line of

central-plan royal buildings. Although our main artistic interest is naturally in the elements that differentiate this building from San Vitale in Ravenna, these are really only secondary phenomena and can be traced to latent anti-traditionalist forces in the Germanic populace and to momentary and local exigencies that affect the fundamentally typological character of the building with increasing artistic autonomy and enrichment.

With the urge to create a treasury of building forms, the powers rooted in universal human behavior—the experience of the holy, the desire for permanence, the honor of the gods, power, and justice—had already imposed an apparatus of architectural types by pre-Christian times. Those powers can be briefly characterized by their chief manifestations: sacral kingship and the cult of the dead. But the opposing forces—unconscious habit and the renunciation of worldly involvement, which were always at work though they manifested themselves in different ways—must not be passed over in silence. In order to correctly understand the architectural choices of the Western emperors, the popes, the monastic orders, the cities, and the local sovereigns, it is necessary to investigate the origins of the views these choices represented. It is only against this background that the events in medieval architecture that interest us acquire their clear outlines.

Turning Toward Historicity

State, Religion, and Law

By including prehistoric and non-European cultures in the realm of the visual arts, we have become aware in recent decades of the contrast between historical forms and forms devoid of history. However, this is a distinction that had been observed already much earlier in the study of religions and social conditions. The concept of history here must be understood in its twofold nature. On the one hand, it designates an increasing consciousness of the events and forms that a group of people encounters in a common destiny; this consciousness can be gauged from the time when a theme or story was considered worth representing, as in foundation myths of a people.[12] On the other hand, the concept of history includes a specific, continuous, and interwoven complex and temporal "tissue" of ideas whose outstanding points are transmitted and of which we are still a part. The first aspect is also applicable to cultures outside the genesis of the West, such as the Chinese, Mayan, Inca, or Indus Valley cultures. It demonstrates a general phase in the process of coming to consciousness. The second begins with the great Mediterranean cultures and is confined to a specific space and consciousness whose borders

are still clearly visible to us even as they are dissolving.[13] Into this space and this consciousness, people "without history" entered, gained power, and "entered into the light of history" in that they made use of transmitted forms to legitimize their power.

As is widely acknowledged, ahistorical (prehistoric) conditions do affect historical ones in that prehistoric customs and habits become legally codified,[14] and therefore it should be possible to show how they develop into historical conditions. Nevertheless, the two conditions can be distinguished from and juxtaposed to each other on the basis of their typological modes of existence. Historical and ahistorical forms still thrive, side by side, even today.

Forms without history appear "natural"; they appear to be adaptations to their environment. Such forms do not appear to require obligatory formulations and effects.[15] Their persistence is rooted in the conditions that gave rise to them, and when these disappear, the forms perish without a struggle. They betray their origins in earlier anthropological situations in that they are mostly unconscious. We will not seek to investigate and define those conditions. Among those "ahistorical" forms are the community formations of family, tribe, clan, and cooperative society as well as customary law, and nature religions.[16] As far as the visual arts are concerned, forms "without history" are, among others, those that arose out of technical necessity and purely decorative requirements. They fade with new technical requirements and changes of fashion.

In contrast, there are those forms that grow out of human self-consciousness and strive to endure in history. Those forms change the continually repeated—that is, the constructions of traditional vernacular architecture—into the unique objects of history, of individually identifiable monuments (Rothacker 1937:6).[17] Objects are lifted out of the cycle of coming into being and passing away and instead come to be thought of as preexistent and permanent and are depicted in the visual arts. This change mirrors the path from a religion of nature to a religion of the cosmos (Mensching 1938), from a law of custom to a law of fixed rules (Latte 1920; Melicher 1930),[18] and from a natural community to a state.[19]

In the ancient Near East in the third millennium B.C., this process of formulating, imprinting, and outfitting with transcendent aspirations initially gave rise to the idea that earthly events might be reproducing the "real" happenings of a cosmic world. This indicates the passing from a nomadic tribal culture to a settled farming culture, from a tribe to the formation of a state and thus to history. The claim to earthly and religious world-rulership was also born in this way. It was born in Babylon and survived throughout the Hellenistic, Roman, Byzantine, and Western worlds (Jastrow 1905:113; Erdmann

1932:384ff.; Ensslin 1943:7ff.; Eichmann 1942:3ff.). A new degree of con-
sciousness, self-awareness, and sense of power manifested itself that seeks to
make the individual (or the collectivity perceived as a unit) eternal: elective
monarchy was changed into hereditary monarchy; divine revelation became
eternal salvation; and laws had to be written down and became inviolable.[20]

Sacred Kingship

The self-propagating idea of sacred rulership, which links the art of Antiqui-
ty to that of the Middle Ages, has its origins here. From the ancient oriental
god-king to the most recent Western ruler "by the grace of God" stretches an
arc that is enclosed by forms that owe their origin to claims of sacred kingship
(Ensslin 1943). The forms, deriving from magic rooted in prehistoric times,
were originally coined in Egypt and Babylon (Jakobsohn 1939; Moret 1902;
Müller 1936; Dworak 1938; Jeremias 1919; Kampers 1924:30ff.).[21] They were
stabilized by the rulers' own personal cults,[22] received by Alexander the Great,
mainly under Persian influence, and have continued to exert a lasting influ-
ence on the West.[23]

Rulers' heads and representations of historical events had long been com-
mon on coins in the Near East. Although they were nonexistent in pre-
Alexandrian Hellas, they suddenly appeared with Alexander (Schlosser
1927a:49, 1927c:188). At first they were not individually differentiated, but by
the time of Alexander's successors, the Diadochi and Seleucids, portraits of
individuals appeared, marked by divine attributes, such as rams' horns or
wings, or crowned with rays of light and at times combined with a baldachin
(Regling 1924:81, 107; Schubart 1937:123; Herzog-Hauser 1924:806ff.).

Kinship or equivalence with the sun god is typical, as is the character of
the ruler as savior of the world. We can trace this idea as it developed from
Cyrus and Alexander to the Ptolemies and Seleucids, was taken over by the
Roman rulers, and was transferred from Caesar through Augustus and Dio-
cletian to Constantine (Straub 1939; Dworak 1938:42ff.; Kornemann
1901:51ff.; Ensslin 1943:38; Vogt 1949:151).[24] The Roman ruler was *pontifex
maximus* and acknowledged no higher authority (Hirschfeld 1888:861ff.); he
required no further earthly confirmation. He was worshiped and honored in
his portrait (Hahn 1913:19ff.). His palace and all that belonged to him were
sacred.[25] As the dwelling of the imperial god, the palace was a temple and ac-
cess was barred to commoners (Koch 1942:133ff.). The palace was invested
with the meaning of the world-house, the cosmos captured in stone. The em-
peror was worshiped as the savior of the world and bringer of peace (Beurli-
er 1891; Bickermann 1929).[26]

Writing

Writing is an important hallmark for entering into history, but this applies to writing as a medium of transmission, not as a magic sign. The need to make a situation or occurrence enduring—to transmit and eternalize it through a literal fixing, making it fast—presupposes the discovery and consciousness of what is fleeting and passing away, the fear that something holy or one's own self or the society one belongs to can be forgotten. Writing also expresses a change in the world of ideas, in that magic powers previously bound up within an object might be set free and be summoned up by other human beings through certain created signs; that is, those powers could be transplanted. The soul begins to detach itself from the substance. The god is no longer the object itself; rather, the god now appears only in figures and signs.

Writing is also a decisive precondition for the formation of the state, which is thereby separated from prehistoric forms or ahistorical community-based forms, whose parts were held together by "natural" connections. When the state takes unto itself the elements of a constitution (laws, a written record of tradition and power), it wishes to elevate itself above what is continually passing away.[27]

It is characteristic of the attitude toward writing in Hellas that all conception of the sanctity of letters and a privileged, literate priestly class was originally lacking. It was only after Alexander and under the influence of the older cultures of the Near East that the concept of a "holy script" was introduced (Curtius 1943:61ff.). Wherever we find the concept of a state religion, we find rulers exerting themselves to collect holy books and to introduce a compulsory, fixed, written order of worship; this happened in China, in Sassanid Iran, under Constantine, and under Charlemagne (Dworak 1938:56).[28] When there is no prehistoric way of life calling for adaptability or flexibility, the historically sanctioned power of written formulas becomes particularly evident. The concept of the modern Vatican state, based on no prehistoric power or territorial relations, is built on a passionate love "for the written word, the *lex scripta*, and the formal contract" (Binchy 1946:49; Schnürer 1894; Seppelt 1934; Jordan 1939; Bierbach 1939; Harnack 1902:156). In the Germanic states, in contrast, there was hardly any necessity for written formulation. The fact that the German states early on detached themselves from the universalism of the Middle Ages betrays their derivation from the tribes and clans of a prehistoric communal society disinclined to enlarge the specific powers of the state as a superstructure (Grasser 1946:12).[29]

It is characteristic of Western history that in the succession of state-formations these two forms, the historical and the ahistorical (or prehistori-

cal), are juxtaposed and even coexist to the extent that the dominant, histor-ically conscious collective structure still allows the other one room to thrive.[30]

Mostly as a result of the great migrations of the Indo-Europeans, peoples "without history" repeatedly entered into the world of Mediterranean his-toricity, where the forms were rooted in the old Near Eastern state structures. Through intermarriage with settled farmers, these newcomers transformed themselves from nomadic pastoral and warrior peoples into settled nations (Meyer 1937).[31] It was there that the form of government of the royal house, with all its subsidiary phenomena so important for the formation of the his-torical state, first arose. The Ionians, the Aeolians, and the Achaeans came from the North and assimilated themselves to or displaced the Pelasgians, Cretans, Heneti, and Ethiopian settlers and their prehistoric matriarchal ways of life.

It is interesting to note what was received by the invading peoples when they entered into history and what they replaced with their own customary forms. In the Indo-European language of the conquering Hittites, the origi-nal language of the conquered Anatolian peoples survived in the cult, as did local words for matters of state and society and for the hitherto unfamiliar flora and fauna (Schenk 1947:186ff.). However, it was the grammar and syn-tax of the conquerors that prevailed (Götze 1933:51). In other words, al-though new content (Anatolian vocabulary) was added, traditional forms (Hittite grammar and syntax) were retained. While the typical embodiments of the historical, of the state, and of a higher religion were alien to the new masters, they coped with the new in their own way. The traditional (i.e., lo-cal) forms of sacral architecture of the conquered Anatolians were also taken over at that time (Krahe 1938a:2, 1938b, 1939:185ff.).

Wherever Indo-European peoples secured a place for themselves in the Mediterranean world, we can observe this behavior. This how the Greeks dealt with the Cretans and Egyptians, the Romans with the Etruscan and Greek populations, the Franks with the provincial Romans, and the Nor-mans with the Frankish culture, and the same happened in encounters of lesser magnitude. However much it might have originally inherited from Hellenism, Christianity similarly had to rely on receiving the elements of state power it originally lacked so as to advance its claims to becoming a pow-er in history. In all these cases, the typical forms—the objects—were taken up as a whole, but the processing of the meaning they represented followed in a more unconscious, internalized fashion. Growing by means of other peo-ple's own forms that have already developed into types can be of considerable importance if those forms have already been prepared to point to a higher, in-dicative purpose and meaning.[32]

Portraiture

Next to writing, the image is the essential hallmark of historical formulation. Its primary genres are the portrait—that is, the depiction of a specific person—and the depiction of historical events (Hager 1939). For many of the Germanic peoples who lived in those regions that were brought from their prehistorical condition into history under Charlemagne, the portrait was still a foreign object. Initially, the role of the portrait had to contend with the non-representational customs of the regions on the borders of the area of power. When the rulers in Frisia and in the North started to issue coins of their own, they allowed the ancient images, the portraits of rulers as they knew them on Roman coins, to atrophy into caricatures (Schramm 1935–1936:14). Significantly, in Carolingian times the picture of the emperor initially (and quite commonly) appears on legal documents (Schramm 1935–1936:38, cf. 28) where the figure of the emperor—the image as his deputy—must appear to lend the documents authority and to sanction their content.[33] It is only when we find that the image of the emperor is being prayed to or being set up in temples that we might assume that the figure of the ruler is also being elevated to something sacred and distanced from earthly things (Kruse 1934:12ff., 46, 51ff., 79ff.; Schramm 1935–1936:4ff.).

What effect does the symbolic portrait have on our concept of the type? Because of its frontal presentation and the restriction of possible movement to a very few gestures and also through the universality of its physiognomy, the symbolic portrait functions as a very important indicator. It points unambiguously to an important concept. The decisive factor is one that we no longer readily understand in a positive light—the portrait's implicit relation to that of the subject's predecessor, often that of a copy. For example, in order to show that they had acceded to the office of emperor, Roman emperors often had their heads set on the statues of their deceased predecessors. This was also done in the Middle Ages. For example, a portrait of Otto III that had originally been prepared for a manuscript illumination was set aside because it could be replaced by a better one. Later it was reused as a portrait of Henry II and accordingly labeled with his name (Schramm 1935–1936:7).[34] This typical behavior of the portrait as *insignium* and indicator of office illustrates the deputizing character of this particular coinage, which although originally present in every portrait, with the diminution of animistic naïveté lived on only in places of official symbolism—on seals and in places of legal judgment.

In pre-Carolingian times, the official cult of the emperor was on the wane, a cult that had a particular interest in mimetic portraits. Resisted by

the Christians and deprived of its all-encompassing character through Constantine's recognition of Christianity, the relationship between the portrait and the thing portrayed still lived on in the lasting honor paid to the emperor's portrait, particularly in Byzantium. Yet even in Christian Rome, we find evidence of the honor shown to a deputizing imperial portrait. In 602, for example, it was reported that Gregory the Great received portraits of the emperor, which were ritually acclaimed in the Lateran by the clergy and senate and then set up in a place of honor in the oratory of the papal palace (Schramm 1935–1936:17).

Images of Events

With pictures showing a historical event, it is necessary to distinguish between representational pictures that reflect something lasting and nonpersonal, usually accomplished with the assistance of a saintly figure, and historical pictures that simply document events. Representational pictures are characteristic and common in the early and central Middle Ages, but they cannot be regarded as an unchanged continuation of the classical genre.

In the Middle Ages, historical events were not worthy of depiction in and of themselves but only in their relation to the order of the world as revealed by God. In the picture, the one holding the worldly powers depicts himself as the agent of the divine order since the office and commission with which they are entrusted remain even if the person holding the office changes; the function outlasts the person holding it (Hager 1939:45; Dworak 1938:9).

Along these lines, the concept of personal fame, dating from Antiquity when fame was considered to consist in the achievement of historical greatness, was circumscribed and narrowed. Earthly forms and events *were* now worthy of depiction, but fame was no longer grounded in itself; rather, it was to be understood only in its relation to the will of God, in how it contributed to the unfolding of the Plan of Salvation in the context of the earthly *imperium*. As a formal consequence, the temporal phenomenon takes place in the presence of the divinity and is divested of the element of chance. Figures are presented together in ceremonial fashion and are marked as enduring figures by means of attributes, inscriptions, and postures (Hager 1939:44, 96).

Conversely, when we encounter a people in the Middle Ages entering into this historical sphere completely fresh, ascribing its success to itself alone, then the picture is not sacral; rather, it is frankly and unequivocally tied to the causes and events presented. The chief testimony of such a sensibility is the Bayeux Tapestry (Hager 1939:46ff.), with which the Normans enter into Western history but without pressing the slightest claim to integrate them-

selves into a universal scheme. All divine legitimization of the deed is lacking, although it could have been implied through the iconographic presence of holy figures.[35] The accompanying modern nationalism that explains the chronicle style of Orderic Vitalis (Spörl 1935:51ff., 65ff., 73ff.)[36] does not imply a developmental breakthrough leaving the universalism of the Middle Ages behind.[37] Rather, it is a naïve testimony stemming from the timeless world of the tribal order of peoples emerging from the period extending from the Stone Age to the Iron Age.[38]

The rulers of other early Germanic states also displayed similar propensities for unhierarchic historiated pictures, thus expressing not only a prehistoric artlessness but also the sense of personal greatness connected with the ancient cult of the emperor. In this same manner, the historical depictions known from Roman triumphal columns, which had been set as mosaics on the walls of the Byzantine throne halls (Schlosser 1895:158; Richter 1897:262), were perpetuated in Theodoric's time and in the frescoes of Carolingian and Ottonian palaces.[39] One could say that by the twelfth century, these kinds of images of historical scenes had completely disappeared and that images of historical scenes would only gradually reemerge from the illustrations of specific stories (Huizinga 1930:208; Keller 1939:227ff.). In this process, however, the symbolic links of the historical facts to salvation history, which had once justified the depiction of historical events, grew more and more indistinguishable and eventually, as in the apotheoses of the seventeenth and eighteenth centuries, ossified increasingly into empty flourishes (Simson 1937). Despite all these changes in the relationships between hierarchical and nonhierarchical figures, however, we never observe in the West, as we do in the East, that people were content with the one-sided contemplation of the eternal and its symbols, whether in the conception of rulership, the state, or the image: "While we direct our vision with equal attention toward its becoming, we grasp the world by its existing; space and time are not obstacles on the path toward truth for us, rather they are the forms that create the world" (Hager 1939:6).

The Demarcated Area

In architecture, the first movements from the prehistoric to the historic—the growth from what was traditional and without meaning toward the typical and meaningful—occurred in very remote times. But again and again when a new people enters into history, it must come to terms, all over again, with what is initially foreign and has to be mastered, and it must surrender or adapt its own experience.

From etymology, we know that the names for parts of later sacral buildings must have originally had a purely practical, architectonic sense. The word "gable" comes from the "fork" (Ger. *Gabel*) that carried the ridge beam, the word *templum* is related to the purlin in the roof truss, and so on (Trier 1947:9ff.).[40] We know from early Greek temples that even though these forms stemming from the necessities of building with timber lost their technical function with the change to building in stone, they persisted (Durm 1910:1ff.). Similarly, the aftereffects of the technique of building with reed mats in the wide flatlands of the Nile delta and Tigris-Euphrates region can be seen in the brick building of ancient Egypt and Mesopotamia, lasting well into Hellenistic Seleucid and Islamic buildings (Andrae 1930).

The first architectonically momentous intervention in an environment ruled by magic powers was the elevating and enclosing of an area—the *temenos*—that was consequently brought into a special relationship with the supernatural powers. It was here that these powers were now to live or from here that they were to be warded off. In the same way, taking possession of a piece of land was to elevate and designate that piece as having a special position in regard to a community's other possessions.[41] It signified the extension and protection of the person—self-determination and mastery—just as clothing represents man's first defense against the environment. The emotionally uncertain boundaries between the self and the outer world are thereby solidified for the first time (Leeuw 1933:324). The first protective structures of any size and technology were, as Andrae (1930:45) has shown, nothing more than extended clothing, demarcations that had to be protected and yet were always connected with the chthonic powers of the earth, with stone and water.

It seems that for the Indo-European peoples this setting apart and enclosing long satisfied the most important conditions for a shrine.[42] The space as a holy place—the house, the cave—did not originally exist. This "power of the fence," which still lives in the round dance and in circular gatherings,[43] also found its way into many expressions and idioms.[44] However, the demarcation of a region presupposes a settled way of life, and this explains why as far as architecture is concerned, nomadic tribes remain outside the historical situation.[45]

Dwelling, Tomb, Temple

The hallowed area and the dwelling are the first manifestations of self-awareness that have architectonic consequences. These are the first places where the hitherto unfocused reverence of people to whom all things were

full of the divine coalesces. The prehistoric house, which had gradually de-
veloped from the tent, windbreak, and cave, was at first completely filled
with magical presence. Indeed, there is no structure that can claim a greater
presence of divine powers than the home. There was no Other World con-
ceived of as separate. The dead were buried in the house, under the door sill
or under the hearth; the gods were set up in the house and worshiped there.
This practice was maintained in the western Mediterranean region and
northern Europe, regions that remained in a prehistoric condition longer
than the ancient Near East (Schuchardt 1935:146; Burck 1942:124; Andrae
1930). The door (Burck 1942:19), the hearth (Saeftel 1935:82ff.), the sleep-
ing area, and the seat of the head of the family are the first places where
holiness coalesced.[46]

The separation of the shrine from the dwelling brought about a decisive
change (Scharff 1944–1946). Among nomadic peoples it had already affected
the grave. Confined to one spot, the grave had to be left behind and was
therefore given an architectonic treatment that developed out of the transito-
ry structure of the tent. A subterranean tent was built for the dead out of
some lasting material; the place was given a boundary and was identified by
a stone marker. A dwelling was thereby imaged for the first time, and an ar-
chitecture was created that is both symbolic and representational. This sepa-
ration of the dead from the society of the living, this process of setting them
apart in an architectural structure symbolizing the house, signifies a division
of the realms of the sacred and profane. It also distinguishes signifying ele-
ments from strictly utilitarian ones, and intensifies the concept of the Other
World, simultaneously leading to a corresponding diminution of the element
of magic in people's everyday surroundings.

Originally, the intention had been to make a house for the dead that
would be like that of the living, not different from it.[47] But very soon the
wish to give the house of the dead a greater durability asserted itself, or per-
haps some great man wished to render his own house-of-the-dead more
prominent by heightening the individual elements to a degree that would
have been out of the question in any utilitarian, ordinary dwelling. Thus
Diodorus (1933) reports that the citizens of Memphis

consider the period of this life to be of no account whatever but place
the greatest value on the time after death when they will be remem-
bered for their virtue, and while they give the name "lodgings" to the
dwellings of the living, thus intimating that we dwell in them but a
brief time, they call the tombs of the dead "eternal homes," since the
dead spend endless eternity in Hades; consequently they give less

thought to the furnishings of their houses, but on the manner of their burials they do not forgo any excess of zeal. (1.51)

The tomb was already called "house of eternity" in ancient Egypt, and in the inscription on his tomb, the nomarch (regional duke) Chuefhor (Sixth Dynasty) wrote, "I have built my house" (Scharff 1944–1946:9n.2). Among the people it had become customary that the dead should no longer be buried in the house; still, it remained the privilege of the king to be buried in his palace. The house of the king alone still partook of the numinous content that was once attached to the house of the family or the clan (Meissner 1920, 1:426). The tombs of the kings were very often copies of their palaces; for example, the tomb of King Zoser (Third Dynasty) in Saqqara reflected his residence in Memphis (Scharff 1944–1946, n.167, 28; Ricke 1944; Müller 1949). The reed bundles of the dwelling were depicted in limestone (Andrae 1930:63ff.). High officials could also employ forms from the palace, such as niches and splendid false doors, in their tombs (Scharff 1944–1946:28).

All this indicates that the immediate relationship between the tomb and the ordinary house had dissolved. The forms borrowed from the palace have the meanings of "high-ranking," "honorable," and "distinguished." They are no longer pictures depicting objects but have become symbols.

In the course of the Second Dynasty, the practice originated in Lower Egypt of depicting the deceased at the dinner table on the false door, which until then had been without picture or inscription (Scharff 1944–1946:41). The presence that was originally believed to be self-evident was here made visible by artistic means. When the false doors became visually embellished in this way, the rooms behind them atrophied (Scharff 1944–1946:46); one could say that by being more and more captured in a symbol, the original identity of tomb and house increasingly became a merely associative connection. The tomb contained its own reality, separated from that of everyday life.

On a smaller scale, the tomb's character as copy and representation, as an indication and stand-in, survived for a long time (figure 3.4); that is, in smaller versions tombs were reminiscent of dwellings but did not realistically depict them anymore. Thus house-urns and house-sarcophagi are truly portrait-like but no longer attain the original proportions. The representational character of the tomb structure could also be changed according to the status of the dead in a manner that created a distance from the dwelling; indeed, the whole fundamental relationship could be forgotten.

The Babylonian form of the ziggurat, the tower-temple and the tower-tomb, originally signified a reed hut on a clay mound.[48] Gradually, however,

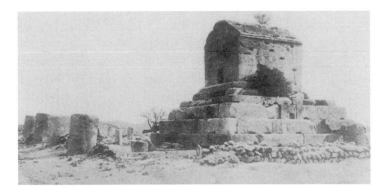

Figure 3.4 Pasargadae, funeral monument of Cyrus, d. 529 B.C. (Foto Sarre)

the mound grew, the walls became steeper and were erected in durable ma-
terials, and the slanting embankment was replaced by steep brick walls. If the
dead were of high status, or if the ziggurat was the dwelling place of a god,
the structure could take on a life of its own as a distinctive creation and a cult
place. Thus the ziggurat of the Babylonian royal god Marduk was extraordi-
narily tall, but a tiny hut, containing a table and bed for the god and seem-
ingly built of flimsy material, stood on top of the hill of stone (Andrae
1930:1ff.). It was the house of the god, who was thought to live there and to
always be present. Absent are the monumental entryway and stairs that were
so remarkable in the epiphany- or apparition-temple—Andrae's *Erschein-
ungstempel*—so called because the god was not always present but appeared
only for the ceremonies. The dwelling-temple, on the contrary, was the house
of an ever-present god who was *not* honored by a community cult in his
house. As we shall see, this archaic form was of great importance.

Just as the living and dead originally cohabited in the dwelling and then
progressively began to inhabit different places, so the gods only later got
their own buildings. Originally, this always meant a dwelling. Their chang-
ing forms in different cultures correspond to the different types of dwellings
in those cultures and reflect the dwellings those people had in prehistoric
times. According to the people's sociological structure and ethnic back-
ground and depending, above all, on the building materials available, the
differences in building types could be very great. The stone construction that
was indigenous to the West—that is, in the Mediterranean region—had
structural features different from those of the northern structures that de-
veloped from wooden buildings. This, in turn, was different from the clay
and reed-mat construction of the ancient Near East. Even in regions where

a single building material is used there are differences in the house forms that, on the one hand, correspond to the development (in the sense of a possible perfecting) of the dwelling as it gradually became a profane building and, on the other hand, are connected with prehistoric wanderings we can no longer know of today. In this respect, the ancient Near Eastern dwelling—and with it the temple of Assyria, the neighbor and later conqueror of Babylon—can be compared with the northern longhouse or to the *megaron* (Andrae 1930:18). The early temples of Ishtar and Assur differed in no way from contemporary dwellings. Despite being built in more sumptuous style, the royal palace, too, was not yet fundamentally different from an ordinary dwelling (Andrae 1927:1033ff.).

Once the building sacred to the cult becomes independent, certain features appear. After the second half of the third millennium B.C., stairs became increasingly important, and portals were impressively decorated (Andrae 1930:11, 20, figs. 12, 15, 16). The god "appeared" in the temple. A shrine within a shrine—a house within a house—was portrayed by means of a niche that originally signified a house. Since the niche chamber lay on an axis with the entrance and the antechamber was transversally placed, the image of the god appearing within a mighty portal could be presented.[49] The transept linked with the portal continued to be used even when, beginning with the eighteenth century B.C. in Babylon, the main room begins to be placed lengthwise, on the long axis (figure 3.5).[50] A complicated arrangement of rooms with

Figure 3.5 Schema of a late Assyrian long-naved temple.
(From Andrae 1930:24, ill. 21)

forecourt, sanctuary, and holy of holies made it more difficult to see the god-
head and testifies to the progressive retreat of the god. At the same time, this
arrangement shows the growing separation of the sacred from the profane,
of the priests from the laity. Awareness of this phenomenon is also revealing
for understanding the subsequent development of Christian architecture, in
which, despite the repeated efforts to prevent the godhead from being re-
moved in this hierarchical withdrawal, the process of removal continues. Just
such a process is transmitted to us by the ancient history of Judaism. Abra-
ham, the patriarch, spoke with Yahweh everywhere, even in the open air, but
Solomon, the king, built him a temple, whose holy of holies was accessible to
only the high priest.

The separation of the sacred and profane spheres underscored the inde-
pendence of the house-of-god, but one could say that fundamentally the
temple always retained this character of being a house. Intensified ornamen-
tation and magnificence of the building and their increasingly less relevant
references to meanings result in the elements of tombs and temples that point
toward the structure of a dwelling becoming less pronounced. Nevertheless,
it is these ancient forms, now expressed in new techniques, that give the ed-
ifice its meaning as cult building.[51] We see this in the way that the grooves of
the clay and reed structures persist in Babylonian brick buildings (Andrae
1930:8, 33) as a useless technique, rendering the process of building extraor-
dinarily more difficult. This difficulty speaks against their surviving as only
an unconsciously used form. Yet it would be even more impossible to see in
these tightly arranged vertical members some sort of formal manifestation of
a unique *Kunstwollen* and interpret the building forms with this in mind, as,
for example, the expression of a religious concept, as a soaring upward.
Mesopotamian architecture, even in the more advanced form of the massive
brick building, developed out of reed-mat construction that is held together
by means of bending and bracing. Hence it is false to apply aesthetic cate-
gories that derive from the Greek and thus from wood and stone buildings,
which must concern themselves with more or less harmonious load-bearing
and stress. Applying these interpretations to Gothic cathedrals, which in
comparison with these primitive buildings could be called modern, would be
inappropriate and romantic.

The immediate relationship of these survivals of construction practices of
primeval dwellings to the meanings directly connected with practical struc-
tural concerns disappeared. They were replaced by the meanings "old, honor-
able," "belonging to the cult building," and "linked to the deity." This change
in meaning becomes clear if one examines a reception shown by Andrae
(1930:28). In 689 B.C., Sennacherib, king of Assyria, destroyed the rebellious

*Figure 3.6 Assur, temple of Kar-Tukulti-Ninurta, thirteenth century B.C. Floor plan.
(From Andrae 1930:18, ill. 10)*

Babylon, chief city of the older neighboring realm that had continually tried to free itself from the dominance of the Assyrians. He announced that he would set his local god Assur in the place of the foremost Babylonian god, Marduk. He then brought the cult form and the building type of the shrine of Marduk—the ziggurat—back to Assyria in order to win the power of Marduk for himself. The originally common type of temple of Assur—the portal-and-hearth type of temple—was abandoned, and a Babylonian ziggurat was erected. In terms of religious history, the temple type of the ziggurat was more ancient, having already been superseded in Assyria by the epiphany-temple. Another example of this kind of reception had, indeed, already happened 550 years earlier, when a Babylonian ziggurat was attached to the Assyrian epiphany-temple of the shrine of Assur in Kar-Tukulti-Ninurta (figure 3.6).

Although both these temple types reflect prehistoric dwelling types of the same family, the meaning toward which each pointed must have become less important than their historical, individual meaning in each specific situation. The ziggurat had become an attribute of Marduk, whose power Sennacherib wished to obtain. This action of Sennacherib—that is, bringing the cult form and the building type of the shrine of Marduk back to Assyria—was neither a clever calculation nor the legitimization of an altered political situation, but based on his instinctive certainty that magical power inhered in the imprinted objects, in the forms of the cult and the type of the temple.[52] It also reflects the general religious-historical situation before Christianity, which corresponded to a thorough saturation of the world with the divine. People always believed in a multiplicity of gods; none of them could be eliminated, but their hierarchy could always be rearranged. The god of the strongest land held the apex of the pyramid. In this manner, the earthly events of realpolitik appear as a projection of a simultaneous divine contest.

But even this historical meaning can fade, and the old symbolic form can turn into a highly valued but meaningless element of adornment. We can fix those points in time when something originally formed a dwelling, then represented it, and eventually meant something that was generally deemed worthy of honor but was utilized only in the form retained in the cult building. In the meantime, the dwelling had completely changed. Returning once again to our earlier considerations, we can say that it is only in the case of the initial application of the apparatus of types of the sacral building or when there is a change in that apparatus that we can speak with certainty of an actual or a changed meaning of the building as a reflection of something else. When it comes to reception—above all, reception from another culture—the historical meaning takes precedence over the symbolic.

Building in Stone

The change in the manner of building from transitory materials to durable stone and brick was mentioned in the preceding reflections. In any investigation of the factors leading to the formation of architectural types, extensive consideration must be devoted to this change. Building in stone or brick is not something that arises for more or less self-evident geological reasons under conditions of wealth, civilization, and self-improvement. Rather, like the invention of writing, it is a sign that depicts and symbolizes. It marks a turning point, one whose meaning is perhaps not equaled by any other later development in the history of mankind. It is only today, now that we have learned to build with concrete, glass, and iron, that the particular status and power of stone has reemerged, a status our ancestors forgot once building in stone had become the customary and, indeed, the only possible medium of building. For millennia, it has seemed to be self-evident that architectural elements should be made out of that material. Only now can we again see stone in its former status—in its historic connections—as a testimony of bygone conditions.

It is significant that the trend in early Sumerian times toward massive rectangular buildings made with fired bricks apparently coincided around 3000 B.C. in Mesopotamia with the invention of writing (Andrae 1930:85ff.).[53] A short period of building with wattle followed the ages of prehistoric buildings made only of reed mats and bundles. In this period, closely placed clay rods were pressed into a supple air-dried material, which created a firm top layer and repeated the textile pattern of the earlier buildings made of reed mats. Then followed the technique of glazed fired bricks—so characteristic for the Mesopotamians—that survives in their royal palaces and temples. The transition from brick to stone building had already taken place in Egypt.

Not only was building in stone, which should be understood to include fired brick, important for the fixing of types and for their canonical formulation, but it also presupposes a decisive step of mankind.

Clearly, the necessity for perpetuation must have grown stronger and more conscious in society or in the individual along with the need to maintain a stable, eternal relationship with the gods. This assumes that more than ever before people felt themselves destined to pass away and be abandoned. And this cannot be understood apart from a growing sense of consciousness of the individual and a growing sovereignty over the objective environment.

Stone, more than any other building material, satisfies this requirement. Working stone, however, requires the liberation from the chthonic bonds that had constrained people at an earlier stage and then induced them to view working of stones, felling of trees, and scratching the earth as a sacrilege they had to atone for with their sacrifices and offerings.[54]

First, the stone had to be made workable by being emptied of its daimon. Only then could it be given features that could state something and indicate something that was not the stone. Just as the first forms made by man—such as the designs covering a freestanding boulder—made that object into something else, so making the first hewn stones into building materials seems to be linked to the unfolding of some other concept. Idea and object, the concept and the physical world, meaning and being are no longer identical. Man has thereby become a creator who can shape and enliven things in that he can give a name to inanimate things and impress characteristics upon them.

The working of the stone is the decisive moment. In the western Mediterranean, where, despite the absence of tomb and temple buildings, building with stone had long been common practice, the working of stone first occurred at a specific historical moment (Glück 1933; Schuchardt 1935). It is one thing if the stone cave in which one takes shelter is built of boulders piled on top of one another and quite a another if the stone is worked. Even the discovery of metalworking created only a technical possibility of strengthening the original metal, not the spiritual readiness to do so (Quiring 1948:54ff.).

By being worked, the stone is elevated into the realm of the symbolic and meaningful. What were monumental layerings assembled by nature, where stones towered up on top of one another and where the power of the stone still slept undisturbed, could now become intellectualized and organized. In place of piled-up stones, there would be an orthostatic layering consisting of regularly worked, rectangular stones fitted together according to a preconceived plan. In this instant the indicative, representing meaning of the individual stone withdrew in deference to that of the whole assemblage. The house of the dead—of the king or of the god—would convey meaning and do so without

yet being able to satisfy the general practical purposes of everyday life (Kaschnitz-Weinberg 1944:38). If the individual components of the building—the stone from which it is made, the beam, gable, or doorway—are to serve a higher purpose, they must also be stripped of their functional character, and in many cases only the outline or a designation describing the visual place of the component remains of the original meaning of the actual element.

Thus, for example, the Roman engaged column, which we first encounter in the interiors of *cellae* (Curtius 1913, 2:10), is no longer presented in its fully plastic, Hellenistic reality. Instead, a picture of it confined to a two-dimensional plane suffices as a statement to anchor its meaning. Art and abstraction, the hallmarks of higher culture, are born in this way (Hallmann 1943:4ff.).

Now those house forms that had once been sunk into the earth as funerary buildings could be brought back onto the earth's surface and made visible (Glück 1933:349; Krautheimer 1942b:27ff.). And now, to name but a single symptom, the false vaulting that resulted from stones jutting out toward each other could become true vaulting. A statement from another cultural context, relating to the Hindu temple before contact with Islam, might show the status that stone buildings everywhere enjoyed in a world of mostly wooden buildings: "He who builds or renews a wooden or thatch-roofed temple lives ten million years with the gods. With a brick building the term is a hundred times as long, with a stone temple ten thousand times as long as with a brick temple" (*Mahanirvanatantra*, chap. 13, 24, quoted in Zimmer 1937:134).

That the meaning of stone as it appears in its natural condition had not been forgotten is evident from the fashion of *rustica* square-stone masonry, which became prevalent again in Hellenistic times. The technique of building with these stones, which were left unfinished on the front and occasionally had trimmed borders, was confined to city walls and palaces. These cannot be explained as traditionally shaped foundation stones, once hidden underground, that later became fashionable for the upper parts of the building. Rather, using these stones is a question of the symbolically and even aesthetically imprinted knowledge, even if in very faded form, of the superior power and might of stone in its natural form. Other arguments, such as those for a greater actual strength or cheapness of construction, are not at all convincing. Buildings whose purpose was to appear powerful and strong were specifically constructed in this manner.[55]

If we ask ourselves whether the same basic intellectual change must also have occurred in the Middle Ages before the Germanic peoples began building in stone, certain qualifying factors must be mentioned that will limit the universality our perspective has hitherto had. For one thing, it is likely that the ancient buildings in fully dressed stone, which had been known to the

Germanic tribes for a long time, would have cushioned the shock of the new techniques. For another thing, it is likely that the command to adopt the Roman manner of building in stone came from circles that had, through their education and upbringing, to all intents and purposes already made this change. Yet, we must assume that the magic of earth and stone was operative to a degree we no longer know from our own experience. Certainly rulers such as Charlemagne and Ramiro of Asturias were alive to the concept discussed above that one could perpetuate oneself and one's claims more strongly and could legitimize one's own power by building in stone. In other words, we cannot say to what degree the transition to stone construction was anchored in these peoples' own development, but as far as the aspect of reception is concerned, it was certainly powerfully determined by the historical meaning inherent in building with stone.[56] Particular attention should be paid to ashlar masonry in stone construction; this technique was especially cultivated in Syria in early Christian times, in certain state buildings in Carolingian times (the westwork of Aachen), in Hirsau and by the Salians[57] in the upper Rhine Valley in the eleventh century, and, above all, by the Hohenstaufens in the twelfth century.

The Holy Place

The necessity of connecting a building with a place sanctified by tradition was another impulse that expressed itself only in more general terms and only after a more or less lengthy period of settlement. A place with traditional associations carried historical meanings that presented conditions and imposed restrictions on what a building constructed at that site could look like. The place's historical meaning compels a certain kind of reception. The holy place, one certified by tradition, where holy powers were already known and where they could be shown to dwell, will always be visited, and if there are new gods, they have to be connected to these holy places. Invading peoples thus visited the holy places of the conquered peoples; the Romans erected their temples on the sites of the local Germanic and Celtic divinities. Similarly, Christian communities built their churches on the places of the pagan cults (Formigé 1928:310),[58] and the new political powers also installed themselves in the places of the subjugated ones.[59]

Spolia

A conqueror of a newly subjugated state who wanted to continue his deposed predecessor's rule and to erect palaces or churches outside its former borders where no traditional holy places were yet established that could transfer their

sacred power to the new edifice had two options to ensure that the new build-
ings would be consecrated. He could attempt to copy an honored model, or
he could make an effort to transport parts of the old buildings into the new
one as architectural relics, so to speak. This process, often observed in me-
dieval architecture, can mean more than just artistic poverty or embarrassed
circumstances. It can indicate the unconscious extension of a continuum,[60]
the translation of relics,[61] or the conscious adoption of a tradition because of
the historical meaning embodied in the transported parts.[62] This is the case
especially when builders have recourse to forms that are not part of a people's
unconsciously perpetuated repertory of forms and when the spolia are placed
in a prominent part of the new building—for example, in the apse or on the
portal of a church.[63] Examples of this abound in early medieval architec-
ture;[64] columns from the Temple of Sol Invictus in Rome were used in the no
longer extant Constantinian Hagia Sophia in Constantinople (Preger
1901b:76, 8), for example, and Charlemagne had columns and capitals
fetched from Ravenna and other places in Italy for his court chapel in
Aachen and for Saint-Riquier in Centula (Einhard 1829:447; Weigert 1936).
The plunder of spolia should be understood as an inversion of the require-
ment to situate a building at a holy place; the holy place can just as well be
transferred piecemeal.

Axial Arrangement Within a Structured Area

If we are seeking additional factors that channeled prehistoric building prac-
tice in certain directions and elevated it into types so that a gradual division
between sacred and profane architecture followed, then the way the struc-
tures were arranged must be mentioned because the effect of this was felt in
very specific ways.[65] This arrangement can refer either to the orientation of
the entire edifice in its environment or to the relation of individual areas in
the building to each other.

Arrangements of both kinds were already present in fully developed form
in prehistoric dwellings. For example, Babylonian courtyard houses show a
rectangular court with a rectangular, transversally placed dwelling carefully
positioned opposite the entrance, so that the axiality and symmetry of the
whole arrangement are evident (Andrae 1930:18, fig. 13). The *megaron*, on the
contrary, lacked a court and showed the axial relationship of the rooms with-
in the house in the succession of antechamber and main room, one in front of
the other. In contrast to this we find cult sites, mostly in the Greek realm,
where several differently aligned buildings appear scattered in a single demar-
cated area (Durm 1910:figs. 46, 403–408). In a cult site from *historical* times,

however, it is practically impossible to find the individual spatial units of a single building arranged informally as though proliferating at random. In our observations on building in stone, we could simply assume a fundamental meaning; however, in the case of symmetrical arrangement we cannot do so. Instead, we can only take the examples available to us that seem to exhibit an improved scheme of arrangement and contrast them to what had been customary up to that point. We can then investigate the possible reasons for such a new arrangement and the possible interrelationships between arrangements.

A building can relate to a larger plan in different ways. For example, there can be a formally legible relationship between two or more buildings that serve different purposes, such as that between temple and palace, palace and city gate, church and city gate, church and baptistery. There is also orientation, the alignment of the building with a specific celestial direction. And, finally, several smaller individual spatial units can be enclosed within a structure's overall plan. As a symbolic representation, this arrangement can reflect that of hitherto separated buildings, as the whole of the structure might "mean" a city in Kitschelt's (1938) sense. A building's can also physically reflect the hierarchy embodied in the actions performed by the collectivity it houses. For example, the throne hall in the palace and the presbytery in the church are higher in rank than the entrances and antechambers and galleries and make the course of the ceremonial and liturgical acts legible in the architecture. We can say that the intended purpose of the building—the hieratic and ceremonial—has caused the spaces that compose it to be built and grouped in a monumental way, thus emphasizing and reinforcing the functions taking place there.

The most primitive prehistoric shelter naturally acquired a certain symmetry and a relation to a building axis (Oelmann 1927, 1:65ff.). Tree trunks, tents, the simplest mastery of mechanical skills all lead to solutions based on circles and rectangles, the simplest geometrical figures. We cannot speak of arrangement (in our sense) in buildings of this kind when they comprise only one room. The two or more rooms of the northern longhouse or the Greek *megaron* are placed in an overall rectangular ground plan in a geometrical relationship that reveals a hierarchically differentiated meaning—the difference in status between hearth room and antechamber, for example—and it is not easy to determine and interpret the precise nature of the arrangement. For example, we cannot describe the arrangement—so like the *megaron* or the northern longhouse—in the classic Greek temple *in antis*, where the walls of the *cella* are prolonged to define a porch either as an intensification of those relationships that govern the *megaron*-as-dwelling or as an elevation of it to the rank of a type.

If we look at ground plans for houses, temples, and palaces in Egypt, Mesopotamia, Asia Minor, Greece, and Rome in the period up to the time of

universal Hellenism, we can see that in the Greek world the idea of any arrangement that goes beyond the prehistoric form of the single dwelling is clearly out of the question. However, in the ancient Near East there are arrangements to be found early on that do express a strict symmetry.

This contrast between the sequence of development of the Near Eastern ground plans and the Greek ones is particularly obvious in palace architecture. In earliest times, palaces were amplified versions of the house with a courtyard, and, generally speaking, the palace building changed in accordance with changing needs. In the palace of Knossos, for example, chambers proliferate seemingly at random within its precincts, but in the castle of Tiryns antechambers and main rooms are distinguishable, and the whole is enclosed by a common facade (Rodenwaldt 1921:5). Despite this increasing organization, however, relationships within the whole remain arbitrary. Greek palace buildings do not differ in this respect from those of Babylon, Assyria, northern Syria, Asia Minor, ancient Crete, or early imperial Rome. A loose, open assemblage prevailed, one that allows single buildings to be perceived as individual structures. In the Old Kingdom in Egypt, by way of contrast, there were tightly organized layouts ordering individual elements within a complex whole (Oelmann 1922b:163ff.). In the western Mediterranean, this tendency became evident in Hellenistic times, in part prepared through local developments and in part stimulated through direct contacts with the Hellenistic East. This feature of tight organization of individual buildings as components of an architectural whole is part of a greater phenomenon—the idea, which had been spreading continually since the time of Alexander, of the godlike ruler whose kingdom is the entire world. From that time onward, a broad, often clearly observable stream of ancient Eastern meanings—meanings that had acquired historical associations with those aspirations to universal rulership—was to flow into the western Mediterranean region.

These tendencies toward meaningful or hierarchical organization of space can be observed in architecture; structures that were once loosely grouped were now logically arranged and integrated into a ground plan. The peristyle villa is replaced by the *porticus* villa (Swoboda 1919: chap. 2), the Hellenistic temple tends toward alignment (Blanckenhagen 1942:312), axially arranged baths are built, and facades and cross vaulting emerge as elements that architecturally objectify these perceptions. This is not the place to judge the extent to which ancient Eastern and later Persian influences played a role or the ground had already been prepared by ancient Italic and Etruscan traditions (Rodenwaldt 1942a:80). The Roman temple had always distinguished itself from the Greek through greater architectonic restraint. Its front and back were treated differently, and its whole structure could be

attached to a wall (Rodenwaldt 1947:33). In addition, the Roman house had always been more oriented and more rigorously and thoroughly organized than the Greek house. All we can say is that in Hellenistic times this axial arrangement came to the fore everywhere and that with it a similarity to ancient Eastern solutions was achieved, one whose direct and immediate cause could be the inclusion of those regions within the Roman Empire. However, a far more effective explanation may be the Roman adoption of the ancient Eastern conceptions of the state (Rodenwaldt 1942b:36on.1).

A limitless wealth of architectonic forms developed during this time, and a large variety of solutions to building requirements were found, due less to the functions of the buildings than to the force of the fundamental meanings with which the forms employed were invested. The powers that ordained the creation of those buildings and used those forms in those buildings did so to make those meanings visible on a monumental scale.[66] As complexes, city, army camp, palace, and forum became interchangeable. As individual buildings, the throne room, library, *heroön*, and *caldarium* became interchangeable, too.[67] Even the basilica was not bound to any specific function. Alongside the time-honored types of the Greek temple, a profusion of other forms originating from a great variety of sources developed and were adopted. It is because Christian church architecture from the fourth century grows out of precisely this Hellenistic stratum that it is so difficult to establish connections to building types rooted in Antiquity that are based on function and meaning. Anticipating our later observations, we can say that some of the Hellenistic solutions lived on for some time in Christian architecture; these slowly atrophied or were discontinued, and those that remained became embedded in types, a process through which formulations developed in the East that differed from those in the West. The simple rectangular solutions to complicated oriented layouts that emerged, primarily in the context of "unofficial" tendencies in Christendom, however, owed their existence to developments *within* Christianity. Those "unofficial" solutions—that is, structures built by those outside the power structures of the state or hostile to it—were nevertheless always "corrected" and enlivened by the great "official" church types.[68]

This "unofficial" architecture as it has come down to us in St. Alban in Mainz, St. Victor in Xanten, St. Cassius in Bonn, and other buildings (Bader 1946–1947) can be seen as developing from early Christian structures consisting of chapels resembling simple chambers and situated above the graves of martyrs, occasionally with an apse in which (or an interior division before which) one could place an altar. Here we can observe very clearly how the monumental layout slowly took over these simple buildings, lifted them out of their humble contexts, and made them into types. That is, they became es-

tablished formulations that in the eleventh and twelfth centuries were eventually reconciled with the descendants of the "official" architecture, culminating in the West in the oriented, cruciform basilica with towers.

This development of the cruciform basilica has often been described, albeit with varying emphasis on the different forces in the process that those presenting the development perceive as propelling it forward (most recently, Guyer 1950).

As the arrangements of buildings and spaces inherited from the Hellenistic tradition were gradually reduced and fell out of practice in "official" Christian architecture, there was a corresponding slow cultivation of the same monumental arrangements in the "unofficial" architecture. In the end, this brought about a partial convergence of the results of "unofficial" architecture with the same Hellenistic solutions. We should now turn to some of those manifestations.

Developing from the prehistoric house with courtyard, different types occurred simultaneously in Hellenistic times and then variously produced further types: for example, where a principal building is found inside a rectangular (rarely round) surrounding wall.[69] While in pre-Hellenistic times in the western Mediterranean the temple (or temples) do not stand in any geometrically regular relationship to the hallowed region or *temenos*, and while city walls adapt to changing topographic situations (Gerkan 1924),[70] in Hellenistic times we encounter the great geometrically regular precinct within which the principal building stands. The use of axiality in the temple complex in the second century B.C. was preceded by its use in the agora, the profane area. The ancient Near Eastern structured complex of palace-as-temple brought order into the hitherto unordered administrative and public arrangements long before the tradition-bound temple precinct was affected. When that happened—in contrast to the palace and judiciary layouts—a longitudinally axial building was placed in the middle of the arrangement. Since Christendom chose the basilica (with its profane origins) as the principal building for its worship, this building entered into the longitudinally axial position in place of the temple.[71]

The principal structure *can* stand freely in the middle of the enclosure—not leaning against a side of the external wall—but most often it is backed against the side of the enclosure opposite the main portal and may compose part of the quadrangular enclosure.[72] It may also jut backward out of the enclosure so that the plaza (or square) appears as a forecourt.[73] The other sides of the enclosure walls can be filled in with rows of smaller structures.

Different features of this basic type could be emphasized, depending on the ultimate purpose of the arrangement. This could result in a change in the interrelationship between the plaza and the buildings that enclose it. If

the palace was the major focus, then the square became small, almost an in-
ner courtyard of a greater three-winged building, undeveloped on the side
with the portal.[74] If the fourth (open) side was already closed by a large en-
trance building—the relationship to the atrium-house is obvious—the
open area forms a part of the house and represents a basic prehistoric form
common in the whole Mediterranean region.[75] If the open area was to
become dominant, the principal building can appear unimportant or even
vanish completely.[76]

Before we ask to what extent this arrangement affected Christian archi-
tecture, the main features of the pagan arrangement must be clear. First,
without exception, the palace, the temple, the shrine of the regimental stan-
dards, and the baths were set with the broad side to the front.[77] Second,
transversal structures of this kind were not generally accessible to the mass-
es. They saw only the facade of the dominant building and understood it to
be of great importance. An altar often stood in the square.

In contrast, the Christian church differs in both points. It was axially ori-
ented and was always the church of a community.[78] Only later was a space cre-
ated in the attached transept from which the assembled laity was excluded.
Henceforth, the courtyard around the church was only a place for preparation
and gathering for the faithful, particularly since an altar no longer occupied
its center. In early Christian times, we find arrangements that differ in no way
from Hellenistic courtyard layouts. With these courtyards—and this differ-
entiates them from the medieval atrium—the court is bigger and wider than
the cult building. The Justinianic church of Baalbek is placed within a pagan
courtyard (Thiersch 1923). Eusebius reports (314) that the Basilica of Tyre was
located within a great *peribolos* (Wulff 1914–1918, 1:206ff.). Extensive galleries
with columns are reported surrounding the Church of St. John in Constan-
tinople in the time of Theodosius the Great as well as Constantine's Church
of the Holy Apostles and Justinian's Hagia Sophia in Thessaloniki (Lenoir
1852:237). They were also found in Syrian and African monasteries, in whose
courtyard walls the monks' cells were located, while the church stood in the
middle and a large gatehouse reinforced the resemblance to a fortified city.[79]
The North African Monastery of Bénian (434–439) includes a plaza virtually
compressed into a stronghold, in the middle of which stood the church (Gsell
1900:pl. 2, 175, in Lasteyrie 1912, 1:32, fig. 24).

In contrast to these relatively rare relics of Hellenistic arrangement, with
the church in the center of the courtyard—significantly, these are found pri-
marily in early Christian monasteries[80]—a larger and at the time more wide-
spread group of churches developed the Hellenistic type, in which the build-
ing is constructed with its front forming one side of the square and the rest

of the building projecting out back. The court is thus made into a forecourt, an atrium that serves the concept of the church and the requirements of the liturgy much better than the arrangement with the church in the center of the courtyard (Joutz 1936; Bandmann 1949a:219ff.). The history of the atrium shows that it is not a new creation, as we might believe the monumental portal on church facades to be, given its wide diffusion. Rather, the atrium represents a gradual fading of Hellenistic attitudes toward architecture. They are also not nearly as widely distributed as the handbooks would have us believe. In the architecture of northern Europe, the atrium is found only in buildings of the very highest status, ones that clearly sought to prolong values associated with Antiquity in other ways as well. In early Christian times, the atrium characteristically extends beyond the width of the church[81] and the *porticus* in the facade never disappears, thus keeping the square centered and indicating that the atrium represents a compression of the forum or *peribolos*.[82] Here, again, it is the great monastery layouts, with their large atria, that keep the memory of ancient forms alive well into the eighth century.[83]

The Hellenistic ideas that organized the context of the church building and imprinted its surrounding structural environment with a specific vision of the world played no role in the architecture of the Western Middle Ages, apart from their atrophied survival in the atrium and cloister. Hence, those few resonances of that vision that actually *do* insist on a monumental arrangement of the surroundings of the buildings express themselves all the more emphatically. No unitary conception underlies most of them; there is merely a hesitant groping in a certain direction. The resulting architectural solutions only faintly resemble those monumental Roman conceptions of order that could encompass a whole city. Instead, there is a single dominant idea that determines the direction, the idea that due to the sacral status of rulership, the ruler will combine his buildings with the church. This conception of kingship lifts the variable position of the palace vis-à-vis the church out of any accidental juxtaposition, giving form to the idealized relations by ordering them with a monumental clarity or at least trying to do so.[84] The otherwise countless possibilities of available building types are thereby restricted to one.

As the Franks settled in larger areas north of the Alps, they were unable to fill the old Roman cities, by then mostly in a ruined condition, with their former vitality. The whole structure of the Frankish state and its religious and economic organization was inimical to city life. Merovingian art is quite unusual in that well into the sixth century, Frankish art of the time of the migrations remained alive alongside that of late Roman Antiquity, which continued without a break in customs (Pirenne 1941:133ff.). In other words, despite the continuity of Roman language, monetary policy, writing, diet, religion, law,

and government—all sustained by the ancient, still intact Mediterranean world—there was no connection between Frankish culture and aspirations of empire (Paulus 1944:36; Knögel 1936:introduction). So even if the cities of Paris, Fréjus, Nîmes, Toulouse, Meaux, Soissons, Metz, Reims, and Orléans remained centers of government in Neustria, we cannot link the structure of the city to any working relationships. The new rulers sat self-confidently in their country seats outside the cities, and even the kings were not bound to one residence, a condition characteristic of the entire Middle Ages.[85]

In the destroyed and overrun cities, counts—Frankish viceroys and executives who in the shifting game of local power represented the higher power of the king—were installed as deputies for the king. Although their large country estates and the heritable nature of their office soon allowed them to let this mandate lapse and to act as local lords in opposition to the will of the king, it was the counts who adopted ancient customs in their buildings. In their city palaces, being the regional counts' castles, the counts reflected conditions in the royal palaces, thus carrying on the tradition of the Roman legate's palace in the destroyed cities.[86] What was taking place here, then, was the reception of certain building forms for their historical meaning. The building types of the dominant ruler (the king) and the predecessor (the Roman legate), in whose place one wished to be accepted, were appropriated. With the ancient concept of kingship came a place for the cult within the palace. However, proximity to the cathedral, the major building that the Christian community retained from Roman times, was not part of the arrangement of the count's castle, nor was the castle intended to replace the cathedral. In Merovingian times, the organization of the church was completely subordinated to the kings and counts (Pirenne 1941:129); it was a state church. All advancement within it came from the ruler, for the king nominated all the church dignitaries (Pirenne 1941:49, 56ff.). Only with the Carolingians did the church acquire some independence in a quasi-contractual relationship with the state, and as a result the church could represent the state. In other words, only by standing apart from the state could the church represent the state and its edifice become an image or analog of the state (Paulus 1944:35ff.). The result of this historical relationship is that in the Merovingian period, palace architecture first exhibits a certain emphasis, making the surroundings clearly refer to the palace building.

In Cologne, for example, we cannot determine exactly where the oldest cathedral—the principal building of the Christian community predating the Frankish period—stood; in any event, it was not on the site of the current cathedral. The bishop's residence was apparently connected to it. It possessed numerous rights and donations that had been bestowed on it by the

state since the time of Constantine (Corsten 1936:10ff.); it was, however, physically separated from the governmental and administrative buildings dating from Roman times. The eccentric position of that cathedral reflects the extreme antiquity of the Christian community of Cologne. When the Franks occupied the city, the neighborhood of the *present* cathedral became a royal domain.[87] Here the royal castle was erected, because here also, in all probability, the Roman governors of Germania Inferior had their official seat.[88] The Frankish layout perhaps also enclosed a church or palace chapel, which did not, however, hold the rank of cathedral (Doppelfeld 1948b:100). The martyr's church of St. Gereon spoke much more to the hearts of the Franks. It was only in Carolingian times that a new cathedral (consecrated in 870) was begun on the site of the royal castle. Since the bishop had not yet replaced the regional count as the emperor's representative, as he would in Ottonian times, this transferral of the cathedral must be understood as the incorporation of the church into the apparatus of the state, recognizing, in other words, the civil responsibilities inherent in the contemporary interpretation of the Donation of Constantine. In addition to being entrusted with other official duties, Hildebold, the founder of the new cathedral, was court chaplain to Charles the Bald. The Carolingian state was becoming a particular kind of clerical state; in Merovingian times, though, the ruler had held absolute power, including power over the church, in accordance with the practice of Antiquity (Pirenne 1941:58).[89] In this light, the transformation of royal possessions into church properties, which can be seen everywhere (e.g., in Cologne, Trier, Speyer, etc.), should be interpreted not just as a donation to the church, but also as a method of outfitting a branch of government, a practice that became pernicious only later when church and state came to be perceived as opposites.

The relationships in Trier were similar. What today is called the Basilica was erected in 310 on the site of the palace of the prefect as the *magna aula*, part of the imperial palace (Massow 1948:27; Koethe 1937). It was used for governmental functions, receptions, proclamations, and orations. The emperor was enthroned in the apse surrounded by the gods of the days of the week. In the fifth century, the Franks confiscated the building as a royal possession and turned it into a castle for the regional count. With their increasing involvement in the affairs of state, the bishops took it over little by little, and the imposing bishop's palace was erected here in the Baroque period. In Trier, unlike in Cologne and Speyer, we cannot say that the cathedral originally stood outside the governmental compound. Already in Constantinian times, the unique position of Trier in the fourth century as imperial residence and seat of the prefecture of Gaul would have presented

a relationship between palace and church similar to what has come down to us from this early period only in Rome, Aquileia, and Constantinople. As its place within the city plan indicates, the Constantinian cathedral began to be constructed probably on the site of a palace dating from the time of the governors (Kempf 1948:figs. 1–4).

In Speyer, the situation was even clearer. Here, in Merovingian times the Salians were already regional counts and royal governors (Sprater 1947:3). Their castle in Speyer was on a street leading to the royal palace. Thus the royal palace and the castle of the regional count were also separate here (figure 3.7). The royal palace was immediately adjacent to today's cathedral, but, as in Cologne, the old Frankish cathedral was unconnected to it and adjacent to the city wall. Here we can see how the palace defines its surroundings. Although the architectural form of the palace itself is unknown, the street system testifies to conscious planning and shaping of the surroundings. The middle street, running perpendicularly toward the palace (the present-day Kleine Pfaffengasse), is still in its Roman position, and the streets radiating

Plan der Stadt Speyer
um 1730

Figure 3.7 Speyer. Reconstruction of the city layout in Merovingian times.
(From Sprater 1947)

symmetrically to the left and right (Grosse Pfaffengasse and Grosse Him-
melsgasse) and the semicircular street (Herdstrasse) connecting them accu-
rately show the main streets and boundaries of the Merovingian–Carolingian
city. We must emphasize the hypothetical character of this reconstruction,
and the question whether this whole arrangement was planned or grew out
of the topographic relationships must remain unanswered. Nevertheless, we
can state that the Merovingian–Carolingian city was small compared with
the earlier Roman and later Salian ones. The main streets were laid out to re-
fer to the royal palace at the center. This arrangement accented the building,
recalling Hellenistic foundations and even Baroque ones such as Karlsruhe.

The later relationships in Speyer, some of which have parallels in Worms,
are particularly interesting (Sprater 1947:15). With the change in the form of
governance in Ottonian times, the bishops acted as the highest representatives
of the state in the Palatinate. In 947, Otto II confirmed the cathedral's right to
mint coins (Sprater 1947:5), and the palace was jointly owned until the time
of Henry IV. In the Middle Ages, the episcopal palaces and monasteries sup-
ported by the state also often served as residence for the emperor and his court
on their journeys around the empire (Klewitz 1939b:138). The specific cir-
cumstances that made the Salian regional counts into emperors after the Ot-
tos might have determined the new status of Speyer and the new cathedral
building of Conrad. The new cathedral was particularly highlighted by the
urban arrangement; a new main street (Hauptstrasse) was built from the
cathedral portal to the old city gate (Altpörtel).[90] In the time of Henry IV, the
Investiture Controversy completely changed the relationships. Between 1096
and 1101, the emperor renounced all possessions within the cathedral
precinct, so the episcopal palace was no longer in joint ownership, and the
bishop was no longer an absolutely subservient civil servant installed by the
emperor.[91] After Henry IV, the name of the bishop appeared on the coins
rather than that of the emperor (Sprater 1947:5ff.). The bishop had become
the advocate of an autonomous church and, thanks to the rights bestowed on
him by earlier emperors, could appear as a local sovereign in opposition to the
universal claims of the emperor. Now when he sojourned in Speyer, Henry
IV was relegated to the old castle of the regional duke, the old seat of his fam-
ily before their accession to imperial dignity. After 1111, the contemporane-
ous separation of the sovereign bishop from the city, which was gradually
growing and striving toward self-determination, created the paradoxical sit-
uation of the emperor backing the cities against the bishops, as the Hohen-
staufen would also later do in Cologne, Worms, Mainz, and Speyer.

The particular relationships among the royal palace, episcopal palace,
and cathedral will be discussed in detail later. Here we merely want to indi-

cate that the forces responsible for the architectonically ordered environment originate primarily from political power blocs, for visible claims to worldly power must have been especially important to them. However, no arrangement of multiple buildings and plazas in the Middle Ages approached the Roman complexes in either extent or perfection.[92]

Axial Arrangement Within a Building

The question remains how the organizing forces took effect within the Christian house of God, lifting it above the meaningless space in which the community assembled and creating a typical arrangement that differentiates it from all other buildings. It has already been pointed out that the intended purpose of the building is not the most important factor. It is not the intended purpose that provoked the division and combination of the spaces within the church building (Liesenberg 1928; Gause 1901). Rather, there were certain assumptions operating that allowed accents in the form of architecturally symbolic elements to be introduced into the building that pointed to certain concepts and captured them in the building material. In pursuing this line of argument, it must be remembered that although a sense of the exterior as a monumental structure came to the fore later, in Christianity the cult always took place within a building. Although a distinction would be made between what is holy and the holy of holies and although the processional route and movement in general would play a great role, the interior never became divorced from its original purpose as a place where the community met to celebrate the cultic rite. Thus the arrangement of building elements and establishment of types happened first inside the building.

Christianity's inheritance of the traditions of pagan cults was not at first self-evident. The divine service took place in buildings that had long since been commonplace and were imprinted with the conceptions of Antiquity. However, Christianity did not identify itself with these conceptions. The Jewish temple, the domestic basilica, and the auditorium were all rooms capable of accommodating a large gathering without the building having to undergo any change (Kirsch 1933; Dyggve 1940:103ff.). The commemorative meal was celebrated in an eschatological spirit, with all earthly claims being denied. The "powers that be" of this world did not yet appear as a representation, however faint, of the divine order. Rather, they were seen as an obstacle to the eventual consummation of final salvation—indeed, as diametrically opposed (Weinel 1908; Sohm 1895:1ff.; Stach 1935:435).[93] The reprehensible Babylon of the Apocalypse functioned as an allusion to pagan Rome (Revelation 17) (Windisch 1931; Dölger 1932:117ff.; Ensslin 1943; Tellenbach 1936:32ff.).

However, due to man's inborn instinct for survival and, even more so, due to his creative impulse, primitive Christianity's urge to flee the world and renounce all worldly things did not prevail, and soon historical forces came into play that supported a focus on an earthly establishment. Because the Second Coming was delayed, the Christian community—the *ecclesia*—was forced to organize itself for the duration as an end in itself and to constitute itself as a partial realization of the kingdom of God (Frick 1928):

> The next world for which the church prepares itself is no longer a temporal, but rather a spatial one. In addition, the community of the beyond is not a kingdom of God that can be differentiated from the Church, but rather the actual church itself and the self-same hierarchy, which, as it provides the skeleton of the earthly community of the church, extends its dominance even into the beyond and prescribes and conveys the supplications and allots the spiritual earnings of the Church Triumphant. (Schmidt 1895:109)

"The *jus divinum* of the Catholic church took the place of the charismatic organization of the early church, of the enthusiasm and chiliasm of the first Christian generations" (Rieker 1914:17). The "Heavenly Jerusalem" is not an apocalyptic historical condition, as current historicist thinking would have it, "but rather the final stage of the current condition" (Herwegen 1932:47). With this change, the previously neutral building was drawn into a higher sphere; it now represented the heavenly order, and like the community, the building began to be called *ecclesia*.[94]

Previously, the attitude toward the world and toward the cult building had been different. In the Acts of the Apostles, St. Stephen, in order to present a contrast to the pagan temple, says, "The most High dwelleth not in temples made with hands" (Acts 7:48). St. Paul says, "God that made the world and all things therein, seeing that he is Lord of heaven and earth, dwelleth not in temples made with hands" (Acts 17:24). The pious heart of man alone is the temple of God, Clement of Alexandria (*Stromata*, 7.5) writes,

> For is it not the case that rightly and truly we do not circumscribe in any place, that which cannot be circumscribed; nor do we shut up in temples made with hands that which contains all things? What work of builders, and stonecutters, and what mechanical art can be holy? Superior to these are not they who think that the air, and the enclosing space, or rather the whole world and the universe, are meet for the excellency of God? ... And if sacred has a twofold application, designat-

ing both God Himself and the structure raised to His honor, how shall we not with propriety call the Church holy, through knowledge, made for the honor of God, sacred to God, of great value, and not constructed by mechanical art nor embellished by the hand of an impostor, but by the will of God fashioned into a temple? For it is not now the place, but the assemblage of the elect, that I call the Church. This temple is better for the reception of the greatness of the dignity of God. For the living creature that is of high value, is made sacred by that which is worth all, or rather which has no equivalent, in virtue of the exceeding sanctity of the latter. Now this is the Gnostic, who is of great value, who is honored by God, in whom God is enshrined, that is, the knowledge respecting God is consecrated. (1925:530)[95]

At that time, Christians had no concept of the sanctity of objects and therefore no notion of Christian sacrilege. Thus Lactantius could say in *Of the Origin of Error*, "Where, then, is truth? Where no violence can be applied to religion; where there appears to be nothing which can be injured; where no sacrilege can be committed." "The true religion offers absolutely no material surface to the act of violence or sacrilegious assault, because the only sanctity it possesses is in the intellect and the spirit" (quoted in Koch 1942:97). What can be perceived by the senses can be destroyed and therefore cannot be holy. But a little later, at the end of the fourth century, Optatus of Mileve could say, "It is a violation of the sanctuary if the altar of God is broken, discarded, or moved" (quoted in Koch 1942:97).

After the beginning of the fourth century, the terminology of the ancient cult—*templum, fanum, aedes, sacra*—began to be used for the Christian house of assembly. The metamorphosis of the overseer and elder (*episkope* and *presbyter*) into priests is in line with this, as is the new situation whereby the individual Christian no longer possesses the charisma necessary to perform exorcisms, and instead a special consecration has now become necessary.

This change can also be detected at the end of the second century (Sauer 1924:100; Kitschelt 1938:9ff.). The earliest formulations of the liturgy by the Roman antibishop Hippolytus around 220 can be read as a sign that the diversity hitherto existing under local charismatic leadership was being consolidated and transmitted.[96] Latin also became firmly established as the language of the cult at this time. Greek, as a popular and colloquial language and as the language of the New Testament, had been commonly used for the divine service. From the second century on, Greek began to be replaced in the western regions by Latin, which penetrated into the liturgy, became established, and remained the language of the cult in the Catholic church even

among peoples who spoke other languages (Eisenhofer 1932:149ff.; Liesenberg 1928:25).

Besides the delay of the Second Coming, there were other factors responsible for encouraging the establishment of the church in the world and establishing the church building as a type: the importation of relics into the church under the influence of the churches of the martyrs and the accompanying change in the conception of the altar (Galling 1927–1932a, 1927–1932b; Stuhlfauth 1912–1932; Eisenhofer 1932:542ff.; Dölger 1930:161ff.). This prepared the way for the momentous liaison with classical pagan funerary and memorial structures. A whole field of "meaningful" ancient architecture was thereby opened up, and a specific apparatus of forms became worthy of reception.

Constantine's ratification of Galerius's Edict of Toleration in Milan in 312 eventually brought about a complete realignment of the church toward earthly aspirations. With this, Christianity's installation as a civic religion was made possible, pagan Rome took its place in Christ's Plan of Salvation (Heckscher 1936:17), the Roman Empire became the legitimate sphere of Christendom, and the persistence of the empire until Judgment Day was postulated and indeed advocated (Hashagen 1930:137; Troeltsch 1912). Yet another great treasure house of classical, official "meaningful" architecture—the forms of Roman imperial architecture—was thereby unlocked and made available for reception. Nevertheless, it should always be kept in mind that the original position of primitive Christianity, which renounced all claims on the world and rejected any use of symbols of power, was an ever-present limiting factor on Western universalism, one that has remained alive in reform movements down to the present day.[97] The empire of Constantine, on the one hand, and the community of the early Christians, on the other, each served as the ideal and legitimization of two antithetical conceptions of the meaning and use of architectural form, ideals that continued to coexist, with sometimes one dominating, sometimes the other. The conflict between saving the world and fleeing from it—"that most medieval of all questions" (Schramm 1935–1936:102)—was already present in earliest times. The message of Christianity can be shown equally by meaningful buildings and by "meaningless" ones; Christendom can be represented both by buildings that make allusions and by those that say nothing at all.

It is not always easy to identify the area of origin of specific forms that appear in church architecture after the fourth century and comprise the new types. In some cases, it is possible and has already been done successfully. For example, the link to the classical mausoleum (Grabar 1946) had a very definite effect on the adjoining of the pure cruciform building with tower and

triconchos to the old basilica and on the preference for the central-plan building with interior placement of supports (Glück 1933:125ff., 253; Paulus 1944:4ff.). Since the church adopted many forms, allegorized them as quickly as possible, and turned them to purposeful liturgical uses, in many cases firm statements about their origins are no longer possible. Nevertheless, a few examples of the effect of this "tendency toward arrangement" on specific forms and on their further development will be examined here. In particular, we will focus on the connection to the ancient *imperium*, which inevitably had architectural ramifications, all the more so when we consider that the forms of the imperial cult found their way into the Christian liturgy, vestments, and almost all church institutions—incense, kneeling, candles, garments, the baldachin over the bishop's throne, and the altar and the steps leading up to both (Alföldi 1935; Delbrück 1932b; Köhler 1934:43ff.).[98]

There are two principles that raise a building above the instability and variable relationships of prehistoric, meaningless conditions and that must be examined with regard to layout in Christian architecture.

The first principle is orientation. Much has already been written about the emergence of this kind of arrangement in the Christian church building, and this is not the place to revisit the question of its emergence and diffusion.[99] Orientation is a concept dating from primeval times filled with magic and based on our experience that light and warmth come from the east, with the sun, while darkness and cold abide in the west. With the development of the cult of the sun in the ancient Near East, buildings, like images of the cosmos that is centered on the sun, were aimed toward the east. Or in the case of a cult focused on a personality—perhaps a living one, such as the emperor—orientation would imply that the emperor, enthroned in the east, is like the sun in all things.[100] The ruler appears as a sign or token of the sun and, more specifically, as the sun god in that he carries its attributes: a crown of rays and the orb of the world (Becker 1913:166; Drexler 1916).[101] His status as savior of the world and *soter* ensures his identity with *Sol invictus* (L'Orange 1935; Nissen 1906–1910:415). Constantine was represented as the sun god and had a statue of himself as such erected in Constantinople (Preger 1901a; Straub 1942:386). The epithets *Helios basileus* and *Lux mundi* for the Byzantine emperor perpetuated that memory (Schneider 1941a:14).[102] Since for Christians the sun god had also become a rhetorical figure for discourse about their God,[103] and Constantine also portrayed and deputized for Christ (Straub 1942:374; Delbrück 1932b; see also Eusebius's *De vita Constantini* [n.d.:chap. 3:15]), the blurring of the boundary between these two images allowed Constantine to be depicted, if only for a short period, clothed as the sun god holding a cross banner in his hand (Alföldi 1939:18, pl. 2:1; Paulus

1944:16; Vogt 1949:173). Wherever we encounter a renewal of the sacral status of the emperor in the Middle Ages after this period, we find this exchange of attributes and insignia in the intermingling of the cult of the ruler and that of the sun.[104] For example, in the Aachen Gospels of Otto III (Aachen, Domschatz, MS s.n., f. 16r, in Schramm 1935–1936:88, fig. 69), the emperor appears like Christ surrounded by the symbols of the Evangelists in a *mandorla* composed of a wreath of the sun's rays and is presented as lord of the world and acclaimed by two kings.[105] In the time of Augustine and Ambrose of Milan, Christ was depicted in the form of the emperor (Gerke 1940:26, 1948:49ff.; Alföldi 1939; Delbrück 1932b). From these equivalences, it is understandable how orientation could come to symbolize the imperial situation in the Christian church building (Rahmani 1899:chap. 19; Sauer 1924:4; Baumstark 1906:33ff.; Funk 1905, 1: chap. 52, 2–7).

The second principle in the elevation of the Christian church into types—often contemporaneous with or preceding orientation—was the dividing of the interior space into two: the division into space for the laity and space for the clergy, accompanied by the withdrawal of the holy of holies, which all stood facing reverently. This separation expresses in architectonic terms the give-and-take of the Christian liturgy and is found in all sacral architecture that supports an established cult. What is specifically Christian is the fact that this separation takes place in the interior. The resulting situation is different from that of the Greco-Roman cult, where the courtyard of the community is separated from the inaccessible temple. Late classical pagan mystery cults and the gatherings of Gnostics are also exceptions in that they, too, took place indoors.

The Christian arrangement is not without predecessors, however. In Assyrian temples (see figure 3.5) and in Near Eastern and Hellenistic palaces (figures 3.8 and 3.9), this combination of a long, axial room for the community and an abutting transept or attached niche for a cult figure was already present in the interior in many forms (Wachtsmuth 1930:53ff.). This situation is architectonically represented in the way the Basilica Ulpia is related to the Forum of Trajan (figure 3.10) or the law court Basilica of Leptis Magna to its forum (see figure 2.36) or the main palace of Hatra to its forecourt, even though these concern the arrangement of squares and buildings and the squares are the actual places of assembly.

Nevertheless, these layouts are closely related to the later Christian arrangement of space and indeed influenced it directly. The similarities can be seen particularly in the transverse nature of the frontally encountered facade that surrounds the niche holding the cult statue.[106] And finally, despite the change in emphasis from the powerful proportions to the placement of

Figure 3.8 Babylon,
Nebuchadnezzar's throne
room in the South Fortress.
Floor plan. (From Wachtsmuth
1929–1935, 1:fig. 2)

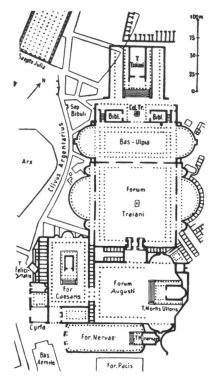

Figure 3.10 Rome, Forum of Trajan.
(From Rodenwaldt 1927)

Figure 3.9 Hatra, Building V,
first to second century. Floor plan.
(From Wachtsmuth 1930:53)

the participant community, the relationship of the basilica to the forum can still be seen, albeit indirectly, in the great Constantinian layouts.[107] The nave was the processional route of the priest at the *adventus* (the entrance to the solemn high mass), and the side aisles (also called *porticus*) served as the gathering places for men and women (Rahmani 1899).

The genesis of the pagan law courts and judicial basilicas shows that they were not originally covered streets, but covered fora, areas for the community:[108] "The basilica served the same purposes as the forum, and its building forms represent a copy of a forum with a roofed center" (Sackur 1925).

> When the open area was to be covered, the two sides facing each other had to be brought closer together in order to make the construction of the roof possible. The normally wide, rectangular, open area thus became a narrow, rectangular, covered central space around which, as before, a hall of columns ran like a ring. The central space retained the commercial life while the surrounding side aisles were free for other purposes. It was only outside these circumscribing corridors that tribunals, *conchae*, or the like were attached as needed. (Wachtsmuth 1929–1935, 2:30)

The more widely diffused early Christian basilica might, indeed, be closer to the smaller domestic basilica, the synagogue, or the ancient Near Eastern throne basilica than to the law court basilica (Deichmann 1950b; Langlotz 1950). However, for the great Constantinian layouts, such as the Lateran and St. Peter's, the law court basilica is the model, for it had already in pagan times so closely approached the Christian basilica in form that the portico no longer completely surrounded it but was interrupted on the narrow side (see figure 2.36).[109] But in many cases, the Christian basilica still kept elements of the pagan law court basilica—for example, the separation of the apse, which, like the old tribunal, could be screened by columns and indeed could be called a "tribunal."[110] For the exegetes of the Middle Ages, the apse was conceived not only in the more recent sense as the head (Lat. *caput*, Fr. *chevet*) of Christ (Sauer 1924:128n.1) but also in its older meaning as "a structure, somewhat separated from a temple or palace" (Sauer 1924:132).[111] In the written sources, the church apse is always appropriately shown as primarily the seat of the bishop, not as a place for burials or for an altar.[112]

The separation of the clergy's space from that of the laity was already evident in the oldest written descriptions of building arrangements, the *Testamentum Domini nostri Jesu Christi* (Rahmani 1899) and the *Apostolic Constitutions* (Funk 1905).[113]

In the case of smaller, hall-like structures, such a separation can be indicated by an adjoining apse. This solution definitely was not the first one in community churches. We know of similar layouts in early Christian funerary architecture, which can be connected to certain types of mausoleum—for example, the Chapel of St. Anastasius in Salona-Marusinac (Dyggve 1939). Here, the apse did indeed hold an altar and the grave was placed beneath it, so that the apse can be construed as a funerary niche. It is wrong, however, to suppose that the apse of a great basilica was introduced because of this funerary relationship and to explain the apse as a development of the altar grave.[114]

In the great basilicas, the bishop's throne stood *in* the apse, and the altar was placed *in front of* the apse (see figure 2.1).

The type of the single-naved, often barrel-vaulted funerary building remained tied to its purpose in early Christian times. It is only after the emergence of Germanic elements from the seventh century on until the Carolingian era, when the basilica was received from Antiquity, that we see this type being clearly and widely disseminated as a community church. In the Germanic regions of northern Germany, England, and Scandinavia, the rectangular single-naved church with round or rectangular choir was thereafter confined to village churches (Bachmann 1941; Dellemann 1937; Rogge 1943).[115] In northern Germany, Denmark, Sweden, England, Norway, Friesland, and Pomerania, the nave was usually extended by a simple rectangular choir that could be quite long. The relationship to the Iron Age dwellings of northern Germany is obvious (Frey 1942:50ff.). In the Visigothic regions, Spain, and southwestern France, this ground plan with barrel vaulting is found very early on, thus demonstrating a connection with the type of the early Christian mausoleum.[116]

In early Christian times, the single rectangular nave remained confined primarily to funerary architecture, where the sacred space inside was emphasized by the addition of the apse.[117]

Another way of differentiating the holy from the holy of holies—the community space from the altar area—was to erect barriers or even stone walls to create divisions in the otherwise undivided space.[118] The eastern part being thus set off, the separated, emphasized space could then be shaped very differently. It is wrong to suppose that the liturgy could have given rise to the different types as it became more and more differentiated and established, for all the solutions, even if in different contexts, are already to be found in Antiquity. Indeed, we are justified in doubting whether it was on the grounds of suitability to liturgy that those forms current in Antiquity were received and adapted. Liturgy is no abstract, self-referential organism that develops autonomously.[119] Rather, liturgy is also based on the same underlying conceptions, tendencies, and allusions that led to the reception of build-

ing forms. Both illustrate and call to mind those notions rooted in the history of mankind and well known at least since Antiquity. Those forms thus symbolically represented the conditions under which they developed.[120] In the process, the power inhering in the long known and familiar was thereby infused into the new cult objects. Two deeply rooted, fundamental concepts are reflected in the east end of the church: the cult of the grave and the cult of the emperor. With this in mind, some of the most important early Christian types will now be investigated.

The Effects of Historical Meaning

The Emperor and Architecture

Several comprehensive works have been published on the continuing spread of the classical funerary cult in Christianity (Klauser 1927; Grabar 1946). Insofar as that spread entails historical relationships, the architectonic consequences have been copiously documented, primarily as they affect the history of the cult of relics and the Christian altar (Braun 1934).[121] However, due to the prominence of the eschatological posture of primitive Christianity, research on the connections between the constellation of ideas surrounding the funerary cult and the ideas surrounding the classical *imperium*, at least within the historical context, has remained chiefly confined to the areas of liturgical history, pictorial iconography, the attributes of Christ, and clerical vestments (see p. 162).

The interpretation of the architectonic consequences, on the contrary, has been much more historically circumscribed, and only very recently has any broader investigation been attempted.[122] There are several reasons for this reticence. First, the imperial architecture of Roman times developed amid an apparatus of profane forms that were distinct from those of temple architecture, and only gradually, with the strengthening of the ancient Eastern idea of divine kingship, were sacral building forms incorporated. For example, a pediment, a form originally confined to temples, was mounted on Caesar's palace (Koch 1942:149). Not much later, but still in pre-Christian times, these forms became secularized and were assimilated and imitated in the buildings of the ruler's deputies. Soon pediments were found on libraries, theater facades, and so on. In this way, a blurring and a general dissemination of the building forms occurred. Having become commonplace, with a corresponding loss of status, and retaining only a dimly recognizable imperial character, these forms became little more than decorative elements. This secularization would shortly enable their application in church architecture and their simultaneous association with imperial concepts. The very rapid convergence of funerary and imperial forms

within Christendom—as in the mausoleums of Christian rulers from Constantine on—is an additional factor that prevents us from distinguishing those forms from each other.[123] Nevertheless, Western rulers reaching back into the past for the purest possible types furnish important indications of the historical meaning they sought to appropriate for themselves.[124] Another reason why better understanding and more clarity have been elusive is that art history has held on to the notion of "development" as a working hypothesis, as mentioned earlier, and has therefore remained content with examining the monuments of Christian church architecture. The liberal sentiments of the nineteenth century, with its antipathy to all things "Byzantine," might also have played a role.[125] And, finally, whenever one is involved with any investigation of interrelationships of church and state, pope and emperor in early Christian times, there are the difficulties inherent in any state-supported or confession-based (e.g., Lutheran or Roman Catholic) views that are based on the historical situation as it emerged around the time of the Carolingians, became fixed through the Donation of Constantine, and differed so sharply from the archaic Byzantine situation.[126]

The Transept as Throne Hall

In investigating the earliest observably distinctive Christian church architecture, we encounter imperial architectural meanings already in the buildings of the great complexes that immediately preceded the Constantinian state basilicas (or were contemporary with them) in the form of the transversal building joined to an assembly hall through a three-portal structure.

The most important example, and the one that can be most completely reconstructed, is the cathedral of Aquileia, which was erected by Bishop Theodorus between 312 and 320 adjacent to and connecting with Emperor Maximian's palace, dating from the end of the third century (Gnirs 1915) (figure 3.11).

Within a large, carefully oriented, rectangular layout, two axially structured, aisled buildings are connected by a transversally positioned aisled structure that served as a *vestibulum* (Gnirs 1915:143, 156ff., 161ff., 166ff.). To one side of the *vestibulum* are various incompletely excavated areas, one of which contained a baptistery. The transversally placed *vestibulum* opened into the northern building through a door and into the southern one through a three-arched opening. We are better informed about the southern building than the northern one because the latter was largely destroyed by the subsequent construction of the campanile of the present cathedral. The southern building was a three-aisled structure, probably not basilican, some 9 meters

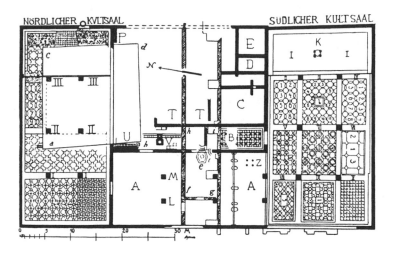

Figure 3.11 Aquileia, cathedral complex.
Sketch of the plan in Constantinian times. (From Gnirs 1915:fig. 105)

(29.5 feet) in height, and the floor was completely covered with well-preserved mosaics. A transversal structure (probably covered with a barrel vault) was attached on the east and separated from the nave by means of a compact three-arched structure. This southern building was dedicated to the functions of the *episkopos* (Gnirs 1915:166ff.) and was the bishop's "throne-and epiphany-basilica." The transverse structure was not only the *salutorium* but also the *consignatorium*, where the bishop performed the ceremony of confirmation upon the laity as they entered the nave after baptism. Like baptism, confirmation had a very important place in the early Christian cult (Leclercq 1907; Dölger 1906, 1911:171ff.). Indeed, no altar was found in this southern building, but the northern building—which was dedicated to the preaching of sermons, the reading of Scripture, and the eucharistic celebration—contained an altar. There the altar area, the *sanctuarium*, was also a transversal structure but probably separated from the nave only by low screens. In contrast to the northern building, the southern one has uninterrupted mosaic pavement all the way through (Gnirs 1915:158).[127]

We know about the arrangement of space in the southern building from the carving on a fourth-century casket depicting this or a very similar arrangement in a naturalistic manner (see figure 2.40). It comes from Aquileia and is dedicated to the memory of Bishop Theodorus, whose church we are discussing. The hanging lamp shows that the people are inside a room, rather than in front of a closed city gate or church door, and

the status of the adjoining room is indicated by the three-portal group and the curtains between them.

Summing up the evidence, we can determine, first, that the southern building served functions that only a little later would no longer require a separate, dedicated building. Second, since these functions corresponded to the official forms of "appointment" and "homage" in the imperial cult, they were thought of, in a special way, as "representative." Third, although the northern space was the location of the actual divine service, it was a copy of the southern building and fell short of the latter in embellishment and in the symbolic resonances of the spatial subdivisions. We cannot tell to what degree the immediate proximity of the imperial palace expressed an official deputizing presence on behalf of the emperor.

This layout is not unique to Aquileia (Egger 1936; Gerber 1911; Liesenberg 1928:190ff.). The Constantinian arrangement of the cathedral in Trier—also a double-church layout—is strikingly similar (Kempf 1947) (figure 3.12).

In this arrangement, dating from 324 to 348, a transversal building like a throne hall also stands out within the long, rectangular church and is separated by a massive three-arched structure from the nave, probably basilican and certainly aisled. Here, also, the imperial palace was in the immediate neighborhood. It was during Gratian's rebuilding in 370 to 380 that this transversal structure was first expanded to a rectangular one with four interior supports, and the triple-arched group was retained. This feature has survived in the triumphal arch of all later basilicas that have transepts (figure 3.13).

The question is whether or not it was the concept of the City of God that persuaded Gratian to abandon the character of the sanctuary as a throne hall in his rebuilding of the sanctuary. In accordance with the description in the Apocalypse (Revelation 21), the Heavenly Jerusalem would have to be represented in its typical rectangular layout (Kempf 1947). Yet another explanation for this remarkable rebuilding has been suggested. Kempf holds that the curved structure between the nave and the square building was the place from which the bishop attended the divine service (see figure 3.13). It is conceivable that the concept of the private episcopal chapel, which is inspired by Byzantine central-plan structures, replaces the concept of the throne hall with its transversally placed chamber.[128] In that case, the square structure would be a building, like the later westwork, devoted to a private liturgy. The congregation at the bishop's back would then not take an active part in the service. This is the situation in later layouts where the emperor often attended church services in the westwork as a proprietary lord, an *Eigenkirchenherr*, in his own church, in a rectangular space placed before the

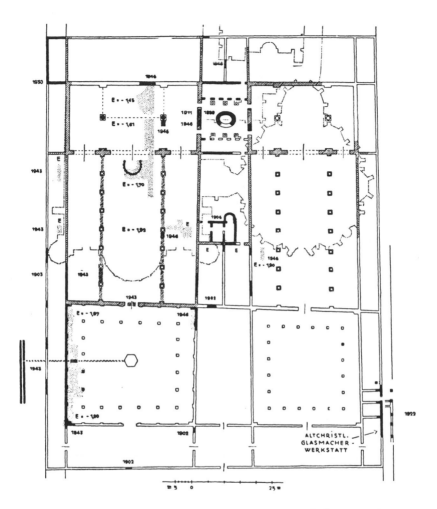

Figure 3.12 Trier, Constantinian cathedral complex. Overall plan, 324–348.
(From Kempf 1947:135)

monastery church. After the Investiture Controversy, these proprietary churches disassociated themselves from the main church and survived as central-plan buildings of a private character within royal palaces, castles, and episcopal palace complexes. In the Baroque era, however, we find the disposition of Trier again. The elector prince-archbishop of Cologne erected his private chapel in Brühl so that it formed the eastern end of the community church. The two rooms were connected by an opening so that the congregation could take part, both visually and acoustically, in the archbishop's private mass.[129]

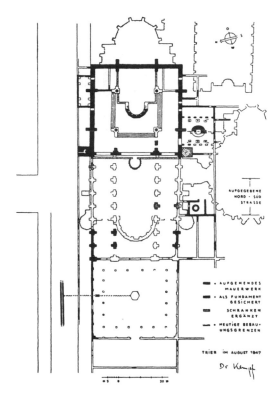

Figure 3.13 Trier, cathedral. Plan in early
Christian times, fourth century. (From Kempf 1947:135)

One could argue that these arrangements in Aquileia and Trier only re-
flect a monumentalization of the functional separation of the sanctuary and
spaces for the laity in smaller buildings, and that since three openings in-
evitably result when a basilica is connected with a building placed crosswise
at its end, the three-arched group is merely the consequence of the conjunc-
tion of basilica and transept. Nonetheless, even if we accept this argument
provisionally, it must be admitted that a similarity is thereby created that
links itself with the official building form that enjoyed the highest status at
the time—the emperor's throne hall. Further evidence of a textual, pictori-
al, liturgical, and historical nature enables us to say, however, that this con-
nection is much closer than one that was at first merely coincidental and then
became traditional. This three-arched group embodies aspirations; it sym-
bolically depicts and perhaps even, in a manner we can no longer complete-
ly perceive, acts as a deputy and equivalent. The idea, attested by many
sources, that the bishop of Rome was perceived as the deputy for the West-

ern *imperium* of the emperor who had emigrated to Constantinople bears witness to the supreme degree of realism of the layout—its identity with the imperial (Krautheimer 1942a:14).[130]

Any investigation of the morphology of these transversal structures, these transepts—particularly ones with an attached cult niche—would repeatedly come across arrangements that are extraordinarily similar. Among such structures are the royal hall of Attila (figures 3.14 and 3.15), which was

Figure 3.14 Attila's royal hall, mid-fifth century. Reconstruction of the floor plan. (From Stephani 1902:179, ill. 53)

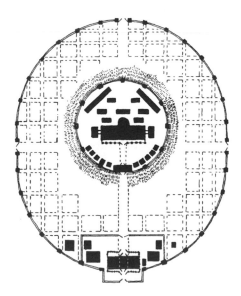

Figure 3.15 Attila's camp. Reconstruction of the plan. (From Stephani 1902:ill. 52)

built later and was certainly not influenced by church architecture; the arrangements found among the Germanic royal halls, which have (at least) documentary attestation and survived in the medieval palace; and the series of almost identical types at whose beginning stands the throne hall of Nebuchadnezzar's palace in the South Fortress of Babylon (see figure 3.8).[131]

A further indication of the meaning of the three-arched group is the fact that in Byzantine architecture, where the imperial idea remained particularly alive, the separation of the sanctuary from the space of the laity was effected in an especially extreme way by means of the iconostasis (Holl 1906:365ff.).[132] In Western architecture, on the contrary, the predominance of the community cult softened this strict separation, as can already be observed in the difference between the northern and southern buildings of Aquileia. This emphasis on the character of the community (expressed in liturgy as well as in architecture) can be connected with a weakening in the West of the ancient oriental concept of monarchy, which continued to prevail in the East.

As Christ appears with the same symbolism as the emperor and the sun god, so in each offering of the Holy Eucharist the bishop (and, indeed, every priest) is an *Imitator Christi*, to be seen "as the Lord himself" (Lietzemann 1937–1944, 2:49).[133] As has been mentioned, like the throne, the seat of the bishop was commonly placed in the apse (Eusebius, n.d., *Historia Ecclesiastica*, 10.4, 868). Later, the altar, understood as the throne of Christ, was also moved into the apse.[134] The *parastasis* at court, where the emperor is surrounded by his satellites, has its true parallel in the encircling of the altar by the presbyters and deacons (Dietrich 1912:12). As the throne of Christ, the altar was raised up on steps and covered by a ciborium. In this place, more than any other, the liturgical forms of court ceremonial can be observed (Alföldi 1934:127ff.; Kitschelt 1938:56ff.), with the cross taking on the significance of the imperial *insignium*.[135] The designation *sacrarium* for the throne hall of the imperial palace indicates the high status of that room (Alföldi 1934:33),[136] while the term *aula* for the church sanctuary unequivocally points to its origins in palace architecture.[137] Even the way the decoration on the apse and triumphal arch is arranged indicates the royal character of Christ (Kitschelt 1938:58).

If functional purposes—such as the way the offering tables were set up (Klauser 1937)—or the symbolic interpretation of the cruciform shape in relation to Christ's death on the cross (Christ 1935:293ff.) played a role in the eventual dominance of the transept, the examples of the cathedrals of Aquileia and Trier, where these reasons were not operative, show that the meaning of throne hall predated these purposes and exerted greater influence.[138]

With this meaning of the transept firmly established within the splendid Constantinian state basilicas (figure 3.16),[139] the whole layout assumes a very specific intention; that is, the basilican nave, although it had probably been used previously as a Christian cult building (Vincent and Abel 1932; Lassus 1947:81), now entered into a closer relationship with the court and throne basilica, which in pagan times were already invested with sacral connotations.[140] According to Dio Cassius, the ceiling of the basilica in which Septimius Severus held court in the imperial palace on the Palatine (ca. A.D. 200) was painted with stars, and the gods of the days of the week were represented in stucco in the apse on either side of the throne (Maass 1902:143ff.).[141] The rafters of the ceiling of the nave in Old St. Peter's were also painted with stars and underwent this elevating process so that the whole might represent more than just a room for the gathering of the community (Lehmann 1945:8ff.).

All this indicates that by the time of Constantine and in later Byzantine art, the forms of the Christian cult and its architecture were already determined by the status of the emperor. These elements were not received by Christianity simply because of their vividness and magnificence; rather, the sacral position of the emperor, now enshrined within the Plan of Salvation, made their propagation a matter of course.

But a union of the two warring spheres was first necessary, and this took place under Constantine when he put an end to the *Kulturkampf* with Christianity (Köhler 1934:40; Vogelstein 1930). Christians were permitted by their

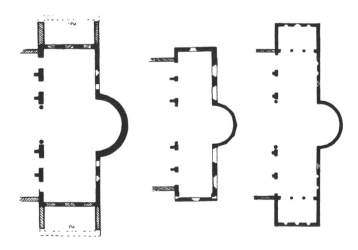

Figure 3.16 Rome, transepts of (from left to right) *Old St. Peter's, St. John Lateran, and San Paolo fuori le mura. (From Glück 1926:201, fig. 1)*

bishops to honor the emperor by *proskynesis*, and the emperor for his part no longer compelled them to make odious sacrifices (Alföldi 1934:76ff.). If the cult of Christ and the cult of the emperor once merged, the possibility always remained that *regnum* and *sacerdotium* might separate again. For Constantine, Theodosius, and Justinian, as for their successors in the Germanic kingdoms until Charlemagne, the cult remained an unquestioned dimension of the state (Hahn 1913:57). It was as *pontifex maximus* that the emperor legislated the struggles between the different dogmas (Brieger 1880:20, 26; Piper 1847–1851, 1:83, 159, 164ff.).[142] Priests were installed and confirmed by him, and church laws were part of imperial legislation. In Byzantium, basileiolatry—the adoration of the emperor—remained a scarcely disguised cult of the emperor. The political theology that Eusebius presented in Christian clothing had by then become the basis for a philosophy of life (Straub 1942:385ff.; Eger 1939). As the chosen one and *auctor* of God (Borch 1934), the *basileus* was addressed as *Sancte imperator*, wore a nimbus in his portraits, and could decide questions of dogma (Treitinger 1940). Empowered through his anointing, he possessed the authority to teach, and according to ancient tradition he alone had the right to remain in the holy of holies (Neuss 1946:60). He was chief and father of the mystic clan of rulers (Dölger 1940:397ff.).

In one point, however, the Christian concept of emperor is fundamentally different from the classical pagan one: the emperor is not God; rather, he is emperor by God's grace (Ensslin 1943; Mensching 1947:120; Vogt 1949:224). His competence being thereby limited, it becomes possible to set someone else, also filled with God's grace, at the tip of the pyramid. The whole of the Middle Ages is marked by the struggle between the ecclesiastical-sacramental and the monarchical-theocratic concepts of hierarchy (Tellenbach 1934–1935).

This close connection between the life of the state and that of the church brought the edifice itself into a particular relationship with the emperor. It was in his own personal church—the principal church of the realm and palace church—that the emperor was manifest in his essential being. The evidence concerning the Lateran basilica and Hagia Sophia documents this (Lauer 1911; Schneider 1941a).

The basilica in the Lateran, which was dedicated to the Savior, was founded inside a great palace complex that belonged to Fausta, the wife of Constantine, who placed it at the disposition of Pope Miltiades in 313 (Lauer 1911:27ff.) (see figure 2.2).[143] After 314, the pope lived in the Lateran palace, while Constantine resided in Constantinople. In front of the papal palace stood an equestrian statue believed to be of Constantine, but it really depict-

ed Marcus Aurelius. This statue shared the space with the Roman she-wolf (Lauer 1911:21–23).[144] Soon the notion arose that the Lateran palace had been the palace of Constantine and that it had been given to the pope in his capacity as deputy of the emperor.[145] Later this belief became the basis for the Donation of Constantine. The pavement immediately adjoining the apse, which was found during excavations (Lauer 1911:33, pls. 2 and 4), probably belonged to the ancient buildings first replaced by newer ones during the time of Leo I (440–446).[146] Although the Lateran palace remained the residence of the pope, the Church of St. Peter soon acquired the meaning of principal church (Caspar 1930–1933:213).[147]

For our question, three things are important. First, the Lateran basilica had precedence over the other Constantinian transept basilicas, and we must therefore investigate the relationships that this innovative building could have produced. Second, as the principal church, the *mater ecclesiarum*, the Lateran basilica was primarily the church of the bishops of Rome, who claimed to be deputies of the emperor. And third, it was directly connected with the palace; thus the situation here is the same as in Aquileia and Trier.

This character of the principal church as a proprietary church is manifest also in how the unity of civic and ecclesiastical life is anchored in it. As long as the bishop acts as deputy for the emperor in a place, it is his duty to receive the emperor as often and for as long as the emperor wishes (Klewitz 1939b:138).[148] According to Eusebius, the Constantinian Basilica of Tyre was physically attached to the royal residence (Hauck 1905–1920, 2:581), a relationship we often encounter in later years.[149] If the emperor had a palace of his own in a city and therefore did not have to reside in the bishop's palace, the cathedral would then be located in the immediate proximity of the imperial palace.[150]

In Rome this situation did not persist for long, nor was it obvious for long, because the real, permanent residence of the emperor in Constantinople, the increasing autonomy of the papacy (Vogt 1949:261; Vogelstein 1930:62ff.; Tellenbach 1934–1935:41ff.), and the increasing fame of the churches of the martyrs all combined to allow the original relationships to be forgotten.

In Byzantium, in contrast, the situation reached a climax in the disposition of the Hagia Sophia under Justinian (Schneider 1941a). The question of why Justinian did not follow the building type of the Lateran basilica must be set aside for the time being.[151] What is of primary importance here is that this church was simultaneously the principal church of the empire and the palace and court church of the *basileus*. To contemporaries, it appeared as a symbol of the rulership of Christ encompassing the whole world by means of

the emperor (Schneider 1941a:6, 18ff.). Here the emperor was crowned, here the obsequies were held, and here the triumphal processions reached their climax and conclusion.[152]

Hagia Sophia, the Senate House, and the palace were all located on the Augustaion (Ebersolt 1910a; Wiegand 1934), a large plaza not generally accessible to the public. *The Book of Ceremonies* gives detailed information about the ceremonial entries of the emperor (Dietrich 1912; Unger 1878:nos. 289–290), who traveled from the Golden Gate to the church of Hagia Sophia via the Mese, or main street. This ceremony was an outgrowth of the ancient Hellenistic triumphal procession (Alföldi 1934:88; Peterson 1930; Laqueur 1909:225), and in its older Roman version the emperor carried the insignia of Jupiter during the procession (Koch 1942:135; Deubner 1934:320). Since it was by virtue of his status as savior of the world that the emperor entered the city—or the church, which symbolized the City of God—the whole celebration retained the meaning of the *Parousia* and epiphany of Christ (Kantorowicz 1944; Pfister 1924:sec. 36ff.; Deissmann 1923:314ff.; Grabar 1936). The different versions of the *Ordines ad regem suscipiendum* show that the reception of the ruler in cities and churches represents the reception of the soul in the Heavenly Jerusalem and, indeed, the historical entry of Christ into Jerusalem (Biehl 1937), which, in turn, follows Hellenistic rituals regarding rulers (Kantorowicz 1944:211; Tellenbach 1934–1935:67ff.). The degree to which the reception of medieval rulers reflects the sacral status of the emperor is shown by two *laudes* cited by Kantorowicz (1944):

> Rejoice, O City! Rejoice, O Heavens!
> Exult, O Metz, on the arrival of the king!
> The peaceable king comes to you
> Bringing happiness and joy forever. (209)

> (Gaude civitas Letare polus
> Exulta Mettis De adventu regis
> Rex pacificus Advenit tibi
> Letitiam ferens Gaudiumque per evum.)

And in reference to Frederick II we find:

> At the coming of great Frederick, the servant of God,
> The sun is radiant, the air is mild, the water bubbles up,
> The earth is decked in green . . . Rejoice, O Jerusalem
> For the magnificent king—Jesus then,

Frederick now—both of them ready to
Suffer, are magnified in thee. (210)

(Adveniente Dei famulo magno Frederico,
Sol nitet, aura tepet, aqua bullit.
Terra virescit . . . Jerusalem Gaude . . .
Rex quia magnificus Jesus olim
nunc Fredericus, promptus uterque
Pati, sunt in te magnificati.)

The "Behold I send my angel" (Ecce mitto angelum meum), which was sung
upon the emperor's entrance into the church, is another notable example
(Kantorowicz 1944:217).

Theodulf of Orléans, Walafrid Strabo, Sedulius Scotus, and Notker have
left reports of such "advents" in Rome and in royal abbeys in Carolingian
times (Kantorowicz 1944:210n.23; Eichmann 1942:96ff.). On high festival
days, crowned and decorated with all his insignia, the king processed from
his palace to the royal cathedral (Klewitz 1939a).

It is doubtful whether the meaning of "throne hall" remained visible with
undiminished force in the Lateran basilica. Charlemagne's reception of the
Constantinian transept type, to be discussed later, suggests that in later me-
dieval receptions—particularly once people have ceased seeing a symbolical-
ly depicted originally functional form—the historical meaning of the form
has displaced the symbolic meaning. The venerable, time-honored quality of
the specific models led to their reception more strongly than any symbolic
meaning that had once marked the type. In other words, what mattered was
that Constantine, the prototype of the Christian emperor, had erected the
churches and that they stood in Rome, the *caput mundi*. The type's symbolic
meaning, after all, was mutable and could even be completely forgotten. Al-
ready by the time of Old St. Peter's—a copy of the Lateran basilica—the fo-
cal meaning of the apostle's grave outweighed and outranked all other
claims. More than that, the new symbolism of the cross and the reception of
the pure cross-shaped building from funerary structures had pushed the old
meaning into the background.

The Cruciform Tomb

The physical structure of the mausoleum affected the transept of the basilica
in two ways. The important *natalitia* festivals (Paulus 1944:5, 68ff.), which de-
veloped from ancient funerary customs into a special Christian cult, were held

in *cellae trichorae*—an ancient type of *heroön*—over the graves of martyrs.[153] In conjunction with the new meaning acquired by the altar, this kind of *cella* could also be combined with the community hall, the auditorium, or the basilica.[154] The great memorial churches clearly invited this arrangement for the choir end. Important early examples are to be found in the basilica of the *thermae* in Abu Mina and in the church of the White Monastery in Sohag (Liesenberg 1928:91) as well as in a smaller, later layout in the Chapel of St. Stephen near the monastery church in Werden, which has been shown to have been erected as a mausoleum between 809 and 843 (Koch 1940:154ff.).

Characteristically, these transversal structures, while connected to a nave like the transepts of the Constantinian basilica, differ in one important point. Since they are generally centrally structured and surmounted in the middle by a tower, the impression is not that of a transverse hall lying across the nave at right angles but of a vertically oriented, central-plan structure (Kraus 1896:263; Paulus 1944:78) (figure 3.17). The middle part of the transverse structure thus becomes a square and "prepares," so to speak, a crossing. Like the transept of the state basilica, the *cella trichora* adjoins a nave but differs from the transept that resembles a throne hall, in that it rises like a tower and focuses on the central square. In this, it resembles another great group of antique mausoleums, one that gave rise to a type that later led to important con-

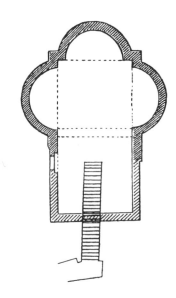

Figure 3.17 Rome, cella cimiterialis *of San Sisto Vecchio. Floor plan.*
(From Kraus 1896:263, fig. 207)

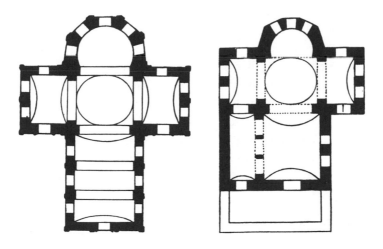

Figure 3.18 Tomarza, Panaghia (left), *and Sivrihisar, Kizil Kilise* (right).
(From Guyer 1945:ill. 4)

sequences for true cruciform churches—the cruciform mausoleum with one extended arm.

Although at first confined to Christian burial churches, this type soon found its way into general ecclesiastical architecture, largely due to the suitability of its arrangement, the new meaning of the altar-tomb, and the symbolic interpretation of its cross-shape that was soon seen as underlying it.

This form began in the interior of Asia Minor. It is found in the ground plans of cruciform Persian *arcosolium* tombs (Justi 1879:49, 55; Texier 1839:1, pl. 61). The arrangement of rock tombs found in Syria, North Africa, and even Rome resulted in the *arcosolia* forming the shape of a cross (Vogüé 1865:pls. 81–92).[155] These tombs were used in the Lycaonian and Cappadocian martyria, in funerary churches, and eventually in the form of the cruciform community church, which became part of the vocabulary of Christian architecture in the fourth century.

The churches mostly had only a single nave, a barrel vault, and a cupola. The crossing is a perfectly "segregated" one as far as the design of the pillars and the roofs are concerned: there is no transept or forechoir (Liesenberg 1928:161–65; Paulus 1944:23ff.; Guyer 1950) (figure 3.18). The first important arrangements are found in the monastic settlement of Binbirkilise, where they accompany the main complex as the mausoleums of the monastery's founders. The principal diffusion was in Cappadocia in the fifth and sixth centuries, where they also served as community churches. To that end, they were subject to the same changes as other common, very early Christian

church types. The long arm could be formed like a basilica, a forechoir or parallel apses could be adjoined, or it might end in a triconch (Guyer 1950:79ff.). Octagonal crossing towers, interior and exterior pilaster articulation, and true cruciform pillars were also sometimes used. We have layouts that as early as the fifth and sixth centuries displayed a "segregated" crossing, complete in every way, even if in small, mostly single-nave structures. This type would become widespread in the West (e.g., Mausoleum of Galla Placidia in Ravenna); already in pre-Carolingian times it led to a widely diffused class of buildings (figures 3.19 and 3.20) that in some parts of France survived into the twelfth century. Of buildings in German regions, the cathe-

Figure 3.19 Orense, Santa Comba de Bande, before 872.
(From Schlunk 1947:fig. 306)

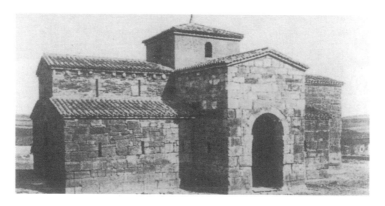

Figure 3.20 Zamora, San Pedro de Nave, before 711 or between 893 and 907.
(From Schlunk 1947:fig. 291)

dral of Eichstätt (Lehmann 1938:fig. 54) (very similar to the Church of Jacob's Well in Sichem), the Chapel of St. Stephen in Werden (Effmann 1926), the eleventh-century Church of the Holy Cross in Trier (Effmann 1890), and the Carolingian cruciform church of Riehen in Switzerland (figure 3.21) should be mentioned.[156]

The concept of the cross, which in its symbolic meaning helped diffuse this type of tomb building, also facilitated the introduction of the idea of the altar as tomb. In all these layouts—in contrast to the early Christian transept basilica, as we know it in the West—the transept arms are an integral part of the ground plan as a whole.

The concept of the cross-shaped church had its effects on the other great building types of the West. Quite diverse formations arose as a result, formations whose epitome and highest form, so to speak, was the cruciform basilica with segregated crossing and crossing tower.

We can reconstruct a picture of the great arrangements of the fifth to ninth centuries only with difficulty. They were demonstrably cruciform but have been destroyed or replaced by later buildings. Although it would be true

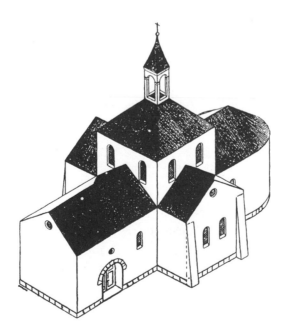

Figure 3.21 Riehen, Carolingian cruciform church.
Reconstruction of the exterior.
(From Laur-Belart and Reinhardt 1943:145)

to say that no layout of the kind we see at Limburg an der Haardt could have been found among them—that is, a cruciform basilica with a fully developed segregated crossing—it would be false to interpret those earlier layouts as incomplete or hindered by the Western transept basilica from achieving their destined cruciform, Cappadocian perfection.[157] For in reality, from the fourth to ninth centuries, the various types still existed side by side; indeed, they even blended and could, by reception, still be realized in their pure forms. It is incorrect, in other words, to see a developmental progression, for the various "stages of development" coexisted often in close geographical proximity. Types from different stages in the imagined sequence could be built by *Bauherren* for reasons having nothing whatsoever to do with building in the latest style. Rather, they could be built because of a specific historical resonance with a great prototype or the acquisition of a relic associated with a specific building. However, by the beginning of the eleventh century, in the eventual union of the forms in Hildesheim, they had lost their respective original meanings and were made completely subordinate to the concept of the cross. Thus it is evident that any interpretation based on a criterion of formal perfection alone will underestimate or overlook the meaning that provided the foundation for the form.

Doubtless it was not the idea of the cruciform mausoleum and memorial building alone that focused the broad sweep of the Constantinian transept on its center, so that the space in which the transepts collided automatically produced a tower, with the colliding parts coming together in the roofs and crossing pillars and lifted vertically by their conjunction. Other elements, also anticipated in the architecture of Antiquity, encouraged this development when they came to be included in Christian architecture.

The Three-Chambered Layout

The articulation of the presbyterium into three *cellae* must be mentioned first; it is derived from the classical tradition of the two rooms flanking the tribunal and enters early Christian architecture in the form of the apse with pastophories. Among other purposes and in much the same way as the transept, these side rooms served to contain the tables for the offerings (Liesenberg 1928:82). Although they were initially used to relieve the holy space of distracting activities and divert them away from the apse, increasing communication can be observed between the pastophories and the side aisles or the transepts, respectively, on the one hand, and between the pastophories and the apse, on the other.[158] At the end of this development

(Lehmann 1938:83), we find, first of all, churches with secondary choirs—which in consequence of the Cluniac reform became standard in many parts of the West[159]—and the remarkable Carolingian churches that, although covered by a shed roof on the outside, seem to have transepts and house three rooms separated by pillars.[160] Second, we find that while from the outside these churches seem to have transepts, on the inside they have only a "compressed" crossing. Within the context of German architecture, it is quite possible to establish an evolutionary sequence from something like the pre-Carolingian Dompeter in Alsace (Lehmann 1938:fig. 77), which closely follows the Eastern pastophory schema, through Werden II (Lehmann 1938:fig. 96) and St. Alban in Mainz (Lehmann 1938:fig. 99) to the cathedral of Metz (Lehmann 1938:fig. 140),[161] where the transept is a segregated one.

To what degree this development was promoted by the model of the Constantinian transept basilica is hard to say. What *is* certain is that the Roman transept layout and the Eastern three-chambered presbyterium encountered each other in the Carolingian period, united to form the Romanesque cruciform basilica, and only under specific historical circumstances ever appeared in their pure forms again.

The Architectural Baldachin

In addition to the cruciform church of Asia Minor and the three-chambered layout of Syrian origin, yet another element from the repertory of classical forms helped to push the Roman transept basilica in its eventual direction: the architectonic baldachin over a sacred place. This concept, too, is very ancient and originated in the prehistoric necessity to protect the hearth or throne by means of a roof. Overhead, this protection was furnished by means of a vault, usually shaped like a cupola, and on the sides by draperies stretched between the supports. In the trend toward historicity discussed earlier, these elements were freed from of their foundation in necessity and became insignia reserved for objects whose status partook of the sacral (Schlesinger 1910:23; Smith 1950; Treitinger 1950).

We find them taking root very early in pre-Christian cultures: in the Iranian fire-shrine surrounded by four supports and covered by a cupola (Erdmann 1932:41; Diez 1944:58ff.), for example, and in the ancient Near Eastern royal throne (Andrae 1930). Here the baldachin can already mean the vault of heaven, and the supports can be anthropomorphically conceived as supporting figures. In this formulation, the baldachin-as-ciborium found

its way into Christian art and survived into the early Middle Ages in Italy and in some places in the North.[162]

Although small baldachins marked out specific spaces in the church's interior, they did not have an influence on the transept design. However, transposed to a larger, monumental scale, baldachins, which are more or less a kind of sculpture, had considerable implications. This transposition—the construction of the baldachin on a large scale—was already developed in pre-Christian times. For example, a four-arched structure with a cupola-baldachin was erected in Firuzabad above the altar of the sacred fire (Diez 1944:64ff.; cf. Kaschnitz-Weinberg 1944:89ff.), and the classical, so-called Theokoleon in Olympia also ended in a sacred space bounded by four columns, but it was not vaulted with a cupola (Holtzinger 1899:108; Liesenberg 1928:137, fig. 50). Without being an exact copy, the post-Constantinian rebuilding of the cathedral of Trier followed this example from Olympia closely (Kempf 1948:29–30, figs. 3 and 4). In this rebuilt Trier Cathedral, a square structure attached to a basilica, four mighty columns surround the altar, which, in turn, stood on a podium that was perhaps crowned by a baldachin, as in the great Basilica of Korykos (Liesenberg 1928:115, fig. 36).

The idea of an architectural baldachin-over-a-tomb also played a particular role in the development of the hall-crypt. In addition to the other types of crypts already current in the Carolingian period in which a subterranean space is supported by pillars (Bandmann 1949a:91ff.) and therefore presents the image of a hall, there is a specific, frequently found solution in which an almost square crypt is subdivided by only four pillars, in the center of which are found a tomb and an altar (Hoferdt 1905:69ff.).[163]

The architectural baldachin appears in the upper church by the seventh century at the latest, not constituting an entire room, as in Trier, but inserted within the basilica, as in Sant' Agostino in Spoleto, for example (Kraus 1896:329, fig. 261; Liesenberg 1928:188; Guyer 1950:93).[164] There, at the end of the nave and in front of the apse in each of the four corners, three diagonally placed columns support a quadripartite cupola over the altar. The connection with the ciborium as liturgical fixture is quite obvious. In the fifth-century basilica on an island in the Ilissos near Athens, the four massive corner buttresses at the end of the nave are probably intended as supports for a baldachin (Liesenberg 1928:140, fig. 53).

Contemporary writers still found sculptural and architectural ciboria one and the same as far as meaning is concerned. Paul the Silentiary (527–565) calls the ciborium over the altar "a mighty tower" and the roof of the ciborium

"heaven." The designation *turriculum* (little tower) for the small ciborium over a monstrance is certainly common.[165] The report given in Gregory of Tours's *Liber in gloria martyrum* (Knögel 1936:no. 241) that Bishop Apollinaris of Clermont had a tower erected on the Church of St. Antolianus—"He erected a tower surpassing the Columns of Pharos and the Pillars of Hercules" (Turrem a columnis Pharis Heraclisque transvolutis arcibus erexit)—typifies its visual impression in this period. It is further related that this tower rose above the altar on four arcades supported by marble columns. Above, there would be several recessed terraced stories, each with arcaded openings.

We might well conclude that in the North the absence of sculpted altar-baldachins and the presence of crossing towers are causally related. By way of contrast, in Italy the altar-baldachin survived as a liturgical fixture well into the Middle Ages because there is no architectonic transposition into crossing or choir towers. On the same grounds, we might also object to classifying the thirteenth-century ciborium of Maria Laach as an altar ciborium. As the research, unfortunately unpublished, of P. Frowin, O.S.B., of the Abbey of Maria Laach, demonstrates, it does not belong to the tomb of the founder of the abbey but is nonetheless a copy of the Holy Sepulchre. In view of the depictions of the Holy Sepulchre in ivory reliefs, this connection would have been clearer if a small gallery of columns between the support and the helm of the ciborium had not been removed in 1947 because it did not accord with the aesthetic taste of the times. This action was justified—without documentation—on the assumption that the gallery had been a later insertion of parts of the former choir screen. The ciborium of Maria Laach, whose formal idiom resembles so closely that of the Matthiaskapelle in Kobern, which, in turn, is one of a group of chapels of knightly orders that were modeled on the Holy Sepulchre, should be seen as a sculptural replica of the Church of the Anastasis and perhaps stood behind the high altar, but certainly not over it.

The Church of Jacob's Well in Sichem (see p. 183) and the pilgrimage churches of Qal'at Si'man and St. John in Ephesus (figures 3.22 and 3.23) present a special case, albeit one quite clearly reflecting the original situation.[166] In all three churches, the first given fact was the holy object that had risen to become the focus of a famous pilgrimage or commemorative site: the well of Jacob, the pillar of St. Simeon, and the tomb of St. John. Buildings with several aisles (only one nave in Sichem) were built on all four sides leading up to these shrines from all four cardinal directions—colonnaded streets in Kitschelt's sense—and this resulted in true cruciform ground plans.

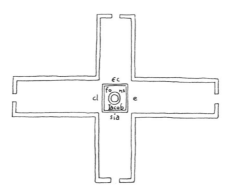

*Figure 3.22 Sichem, Church of Jacob's Well.
Floor plan. (From Bettini 1946:pl. 1)*

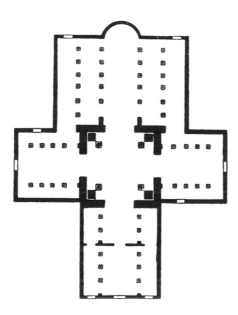

*Figure 3.23 Ephesus, St. John. Reconstruction
of the floor plan in pre-Justinianic times.
(From Bettini 1946:pl. 2)*

Although the central shrine in Qal'at Si'man probably remained un-roofed (Guyer 1934; Krencker 1939), so that its original character as a square with four streets leading into it might remain visible, the tomb of St. John became a true part of the church. The oldest remaining parts of the tomb of St. John stood as a square building in the center of a cruciform arrangement surrounded by the four inserted supports of the crossing. Only a small step was necessary for these slowly accumulating parts to be reflected within a unified whole, such as the cruciform church in Salona (Gerber 1911:120) and the basilicas of Nikopolis (Soteriou 1940:372) and Apollonia (Guyer 1950:91ff.). Here we are already dealing with buildings influenced by the concept of the cruciform church where the cupola-crowned centerpiece, resembling a baldachin, is set in the center of a basilica already shaped like a cross.

This tendency of the baldachin to centralize, to mark the focus of attention, and to gather potentially disparate elements together and unify them also had an effect on the continuous Roman transept. The decorated supports of the triumphal arch marking the entry into the throne hall (on the west side of the crossing) found a response in the arch of the apse facing it (on the east side of the crossing). The columns in San Paolo fuori le mura, St. John Lateran, and Sant' Anastasia in Rome were still freestanding ones (Krautheimer 1942a:fig. 4B and O). Later they fused with the massive pillars to form engaged columns, the form what was henceforth to be found on all crossing pillars. The arches mark this area as one set apart, and the vault and tower give the whole a centered appearance like that of a baldachin. Particularly in French architecture, where the original arrangement was retained for so long, we find that the inserted architectural baldachin still appears in sharply delineated form in Romanesque times—for example, in Saint-Savin (Dehio and von Bezold 1884–1901:pl. 117, fig. 10), Fontevrault (Aubert 1941:55, fig. 58), and the church of Les Aix-d'Angillon (Deshoulières 1932:3) (figure 3.24). Perhaps we might imagine the Merovingian cruciform basilicas as being somewhat similar. The cruciform Basilica of Saint-Wandrille (Fontenelle) in the seventh century had a *turris in media basilica* (*Miraculi S. Wandregesili* 1887–1888:chap. 3; Paulus 1944:139).

While the shrine in the Church of St. John in Ephesus touched the corners of the surrounding church walls so that, as at Qal'at Si'man, the four arms of the layout appear separated and there is no allusion to the Roman transept in the ground plan, the layout created by the emperors Arcadius (395–408) and Zeno (474–491) at the tomb of St. Menas (Kaufmann 1910:61ff.) was of evident Hellenistic inspiration and was influenced by the Roman transept basilica (Baumstark 1907:9ff.) (figure 3.25). Here the prolonged side aisles penetrate into the great transept and thus annul any separation of nave and

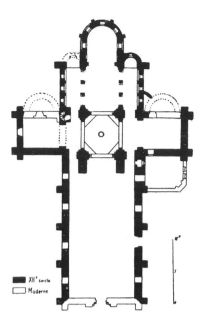

Figure 3.24 Les Aix-d'Angillon,
Saint-Germain. Floor plan.
(From Deshoulières 1932:3)

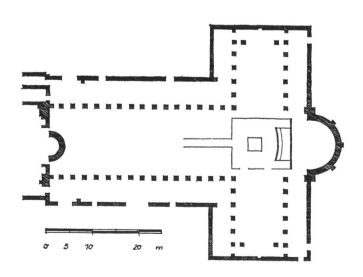

Figure 3.25 Abu Mina (west of Alexandria), Shrine of St. Menas.
Floor plan. (From Wachtsmuth 1929–1935, 2:74)

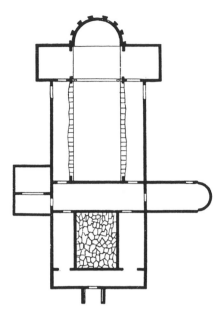

Figure 3.26 Nikopolis, Basilica of Dumetios.
Floor plan. (From Liesenberg 1928:139, fig. 52)

transept. Perhaps the centralizing conjunction here was created more by the notion of a gallery than by that of the cross (Liesenberg 1928:86ff.). The lower church in Perge in Pamphylia (Wachtsmuth 1929–1935, 2:75, fig. 98) and the Basilica of Demetrios in Thessaloniki (Wachtsmuth 1929–1935, 2:149, fig. 195) display similar solutions. However, the closest solution to an early union of the cross arm and the transept can be found in the Basilica of Dumetios in Nikopolis (Schweitzer 1923:248ff.) (figure 3.26) and in the Basilica of Dodona (Guyer 1950:94). Here, it is no longer possible to determine whether the Roman transept, the cross-shaped church, or the inserted baldachin-tower was the first and guiding element.

The Transept Basilica and Cruciform Basilica of the Franks Before Charlemagne

The mutations and modulations of the Roman transept under the impact of the cruciform church—which from its origins in the mausoleum developed into the model for all churches—of the three-chambered presbyterium, and of the inserted tower (or baldachin) have been briefly outlined here in order to highlight the unique place of the Constantinian church

whose reemergence in pure form during the Carolingian period represents something quite extraordinary.

In Roman urban architecture, these transept arrangements were not imitated for six hundred years. Even in Rome itself, they had dropped out of use, and a plain three-aisled basilica with a simple apsidal end took their place. Outside Rome, they survived only when mixed with other types, and we must assume that their original meaning was no longer common knowledge. Indeed, we have numerous reports about cross-shaped basilican layouts, but they leave no definite clues about their design. According to the written records, the great Merovingian buildings in Clermont-Ferrand (fifth century), Saint-Germain-des-Prés in Paris (completed in 558), Saint-Médard in Soissons (completed in 576), Rébais (begun in 634), Saint-Wandrille in Fontenelle (begun in 648), Sainte-Marie in Jumièges (begun in 655), and Saint-Pierre in Corbie (begun in 657) were all cruciform basilicas, which probably always had crossing towers and barrel-vaulted crypts, though these are only occasionally reported (Paulus 1944).

This type lived on in the Carolingian cruciform basilicas of Aniane (782–792), Centula (793–798), and Déas (820). They were characterized by their forechoir and tower and formed an important basis for the basilica-with-segregated-crossing that followed in Ottonian times. This type had experienced substantial stimulus from Constantinople via Milan and should be distinguished from the arrangement with continuous transept and forechoir (e.g., Hersfeld III). St. Ambrose's Church of the Holy Apostles in Milan (end of the fourth century) was cruciform (Hübsch 1862–1863:7), and in this it followed Eastern models.[167] It became the model for the first cruciform basilicas in Gaul, for those in Clermont-Ferrand, and perhaps for the one in Tours. Whether the change from cruciform single-naved building to cruciform basilica happened first in Milan or Gaul cannot be determined. Until well into the fifth century, Gaul was part of the Western Roman Empire and was dependent on the imperial residential capital of Milan in many things, including liturgy (Levison 1898:61). What is most important for the following period is that in this manner the cross-shaped church, which in western Europe had hitherto remained confined to funerary buildings and had therefore been subordinated to the principal church, could also become a type of principal church now that it was shaped like a basilica. This type was promoted by the great official funerary churches of the Merovingian kings. First in the list is the court and funerary church of Saint-Germain-des-Prés (completed in 558 under Childebert)—"built in the manner of a cross" (*in modum crucis aedificare disposuit*) (Paulus 1944:138)—followed by the funerary church of Chlothar I in Soissons (completed in 576). The subsequent monastery churches in Rébais,

Fontenelle, Jumièges, Corbie, Aniane, Centula, and Déas also represent this type, although Benedictine houses founded from Monte Cassino probably at first followed the Roman urban transept type.[168] We could trace this transition to the true cross-form in the construction of the monastery church back to various causes. Herbert Paulus (1944:40ff.) is of the opinion that the Irish missionaries who worked from the sixth century on alongside the Benedictines in Gaul and accepted prehistoric Celtic customs introduced the funerary cult into ecclesiastical architecture in the form of the crypt (Heussi 1927–1932, 1:1709; Levison 1912:1ff.; Harnack 1908; Ebrard 1873). It was this general turn toward the funerary cult that brought the form of the cross into monastic architecture. With the merging of the Irish missions and the Benedictines at Luxeuil in 625 (Paulus 1944:112n.33), this type then became generally obligatory for monastic churches. Since it was the Irish missions that first made Christianity a religion of the people, the cruciform basilica with crypt thus stands as a first witness to a popular West Frankish building style (Paulus 1944:50).

Without wishing to denigrate the importance of the Irish missions, we should consider that perhaps the position of the Christian monastic orders in the Frankish kingdoms was really more determined by the particular Merovingian conception of kingship. Perhaps we should assume that the earlier royal funerary churches in Saint-Germain-des-Prés and Soissons influenced the attraction of the Benedictines to the cruciform basilica; the transition marked the start of the inclusion of the Benedictines in that church–state union that was to be so typical for the subsequent centuries.

After the baptism of Clovis in 496, the Merovingian kings saw themselves in a situation not dissimilar to that of the emperors in Byzantium. Through the bishops, who were attached to the court, they had influence over the building of churches (Schlosser 1891:54ff.; Neuss 1946:43ff.; Feine 1939:120ff.; Ensslin 1943:108ff.). Although a "Roman" opposition from Tours can also be ascertained, the national church, as represented architectonically by the proprietary churches, was independent from Rome. The king claimed power of jurisdiction even in ecclesiastical matters. In the establishment of funerary churches and royal mausoleums and, above all, in his interest in an official state architecture, he clearly followed Byzantine models.[169] It cannot be said that the Merovingians were markedly hostile to Rome, since Rome did not exist as a power as such, unless one were to designate the tendencies inherent in Christianity (at that time) that were hostile to secular authority as being "Roman." Like the other lords of the new Germanic states, the Merovingian rulers entered into a general Mediterranean tradition that, at this point in time, would have been exemplified by Byzantium (Gasquet 1888).[170] The office of the king became absolute and hereditary, the rulers took on Roman titles,[171] and after

630 they wore Roman-style clothes (Delbrück 1932a; Alföldi 1935:131). The rulers advocated the idea of the state church, whose dignitaries were appointed by the king (Pirenne 1941:49, 56, 129). They attempted to make the cities centers of their realm (e.g., Fréjus, Nîmes, Toulouse, Cologne, Mainz, Trier, and Paris), and they adopted a simplified church Latin as the language of the laity.[172] Continuity in language, currency, writing, measurement, diet, social order, law, religion, and administration was ensured (Pirenne 1941:133; Dopsch 1926:159–82).

Although it was to be so influential for the whole of medieval architecture, the actual form of the Frankish cruciform basilica can be only dimly reconstructed.[173] Perhaps, corresponding to the inexperienced, strife-torn, and fragmented nature of the Merovingian rulership,[174] it was never really firmly architectonically formulated in the first place: "Seen as a whole . . . responsible creative initiative cannot be ascribed to the Merovingian kingdoms" (Paulus 1944:55). Even as it survived into the twelfth century in the various regional building traditions of France that remained outside Carolingian trends, Merovingian architecture reveals to us that except for a faint reflection of Byzantine traditions in the cruciform church, in the long run, the Merovingians really only continued provincial Roman architectural traditions (Adhémar 1937).[175]

The Central-Plan Building

From the time of Charles Martel and increasingly under Pippin III (751–768) and even more so under Charlemagne (768–814), new power accrued to the rulers of the Franks. The relationship to the pope became much closer than before, for the king of the Franks had taken over from the Byzantine emperor the position of protector of the papacy, and Pope Stephen II had often asked the king for protection and help. Initially, however, the Frankish concept of rulership underwent no essential change. But in his arrangement of the Palatine Chapel in Aachen (before his coronation as emperor) (see pp. 110–11) before its western structure was added, Charlemagne had introduced into Western art the architectural idea that the royal church, built to a central-plan design, was to be the principal church of the kingdom, a concept that hitherto had been found only in the Byzantine Empire after the time of Justinian. Whether royal palace chapels had already followed this type in Merovingian times is not known. It is certain, however, that they did not have the documented high status of the great official funerary and monastery churches in cruciform and basilican form. One could perhaps say that in Merovingian times, the Roman basilica took on the central-plan and cruciform building concepts favored by

royalty, and the Frankish cruciform basilica was created by combining these with the crossing tower and crypt. No church type emerged preeminent from these early assimilations, since a type like the Byzantine central-plan structure would have conflicted with the Gallican as well as the Roman liturgy.

Certainly, central-plan structures were not unknown, but as mausoleums and baptismal churches they were tied to specific functions and subordinated in both status and size to the great monastery and cathedral churches. Two martyr's churches whose layouts apparently harken back to Roman times are the exceptions: St. Gereon in Cologne and La Daurade in Toulouse.[176] Charlemagne built a palace church in Aachen whose furnishings surpassed those of the contemporary cathedrals and monastery churches (see pp. 110–11) (see figure 2.35). With this building, which reveals how strong his sense of power was even before his coronation, Charlemagne presented a vision that would have to be scaled back only a few years later but whose consequences nevertheless lasted well into the thirteenth century. The form had arisen in Byzantium, where the *imperium* lifted the central-plan building out of mere functionality (Liesenberg 1928:165; Lassus 1947:124ff.). Or one could say that due to the patronage of the emperor, the classical mausoleum set itself up as the principal church (Wulff 1914–1918, 1:244ff.; Paulus 1944:29). What in Constantine's mausoleum had been a relatively isolated arrangement (Heisenberg 1908:97ff.; Vogt 1949:259ff.) was given ideological connections and linked with the concept of the emperor in the central-plan throne hall of the Chrysotriclinium built under Justin II (Ebersolt 1910a; Richter 1897:315ff.). As a result, in conjunction with the Church of the Holy Sepulchre in Jerusalem, it became possible for a very large central-plan building to function as a community church, and that is indeed what occurred with the Octagon of Antioch in 381 (Wulff 1914–1918, 1:251; Lassus 1947:124).[177]

There is indeed a direct connection between the Palatine Chapel in Aachen and San Vitale in Ravenna,[178] which, in turn, was modeled on the church built by Theodosius in the Hebdomon Palace, which was related to the Octagon in Antioch (Wulff 1914–1918, 2:370). And for Charlemagne the figure of Theodoric was more influential for his building project than that of Justinian, who had only had the mosaics installed in San Vitale after consecration. Nevertheless, as later buildings modeled on it show, Aachen belongs firmly within the broader category of central-plan palace and court churches, whether polygonal, square, or cruciform. Its principal characteristics— central-plan arrangement, galleries, and vaulting—make it fundamentally different from the Western concept of what constitutes a principal church. The Byzantine combination of the cruciform church with the basilica in the (almost) square cupola-church belongs in this tradition as well.

Despite the wealth of visual elements from San Vitale, the resemblances between the Palatine Chapel in Aachen and San Vitale go beyond that specific relationship. If we recall the particular characteristics of the medieval concept of the "copy" (see pp. 49–51), then the deputizing meaning of the Palatine Chapel in Aachen becomes clear across a whole complex of ideas, for the way it depicts, represents, and embodies them. It also becomes clear why the church that Theodulf, Charlemagne's chancellor and bishop of Orléans, erected at Germigny-des-Prés (805–818), which has only its central-plan character in common with Aachen, was seen by his contemporaries as a basilica built in the manner of the one in Aachen (basilica instar eius quae Aquis est constituta) (Schlosser 1892:216, no. 682). Any investigation of the form of the church at Germigny-des-Prés would lead to geographically very different regions: to the cruciform cupola-churches in the Middle Byzantine style of Etchmiadzin and Bagaran in Armenia and to Visigothic churches in Spain and Toledo (Aubert 1941:22; Hubert 1938:75). In ground plan and decorative forms, for example, Germigny-des-Prés is more closely related to the Sassanid fire-shrine of Djerre than to Aachen (Erdmann 1943:42).

While observations such as these will uncover a great deal of curious facts about the geographical distribution of art and ultimately lead to meaningless connections, a consideration of such written sources for the relationships of Aachen as have come down to us will tie the whole complex together: court and palace church and central-plan proprietary church. A very rough, formal definition of the type, but with a precise determination of claims and status, leads, then, into areas where the meaning of the ruler as *auctor* and *pontifex maximus* was already determined in pre-Christian times. The palace of Firuzabad (destroyed under Adashir in 223–240) already recalls these central-plan buildings in its disposition and in the way its pronounced, barrel-vaulted entry leads to a high structure like a tower, intended for ceremonies such as state receptions (Erdmann 1943:19ff., fig. 3).[179]

From Byzantine architecture of the fifth through twelfth centuries we can cite countless examples of these central-plan principal churches, some of which have direct and traceable relationships to Western court and palace churches. The cupola basilicas in the Isaurian Koja Kalessi (Wulff 1914–1918, 1:255, fig. 246) and in Meriamlik (Wulff 1914–1918, 1:256), both from the second half of the fifth century, are two examples of a room vaulted with a cupola and surrounded by adjacent barrel-vaulted or flat-roofed rooms. Churches where an octagon is placed within a rectangle are to be included in this type,[180] as are layouts such as those of San Vitale and Hagia Sophia. The central-plan buildings of the Western courts and even the westwork, which will be discussed later, are extremely similar to these simplified cruciform

cupola-churches where a cupola is inserted on supports arranged in a rectangle inside a surrounding rectangle, such as Hagia Sophia in Thessaloniki (Wulff 1914–1918, 2:385ff.).

According to Kautzsch (1936:41ff.), the palace church of Qasr-ibn-Wardan, built on imperial commission in 564 (Wulff 1914–1918, 2:387; Butler 1929:167, fig. 178) (figure 3.27)—as well as El-Anderin and R'safah (Butler 1929:169, figs. 180–181)—had a direct influence on the episcopal court chapel in Mainz (figure 3.28)[181] and a more distant one on the Liebfrauenkirche in Goslar.

Buildings like the Kalendarhane Camii and the Koça Mustafa Pasha Camii in Constantinople (Wulff 1914–1918, 2:389, fig. 337, 391, fig. 338), where the cruciform interior is more clearly expressed, perhaps served as models for the proprietary and funerary church of Arnold of Wied in Schwarzrheindorf. The latter was erected after this *Bauherr*'s lengthy sojourn in Constantinople around 1150 in the retinue of the emperor (Clemen 1906).[182] The court and triumphal church of King Ramiro I—San Miguel de Lillo, near Oviedo—also belongs in this group (Haupt 1909:203) (figures 3.29 and 3.30).[183] This church was dedicated to St. Michael in the middle of the ninth century and built in immediate proximity to the palace. Of the latter, only the church of Santa María de Naranco, which had once served as a royal hall, still remains.[184] Buildings on Spanish soil stood more firmly within the orbit of Byzantine building traditions before the Arab invasions. After the conversion of the Asturian royal house to Catholicism, new forces came into play, chiefly evident in the buildings of the early ninth century, where rubble and mortar construction replaces ashlar without mortar and round arches replace pointed or horseshoe ones (Schlunk 1937:241ff.)—as at San Julian de los Prados and Santa Cristina de Lena (Lozoya 1931, 1:275ff.). Nevertheless, in San Miguel de Lillo, the meaningful relationship with Byzantine court churches is evident.

The palace church of Basil I, the Macedonian—the Nea, consecrated in 881—reflects the same situation as the Western palace churches. In both cases, the palace is connected by an arcaded gallery to a central-plan church where the ruler participated in the divine service from a gallery (Wulff 1914–1918, 2:454), unless he entered through the main entrance in solemn procession, as he did on festive occasions.

Additional layouts of similar nature from the Middle Byzantine and later periods can be found in the Koimesis church of Nicaea (Wulff 1914–1918, 2:453), the church of Skripou in Boeotia (873–874) (Wulff 1914–1918, 2:453), the cathedrals of St. Sophia in Kiev (1017–1037) and in Novgorod (1045–1052) (Brunoff 1927:36), the monastery church of Daphni (Wulff 1914–1918,

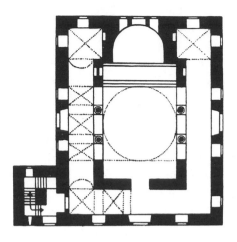

*Figure 3.27 Qasr-ibn-Wardan,
palace church, 564. Floor plan.
(From Kautzsch 1936:43)*

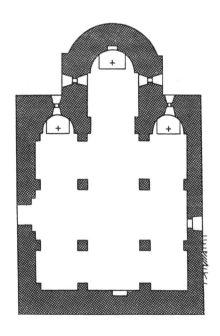

*Figure 3.28 Mainz, cathedral.
Chapel of St. Gotthard. Floor plan.
(From Schneider 1886:pl. 1)*

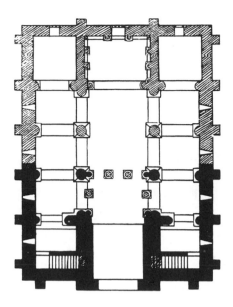

Figure 3.29 Near Oviedo,
San Miguel de Lillo, mid-ninth century.
Floor plan. (From Haupt 1909: 203, ill. 124)

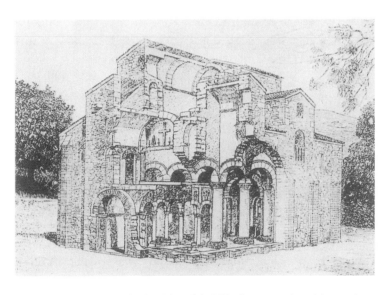

Figure 3.30 Near Oviedo, San Miguel de Lillo. Reconstruction of the exterior.
(From Haupt 1909:204, ill. 125)

2:465), and, finally, the Panaghia Parigoritissa in Arta, erected by the despot of Epirus as a palace church at the beginning of the thirteenth century (Wulff 1914–1918, 2:468, fig. 393); they are also present in the Hagios Pantocrator in Constantinople, begun in the twelfth century by Emperor John Comnenos as a funerary church for himself and his wife (Wulff 1914–1918, 2:485).

Looking at all these buildings and comparing them with Western ones of a similar purpose (i.e., that of palace chapel), we can say that only the Palatine Chapel in Aachen can claim equal status. Apart from features to be discussed later, Aachen most closely resembles these Byzantine buildings. The palace chapels built on the Aachen model still resemble those Eastern buildings that were simplified in the Middle Byzantine period, in part through the omission of galleries and the separating out of the conglomeration of secondary rooms (Wulff 1914–1918, 2:450). From the eleventh century onward, due to the weakening of relationships within the Mediterranean region as a whole, Western architecture only occasionally took up forms from Byzantium and mostly used archaic forms. As a result, the types, such as that of the palace chapel, became detached from their sources in Byzantium, and an increasing distancing from Byzantine architecture began. The whole of Byzantine architecture entered into a rich, late phase (Wulff 1914–1918, 2:461), and in the church of the imperial monastery Hosios Lukas in Stiris (eleventh century) still other solutions to the problems of octagonal buildings were undertaken. In most cases, however, German architecture continued to follow a simplified model of Aachen. In the polygonal ground plan and galleries and, above all, in the column pattern (Bogner 1906), the churches and chapels in Nijmegen, Ottmarsheim, and Groningen; Saint-Jean in Liège; Georgenberg near Goslar; and—in their western structures—the Minster of Essen and St. Maria im Kapitol in Cologne recognizably follow Aachen (Sommerfeld 1906; Humann 1918:81ff.). These formal connections are also substantiated by written evidence in Germigny-des-Prés (see p. 196), Mettlach,[185] and Diedenhofen.[186]

After Aachen, the proprietary church survived into the seventeenth century but only in the more private sphere of castle, palace, and court chapels, and it survives in canon law even to the present day as the right of advowson (Schürer 1929).

If Charlemagne in building Aachen represented the Byzantine tradition with particular clarity, it must also be said that distinctive features were already being introduced that point to Rome and specifically to the fourth century. The great western niche was mentioned earlier as being a later addition and was explained by tendencies that were operative only after Charlemagne's coronation in 800 (see pp. 111–13). The Western Roman

predilection for directionality, for axial structures as opposed to central-plan ones, which also sets the church nave at the center of architectural activity, may be regarded as a formal consequence of this differentiation in terms of meaning between the emperor's building and the "pure" church, one that is not implicated in a worldly power structure. There was now a hierarchical differentiation among the world of the laity (atrium), the secular ruler (*Westbau*), and the church proper—distinctions that were graphically demonstrated and could be physically experienced step by step during processions.

Like the Pippinids, who had labored long to legitimize their power by means of a close connection with Rome, Charlemagne, as king of the Franks, was connected to Rome in many ways.[187] It is typical that the exterior of the soaring central part of the Palatine Chapel in Aachen shows Roman pilasters rather than Ravennate blind arches. It is even tempting to see the fixing of an iron eagle onto the roof of the choir—assumed by Buchkremer (1947:10; cf. also Eichmann 1942, 1:45)—as a reversion to the concepts of the Rome of Antiquity.

The Westwork

In the West, the reception of this central-plan building of Eastern and Byzantine origin is distinguished by the "Roman" shift toward subdividing the spaces and arranging them along an axis. The freestanding central-plan building became a westwork attached to a church. A characteristic occurrence of the ninth and eleventh centuries on Frankish soil, westworks are present or documented in Centula, Corvey, Fontenelle, Fécamp, Lorsch, Reims, the cathedral in Hildesheim, Maastricht, Paderborn, Farfa, St. Pantaleon in Cologne, Werden, and Münstereifel. In the sources, they are called *turris*, *opus*, *oratorium*, *castellum*, or simply *ecclesia*.[188]

Although the type has been perceived as more unified than it is—perhaps under the influence of Wilhelm Effmann's reconstructions—one can say that its character as a proprietary church always remains clear, particularly in its formal expression.[189] There is a proper central space, equipped with galleries and surrounded by secondary spaces much like passages. It is more or less separated from the adjoining basilica and has its own altars and patron saints (figure 3.31; cf. figures 3.27–3.29).[190] As in Aachen and San Miguel de Lillo, the westwork has a loggia that opens toward the west and shows much closer connections to the Byzantine churches mentioned earlier than to Western central-plan churches. In connection with Byzantine customs, the conspicuous cult of the archangels, particularly that of St. Michael, should also be

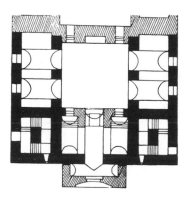

Figure 3.31 Werden, St. Peter. Floor plan of the westwork.
(From Effmann 1899:217, fig. 164)

mentioned, for this cult was almost unknown in Rome but had entered into the independent Gallican liturgy (Wulff 1914–1918, 2:460; Gruber 1936; Krefting 1937; Vallery-Radot 1929).

The westwork remained the focus of particular legal activities that partook more of the world and the laity, some of which involved the active participation of the ruler: baptism, marriage, parish church services, Easter communion, and, above all, the ecclesiastical assizes of the *Sendgericht*.[191] As mentioned earlier, while the westwork's designation as a place of judgment for the ruler or his representative remained operative for a long time, the more "worldly" transactions were gradually moved out of the westwork in consequence of the ideas of an autonomous church advanced by the Cluniac reform and, as a result, were no longer part of the perception of its original meaning. In the idiosyncratic alterations of the twelfth and thirteenth centuries, these western structures—as in Werden and Xanten, for example— were completely fused to the main space.

It is false, however, to see the reasons for the origins of the spatial disposition and the formal appearance of the westwork in the purposes handed down to us. Fuchs (1947) states "as they are conceived, the completely developed westworks are so placed that, opening onto the atrium at the ground level, they could both serve as baptisteries and for the parish church services and be fitted out with galleries for the visits of the ruler." Thus the westwork would seem to be the innovative architectonic solution of a Carolingian architect—probably the architect of Centula—to satisfy these requirements. Fuchs departs from his definition at one point, however, and recognizes the

intention of the westwork's meaning as proprietary and guest church for the emperor in the evident analogy to Aachen (Fuchs 1947:20n.43).

Other interpretations of the westwork are also unsatisfying, for they are based largely on individual monuments; for example, when looking at Maastricht, Rave (1937) says that the westwork is a combination of the western choir with the crypt underneath it, resulting from the interpenetration of the transversal Germanic royal hall with a three-aisled basilica.[192] Without denying the impact of the Germanic royal hall on the imperial hall of Maastricht, it must be stated that most layouts are centrally arranged, mostly square, and, above all, marked by their culmination in a tower in the center. The concept of interpenetration of basilica and transept is also based on a modern understanding of ground plans and lies well outside the medieval method of construction.[193] One also wonders how the side galleries could be influenced by the basilicas of the West, which for the most part had no galleries.

Another interpretation found in the research literature applies a formal and developmental or historical understanding and describes the evolution from westwork to double choir as follows: the westwork was a separately conceived structure that was still animated by the spirit of Antiquity. It was appended to the basilica in a rather unharmonious way; it was only gradually artistically integrated and adapted to the existing archaic style of the rest of the structure. As with the development of the segregated crossing discussed earlier, concepts of autonomous artistic and stylistic development prevail here, concepts that do not capture the historical meaning of the attachment of the westwork to the church or the later elimination of the westwork.[194]

Gruber's (1936) definition of the westwork, discussed in chapter 2, as the architectonic picture of an allegorical reconstruction of the two hierarchies of Dionysius Areopagitica, can be disregarded. The concept of the proprietary church in canon law is just as insufficient for the understanding of the westwork as a whole as is the derivation from Byzantine forms.

Following the work of Ulrich Stutz, the concept of the proprietary church (*Eigenkirche*) has been increasingly prominent in research in canon law and in constitutional and political history. An *Eigenkirche* is understood as "a church, the ownership [*Eigentum*] of which—or better, the proprietary control [*Eigenherrschaft*] of which—carries the implication that it is at the disposition of the owner, not simply in the sense of the disposition of property, but that it also entails the full power of spiritual dominion" (Stutz 1895).

When the Germanic kings in the early Middle Ages took possession of the territory of the former Roman *imperium*, these lands became the property of the king, who then granted them as fiefs to his followers. These followers were

then assessed specific duties and obligations, and they, in turn, could further give those lands as fiefs to others who would thereby acquire duties and obligations to them. They were more or less absolute lords and rulers over their respective territory. The administration of justice—in accordance with the tribal laws—and the supervision of the cult lay in their hands. The Germanic tribes thus continued their pre-Christian traditions, as comparative religion has long known. Just as the head of the family, or paterfamilias, is the officiating priest and charismatic deputy of holy powers in the primeval family cults, so is the chieftain or duke in tribal cults and the king in national religions.

As the Germanic tribes became settled and converted to Christianity, they continued these practices as a matter of course, although there were essential forces in Christianity that resisted such practices: the ultimate religious authority in Rome—ultimate at least as far as the Western empire was concerned—and Christianity's character as universal religion, which could operate independently of social communities based on blood relationships. Initially, however, these customs were retained, and the institution of the proprietary church persisted and was recognized by Rome.

The relationship to pre-Christian traditions had changed in that the lord of the manor did not actively direct the divine service himself, since he was no longer gifted with the charisma empowering him to lead the rite. Instead, he installed a cleric who had to be confirmed by the bishop, but he retained far-reaching rights and powers regarding the spiritual and material relationships of his church. He built it with his own means on his own land; he could sell it or pass it on to his heir; he determined the revenues for the church and disposed of the tithes; he had the right to be buried in the church. At the divine services, he occupied the preeminent place, and he administered local justice in the church precincts, often in the presence of and with the legitimization of a visual image representing Christ as the judge of the world.

Who could be an *Eigenkirchenherr*, the lord of a proprietary church? Essentially, any free landholder, lord of a manor, or noble could erect an oratory for himself on his property, a practice still visible today in castle chapels or churches with rights of advowson. Since Ottonian times, a bishop, being endowed with sovereign secular rights, could also build such a church, but, above all, the emperor could be an *Eigenkirchenherr*. To him belonged the imperial fisc, which he conferred or on which he founded monasteries. As imperial monasteries, the latter were free from episcopal supervision and directly answerable to the pope. These imperial monasteries often held the highest status, were richly endowed with lands, and were ruled by abbots of princely rank. In newly conquered or politically unstable regions—for ex-

ample, on the Saxon border in Carolingian times—these establishments were valued as elements of a security system, institutions of propaganda value, and foci of loyalty. Since the emperor was not tied to a fixed residence, these imperial monasteries also had the duty of lodging him on his continuous journeys. The monastery was less a hotel than a temporary seat of the imperial court (Klewitz 1939b:138). Just as the choir must be maintained in a serviceable condition for the choir service of the monks, so also the building must be held ready for the arrival of the emperor, and it must be outfitted for the duties of the abbot as proprietary lord.[195]

Let us take an example. Thanks to the research of Wilhelm Effmann (1899), we are very well informed about the circumstances surrounding the westwork of Werden. Legally, the whole monastery was a proprietary church; that is, it had been given in fief by the emperor into the possession of the Ludgerids. The church as a whole served as a parish church for the numerous communities belonging to the monastery, but it was the westwork, the western Church of St. Peter, that fulfilled the particular functions connected with the proprietary church (see figure 3.31). In practice, that was where the parish church services, baptisms, Easter communion, and solemnization of marriage contracts took place (Effmann 1899:178ff.). In it the assizes of the *Sendgericht* also took place, as the dedication document of 943 expressly states: "All that pertained to the synod took place in that place" (Quidquid ad synodalia pertinet, in ea exagitur) (Effmann 1899:170). These assizes were ecclesiastical visitations with accompanying administration of justice and had been an acknowledged ecclesiastical arrangement since the end of the ninth century. They continued, even down to formal details, the original civil *inquisitio* that took place during visits of the emperor or his deputy (Schmidt 1915). If the transfer of this activity to ecclesiastical authority can be regarded as a vestige of the ebbing royal authority of late Carolingian times, it can also be seen in a positive light as a sign of the gradual increase of episcopal power in state functions. And this is how it would soon be officially expressed in the position of bishops in Ottonian times. Since the type of the Peterskirche in Werden was already widespread before the *ecclesiastical* practice of the *Sendgericht*, it is likely that in earlier times it also housed the *inquisitio* of the ultimate proprietary church lord, the emperor, when he resided in the imperial monastery during his visit. We can determine that the specific proprietary church rights that applied to the whole monastery—tithe, judgment, baptism, burial, and parish church rights—were concentrated in architectural terms in this distinctive part of the building.

In Werden, the westwork (875–943) was built immediately after the completion of the basilica (825–875). Until then, the monastery had been the

property of the Ludgerids, some of whom—like Hildegrim II, for example, who was bishop of Halberstadt from 853 to 886—no longer lived in Werden. In order to acquire greater control over the donations of the laity, he wanted the monastery, hitherto without rights, to acquire an autonomous legal status. Hildegrim reached an agreement with Archbishop Willibert of Cologne when they were both at Werden for the consecration of the church. Hildegrim committed himself to commend the monastery to the king, and the church thereby became a monastery under royal protection. King Louis III granted immunity and rights of jurisdiction and henceforth installed the abbots. He was permanently represented in the monastery by a steward. It was at this moment, once the legal position of the monastery as being under royal protection was fixed, that the westwork was begun, and we have cause to assume that it is related to these new claims to status (Nottarp 1916:80ff.).

The attachment of what was once a central-plan building to a basilican nave should be understood in light of the new relationship of the Western emperor to Rome. What brought about the attachment of the westwork to a Roman-style basilica in a church claiming the status of a principal church was the influence coming from Rome that strove for genuine autonomy for the church and on which the political and legal action of the imperial coronation by the pope was founded. The form of the westwork therefore had to be restricted to a rectangular ground plan; the polygonal form that was possible with the freestanding Byzantine churches and in Aachen was out of the question here. Such rectangular ground plans are indeed widespread in Byzantium—for example, the Hagia Theodosia in Constantinople from the second half of the ninth century, the Pammakaristos in Constantinople from the eleventh century, and the Panaghia Parigoritissa in Arta, the palace church of the despots of Epirus, from the thirteenth century (Wulff 1914–1918, 2:468, fig. 393).

In contrast to the position of the Byzantine emperor, that of the Western emperor was less absolute. The legality bestowed by Rome entailed the recognition of the Roman church as a power, and from then on a separation between secular *imperium* and independent *sacerdotium* was a possibility. The emperor, the highest *Eigenkirchenherr*, no longer stood in first place as the *vicarius Christi* and first representative of the *civitas Dei*; rather, he was principal *patronus*, *advocatus*, and *defensor ecclesiae* (Bögl 1932:59; Hoechstedter 1934).

As a type, the westwork has its origins in the Byzantine principal church of central-plan shape. This derivation, however, contradicts Stutz's definition of the proprietary church. Based on legal documentary sources, Stutz concludes that the proprietary church is something specifically Germanic and can already be found in pre-Christian relationships within the Germanic

tribes. For example, he sees it in Tacitus's description of the Germanic high priesthood (*Germania*, chap. 10). His proprietary church would then represent the combination of the native religious and legal conceptions with Christian content. But this idea, which still appears in the historical literature, contradicts the derivation from Byzantium accepted in art history.[196]

What are we to make of all this? Defenders of Stutz's interpretation could argue that since the Germanic peoples as Arians (Visigoths and Ostrogoths) first came into contact with the Byzantine world, they fortuitously availed themselves of the first architectural forms they thus encountered. By contrast, art historians can show that with respect to content the meaning of the Byzantine church comes very close to that of the Western concept of the proprietary church, that proprietary churches were found in the lands of the western Roman Empire before the Germanic peoples arrived—for example, when a landholder founded an oratory on his property for his personal use (Klauser 1942)—and that the proprietary church did not play the same role among the North Germanic peoples as it did in Frankish lands (Neuss 1946:117–18). Similarly, tracing the proprietary church to the economic patterns of landholding and hence the notion found in studies of canon law that this phenomenon is an expression of the feudal system imposed on the church is not satisfactory, for in Byzantium, where the urban culture of Antiquity survived, proprietary churches were found even in the cities. Moreover, it must be pointed out that by the time of Constantine, the state in the Mediterranean region was no longer generally based on a union of cities with free citizens but on rich landholders and their dependent peasantry. The wealthy landowners soon were granted the right to collect taxes and administer justice at the lower levels. Medieval feudalism is therefore not peculiar to any ethnic group (Vogt 1949:266).

An answer to the question regarding the derivation of the proprietary church that does not connect different behaviors toward holy things to racial factors, as in our example of the Germanic peoples or Byzantines, but is based on anthropological factors, comes from comparative religion. From this perspective, the pre-Christian Germanic peoples and the culture of Antiquity as perpetuated by the Byzantines have something in common: the connection of the cult practices, not to a community of belief or of creed that transcended the social community, but to an inheritable community (Mensching 1947).

The society of natural bonds—the family, the clan, and the people—forms the environment in which humanity lived in earlier times. From these units grew the cults headed by the paterfamilias, the chieftain of the clan, and the king of the people. The social community is also the sacral community and the subject of religion. The individual is born into it and

requires no personal confession of faith. Divinities of other communities are certainly imaginable but can be brought into an orderly hierarchy based on power relationships, the gods of the most powerful community becoming the most powerful ones (Mensching 1947:25ff.). In more developed societies, several families or several clans or, in the case of the Hellenistic empire, several peoples could worship a divinity or honor a shrine. The paterfamilias of the smaller family community then would be the priest for only the cult of the family's own ancestors, and the emperor would be the highest authority and *pontifex maximus*. Both the Byzantines and the Germanic clans before their conversion to Christianity were in this situation: they had clan and national gods. Byzantium had received this relationship in unbroken continuity from the ancient Near Eastern cultures by way of the Hellenistic and Roman rulers, ending with Constantine.

With Constantine's recognition of Christianity and the coining of a specifically Christian imperial metaphysic, Christianity, which had begun as a radically different universal and confessional religion, began to become part of the inheritable community of the Roman Empire. Originally not tied to blood relationship and heritable community, Christianity became the religion of the people. Individuals were born into society as Christians, and the radical significance of the act of baptism, by means of which the person had once removed himself from an inheritable community and joined a religious community by his confession, began to decline. Man was no longer thought of as living in an all-encompassing state of peril from which he could escape only through grace or the acknowledgment of a single all-embracing deity, as in a true universal religion. Rather, he was born into a community that continued the Roman Empire, the image of the Heavenly Kingdom, and as representation of the Heavenly Jerusalem reaching into worldly affairs. Both of these attitudes underwent transformations during the history of Christianity, but we cannot go into that here. In any event, we can be assured that the proprietary church was as appropriate to the situation of the Germanic tribes when they became settled and Christianized as it was an ancient inheritance still alive in Byzantium. The adoption of Byzantine church types is based on the Germanic peoples' endeavors to continue the *imperium romanum*.

From the perspective of the history of religion, however, by reason of their early connection with Rome that legitimized their power, the Germanic peoples entered into a new situation. In Rome, there was a supreme authority that de facto represented the original universal character of Christianity. The Western emperor and those with proprietary church rights had to reconcile their religious position with that of the Roman pontiff. While the Merovingians ignored both Rome and its claims, the Carolingian *imperium*,

due to its consecration by Rome, had to recognize the *sacerdotium*. Later, the Ottonians managed for a short time to incorporate deputies of the universal religion, the bishops, in their state organization by making them lords of the inherited community, princes, and civil servants. But Rome's claims to represent the universal character of Christendom always remained and eventually prevailed. This can be demonstrated in detail even in architecture. We are not discussing power struggles in the sense of nineteenth-century realpolitik but one of the most comprehensive conflicts in the history of mankind.

We are not claiming here that the westwork can be derived exclusively from central-plan court churches that were then, under the influence of the new connection with Rome, attached to basilicas. The westwork of Centula (790–799), which is earlier than that of Aachen and predates the imperial coronation, would contradict that. Among the fully developed westworks, we must distinguish between layouts that are based on a central plan—where a completely centered space is surmounted by a tower—and those that are transversally placed and have a crypt that opens broadly into the attached church. For these latter buildings, to which Centula also belongs,[197] the Byzantine court church and, indeed, other building forms connected with kingship that have the legal characteristics of an *Eigenkirche* must be considered. The tower and the transversally placed structure with galleries belong to the class of *Westbauten*, those buildings at the western ends of churches that prepare the westwork both architectonically and by analogy (Frey 1938:42; Lehmann 1937:259ff., 1938:91ff.; Behn 1933:433). Towers are found very early in connection with church buildings in Syria, where they were taken over from the pre-Christian palace (Bissing 1923). Apart from the church proper, they are found flanking gatehouses in the rectangle of walls surrounding and enclosing the whole layout—for example, Il-Uber, Id-Der, and Dêr-Nawa (Butler 1929:88, 90, 110, figs. 91, 93, 112). The shared meanings of these elements as defense and city-gate buildings make their analogous occurrence as native Western structures possible, but they could also have been adopted from Syria.[198] By the seventh century, Benedictine monasteries had towers above their gates that were dedicated to St. Michael as their protector.[199] The simultaneous funerary/memorial meaning of a tower marking a burial place very near but outside the church played a significant role (Paulus 1944:62, 79; see also Lasteyrie 1912:382ff.), and the symbolic meaning of the whole structure as both city and city-gate ought not to be forgotten.

When investigating the morphology of these western transversal structures decked out with galleries, we encounter several different sources. There is the simple western gallery as the emperor's seat, which in the Rule

of St. Benedict (chap. 19) is also set aside for the *chorus angelicus*. The western structure can also serve to hold the altar of St. Michael (Fuchs 1929:9; Vallery-Radot 1929). There are large-scale, transversally placed entry buildings that are attached to a simple, single nave.[200] However, this is a case of something being *attached to* a building rather than *developed out of* it. These transversal buildings also display a similarity with the royal hall structures detached from the church that have been documented as the *capella regia* in Farfa, Ingelheim, Mainz, and Centula (Rave 1937:65) and of which one has survived intact in Lorsch.

Thanks to the excavations of Friedrich Behn (1934; see also 1948:321ff.) of the Torhalle at Lorsch—a building that was perhaps derived from a similar structure at St. Emmeram in Regensburg (Schwäbl 1919:13ff.)—we are more certain about its intended function. The Torhalle's relationship to an atrium gate like that of Old St. Peter's in Rome has faded, and the type of the Germanic royal hall has come more clearly to the fore.[201] Dagobert Frey (1938:29; see also Heyne 1899:25, 36–38, 48) has already demonstrated the Germanic roots of this two-story hall in relation to its transversal placement, its independent position within the layout as a whole, and its open roof-truss. This last component is operative in palaces and, above all, in the architecture of subsequent town halls.[202] But the Mediterranean references—the change to building in stone, the pattern of engaged columns, the capitals, the facade effect of the Torhalle—all assign it a specific place within another tradition, one that includes Roman triumphal arches (Schneider 1878:1ff.)[203] and Hellenistic palace facades, such as that of Raqqah (Behn 1933). If one were to imagine placing such a two-storied, transversal structure up against a church building, then it would be clear how these separate stories become galleries opening onto a common space. The lower story would become an antechamber, a crypt, and a place of burial; the upper story, a chapel dedicated to St. Michael, seat of the ruler, and place for the angelic choir. Such isolated buildings therefore form part of the genesis of the westwork.

From these points of view, the westwork appears to be defined in the Carolingian epoch by the following distinguishing traits: the *Westbauten* of this time are built in so centrally structured a fashion that they appear to be central-plan buildings attached to the church, and only at this time is the fully developed westwork to be found. All the other later solutions can indeed be derived from the westwork, but they are reductions: the three-tower group (St. Maria im Kapitol in Cologne, Brauweiler), the truncated *Westbau* (Speyer, Mainz, Maria Laach), the west-tower (St. Lucius in Werden), the western *Chorhalle* (choir-hall) (Verbeek 1936), and certain two-

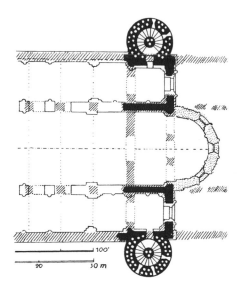

Figure 3.32 Mainz, Willigis's cathedral.
Attempt at a reconstruction of the floor plan. (From Kunze 1925–1926:41)

tower facades (Thümmler 1937; Wersebe 1938, n.157; Fuchs 1929:61). Well
into the era of the Salian and Hohenstaufen dynasties, buildings under-
taken by the ruler again and again show an emphasis on the western parts
of the church: the location of the architectural structures that refer to the
functions of ruler—palace chapel, assizes of the *Sendgericht*, ritual appear-
ance, and so on. Even in churches that represent the diametrically opposite
type of building (in architectonic terms) of facing double choirs, the gal-
leries can be inserted, thereby recalling again the true westwork. In the
cathedral of Mainz, for example, where the western choir is the principal
liturgical choir, the eastern choir is outfitted with galleries over the lateral
entrances, which do more than serve as substructures or supports for the
towers (Kautzsch 1943:6) (figure 3.32).

 They obviously reflect, although they no longer belong to, an older
arrangement—that of the earlier cathedral built by archbishops Willigis and
Bardo in the eleventh century. The content of that arrangement stands out
more clearly and is more easily grasped in Maria Laach, which was built as a
copy of Mainz (figure 3.33). Here the Count Palatine had a gallery structure
inserted into the western choir from which he took part in the divine service
and in which he eventually was buried. These great worthies of the empire—
the archbishop of Mainz and the Count Palatine of the Rhine—perpetuated
the manner of building as it had been cultivated in Maastricht with respect

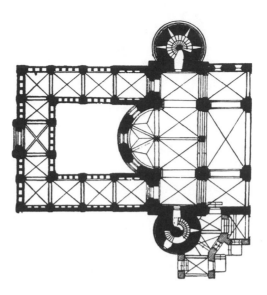

Figure 3.33 Maria Laach, abbey church. Floor plan of the Westbau.
(From Adenauer et al. 1943:289, fig. 236)

to the interior galleries, in Speyer with respect to the western transept, and in Fulda with respect to the antichoir, a secondary choir facing the main choir from the opposite end of the nave.

Tendencies of the Western *Imperium*

As mentioned earlier, the position of the emperor as absolute ruler was diminished through Charlemagne's coronation as emperor, despite all the enhancement of status and legal safeguarding of power. The equality of the church as it was formulated in the more or less contemporary Donation of Constantine (Laehr 1926),[204] and as the popes themselves had depicted it in visual representations,[205] prepared the separation of worldly *regnum* and independent *sacerdotium*, which would henceforth be possible. The Frankish kings now became the legitimate heads of the *imperium romanum* destined to encompass the known world for all eternity and were incorporated into the sequence of rulers begun by Augustus (Spörl 1935:112ff.). However, their position was restricted by a church that now *also* represented the *imperium*. In the early Middle Ages, the consecration of a king was a sacrament. With this anointing, the emperor was inducted into the ranks of the clergy (Tellenbach 1934–1935:70ff.).[206] He wore episcopal vestments at his ecclesiastical corona-

tion. Paulinus, the patriarch of Aquileia, said of Charlemagne "that he is to be king and priest as well" (*sit rex atque sacerdos*) (Eichmann 1942:106). Louis the Pious called the bishops his "helpers" (*audiutores*) and allotted them "a share in our ministry" (*partem ministerii nostri*) (Eichmann 1942:107). But in Rome after the tenth century, the emperor was denied the anointing of the head, which was reserved exclusively for the bishops as a sign of their higher rank (Tellenbach 1934–1935:72ff.). After Henry V, the emperor was a layman (Eichmann 1942:224ff.).

The rulers of the Franks were welcomed with open arms into the traditions of the *imperium* because they legitimized themselves through the adoption of specifically Roman trappings. At the same time, however, there were forces and institutions that could present legitimate opposition. From that time on, medieval architecture until the thirteenth century was shaped by the following factors: the survival of the sacral rulership dating from Antiquity; the potential rivalry between the church and other heirs of the *imperium romanum*; the internal Germanic institutions based on actual power relations; the newly emerging "nations"; the opposition—through shifting coalitions of the powers involved—to the ascendancy of any single one of these vying institutions; and an inherent "evangelical" tendency persisting from the early centuries and always alive within Christianity.

The survival of the absolute character of pre-Christian rulership, which was consciously promoted in times of struggle but gradually became less and less important, was discussed in the section on the proprietary church and its modifications (see pp. 203–9). This character was expressed in the official titles deemed proper to the sacral *imperium*,[207] in the emperor's iconographic relationship to classical rulers,[208] in the right to install bishops—self-evident until the Investiture Controversy—and, in the Ottonian period, in the right to consider them as the deputies of imperial power (Köhler 1935; Klewitz 1939b; Schnitger 1939)[209] as well as in the idea that the imperial office was received from God and not from any other authority (Hahn 1913:89; Unterkirchner 1943:27).

In this manner, the Western emperor aspired to a status originally accorded to only the Byzantine emperor.[210] It was supported by Roman law and the Justinianic philosophy of the state (Moddermann 1875:30ff.; Schramm 1929:278ff.). Particularly after the Investiture Controversy, when the emperor opposed the curia and the Western nation-states no longer recognized the universal status of the empire, the emperor sought to formulate an imperial ideology in which the role of the pope was subordinate. The precedence of *regnum* over *sacerdotium* was consistently emphasized under

Frederick Barbarossa (Kampers 1925; Jordan 1938:7; Schramm 1935–1936: 12ff.), primarily by Otto of Freising (Spörl 1935; Pomtow 1885), and under Frederick II, who almost completely divorced himself from Rome and cultivated the Byzantine ceremonial at his court (Köhler 1935:45ff.).[211] The elaboration of an imperial ideology in the classical manner came about only gradually under the effect of the rivalry with the church. While Carolingian historiography without exception lacks the metaphysical construction of a world-empire, and none was ever developed by people outside Germany, Otto of Freising (1912a:140, 260) created a "theology" of empire according to which the Germans, *sub romano nomine*, would carry the *imperium* to even greater heights. Hence the sudden proliferation of secular classical forms, such as vaulting and galleries, into officially sponsored church architecture can be explained by the fact that after Henry IV and in the times of the Hohenstaufen, the repertory of forms from Christian Antiquity was greatly enriched by forms from pagan Antiquity.

After Henry IV, the official philosophy of empire increasingly lost touch with the real political situation. The much-sought-after independent permanence of the Western *imperium* expressed itself not only in the concept of the proprietary church—where the central-plan "Byzantine" building, despite survivals in the *Westbauten* of the Ottonians and Hohenstaufen, forfeited its independence by being attached to the axial basilica—but also in the ashlar and vaulted buildings, regardless of what was being built in Rome. The models from pre-Christian Antiquity, such as baths and the Basilica of Maxentius, were what became influential,[212] and, despite many similarities, imperial architecture distanced itself from the cathedrals of Italy and the great showpieces of the reforming monastic orders.

The Beginnings of Norman Architecture in Relation to the Architecture of the Empire

Around the middle of the eleventh century in Normandy and on the upper Rhine, the nave walls of flat-roofed churches began to be adorned with projections in the form of engaged columns. Although Speyer led the way, it did not influence Normandy directly.

Speyer was vaulted toward the end of the eleventh century, and vaulted buildings of this kind appeared also in Normandy, Burgundy, and northern Italy at approximately the same time. From the differences in the way the forms were shaped, Ernst Gall deduced that only Normandy had a true relationship with the vault, for only there did the vault appear as the formal consequence of the system of wall projections. In Normandy the engaged

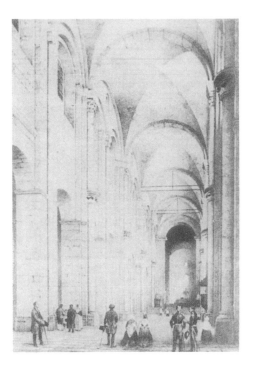

*Figure 3.34 Speyer, cathedral. Interior before it was decorated with frescoes.
(Lithograph by Charles-Claude Bachelier, 1844. From Röttger 1934:105)*

columns ended flush with the top of the high nave walls and supported the
cross-beams of the open roof truss. Thus the projections already functioned
in much the same way as Gothic supports and called for a continuation in
kind. In Speyer, though, the engaged columns ended lower on the wall and
were connected by blind arches (see figure 2.4). The wall system was complete
in itself and did not call for any continuations or imply functional applica-
tions. The vaulting was installed as part of a later building campaign along
with its own system of supports (figure 3.34). This difference caused Gall to
describe Speyer as antiquated. Because he considered Speyer in terms of a
Gothic style, which he imagined as the goal of an evolutionary process, Gall
did not perceive the uninterrupted Roman imperial character in the way the
engaged columns of the wall were connected by means of arches in a distinc-
tive elevation and in the similarity of the arches and entablature. The con-
verse could be said: that it was the Normans who did not recognize the mean-
ing of the engaged columns they were using and that therefore they could
only make them unconsciously into an element of an inherently effective

functionalism developed in building with timber—in other words, the up-rights *had* to support the cross-beams.

An inclination in the second half of the eleventh century to add projections to walls and to vault buildings ought not to be attributed exclusively to a *Kunstwollen* aiming at articulating the building's surfaces. Any inclination, working unconsciously, is surely encouraged, if not actually evoked, by the unconscious desires of the builders to express something. The regions of the upper Rhine, Burgundy, and northern Italy were all imperial territory of the Salian dynasty, and it is here that this distinctive pattern in the wall design is clearest. The wall projections of the Basilica of Maxentius and the buildings of the Flavian era are not independent either, in Gall's sense, of the vaulting. No wall projections ever "grew into" a vault or required the construction of one. The vaulting, attached to its support system, stood isolated in front of the wall. Construction and decoration did not go together. The poured concrete, which allowed the most daring constructions, was clothed with a completely unrelated marble decoration.

One can see that only a purist operating within a system based on a genetic mode of perception would conclude from this situation that a "true" relationship to vaulting arose in Normandy alone. The observation that in Normandy the ribs rest on the engaged columns immediately below them and in visually perceptible continuity with them is based on the fact that the engaged column then stretches up and out above its original form. The capital then had to lose its significance as a crown. In other words, whereas in the context of Roman imperial architecture the column was constrained by the expressiveness of the form, in Normandy the original meaning of these building elements was suppressed due to a functionalism working in opposition to that meaning—the column did something functional rather than indicate a meaning. In contrast to the supporting function of the engaged pillar built by the Normans, it was the immutability and recognizability of the classical form that constituted its monumental character.

In Normandy, this functionalism is rooted in the prehistoric custom of building in timber and corresponds to the medieval peculiarity, characterized earlier, of letting nothing suffice in itself and relating everything to higher realities. Here in almost pure form—"almost" because the Normans eventually did take up both building in stone and using the engaged column—the Nordic principle of abstraction comes to light. It is understandable that the Normans, conscious of their own national power, would represent these forces as straightforwardly in architecture as they did in their pictures—the Bayeux Tapestry, for example—and as their historians expressed themselves in their vehement opposition to the "imperial ideology." The particular kind

of Speyer's vaulting—its resemblance to a series of baldachins (Joachim 1935:19) (see figures 2.4 and 3.34)—bears no comparison with other contemporary vaulted structures like those in Normandy or Burgundy, where the projecting wall patterns, tightly fused to their background, in consequence of a new sensibility to sculptural effects are to be understood as emanating from the walls. There the projecting engaged columns support only the transverse arches, but in Speyer they support both transverse arches and blind engaged wall arches.[213]

The Roman Idiom of the Western *Imperium*

Continuing the tradition in the twelfth century, the Hohenstaufens retained the ground plan of the Ottonians in their new cathedral buildings, but under direct influence from Speyer, as has often been shown, they replaced undressed stone and flat roofs with ashlar and vaulting (Reinhardt 1934; Weigert and Hege 1933; Kunze 1937; Fiedler 1937).

At this time, a result of the emperor's claim to absolute power was de facto limited to Germany[214]—indeed, to the immediate circle around the emperor—and numerous opposing forces, in part through claiming to be legitimate heirs of the *imperium* and in part through their very real increased power, surrounded the powerless emperor and did not accept his authority.[215] Therefore, the established relationship to Charlemagne had to suffice as a legitimizing basis for the empire. Hence, in place of Constantine, Charlemagne became a model and thus also his art. In Magdeburg, Henry I and Otto I saw themselves as Charlemagne's successors (Brackmann 1937:18ff., 26), and Otto III, Charlemagne's most passionate worshiper, became the most extreme exponent of the concept of the *regnum* (Schramm 1935–1936:88ff.). Frederick I, Conrad II, Henry V, and Lothar of Supplinburg all made reference to the empire of Charlemagne (Hoffmann 1919; Schramm 1935–1936:152). The more insecure the actual basis of power became, the greater the necessity for legitimization, which became very apparent particularly in the age of the Hohenstaufen.

In the thirteenth century, even the cities, seeking to secure their rights against the sovereign claims of the bishops, appealed to the memory of Charlemagne and availed themselves of the traditional formal symbols of power and law in the form of a permanent iconographic presence of the lawgiver in statues and equestrian monuments (Kunze 1937:10, 13, 24). In addition to the always effective connection to the inheritance from Antiquity, some form of legitimate descent from the preceding imperial dynasty entered into the assumed foundations of the empire. The Salians relied on the Ottonians, the

Hohenstaufens relied on the Salians (Klewitz 1940), and thus the buildings supported by the emperor inherited the westwork (and its subsequent variations), the alternation of pillar and column, the three arches, the vaulting system, the ground plan of Old St. Peter's, and the Corinthian capital.

Despite the sporadic efforts to emulate the Byzantine Empire, the medieval Western Roman Empire was essentially very different. The Roman Empire was characterized by its connection with the papacy, which placed it into a specifically Roman early Christian tradition. Consequently, a completely different power animated the concept of empire (Düsterwald 1890; Ohr 1902; Günter 1916:376ff., 1933; Brackmann 1916:121ff.; Kampers 1924; Schneider 1926; Heldmann 1928; Dempf 1929; Schramm 1929; Heer 1938; Eichmann 1942). The figure of Constantine[216] emblematizes the comprehensive—indeed, pervasive—rooting of the empire within the Christian Plan of Salvation.[217] Charlemagne received his commission directly from him, not by way of the emperors in Byzantium.[218] The Roman liturgy, as formulated by Gregory the Great, was introduced to the Franks under Pippin III (Netzer 1910; Eisenhofer 1932:3ff.; Klauser 1944:15); St. Peter the Apostle moved into a central position among the saints (Caspar 1930–1933, 2:669ff.; Weisbach 1945:9), and the Church of St. Peter in Rome, surpassing the Lateran basilica in prestige from the sixth century on (Caspar 1935, 213), was respected by Charlemagne above all others, according to Einhard's (1829:chap. 27) testimony. The renewal of Rome became the motto of the Empire: "Golden Rome, once again restored, is born again into the world" (Aurea Roma iterum renovata renascitur orbi). The result of this Carolingian reception of Constantinian forms was all the more successful because the architecture of the city of Rome had become stagnant and provincial since the second half of the fourth century—compared, that is, with the rest of Italy, Syria, and North Africa, where the new style introduced by Justinian had spread, the first universal style since Roman imperial architecture.[219] Post-Constantinian Rome had known no great vaulted projects, no fusions of cruciform, central-plan, and long axial buildings—with the exception of Santa Maria Antiqua (Deichmann 1941:80).

It was Charlemagne who, in order to give the Western *imperium* its own independent foundation, first made the Constantinian buildings of Rome the basis of a new universal style. From the multitude of possible ground-plan solutions, he selected that of St. Peter's in Rome, not because of the symbolic meaning inherent in it—which had given rise to it in the first place—but due to its historical meaning as the principal church of Rome and of Constantine (Krautheimer 1942a). The development toward a true cruciform basilica, discussed earlier, was thereby interrupted, and the old Constantinian ground plan again became the basis for major new buildings.

It is not yet clear whether Saint-Denis, which was remodeled by Pippin III in 754 and consecrated under Charlemagne in 775, followed the type of St. Peter's from the first.[220] Perhaps the earliest building of Saint-Denis—that of Dagobert, dating from 628/629—being a monastery church, copied the basilican T-form type of Monte Cassino, and the true cross-form was chosen only with the rebuilding by Pippin III, when the building was designated the royal burial church.[221] It is certain, however, that Charlemagne's building in Fulda (790–819) took St. Peter's for its model (Richter 1900; Vonderau 1919; Bezold 1936). In its occidentation, its gigantic size, and its use of columns with composite capitals and an architrave, it differed from what was customary north of the Alps. It was fitting that the appearance of Peter's tomb in Rome be replicated in that of his servant Boniface in Fulda (Krautheimer 1942a:12).

As imperial monasteries and as the residence of the emperor on his journeys, the Benedictine monasteries of Saint-Denis, Fulda, Hersfeld (831–850) (Vonderau 1925), and Seligenstadt (831–840) (Müller 1937:254ff.) led the way in this ground-plan type. In the tenth and eleventh centuries, however, the episcopal cathedral came to the fore as the state church and became the premier representative of this ground plan. Examples are Mainz, Speyer, Worms, Strasbourg, Constance, Basel, Augsburg, Salzburg, Magdeburg, Minden, Paderborn, Goslar, Hildesheim, Merseburg, Bamberg, and Naumburg. In all of these, the Roman Church of St. Peter was both evoked and represented. Otto I acquired from the pope the right for Magdeburg to have "in the manner of the holy Roman church" (*ad morem sanctae romanae ecclesiae*) twelve cardinal priests, seven cardinal deacons, and twenty-four cardinal subdeacons who alone would have the right to celebrate mass at the high altar of the church. After all, at the high altar in Rome only the pope and the cardinals are allowed to celebrate the liturgy (Unterkirchner 1943:33).

The Double Choir

In the figure of the bishop as supreme local ecclesiastical and secular servant, the concept of empire experienced, if only for a short time, its most powerful expression of the union of *sacerdotium* and *regnum*. The emperor and pope were both members of the college or chapter and heads of the canons (Schulte 1934:137ff.), and both were to be represented in the church building.[222] It can be assumed that the antichoir and counter-apse, an architectural enrichment that appeared during the time of the Ottonian emperors in the German cathedrals modeled on the ground plan of Old St. Peter's, also bore this meaning. Since the time of Charlemagne, the kingdom of God had been

represented by the emperor and the pope. By the conspicuous addition of a corresponding antichoir and counter-apse—placed antiphonally, so to speak, at the opposite end of the nave, yet within a balanced whole—the church building could be made into an architectonic reflection of the whole of society and brought into a meaningful alignment with the kingdom of God.

By displacing any entrance centered on one end of the building, this layout with a second choir invalidated of the arrangement of the building parts that had hitherto resembled a pathway. Instead of axial longitudinal directionality, these parts were re-formed into weighted groupings, something that would have important consequences for eastern Frankish architecture. Double-choir layouts are already to be found in pre-Christian times (see figure 2.36) and in the Christian pre-Carolingian period across the entire area of the empire, in North Africa, England, and Catalonia. They are most numerous, however, in the Carolingian period and appear most frequently in the Ottonian period in eastern Francia (Kubach 1938:326ff.). Thereafter, their number decreases, and after 1250 they disappear altogether. The most northerly example is Bremen; the westernmost are Besançon, Verdun, and Nivelles; the southernmost, St. Gall and Füssen; the most easterly, Magdeburg, Merseburg, and Regensburg. After the Carolingian era, there are only two examples to be found outside the regions of German settlement: Nevers and Tum (near Łęczyca in Poland). They are found only in connection with monasteries, collegiate churches, and cathedrals, never with parish churches.

The origins and development of the antichoir will not be explored here (Feulner 1942:188) but only the phenomena of its geographical and temporal dissemination. As with the westwork, indications of how it was used do not suffice to explain its appearance. The antichoir's use as a burial place (e.g., for Boniface in Fulda, Bernward in Hildesheim, and Burchard in Worms), as a part of the building dedicated to a second patron saint (e.g., Cologne, Bamberg, Mainz, and Naumburg), as a choir for an attached congregation, as a place for elections and assembly (Quast 1872), and as a choir for the evening liturgy (Kratz 1876) does not necessarily call for building a counter-apse. The other forms of *Westbauten* could have fulfilled the same purposes. Most definitely, the double choir should not be seen as the expression—however defined—of a specific German *Kunstwollen* (Stange 1935).[223] Only after this type had become fixed in the great prototypical buildings did it enter into tradition and come to represent an important element in the formal interpretation of a German *Kunstwollen*.[224]

Certainly, the dramatic spread of the counter-apse in eastern Francia in the ninth to twelfth centuries and its equally dramatic rejection in regions and by forces hostile to the emperor—in Saxony and by the Cluniacs in the

twelfth century, for example—are connected with the meaning accruing to the royal choir primarily in the Ottonian period. The Augustinian concept of the City of God, built around the emperor and pope as equal powers, comes to the fore in the time of the Ottonians and Hohenstaufens (Unterkirchner 1943; Illert 1942:337). The Carolingian westwork was indeed closely linked with the Carolingian concept of the ruler, but much more exclusively so than the antichoir in that the westwork can be derived from a central-plan proprietary church of the Byzantine mold. Even when coupled with the basilica, it still retained its independent character. With this Augustinian concept of the ruler, however, the counter-apse, in its mirror-image repetition of the main apse, takes on a specific, even allegorical meaning. It could be said that the Carolingian *imperium*, which owed its existence to the pope, was compelled to connect the proprietary church to the Roman-style basilica, but that in order to express the concept of the double polarity of the *civitas Dei*, the Ottonian *imperium* had to create a new form of representation. The emperor took part in the divine services of the state from the western choir (Illert 1942:344; Unterkirchner 1943:37),[225] emperor and pope presided equally at synods and councils (Unterkirchner 1943:29), and in contemporary literature—in the *Annolied*, the *Kaiserchronik*, and the *Play of Antichrist*—emperor and pope held equal rank (Unterkirchner 1943:45). Both the powers ensconced in their respective apses derived their legitimacy from the altar of the Holy Cross in the center.

After Canossa, the imperial coronation lost its sacral character, and hence after 1220 the emperor came to be seen as a layman who was no longer a legitimate component in the operation of an ecclesiastical hierarchy. With this symbolic removal of the emperor from the church, the death knell of the double-choir arrangement was rung. It is not surprising, then, that Christ came to be represented no longer as a king but as the Man of Sorrows, the ideology of empire flickered out, and the church building took back the meaning of a space for the community.

Other ways to explain the geographical and temporal expansion of the double choir have been proposed. Western Francia, being old Roman imperial territory, never abandoned the traditional image of the early Christian basilica, with its western entrance. Because of the survival of Roman cities and the responsibility for a parish community, for which a western entrance was expedient, it was retained by almost every church, including monastery churches. In eastern Francia, on the contrary, where from the beginning the monastery church was unencumbered by any concern for a parish community, the Benedictine liturgy, operating more freely, could imprint itself on the shaping of the church. As a result, the antiphony required by the Benedictine liturgy could

create a structure for itself in the west similar to that in the east. The requirements for a western choir were also operative in western Francia,[226] but the disproportionately large number of parish communities, with their need for a western entrance, providing access from the atrium into the church, necessitated a compromise in the architecture of the prototypical building: the western choir was elevated above the western entrance. As had become already common in westworks, the western or angel choir (*chorus angelorum*) was accommodated in a gallery (Reinhardt and Fels 1933, 1937). In addition to the influence of the parish community, after the tenth century there was the pervasive influence of the rule of Cluny in western Francia. Due to the prominent role that Cluny gave to processions, it could not forgo the atrium and the western entrance (Mettler 1909, 1910).

The following circumstances argue against this theory or at least against its exclusive validity. First, from early on there were large cathedrals with double choirs and parish communities (e.g., Cologne, 814) and monasteries with western entrances but without parish communities (e.g., Hersfeld). Second, western entrances can be combined with the antichoir by placing the entrances on either side of the apse, such as at St. Gall, Maria Laach, and Mainz; this solution was not chosen anywhere in western Francia. Third, in pre-Carolingian times there were already double choirs in western Francia; in Ottonian times, however, they disappeared completely. The precise temporal and geographical boundaries argue for a connection with the political situation.

Architectural Ornament

The receptions that can be observed from Carolingian times onward not only in ground plans but also in architectural ornamentation should not be explained as though they happened through some new kind of *Kunstwollen*. Rather, they must be interpreted in terms of the meanings that were connected with those specific ground plans and ornamental elements, meanings to which the *Bauherren* who used them wanted to refer.

Charlemagne had columns and capitals brought from Ravenna and elsewhere in Italy for his court chapel in Aachen and for Saint-Riquier in Centula (Einhard 1829:447; Weigert 1936:16),[227] or he had Roman capitals copied in the Rhineland (Meyer-Barkhausen 1929–1930; Kähler 1939). Some of the reused and copied capitals were Ionic and composite ones, but most were finely worked Corinthian capitals. The prominent use of Corinthian capitals had been particularly cultivated in important buildings under Augustus (Rodenwaldt 1942a:82; Rodenwaldt 1942b:362), but after the fourth century they were only rarely seen in the provinces. In Carolingian times, when the em-

peror took part in the building enterprise, the number of classicizing capitals was fairly high. Afterward, with the formation of local workshops and the independence of individual building projects, individual dialects or repertories of forms emerged and a distancing from the models becomes clearer. This stratum from the Carolingian reception of the classical capital survived until the second half of the eleventh century as the prevailing regional style in the areas of more strictly Carolingian hegemony on the lower Rhine (Meyer-Barkhausen 1939).[228] In contrast, the fresh reception of the classical capital stimulated by the building of the cathedral of Magdeburg by Otto I (Thietmar, *Chronicon*, bk.2: chaps. 11 and 17, cited in Hamann and Rosenfeld 1910:152n.5) remained without any fundamental consequences in the region, for when Saxony turned away from the idea of empire after the Ottonian period, nothing remained to encourage the use of these forms. Nonclassical stereometric forms with Germanic chip-carving were preferred.[229]

Seeking to consolidate their position, all German emperors, especially the first of any new dynasty, busied themselves with the foundation of churches. They showed their active participation by establishing their connections to earlier dynasties and their continuity with them through reception, in the form of both spolia and copies and—as became usual after Salian times—in summoning masons from Italy who were more familiar with the "official" classical forms.[230] This use of *comacini* corresponds to the general policy of the Salian dynasty to favor Lombardy and Burgundy, which had been won by Conrad II. We could say that it was the northern Italian masons rather than the spolia that supplied the appropriate forms.[231] In an edict of King Rotharis of 639, the *maestri comacini* are referred to as a guild of builders with a fixed schedule of rates originally working for the Lombard royal court (Haupt 1909:167; Merzarío 1893; Salmi 1938–1939:49). Rather than being thought of as "artists" and bearers of a specific regional "style," the *comacini* should perhaps be compared with the *conversi* of the Cistercians (Jüttner 1933:28ff.), who were assembled as a gang of construction workers and sent to work on the order's buildings in various places.

If the appearance of the *comacini* in imperial architecture north of the Alps is understood in this manner, we can avoid the unpleasant dispute whether German architecture of the twelfth century is completely Italian (Meier 1900–1901, 1905; Kluckhohn 1940) or arose sui generis (Gaul 1932).

The provenance of the forms employed by these builders from Italy cannot be denied, but it should be remembered that the buildings regarded as the Italian starting points of the dissemination of Salian and Hohenstaufen classicizing architecture—Modena, Pavia,[232] Bari III (Krautheimer 1934; Krönig 1934:298), and Santa Maria Maggiore in Lomello (Thümmler 1939:

157)—were already distinguished by having been commissioned by the emperor (Pühringer 1931; Kautzsch 1932:52ff.; Reinhardt 1934).

The most important stimulus emanated from Speyer under Henry IV; the loveliest capitals of classical technique and appearance can be found there on the main nave pillars and in the Chapel of St. Afra (Röttger 1934; Moller-Racke 1942:53ff.). In addition to the capitals, the swelling profiling of the frieze of round arcading and archivolts shows the handiwork of the northern Italian stonemasons (Joachim 1935:12; Weigert and Hege 1933:12). The corbel frieze, which was copied in simplified form in Frankenthal, Lohenfeld, and Worms, also reflects their presence (Moller-Racke 1942:56).

The plasticity and concreteness connected with this kind of architectural ornament is characteristic of all imperial styles from Hellenism to the Baroque. The prototypes of the classicizing capitals in Speyer are to be found in Tuscany (Thümmler 1939:194)[233]—for example, the Baptistery in Florence (Horn 1938:145ff.)—a region in which the emperors were continually involved, as was their later antagonist Pope Gregory VII.

Comacini worked on the imperial buildings in Mainz and Maria Laach at the time Speyer was being built. After the death of Henry IV, their departure can be clearly observed in the way the sculptured capital reverts to the crude indigenous cubiform capital and its variants.[234] How much this break at the end of the imperial commission was felt is witnessed by the exclamation in the *Vita* of Emperor Henry IV, the *Vita Henrici imp.* (1856):

Alas, Mainz, how much beauty you have lost, you who have lost the great craftsman who would have repaired the ruins of your Minster. Had he survived, and had he completed the work that remains to be done on your Minster, it would certainly rival that famous Minster of Speyer, which he completed, from the ground up, in admirable massings and rich carving, so that that achievement is worthy of praise and admiration above all the works of the kings of Antiquity. (270)

(Heu, Mogontia quantum decus perdidisti, quae ad reparandam monasterii tui ruinam talem artificem amisisti. Si superstes esset, dum monasterii tui, quod inaperat, extremam monum imponeret, nimirum illud illi famoso Spirenci monasterio contenderet quod ille a funde fundatum usque mira mole et sculptili opere complevit, ut hoc opus super omnia regum antiquorum opera lauda et admiratione dignum sit.)

In several traveling bands, the Lombards pushed farther north, and their traces can be seen in Ilbenstadt, Rasdorf, St. Matthias in Trier, Utrecht, Bre-

men, Lund,[235] Klosterrath (Diepen 1926),[236] Königslutter (Meier 1900–1901, 1905; Kluckhohn 1940), Dankwarderode, and elsewhere (Solms-Laubach 1927:182ff.; Ratzinger 1898). The end of royal patronage is as clearly perceptible in Königslutter as in Mainz. In 1135, Emperor Lothar began the building of Königslutter with the vaulted, richly articulated eastern portion where classicizing capitals, closely related to examples in Ferrara and Modena, can be found. This building was designated as his burial place.[237] After Lothar's early death in 1137, the nave was built in the simplest flat-roofed form without any decoration of the kind found in the eastern parts. The stonemasons moved on to Brunswick, where Henry the Lion, a rival to the emperor with imperial pretensions of his own, was engaged in building the castle of Dankwarderode (Guth 1932:87ff.; Joachim 1935).[238]

The Emperor's Rivals

We have seen that the Western *imperium* differed from the classical and Byzantine empires in a greater degree of dependence on the church, acknowledging the church's power as embodied in the person of the Roman pope—indeed, even owing its existence to the recognition by the pope.

Since the recognition of Christianity as the state religion and the establishment of its community under the bishops of Rome, the church had grown into a legitimate heir of the *imperium*, albeit under the supreme authority of the Byzantine emperor.

The church's first reception of imperial forms—perhaps this is better seen as an act of enfiefment—happened after Constantine's recognition of Christianity. Privileges and ceremonies as well as insignia and costumes of the imperial court and the highest civil administration were adopted by bishops and clerics. The episcopal throne or cathedra, lights and incense, the kneeling, the kissing of hand and foot, and the pope's right to have his picture set up in official places (i.e., churches) were originally imperial attributes and privileges and met with opposition from inside the church, primarily from reformers.

Because the papacy was officially under Byzantine patronage until approximately 750, its relationship to the *basileus* was indeed prone to instability, and under the great popes Leo I and Gregory I, it almost broke down. However, de facto independence was ensured only under Pope Hadrian (772–795) after the break with Byzantium over the iconoclastic controversy and under the influence of the Lombard menace, which resulted in a mutual alliance with the Franks. The independent position of the church, represented in the Donation of Constantine and recognized by the new *imperium*, is substantiated by many sources. The insignia and clothing of the dignitaries

of the church no longer revealed the fact that they were originally bestowed by the emperor, and in the pictorial representations in which the emperor and pope appear both are given equal status.[239]

THE ROMAN CURIA The primary object of the Roman curia is the expansion of the church, its governance, and enforcement of its authority. In its formulations, the curia makes use of transmitted symbols and apparatus (Immich 1919:35). The division into dioceses corresponds to the old Roman *civitas* (Ahlhaus 1928); the boundaries of the church follow the boundaries of the *imperium*; in their rank, the cardinals are comparable with the old senators (Pirenne 1941:207). Even the name curia itself was acquired during the Investiture Controversy as an allusion to the Roman senate, the *curia civilis*. To define his position, the pope chose forms that had been used by the rulers of ancient Rome[240] and designated himself as the successor of Constantine.[241] Canon law also takes for granted the concept of the church as the legitimate successor of the *imperium romanum* (Säg-müller 1898).

Although this self-confidence can be observed beginning in the second half of the eighth century, it gathered momentum only after the Investiture Controversy.[242] It also made itself felt in architecture. As a result of the papal alliance with the Franks, the Byzantine element began to be suppressed and an awareness of the Roman past came to the fore. Beginning in the middle of the eighth century, Romans started to bring their own relics out of the catacombs. Numerous translations of relics occurred under Hadrian I and Paschal I (Krautheimer 1942a:14). At this time, the great arch between the nave and the transept was referred to in the biography of Paschal I in the *Liber pontificalis* as the *arcus triumphalis*, or triumphal arch, in contrast to the earlier *arcus maior* (Huelsen 1903:423ff.). This appellation was chosen because of the Arch of Constantine, which in its inscription is referred to as "arcus triumphalis insignis," an uncommon designation even in Antiquity.

And finally the type of Old St. Peter's found a great number of emulators in Rome itself: Sant' Anastasia, Santo Stefano degli Abissini, and Santa Prassede (Krautheimer 1942a:16ff.). Other fourth-century buildings were also copied in the ninth century: Santa Cecilia, San Marco, San Lorenzo in Lucina, San Martino ai Monti, Santa Maria Nova (now Santa Francesca Romana), and Santi Quattro Coronati (Krautheimer 1942a:20ff.). Some of these buildings have architraves, atria, outside staircases, ring-shaped *confessios*, and a column in the opening between the transept and the side aisle—echoing the old five-aisled basilicas—and they are characterized by their large dimensions and careful masonry. We cannot determine to what degree this

movement to revive the early Christian architecture of Rome received its in-
spiration from the kingdom of the Franks, but the great tower over the atri-
um of Santi Quattro Coronati and the rhythmic sequence of the interior sup-
ports point in that direction (Thümmler 1939:149ff.).

THE MONASTIC ORDERS The other great churches that wished to
compete with Old St. Peter's as representatives of the church triumphant—
the great pilgrimage churches such as Ripoll (Puig i Cadafalch 1928:86),
Saint-Sernin in Toulouse, and Santiago di Compostela and, above all, the
major Benedictine monasteries—adopted the same type of early Christian
Roman basilica. Of primary interest in our context is the church built by
Desiderius (1066–1090) in Monte Cassino (Willard 1935; Pantoni 1939; Ca-
giano de Azevedo 1940:198, fig. 12), which had a profound influence on the
architecture of Campania and Apulia (Thümmler 1939:216ff.).[243] On the tri-
umphal arch, Desiderius had "a distich in golden letters set in place, which
was to be found in the same place in St. Peter's Basilica in Rome, and which
was believed to go back to the time of the Emperor Constantine" (Weisbach
1945:59ff.). The type of copy of St. Peter's found in Sicily (Messina), Amalfi,
Calabria, and northern Italy (Acqui, Sant' Abbondio in Como) appears to
stem not from Monte Cassino, but from Abbot Mayeul's church, Cluny II
(955–981) (figure 3.35).[244]

Cluny II, on which the church of Desiderius in Monte Cassino was mod-
eled—both of them based, in turn, on the Constantinian basilicas of the city
of Rome—occupied a completely different place in the context of the architec-

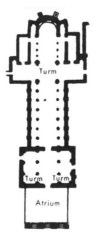

Figure 3.35 Cluny, second abbey church. Reconstruction of the floor plan.
(Sketch after Evans 1938:63, ill. 1)

ture north of the Alps. Those buildings that were built in Normandy, in Burgundy, on the upper Rhine, and later in Saxony that were patterned on Cluny II betray a tendency increasingly hostile to imperial architecture, which will be discussed later (Evans 1938; Mettler 1909, 1910; Lehmann 1940).

As is true for the architecture of the Empire, the architecture of the reform orders was first and foremost shaped by the concept of *renovatio*. Through their receptions, the reformers, with their direct relation to the early Christian past, brought about a new alliance with the repertory of forms of Antiquity. The implications of that *reformatio* were at first wholeheartedly adopted and promoted by the *imperium* of the early Salian times. Otto I, Otto III, Henry II, Conrad II, and Henry III all were on very friendly terms with Cluny. Henry II donated a golden imperial orb to the monastery; Conrad II eagerly supported Poppo of Stavelot. Even Henry IV often made mention of his godfather, Hugh of Cluny (Weisbach 1945:27, 49ff.; cf. also Landers 1938).[245] Hence, until the reign of Henry IV, there was a clear diminution of the *Westbauten* and an intensification of the long axis in the buildings of the Salians, such as Limburg an der Haardt, Speyer I, and Goslar. *Renovatio* and *reformatio* were originally one,[246] but by the time of the building of Cluny III the emphasis on the reforming tendencies in architecture had slackened still further, and the contrast to imperial architecture was no longer expressed in opposition to imperial forms and sentiments but rather in rivalry with them (figure 3.36). This idea of rivalry rings out most clearly in the following written account: "With the help of God, he constructed such a great basilica within twenty years that, had an emperor constructed its like in so short a time, the deed would have been an object of wonder" (Deo juvante talem basilicam levavit intra viginti annos, qualem si tam brevi construxisset imperator, dignum admiratione putaretur).[247] The rivalry was also made visible in the capitals of Cluny, which are so similar to those of Speyer.

It was in the context of the Investiture Controversy—particularly after the year 1080 when the reforming ideas became so strong—that the German church buildings modeled on Cluny II first began to contrast strongly with the imperial buildings (Lehmann 1940). While in Italy it sufficed to remove the vestiges of imperial building activity,[248] in the North we must speak of two formulated opposites: the explicitly imperial and the anti-imperial. Alpirsbach, which derives directly from Hirsau, is typical. If we compare this church from the second half of the eleventh century with the almost contemporary buildings of St. Servatius in Quedlinburg or the Liebfrauenkirche in Magdeburg, we find that besides lacking a crypt, it does not have any architectural ornaments

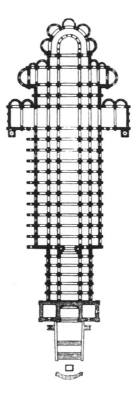

Figure 3.36 Cluny, third abbey church. Floor plan.
(From Baum 1938:fig. 26)

derived from northern Italy and from imperial buildings (Frankl 1927:178). In the Hirsau movement in Germany, which supported the pope, the rejection of Italian sculpture remained obligatory for some time.

In this way, monasticism emerged alongside the *imperium* and the papacy as an authority that would legitimize itself on the basis of the forms of the past. The elaboration of monastic ceremonial and the different degrees of consecration among the members already indicate a spiritual hierarchy that could be related to the society of the kingdom of God in the form of the *imperium* (Dölger 1940:409ff.). In any event, for the buildings of the first reform movements, the status of Christian Antiquity as a model was based less on any meanings of rulership that might have remained in the Roman forms than on those sacral values that marked them as specifically Christian: flat-roofed, no *Westbau*. We could say that to the emperor, Antiquity was more comprehensive and more extensive in that it also included pagan elements,

such as vaulting and central-plan buildings. However, there is no doubt about the consciousness of tradition and connectedness to Antiquity that radiates from Cluny II. The use of columns between the nave and the aisles is also a conscious reception for the Hirsau reformers in Germany since, as its treatment shows, it stands in contradiction to the artistic spirit of this (antiimperial) style for which the use of pillars would have been more appropriate (Maurenbrecher 1929:117).

Aside from the Byzantine *imperium*, which most closely continued the practices of Antiquity (Dölger 1937; Treitinger 1938),[249] other powers appeared in the Middle Ages, claiming to be legitimate heirs of the Roman Empire. Even the caliphate took over the idea of world-empire and unity of belief from late Antiquity (Schaeder 1937:110) and created its buildings out of the same apparatus of forms that fed large areas of Byzantine and Western architecture (Diez 1915).

THE ITALIAN CITIES In their struggle against both emperor and pope, the Italian cities' increasing awareness of the civic architecture inherited from their own Roman past nourished a growing Italian national consciousness (Schneider 1926:chap. 3). Even before Rienzi (Burdach 1926), we encounter manifestations such as the triumphal arch erected by the Milanese on the occasion of their victory over Barbarossa (Hager 1939:93; Köhler 1935:45ff.). The classicizing buildings of the eleventh century in Florence were interpreted by the self-confident historians of the early Renaissance as works from their own history, but they really owe their existence primarily to the efforts of the emperors and their adversary, Gregory VII (Beenken 1926–1927; Horn 1938; Paatz 1940:33ff.; Paatz and Paatz 1940, 1:427ff.). Besides the Baptistery, the starting points are the imperial buildings in Aquileia, San Miniato, and the Badia a Settimo, Santa Reparata, and Santa Felicità in Florence. According to the historical picture painted by the anonymous *Vita Brunelleschi* (Schlosser 1927d:275), art had been destroyed by the barbarians, led by the Germanic tribes, at the time of the migration of peoples, but it was revived by Charlemagne. With the help of native builders, he restored Florence and took the Baptistery, believed to be a classical temple of Mars, for his model. He created the building of San Pietro in Scherraggio and Santi Apostoli. Later the Germans came again, and everything was lost until Brunelleschi restored the old glamour.[250]

As these contemporary representations make clear, the Italian Renaissance of the Quattrocento saw a higher value in Antiquity than the twelfth century did, not only with regard to humanistic aesthetics but also with regard to the content, politically and historically, believed to inhere in the works of the past.

It is a prefiguration of the rivalry between nations marking the later history of the West that not only the Western emperor, but also the *basileus*, the papal curia, monasticism, the caliphate, and the Italian cities could all attach themselves to the concept of Roman *imperium*. This simultaneity was possible both because of the confusion of the real political relationships, which allowed no central power to be recognized by all sides, and because of the intellectual nature of the imperial idea. Because its transmission took place across the widest possible range of connections, the power of the idea and the density of its continuity with Antiquity was ensured and enhanced. At the same time, however, the intensity and uniformity of *meaning* in the transmitted forms was weakened.[251] Nevertheless, the record of these different bearers of tradition should not be overlooked, for they are responsible for reception and they determine the representative types. It is simply not true that a rich treasury of classical forms, locally rooted and unconsciously persisting, lies at hand for the free choice of the artist and serves as material for his genius. On the contrary, it is the will of the patron that seeks out the imprinted form expressing the commitment to tradition and transplants it over great distances of time and space. Particular variations and incidental effects are in comparison only secondary, specifically artistic, factors.

With the decline of authority, these manifestations of a fresh reception and a conscious link to tradition fade; yet beneath the fading of the meaning of their content, the forms persist in the unconscious and renew themselves with new political impulses. These new impulses caused the so-called medieval renaissances (Rodenwaldt 1931; Tietze 1930:43ff.; Rothkirch 1938b; Paatz 1950; Panofsky 1944): the Carolingian (Patzelt 1924), the Ottonian (Naumann 1933), and the Hohenstaufen renaissances (Hashagen 1931:380, 1937; Haskins 1927; Schippers 1926–1927; Hampe 1931:129ff.; Brackmann 1934:229).[252] Without conscious regard for regional inclinations, these renaissances expanded as universal styles across the whole area of influence dominated by the would-be bearers of tradition—that is, the emperor as well as those who would rival him. These bearers of tradition were the ones who selected and used the forms, and accordingly the artistic focus was in their homeland: the regions of the Maas and lower Rhine for the Carolingians, Saxony for the Ottonians, the upper Rhine for the Salians, and the lower Rhine, Alsace, and southern Italy for the Hohenstaufens.

From the Carolingian lower Rhine, Saxony adopted the alternation of supports—that is, of columns and pillars in the nave—and the *Westbau* derived from the westwork (Wersebe 1938). The Salian architecture on the upper Rhine retained the western transversal structure and the stepped portal from Ottonian Saxony (Reissmann 1937), and the Hohenstaufen architecture

on the lower Rhine adopted vaulting, some basic types of capital ornamentation, and the articulation of the choir with column patterns from the Salian upper Rhine.[253]

BISHOPS AND REGIONAL LORDS In order to comprehend the variegated picture of Romanesque architecture, the circumstances of the regional lords must eventually be considered, since these men—including dukes after the Ottonian era and bishops after the Investiture Controversy—unless they are loyal to the emperor, tend to take on a consciously independent position with respect to the traditional powers. They either appropriate imperial privileges and build and create in similar forms or eventually adopt those of a rival bearer of tradition. For example, when the imperial institution of the *inquisitio* became ineffective due to the weakening of royal authority, the assizes of the episcopal *Sendgerichte* continued the same traditions, even down to the level of specific formalities (Schmidt 1915). After the death of Henry IV, the image of the bishop appeared in the place of the emperor's on coins (Kunze 1925). The bishops—among whom were *Bauherren* like Meinwerk of Paderborn, Burchard of Worms, Bruno of Cologne, and Bernward of Hildesheim—were originally authorized as deputies of the imperial government to oppose the particularism of the local lords (who had themselves once been installed as imperial servants, in the form of the regional dukes). Their bishoprics, much like French *départements*, were independent of tribal regions, and the bishops hastened to reinforce their own power and realize their political ambitions, spurred on now by ideas of reform (Köhler 1935:75). In this process, they encouraged a regional particularism in opposition to the universal designs of the emperor. By bringing the bishops—among whom were Godehard of Hildesheim, Benno of Osnabrück, Adalbert of Bremen, and Anno of Cologne—into a situation of conflicting imperial and ecclesiastical loyalties, the Investiture Controversy stabilized their positions as worldly princes (Köhler 1935:99ff.; Hauck 1905–1920, 3:903). Now, after the regional dukes and bishops, the emperors saw the need for a third institution that could function as a counterweight against the regional lords' interests: the cities. In Speyer, Mainz, and Worms, for example, the emperor supported the rights of the cities against their bishops, and a new rank of *Bauherren* became licensed, so to speak, to employ imperial symbols in inscriptions, memorials, and multitowered buildings.

In their conduct, the dukes resembled the bishops, and particularly in Bavaria and Saxony the dukes emerged as autonomous rulers. While the architecture of Bavaria continually contrasts with that of the emperor, rejecting imperial forms from the beginning and maintaining the early Christian or reformers' type of a three-aisled, three-apsed, flat-roofed pillar basilica with-

out transept, the post-Ottonian Saxons—when they did not join with the Hirsau tradition—still built almost exclusively in the "Ottonian" style. In only a few cases did they identify themselves with the contemporary architecture of the imperial regions. Most active among these dukes was Henry the Lion, who employed master builders who had been active on the upper Rhine in Salian times and who hired the men who had worked in Königslutter for his own building projects.[254] It was in this way that Dankwarderode and the minsters of Brunswick, Ratzeburg, and Lübeck were built. But despite this clear connection, the Saxon buildings remained a group apart due to their disinclination toward vaulting, their reticence toward patterns formed by engaged columns and general sculptural enrichment, and their lack of pronounced *Westbauten* (Guth 1932:68). In Salian days, the tendencies of the reform orders were still combined with the imperial ones (e.g., Goslar), whereas in Hohenstaufen times they emancipated themselves into an anti-imperial, regionally defined style. Having been derived from a shared reception, however, a part of the reform orders' heritage was still held in common with the other building traditions, as seen, for example, at Hezilo's cathedral in Hildesheim, Quedlinburg, Riechenberg (near Goslar), and Ilsenburg (Joachim 1935:18; Gaul 1932; Kunze 1925). The subsequent development of the westwork in the Rhineland and in Saxony is typical of these circumstances. In both regions, the starting point is the completely developed Carolingian–Ottonian westwork. In the Rhineland, it is revived in mighty western *termini* such as three-tower groups and west choir halls, which display the character of a fully developed western space, as in St. Georg in Cologne that nicely balances the eastern focus of the apse. The "Saxon facade" is the evident Saxon emulation of the westwork (Thümmler 1937), being relatively flat and shallow and comparable in appearance to the Cluniac French double-tower facade.

THE "NATIONS" Just as the bishops and dukes as deputies of the emperor at first emulated him in their buildings, later broke away and became his rivals, eventually allying themselves with powers hostile to him and opposing him—and thus forming the bases for regionally isolated architectural schools—so also the development of national styles of architecture in the West should be understood in its larger context (Frey 1938:29; Kömstedt 1935).

Historical research usually situates the beginnings of the nation-states in the tenth century—that is, in the post-Carolingian period (Haller 1913:14ff.). Since 840, repeated division under the Frankish kings had alienated the individual regions and thrown them upon their own resources. Also, after the death of Louis the Pious, the German tribal duchies did not recognize the legitimate West Frankish Carolingian ruler but instead made Duke Conrad

king. Thus he can be called the first German king. This would have been the beginning of the history of European nations if the imperial idea, which from then on would stand in a more or less pronounced contrast to the self-confident neighboring nations, had not been taken up again in its universal sense by Otto I. The empire, now built on a national base, would try to regain its transnational character under the Ottos (Mitteis 1944:170). As ethnic particularism expresses the regional character or dialect of art, so national consciousness becomes the foundation of national styles.

Recorded in the writings of Norman, English, and northern Italian historians of the eleventh and twelfth centuries, this national consciousness is turned decidedly against the concept of *imperium* (Spörl 1935:112; Schunter 1926). It is characteristic that in their convictions these historians ally themselves with the Cluniacs, who, like Raoul Glaber, also uphold natural law against traditional powers and claims (Brackmann 1934:233). The reforms are linked to the separatist powers, and wherever the Normans spread out—in England or Italy—we find the typical Cluniac choir with chevronned side chapels in their buildings.

After the reception of the classical manner of building in stone, Norman architecture clung tenaciously to the prehistoric, articulated mode of building; it was the *visual* impact of the symbols—functionalized and deprived of their meaning—that would then form the basis for the architecture of the kingdom growing in the Île-de-France that was to become the true rival of that of the empire. It must be pointed out, however, that despite all its differences from the architecture of the regions settled by Germans—an architecture we call Romanesque—the particular Gothic architecture of the French heartland as it developed in Saint-Denis and then in the royal cathedrals in some ways has more in common with the contemporary Hohenstaufen architecture of western Germany than with the contemporary architecture of the Normans. This commonality is marked by a return to Antiquity's sense of pictorial quality in the rich floral capitals of a classical character, in the galleries that wrap around the *Westbau*, in the tabernacles for statues, and, above all, in the use of proportioned columns as architectural decoration. We can say that it was with these changes, which make sense only if seen as the expression of a claim on history, that the architecture of the Île-de-France first lifted itself above its particular dialect and attained the rank of a universal style. This turn of events, repeating the origins of medieval architecture, brought about a stagnation of the architecture in the empire that would persist until the Baroque, retaining all the while the unity of the artistic language of the Middle Ages. As in the eighth and ninth centuries, when the buildings of Charlemagne between

the Rhine and Maas determined the architecture of the whole western German and northern French regions, so now French Gothic became the language of an even larger region. Because this architecture included the specific claims of the church, it could therefore occur in other national contexts.[255] In Germany imperial architecture, which since the eleventh century had mutated into the regional artistic dialects of the upper Rhine, Saxony, and Alsace, could not prevail against French Gothic (Kubach 1938:329ff.). It was only in the thirteenth century that the ethnic and artistic subdivisions of Germany began to become congruent with each other (Kubach 1936), and we are justified in speaking of Westphalian, Hessian, or Lower German architecture. The later Middle Ages had arrived for Germany. The regionally defined styles arose around 1300 and ended around 1500 when "the new epoch of a national *imperium*" began that "burst the narrow boundaries of tribal nature, effaced their variety, and initiated a common German form" (Pieper 1936:53). Not until the sixteenth century did Germany succeed in making the originally opposing national elements into the foundation of a unified language, something other nations had already achieved centuries earlier. At this time, a strong official anti-Roman tendency began to make itself felt (Köhler 1934:47ff.), one of its symptoms being the addition "of the German Nation" to the name of the Holy Roman Empire. Figures such as Arminius (Hermann the German) began to enter into the German national consciousness (Keller 1940; Spangenberg 1923:26). However, due to the loss of all unity of belief, the efforts of Charles V to awaken the old empire remained without success (Rassow 1932). To those whose eyes were turned toward Antiquity—if only as aesthetically conceived—the Germans would henceforth be the *gens inquietissima* of the visual arts; a reproach that had once been aimed by the Germans at the Normans,[256] northern Italians, and English.

4

The Decline of Symbolic and Historical Meaning

Reform and Secularization

IN THE FOREGOING CHAPTERS we have seen how the meaning of a building, once it had become a historical one, could occasion reception by various subsequent powers. All the powers entering into the tradition were moved by the need to establish and legitimize themselves. Each of these receptions, in relation to Hellenistic architecture in general and Constantinian in particular, led to the construction of distinctive buildings in certain regions; they deposited a stratum, so to speak, of structures that became, in turn, the basis for regional artistic traditions. Individual alliances between the various rival powers were always possible. The emperor, the church, the monastic orders, the cities, and the local lords could either combine forces or fight among themselves. To the degree that they all sought to maintain themselves as historical powers, their final goal remained within a single unified sphere that can be best summed up by the phrase, "continuation of the *imperium romanum*." For despite all the conflicts, overturning the Plan of Salvation once it had been revealed was not allowed, only *reformatio* and *renovatio*, which were mostly directed against the hubris of those powers that were the strongest at the time.

It was the reform orders that wanted most of all to restore the original condition of the church. Their idea of primitive Christianity is what the councils of the ninth century, the synods of the eleventh century, and the reform councils of the fourteenth and fifteenth centuries repeatedly strove to realize.[1] Even the Cluniac reform, which was so

influential in Western architecture, initially expressed its reforming character in strong terms, but its involvement in rivalry with the forces of worldly power very soon won the upper hand. With the construction of Cluny III, it found itself on an equal footing with the powers of this world, such as the empire, and was building with equal means. This is clearly shown by the imitators of Cluny II in Germany. Since the Cluniacs initially opposed every hubris of power as well as its symbols, they were protected by the emperor in their struggle against rivals (Ladner 1936:60ff.). In recent historical research, the contradiction between Cluny II and Cluny III, between spiritual reform and theocratic *renovatio*, between natural law and ecclesiastical canon law, between the outlook of Cardinal Hildebrand and that of Pope Gregory VII has been emphasized (Tellenbach 1936:204ff.; Ladner 1936). In fact, the claims and purposes of these contrasting pairs are so fundamentally different that the one cannot be derived from the other. Nevertheless, it must be admitted that under the influence of Gregory VII and in consequence of Cluny's powerful growth, transformations did occur within the reform movement.[2]

Regarding the Cluniac devotion to tradition, it could be argued that the monks' adherence to the ideal of the primitive church's renunciation of earthly things should have encouraged their entering into the tradition of using meaningful architectural forms, for, in that case, the Cluniacs would have adopted the flat-roofed early Christian basilica of the city of Rome, with its continuous transept. This would have entailed the reception of a form in the manner of the Carolingian and Ottonian emperors—a form that was seen as contrasting with the contemporary vaulted architecture of Henry IV and thus would have become an artistically meaningful opposite. However, it should be kept in mind that the Cluniac reform first came on the scene at a time when the intention of using the building to make a statement—that is, the creation of the church building as a meaningful monument expressing worldly claims—was already on the wane in the Christian community and in its cult, a process that began with the Cistercians and continued with the mendicant orders. There, the ahistorical, "evangelical" forces that are hostile to tradition but are also essential to Christianity would be emphasized. The vaulting of the main nave (Evers 1939:141; Weisbach 1945:52), multiple towers (Krautheimer 1925:9), spaces whose size far exceeds their purposes (Jüttner 1933:23; Weisbach 1945:71; Rüttimann 1911; Sauer 1913),[3] gold, and the proliferation of lights[4] would all be rejected.[5] The structural articulation of the wall becomes secondary, and such systems of applied decoration that might have had sharp protruding angles are planed away to a smooth surface (figure 4.1). In the churches of the mendicants—if the single-naved hall is not preferred (figure 4.2)—the venerable pattern of the basilican roof with its hierarchically differ-

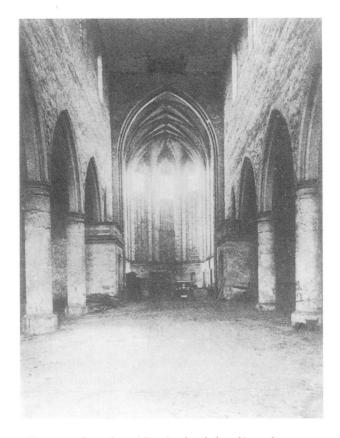

Figure 4.1 Regensburg, Minorite church, late thirteenth century.
(Photo Archives, Kunsthistorisches Institut, Bonn)

entiated heights (high over the nave and altar, low over the side aisles) disappears, and a common saddle roof covers both nave and aisles. In the design of the church building, the involvement of the laity, rather than the representation of a hierarchy, became the prime consideration.[6]

Just as the Cistercians reformed the Cluniacs and went a step further toward simplicity, so the mendicant orders represent a similar reform of the by then "secularized" Cistercians in that their single-naved churches originally had only a flat ending to the choir, without the rounded apse and its allusions to the earthly sovereign. In the meantime, Cistercian architecture had rejected the rectangular choir in favor of a cathedral-style or ambulatory choir in France and a polygonal choir in Germany.

Whether or not the degenerate excess of one side had been the grounds for rejection of the form by the other side, the words of the reformers certainly

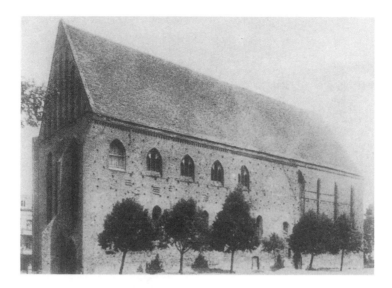

Figure 4.2 Angermünde, Franciscan church, mid-fourteenth century.
(From Krautheimer 1925:pl. 41)

bespeak a fundamentally different attitude toward symbols and the magic of
physical objects. The spirit should stand above all address by means of objects,
however persuasively beautiful they may be; the worldview of magic changes
into one of reason (see p. 29). Hence, reform movements eschew sculpture
(Feulner 1942:167).[7]

A principle that ultimately rejects all art comes again to the fore in the
medieval reform movements. It is an age-old attitude that has been effective
ever since Plato and Lycurgus (Primer 1886); since the writings of the Stoics,
primarily Seneca (Schlosser 1914:73; Birt 1909:153); since St. Augustine's
Confessions (1991: 10.23), St. Jerome (Schlosser 1914:76), and Tertullian's *De
idolatria* (1890:chap. 3.); and since the iconoclastic controversy (Elliger 1930,
1934; Ladner 1931; Bastgen 1911; Delius 1928).[8] It would later be expressed
in the views of the Franciscans (Burdach 1926:38) and Zwingli (1908:187,
1914:180; cf. also Graff 1937–1939), in the cult of nature of the French Revo-
lution, in the writings of Tolstoy, among the Quakers, and so many others.

Pitting themselves, on principle, against the magic of objects, engaging
the spirit and the will[9] on behalf of Christianity, reform movements do not
see symbolic meanings. Only in exceptional cases, therefore, will they allow
something figurative or visual to act as a reference or an allusion to some-
thing invisible or inexpressible. At the same time, however, among those who
would be favorable to symbols and tradition, a powerful force was becoming

active that caused the original meaning of the form to be forgotten—the meaning that had allowed the form to be received in the first place. From being expressive abbreviations and bearers of meaning, the forms became decoration—decoration that could be varied and could be applied independently of its meaning. The forms had become secularized.

The Predominance of Artistic Tendencies

Without having been identified as such, this process has already been mentioned in the discussion of the role of regional habit in architecture. The received forms are elevated to become types and copied over and over again, without always possessing the expressive power of the original. If the intention governing the reception and copying has receded, then the use of a specific type by a patron of lower status means a concomitant diminishing of its significance; it signals a practice no longer perceived as deputizing. At a very early stage, building in stone certainly came to be perceived as something no longer bestowing distinction. It is only in the case of a new enhancement, such as the change from brick to ashlar, that we may infer an emphatic allusion to a specific meaning.

We can observe how vaulting, at first restricted to the choir and *Westbau*, moves into the nave, and the way blind and dwarf galleries, like the *attika* of Antiquity, migrate from the west onto the apse and from there are carried over to the nave. In the interior, we can watch as the triforium is drawn from the curve of the apse into the transept and the nave. We could even say that the way the interior space in Speyer II is formed—pillars that carry a vault resembling a baldachin alternating with engaged column—actually represents a row of consecutive vault-covered crossings, where the supports repeat the familiar motif of the triumphal arch.

Of course, when a form is multiplied and detached from its original locus, we cannot assume that this is always because its original meaning and intention have been forgotten as part of a continuing process of the separation of content and form (see pp. 21–26). Nonetheless, it does indicate that some new stratum of meaning has intruded within the old hierarchy of meanings and has seized the forms of sovereignty. It could also be argued that with the migration of forms from the *West-* and *Ostbau*, the distinctive western and eastern structures, to the nave, the status of the lay community in the nave was undergoing an increasing elevation.[10] However, it cannot be doubted that an increasing artistic freedom in the shaping of those forms could come about only when what had bound them to the concepts underlying their meaning had successfully been dissolved. Although the initial

reaching toward a status-bound form may have had the character of reception, subsequent uses of the form may have been more coincidental and not encumbered with the original meaning.

From Antiquity onward, this process was operative in medieval architecture. Much of the Merovingian architecture on French soil should be seen as following provincial Roman custom. A characteristic example is the filling of the inner curve of the apse with blind columns, a motif we encounter also in Vienne, in Saint-Jean in Poitiers, in La Daurade in Toulouse, and elsewhere. Many features reminiscent of Antiquity survive in the architectural schools south of the Loire, without any of them necessarily ever having been touched by the receptions of the powers of tradition. They seem to be surprising anticipations when compared with the true receptions introduced in the Romanesque epoch proper. Wherever this secularized classical treasury of forms redolent of the powers of tradition was cultivated and invested with new intentions, we find the phenomenon of sudden medieval renaissances—northern Italy, Provence, Tuscany—ramifying into minute details. The most exacting analysis is then required to differentiate reception from customary repertory. No customary repertory was available in eleventh-century Normandy, and so here the first buildings involving the change to columnar patterns and building in stone should be seen as real receptions. But even here, the Normans' proper building customs, which favored assembling the structure out of individual members, must itself have very quickly taken control of the appropriated apparatus of forms. As discussed earlier, the building member that once bore meaning was soon perceived as a shape that called for a corresponding structure in the rib. It was then prolonged—and thereby deformed—into *being* the rib. This emerging into visibility—that is, the form is what it looks like and no more—is the decisive event in the process of secularization.

This process is sometimes remarked with a sense of regret, for it could be proposed that under different historical conditions the archaic situation of continuity in the use of forms and awareness of their meaning might have been retained. This overlooks the fact that we would then have to do without the greatest achievements of Western art, including the pictorial art of later times. More than any other symbols and vehicles of meaning, the forms of architecture—especially in relation to the pre-artistic, prehistoric modes of building purely for a specific purpose—characterize a situation that can only be a transitory phase in a much more long-term development. In the context of the history of religion, an epoch in which the visual arts came alive was one that had already been drawn into the current of secularization. At the very moment when the dead ruler was no longer accompanied by dead servants

but rather by their images, art was born, and what had been uncontrolled reality became a system of belief.

It was precisely the western part of the church—significantly the part of the building that contained the gateway or portal—that first presented vertical or upright forms, whether towers or sculpted figures, and that bore the principal inscriptions and sculptural decorations.[11] It was here that those forms of symbolic, indicating meaning first were gathered and made visible to everyone entering.

The New Awareness of Space

Throughout the course of human history, making visible has meant bringing to awareness; it has meant presenting what was to be claimed or to be wished for as something objectified, something visible that could be pointed to. It is an ongoing process that we are still caught up in. This making visible and providing a rationalized presentation reached its apogee in the thirteenth century. Due to the efforts of Odo of Sully (1196–1208), the *visible* elevation of the Host was introduced, and at the Lateran Council of 1215 transubstantiation, the corporeal presence of Christ in the Eucharist, was elevated to dogma. It was also about this time that the "space" of the church came to be conceived as a whole, not just as "the 'negative' of the plastic structure of the building" (Feulner 1942:186). That is, it was no longer regarded as merely an apparatus of symbolic indications. In the Hohenstaufen period, the exterior of the building also came to be visually perceived as a unified corpus; a unified scheme of decorative forms clothed it and summarized it (Kautzsch 1934:3ff.). Thus this secularizing tendency we have identified, which detached the forms from their original locus and, in the process of rendering them visible, rearranged them according to artistic principles, derived directly from the original situation of the form that bore the symbol; indeed, the secularizing tendency can be seen as its direct consequence. The result is that the aesthetic meaning superseded the symbolic and historic one. Indeed, for our modern times it has become the exclusive meaning.

This process can be demonstrated primarily through the development of the artistically constructed interior. As a formal criterion, the concept of space has been applied by art historical research to all periods in which the interior has played a role (Jantzen 1938). However, it is very questionable whether space has always been perceived primarily as an artistic object, as an image. In early Christian times, at least the interior was primarily a three-dimensional construct animated by the community's existence and activity. It was intelligible in and of itself, so to speak. With the enhancing of

its dimensions in Constantinian times and the application of visual and symbol-bearing forms to the walls surrounding the people, the space became a public square or plaza surrounded by facades. It was raised above its function; it represented things beyond the scope of human action (Rothkirch 1938a:6ff.). Other than inscriptions and the purely pictorial, the components of these interior facades were all transplanted from the exterior of the building.

As part of the physical construction process, components like the pedestal might have had a technical function. Within the context of building in stone, however, this group of elements, contrary to the assertions of technical-morphological research, is very small. Other elements—*triglyph*, *metope*, pediment, *regula*—might have appeared in the classical stone building as formal echoes of the constructional parts of the wooden building. No longer serving a constructive function in the stone building, they represented symbolic abbreviations of the prehistoric house. They cannot be characterized as primarily decorative unless they not only are used on temples, funerary monuments, and palaces of the rulers but have become set pieces, clichés of general secular architecture. Components, however, can also become attached as visual, sculptural representations of the essence of the church building, portraying the inhabitants of the Heavenly Jerusalem represented in the church, or the evil spirits—Gothic waterspouts, gargoyles—being driven out of the house.[12] These components appear to be merely tacked onto the building as fully dimensional shapes, showing no inclination to combine with the mass of their background. Finally, there are the purely decorative forms on the interior facades that in the early Middle Ages were turned into enrichment and enhancement of the architectonically highlighted components, such as the ornamented frieze unrolling on the cornice and the archivolts of Romanesque portals. We should take notice of this last small group of forms, for they stem from a very different attitude toward the interpretation of sensory perception—an attitude that, as the content-related meaning of other building forms increasingly receded, became prevalent and, since the nineteenth century, has indeed been the sole attitude.

All those forms collectively delimiting the cult space of the church building are by nature forms from the building's exterior, the emanation of a physical object that engages the gaze of the beholders and presents something to the eyes. Hence, in this situation, space is not the expression of an artistic impulse, an artistic striving, but a place for declaration. In this process, the surrounding component structure engages with what it surrounds and gathers it together, a process that, in turn, makes architectural sculpture possible. The space is made to stand out, no longer to be taken for granted; it is made visible to the eye by means of those forces bound up with the symbols. This

symbolic space, which is characteristic of the Middle Ages, differs from that of early Christianity in that it carries images and indicators and is elevated above the purely functional. It differs from the pictorial space of the Baroque period in its unconscious manipulation of artistic possibilities—possibilities that must always remain in the service of the purpose of the declaration. The Middle Ages were generally ignorant of devotional space as a place for evoking a certain mood and stimulating contemplation, but already the act of covering the walls on all sides with mosaics and murals represents a step on the way toward a "felt" space, a space enclosed by walls that differ fundamentally from the exterior facade. The interior space is surrounded by a layer appearing visually unified and affecting the viewer through the play of light and shadow rather than through the presence of sculpted individual elements.

This is evident above all and most clearly in the realm of Byzantine art, which moved beyond Western art with respect to space in the sixth century and continued to depend largely on Antiquity's way of thinking in terms of sensory nuances. The church lost its sense of being an external building, a monument, a body, the house of a god who appeared in personal form and was bound to a place. On the outside only *lesènes*, vertical pilaster strips on the wall, with no sense of symbolic abbreviation, produced a makeshift impression of architectural unity. On the inside, all sculpture was subdued. Where sculptures had to appear in combination with structural articulation points by necessity, for instance, such as the head of a column, the forms allegorized the loading and bearing that was happening at that point (e.g., the wreath of leaves radiating from the nucleus of the capital, restrained by the force of the space, working outward from the tightly structured mass). The empty spaces remaining between the nucleus and the leaves and tendrils serve as a foil and owe their existence to the effects of light and shadow. The unified interior space, now perceived and artistically represented as such, becomes enclosed by niches and vaulting and creates its impression much more by its yielding, enfolding matter than through its negative, concave forms. In Byzantine architecture, this process of rendering all projecting members in low relief and the perception of the activity of the interior space as a unity stands in diametrical opposition to the classical temple.

The architecture of the West during the same period persisted in the position of early Christian art and retained the meager sculptural echoes of classical architecture along with the flat, un-vaulted roof. The architecture of medieval Italy did not take the step toward vaulting on its own. The independently developed and unmistakable Quattrocento Italian central-plan building without freestanding pillars, reveals just how far Italian architecture was from perceiving space as a unity and how it clung to the old ideal of

being surrounded by highly detailed *scenae* that in no way differed from the exterior surfaces of the building (Kauffmann 1941).

Like Byzantium, the lands north of the Alps also experienced a development toward unified space, but this happened at a different time and the character of the space was essentially different. It should be remembered that like the Dorian Greeks, the Germanic peoples originally built in wood and thus developed no vaulted forms; an essential element of the concept of enclosing space on all sides was therefore lacking. Vaulting entered as an element in their building only at an early stage where the Germanic peoples came into contact with the vestiges of Antiquity on Roman imperial territory. They then sought to take possession of these vestiges because of the legitimacy they conferred and because they wanted to take on the notion presented in the Plan of Salvation that the *imperium romanum* was the kingdom of Christ as their own.

As discussed earlier, Ernst Gall (1915) showed how in a memorable moment a wall articulation system was employed in Normandy as a form and how from this the necessity arose of seeing the wall articulation continuing up into a vault and the engaged columns continuing as rounded moldings up into cross vaulting, instead of into the open roof truss (see pp. 214–16). This initiative started in Normandy around 1120, and, after the technical possibilities had been formulated in the Île-de-France, this system, the Gothic, determined the agenda of architectural development for all of Europe for the next centuries. All possible means would be employed toward the shaping of a unified, visually perceptible devotional space. The changes in the articulation of the wall can be followed, step by step, over the next three hundred years.

Initially, in the second half of the twelfth century and the first half of the thirteenth, the use of galleries was widespread. Part of the significance of this may be due to galleries' superior potential for the new static task of bracing the vaults placed over the nave without disrupting the external building as a body. But once galleries were abandoned, around 1200 in France and around 1250 in the Rhineland, the appearance of the exterior was willingly sacrificed until only the old western facade remained. Henceforth, an auxiliary support system for the interior space was applied to the exterior surfaces: a system of buttresses was added to buildings. As a result, the exterior appearance of the building was no longer that of an organized arrangement of surfaces and solids. While Romanesque architecture had scarcely come to terms with the possibilities presented by light and shadow by 1150, the increasing illumination of the interior by means of expensive glass windows, visually effective only in the interior of the building, represented a further step in the development toward a unified space of devotion. An additional formal sign that

the space of devotion was gaining ground and that a unifying tonality was enclosing the whole space (Jantzen 1928) was the practice of regularly supplying the sculpted forms with a deeply undercut background space, a foil to set them off, which further accentuated the already high relief. Further evidence can be seen in the change from blind triforium to real triforium after about 1200 (Kubach 1934), the spread of passageways between 1150 and 1250, and the dissolution of the robust high Romanesque cushion capital into flickering tendrils. Even the vaulting ribs, which at first appeared as round ribs or bands of a real plastic weight—and bore witness, so to speak, to the resistance of the material to the increasing power of "the space"—around 1200 underwent a tapering to a sharpened rib. Around the middle of the thirteenth century, "space" also attacked the solid substance of the ribs' flanks, and they received an ogee profile, appearing concave on their sides (W. Müller 1937). Eventually, the colonnettes, which had been perceptibly applied supports fused to the mother column in the high Gothic period, came to dissolve in concave oscillations into a unified support surrounded by freely flowing space (see figure 2.5). "Space" gnawed at their solid strength until only the hollow grooves remained as visually effective pathways for shadows to run along. The ribs, reflecting what was once a technically necessary apparatus for the vaulting and trussing of space, came to be perceived only as ornaments, to be arranged like decorative stars or nets laid over the unified, overarching roof covering the space. And finally in the thirteenth century, the most dramatic step: the turn from graduated, hierarchical cult building to the unified devotional space is expressed in the truly decisive switch from the basilica to the hall church, with its unified naves through which space can flow unencumbered. The interior space in all its parts has now surrounded itself with forms that are determined by it and no longer permit the recognition of the origins of architectural ornament on the building's exterior.

Summary

In the powers active in the realm of medieval architecture that were open to reception of meaning in architecture and that cultivated symbols, in the tendencies in the reform movements that were hostile to meaning in architecture, and in the development from immanent symbol to artistic form—a process we have here characterized with the phrase "secularization"—we have come to know forces that played very powerful roles. Although this knowledge can explain neither the ultimate nor the subtlest differences between individual works of art, in a certain measure these forces are responsible for the existence or absence of typical forms, their selection or rejection,

in a way that we can now scarcely conceive of, accustomed as we are to the possibilities facing the modern artist exercising freedom of choice.

The present study is intentionally limited to the architecture of the early Middle Ages, for this art form is more subject to the forces of history than others are. The architecture of the early Middle Ages has been denied treatment on purely artistic grounds longer than the other arts have. In examining manuscript illumination and wall painting or sculpture in gold and ivory, other factors must be taken into consideration much more than they have been here, such as the problem of parallels in growth, the continuity of craftsmanship, and, above all, receptions based on aesthetic meaning. The symbolic and historic meaning of the typical forms of the Middle Ages encourages a connection to the concept of *renovatio*, but we should beware of enlarging that concept to encompass every manifestation of classicism in this period.[13] Nonetheless, what this concept *did* accomplish must be continually reemphasized, for it illuminates a human condition and worldview that, although our own art has gone beyond it, determined the most important manifestations of the art of the Middle Ages.

Afterword

MEDIEVAL ARCHITECTURE, particularly in its early centuries, has become identified primarily with ecclesiastical architecture. We automatically associate medieval architecture with the monasteries of the Benedictine and Cistercian orders and their mainly Romanesque abbey churches, with the cathedrals of the Romanesque and especially the Gothic period, with the minsters and churches of the mendicant orders in late medieval towns, and even with tiny village churches in rural communities. To a lesser degree, the equally important, but less visible, achievements in castle construction, domestic architecture, and urban planning may come to mind. Even in its humblest expressions, however, medieval ecclesiastical architecture possesses a quality that elevates it above the level of contemporary utilitarian architecture and seems to represent the "true spirit" of its time, more than any achievement of urban planning ever could.

More than the architecture of any other period, medieval architecture is primarily a functional architecture of places of religious assembly and liturgical celebration. Hence it is determined by the concept of the meaning that it expresses through its formal design. Even if the individual parts of a church building—choir, ambulatory, nave, and aisles—were given specific and clearly differentiated tasks within the liturgy of the church, the very idea of a medieval ecclesiastical building as an enclosed space—a space that transcends any idea of dimension or proportion based purely on human canons—makes it a monument that relates to a reality other

than the one immediately surrounding its visitor. In a metaphorical as well as a didactic way, a medieval church points toward a world outside the realm of direct experience. This representational aspect constitutes the essential meaning of any ecclesiastical building erected during the Middle Ages. In other words, the built structure denotes an intellectual concept extraneous to its mere function as a building that provides the space for the assembly of a community.

The ambivalence begins with the word chosen for the building. *Ecclesia*, or "church," initially denoted the community that assembled in the building and was extended to the latter only after a considerable lapse of time during which the building came to symbolize the institution it housed. This interchangeable use of the term to mean both the architectural monument and the spiritual community lies at the bottom of all symbolic interpretation of ecclesiastical architecture. In a marked contrast to this, the temple of Antiquity—including the Temple of Jerusalem—symbolized the deity it enshrined; only the synagogue acquired a sense comparable to that of the church.

Just as the ecclesiastical building symbolizes the community it encloses, so it points toward a higher reality. In this respect, the assembly of the faithful is a temporal image corresponding to the community of saints constituting the eternal church. That the church—indeed, any church—symbolizes a Heavenly Jerusalem is a topos well known and frequently developed in medieval theology.

The notion that the church building as such could serve a didactic purpose goes back to late Antiquity. Juxtaposed to the rather generic identification of the church with the community of saints—which could have been used in any medieval sermon—is the specific meaning of the individual building erected with the intention of conveying a precise message to an immediate audience. Ecclesiastical architecture with its imagery served as a teaching tool, and the famous statement of Pope Gregory the Great that the depiction of events from the Scriptures in churches was a means of educating the uneducated masses is but an early manifestation of this urge to see ecclesiastical buildings as representing something external to their immediate reality. This use of the architectural frame as bearer of images (*Bildträger*) must be distinguished from an approach in which architecture itself served as bearer of meaning (*Bedeutungsträger*). It is to this latter approach that Günter Bandmann's book is dedicated.

Didactic literature devoted to the issue of meaning began to develop in the Middle Ages; its most explicit statements were made in the twelfth century. In the writings of Abbot Suger of Saint-Denis and of his Rhenish contemporary Rupert of Deutz, we find the intentions of important patrons ex-

pressed, patrons whose "symbolistic" approach to exegesis influenced both architecture and art. But while these texts proclaim the symbolism of artistic form in its most fully developed state, there was no comparable, explicit treatment of the issue in the preceding formative centuries, for which the works of art and architecture themselves remain our most prominent sources of information. In order to discover the meaning of medieval architecture, therefore, scholarship has concentrated on these earlier periods since the beginning of the twentieth century, culminating in Richard Krautheimer's seminal article, "Introduction to an Iconography of Medieval Architecture" (1942). Those same years paved the way for and created the scholarly interest for Günter Bandmann's contribution to the deciphering of meaning in medieval architecture.

First published in 1951, Bandmann's *Mittelalterliche Architektur als Bedeutungsträger* marked an important turning point in the history of art and architecture in postwar Germany at a time when the discipline was undergoing an important and necessary reorientation. The political circumstances of the preceding two decades had isolated German scholarship from its international context, and an important group of scholars, especially the most innovative ones, had been forced into exile. Not coincidentally, among those who had fled the country were primarily scholars dealing with questions of symbolism and meaning (i.e., the intellectual framework of art), foremost among them Erwin Panofsky, Richard Krautheimer, Otto von Simson, and Nikolaus Pevsner. The search for meaning in architectural history—a search outside the avenues prescribed by the ideological approach—had been considered subversive by a political system built on atavistic ethnic foundations, a system that looked askance at all attempts to uncover meaning in architectural forms, labeling them as intellectual and, therefore, implicitly suspect. The subsequent reorientation in many cases took the form of a Romantic notion such as the cultural pessimism of Hans Sedlmayr (*Verlust der Mitte*, 1951), who in his work on the genesis of the Gothic cathedral (*Die Entstehung der Kathedrale*, 1950) created the idealistic image of the Heavenly Jerusalem as a positive counterpart to a disoriented reality characterized by the loss of values.

Those who had stayed in the country had largely taken refuge in a positivistic approach that avoided the dangerous realm of content. That is how the geographical method initially became an important vehicle for the establishment of a still (relatively) free area of research that steered clear of the ideological pitfalls. Bandmann himself had adopted this method in his doctoral dissertation, written in 1942, on the late Romanesque abbey church of Essen-Werden. In that dissertation, he explored for the first time the notion that an

already historic formal system had been adopted because of its inherent importance. The main theme of that work—the Carolingian westwork and the reception of a historic system for the nave (even though he apparently fell victim to a tradition that dated this structure too late)—led Bandmann to develop a growing interest in the question of meaning.

The reliance on monuments from his native Rhineland that largely shapes this book does not necessarily represent a regional limitation; after all, it was precisely this region that provided the densest link between the monuments of imperial Rome and their revival by the emperors of the Holy Roman Empire, whose power base and field of action was concentrated in this area. The limitations of the geographical approach (relying largely on the subconscious transmission of architectural forms) as distinct from the phenomenon of conscious reception (as a representation of something outside the architectural realm) made Bandmann argue against the traditional method by differentiating between habit and reception.

Official German scholarship at that time, though, was largely governed by Wilhelm Pinder's formalistic and stylistic approach, which had generated works such as *Vom Wesen und Werden deutscher Formen*. This specifically German school of art history and its construction of stylistic developments—notably the concept of space in medieval architecture—was the main target of Bandmann's critique. Accordingly, he met with resistance that defended the old domain of art historical practice against an apparently extra-artistic approach. Bandmann's book, therefore, took a definite position in the ongoing debate—which still persists in our day—as to whether architectural production follows its own inner drive to stylistic fulfillment or is determined by external factors, such as a patron's intentions or the general public's horizon of expectations. Bandmann's approach, therefore, was to have important consequences for architectural history when these factors came to the forefront of the discussion.

Bandmann presented his ideas for the first time at the first postwar conference of art historians at Schloss Brühl, in suburban Cologne, in 1948; this was the formative meeting of German art history after the collapse of the Third Reich. For over half a century after that, Bandmann's book—never out of print in Germany since its original publication but never translated into any other language—has occupied the minds of architectural historians in his native country. His readers either subscribed to and expanded his theories or openly rejected them. Thus this book might be considered the single most influential book on methodological approaches in medieval architectural history—at least in Germany—even though it is not actually cited that often. His *Gedenkschrift*, the memorial volume published after his death in

1975 by his friends and students, testifies to the scope of his influence and inspiration, which was not limited the study of medieval art and architecture.

Bandmann confined his reflections in this book to the Middle Ages or, to be more precise, to late Antiquity and the early Middle Ages. He contrasted this period with a modern aesthetic appreciation that was to become predominant from the later Middle Ages onward. While arguing against both modern art history and the architectural programs of the mid-twentieth century and remaining suspicious of all superimposed meaning, Bandmann remained unaware of how widely applicable his concept is outside the period under investigation.

The main focus of his book is the reception of forms or types of buildings over distances of time and space, a reception determined not by the forms' aesthetic qualities but by their role as signifiers of an extra-artistic meaning. Based on his assumption that it was the underlying importance of building types that determined their reception in medieval church building, Bandmann rejected the dictum "form follows function," which has been the fundamental credo of modernism in twentieth-century architecture and has greatly affected the modernist interpretation of the Gothic cathedral as a constructional rather than intellectual system. Instead, Bandmann proposed the inverse—that established types could, when necessary, acquire new functions to ensure their survival as symbolic images in an environment of changing liturgical demands. The ongoing reception of a form due to an allegorical meaning it only subsequently acquired—one that had originally not been attributed to it—could allow a form to continue long after the function that originally gave it meaning had disappeared.

It is true that a new meaning can supersede an older one only when the latter has been obliterated and forgotten. In the case of the column, for example, the primordial interpretation as a tree was later exchanged for that of a human figure. But the reverse can also occur, as when at the end of the Middle Ages this forgotten prehistoric meaning acquired a new formal significance and columns were designed in a naturalistic way as tree trunks with the ribs emerging from them like branches. This by no means denotes the end of symbolic interpretation in favor of a more realistic view but simply a shift of paradigms.

In the final chapter of his book, Bandmann draws a clear line between the meaningful Romanesque period and the Gothic, which was increasingly characterized by the absence of meaning; however, more recent research has demonstrated the relative importance of the concept of reception even in the later Middle Ages. According to Bandmann, in the churches of the reform orders—Cistercians as well as mendicants—"the involvement of the laity,

rather than the representation of a hierarchy, became the prime consideration." This might be true for the initial architectural production of these orders; subsequent phases, however, moved away from this austere concept of an architectural style negating any claim on meaning (*Anspruch*) and returned to the old concept of medieval architecture as bearer of meaning. Both the Cistercians' reintroduction, after the death of St. Bernard of Clairvaux, of the ambulatory choir—still in the tradition of the Holy Sepulchre—and the introduction of the single-aisled polygonal choir—a reception of the Sainte-Chapelle—in the architecture of the mendicants clearly reflect the copying of prototypes because of their inherent meaning. The "use of a specific type by a patron of lower status" does not necessarily mean "a concomitant diminishing of [the] significance" of the meaning, but illustrates an important mechanism underlying any kind of reception. It might even be argued that the relationship of dependence between Charlemagne and Justinian led to the reception of Byzantine prototypes in Carolingian times. Even in their immediate reaction to the Catholic and papal Middle Ages, the Protestants did not give up the concept of copying for a historic reason but instead returned to a new awareness of the significance of the meaning of architectural forms and types. The inscription across the facade of the post-Gothic—and Protestant—church in Bückeburg that defines the building as an "exemplum religionis non structurae" (example of religion, not of structure) makes manifest in an outspoken way that the iconological interpretation of the church building still applied to both the Gothic and the postmedieval periods. Nineteenth-century historicism was concerned with this problem, although on a different level. The builders of the Jesuit church in Münster, a post-Gothic edifice contemporaneous with the one in Bückeburg, placed codices and the symbols of the four Evangelists onto the buttresses of its choir, recalling Suger's metaphor of the twelve prophets and apostles surrounding Christ on the main altar of his choir at Saint-Denis.

Speyer Cathedral, a monument that plays a prominent role in Bandmann's book, represents an important example of the reception of architectural forms based on their inherent meaning. The cathedral had been destroyed by the troops of Louis XIV in 1689 and was reconstructed almost a century later by Franz Ignaz Neumann, the son of the celebrated Baroque architect Johann Balthasar Neumann. Instead of using the opportunity to create, as in so many churches in southern Germany at this time, a new Baroque interior within the medieval shell, Neumann followed the gutted original in all aspects of construction and detailing. The reconstruction of the monument to the Salian emperors mirrored the reconstruction of the medieval Holy Roman Empire at the very eve of its disappearance and subsequent transforma-

tion into a modern nation-state. Conversely, the destruction of the abbey church at Cluny was meant to signal the end of the medieval world.

Although Bandmann, in complete accord with the disdain characteristic of his generation, claimed that the nineteenth century lacked a deeper understanding of the meaning of architectural form, he based his thinking largely on the theoretical writings of Gottfried Semper, which deal above all with the use of symbolic forms in architectural practice. It is not surprising, therefore, to see Bandmann—a mere decade after the publication of his *Bedeutungsträger*—become one of the first architectural historians involved in a reevaluation of the architectural production of the nineteenth century as an "aesthetically despised period" (Bandmann 1964); this led to a new interpretation of, for example, Milan's Galleria Vittorio Emanuele (Bandmann 1966). Cologne Cathedral, with its struggle over its patronage between church and state so reminiscent of the Investiture Controversy in the eleventh century, is a telling example of the validity of Bandmann's theories in the age of historicism.

Recent years have seen, and not only in the study of medieval architecture, a renewed interest in questions of meaning beyond a mere formal or functionalist interpretation. Like the relationship between artist and patron, between artifact and audience, the question of the role a work of art can play in society has become an issue of growing interest, and a method addressing the transportation of meaning by a genre that is seemingly free of extra-artistic elements acquires a new relevance. Thus, even half a century after its first publication, Günter Bandmann's book still provides important insights into a crucial aspect of medieval artistic and architectural production.

Hans Josef Böker

Notes

Bearing Bandmann's Meaning:
A Translator's Introduction

1. Much of the information about these iconic domed legislatures can be found in William Seale and Eric Oxendorf, *Domes of America* (San Francisco: Pomegranate Artbooks, 1994).

2. "Art Theory" and "Reception Theory," in *The Johns Hopkins Guide to Literary Theory and Criticism*, ed. Michael Groden and Martin Kreiswirth (Baltimore: Johns Hopkins University Press, 1997).

3. Richard Dawkins, *The Selfish Gene* (New York: Oxford University Press, 1976), passim.

4. The Plan of Salvation is the purpose for humanity that is hidden in the mind of God and revealed through the prophets, Christ, and the Holy Spirit. The concept embraces both God's execution of the plan and human participation in it. See Ephesians 3:9, 1 Corinthians 2:7–8, and M. R. E. Masterman, "Economy, divine, " in *New Catholic Encyclopedia* (New York: McGraw-Hill, 1967), 5:86.

5. Roger Stalley, *Early Medieval Architecture* (Oxford: Oxford University Press, 1999); Richard Krautheimer, *Early Christian and Byzantine Architecture* (Harmondsworth: Penguin, 1965, 1975, 1986); Kenneth John Conant, *Carolingian and Romanesque Architecture, 800–1200* (Harmondsworth: Penguin, 1959, 1973, 1978).

1. The Problem of Meaning in Architecture

1. [Alois Riegl (1893) developed the concept of the *Kunstwollen* to account for certain observable but otherwise inexplicable developments in the history of art, which he ascribed to an inherent drive to actualization. He postulated a transcendent necessity for all cultures and media to express themselves in the way proper to each culture and medium. *Kunstwollen* has been variously translated as "will-to-form," "artistic volition," or "artistic will" or "impetus." It is often left untranslated, a practice followed here.]

2. [The reader is referred to the translator's introduction for explanations of the technical terminology of form and type, *Bauherr*, and *Westbau*; the theoretical concept of reception; Bandmann's metaphoric vocabulary of claim, deputy, indication, and coinage; and the untranslatable Hegelian philosophical concept of *Aufheben*.]

3. Even Georg Dehio and Wilhelm Pinder felt compelled to denigrate the reception of forms as inconsequential in contrast to the fact of the appropriation and conversion of what was received. That the reception, the intellectual conviction accompanying the reception, and the claim accompanying that conviction might be something essentially *positive* does not occur to them, so strongly are they still caught up in the modern concept of artistic originality.

4. Kautzsch (1932:52ff.) agrees with this argument, as does Reinhardt (1934).

5. On the latent meaning of the vault as dome of heaven, compare Lehmann (1945) and Smith (1950).

6. On the sterility and decline of iconology as a science of meanings in the nineteenth century, compare Sedlmayr (1948b:89ff.) and Bandmann (1951).

7. Compare the work of Lévy-Bruhl, Durkheim, Frazer, Leeuw, Rothacker (on levels of personality), and Klages.

8. Nevertheless, in contemporary nonobjective painting, which theoretically derives its effect from the ultimate goals of the work of art (as posited by the theorists of the late nineteenth century), an instrumental stratum is active, one that would address and manipulate the uncontrollable automatic reactions of the inner self to colors, lines, and surfaces.

9. Originally, the idea—the concept of a thing—was, as an ideational potency, consistently conceived to be superior to the artistic (Schweitzer 1925; cf. Frey 1946b:18ff.).

10. "By the contemplation of the image, human thought should be drawn into an immaterial [world]" (Tellenbach 1936:12n.26). [This note is omitted from the English edition (Tellenbach 1940).] For the Platonic–Plotinic foundations of this proposal in the West, see Schweitzer (1925).

11. "The 'meaning' that stands in a relationship of tension with the concrete form of the work of art, can actually be pictorially unrepresentable. It can have a transcendental content, which can be made conceivable only by means of the representing pictorial sign and be conceivable only *in* the sign" (Frey 1946d:19).

12. Although Augustine usually bases his judgment of the relationship of the material appearance to the divine idea on Plato, largely in company with the rest of Antiquity and therefore medieval theories of art (Leisegang 1926; Sauter 1910), here he obviously follows the Stoic train of thought set in motion by Aristotle (Schweitzer 1925). In any event, it should be said that to Augustine, the Aristotelian concept of form, imprinted with the *eidos* born within the artist and growing into something divine, appears equally demonic. The rational element—the structural character of the divine idea—recedes completely in the face of the irrational being that is the demon bound to the work of art. Nevertheless, this "demonizing of art" should be seen as firmly intellectual and rational in contrast to the magic of the earlier cult images, which was taken for granted. For a detailed examination of this change, which is part of the great process of the evolution of consciousness, see Schweitzer (1925).

13. "The process of objectifying subjective reality—the detaching of self from the subject, and the assumption of the object's independence from the self—is the fundamental phenomenon of all creativity. . . . This process of 'making real' basically proceeds by means of artistic processes, for when the object is conceived in terms of an ideal reality, the object's spiritual content becomes firmly and unequivocally wedded to the objective reality of the physical thing" (Frey 1946b:107ff.). Frey also cites examples where an artistically created environment envelopes a holy object, such as a reliquary in the form of a golden foot that houses a relic of a sandal that [hidden within the reliquary] is never seen or a paten decorated with a scene of the Last Supper, where a consecrated wafer is laid in the middle of the table depicted there.

14. In every modern definition of the work of art, the human observer facing the work of art is always included. Through the observer's empathy with the work of art, its efficacy becomes participatory (Lipps 1906, 1:120). The focus of our attention is thereby diverted from any a priori content the work of art might have onto the meaning the artwork has only by virtue of its form.

15. See also Cassirer (1923–1931) and Harnack (1925, 1:198). Compare also Wind's (1931:170ff.) investigations of Aby Warburg's concept of the symbol. Like Vischer (1887), Warburg distinguishes between a magic stage, in which image and meaning are connected (in which, for example, strength and generative power are equated with and interchangeable with the bull and, by extension, its image), and a logical, differentiating stage, in which the bull is the *metaphor* for the elemental force that is being worshiped: "The symbol in the sense of an inextricable union of thing and meaning has become an allegory, where both elements of the comparison are clearly and distinctly juxtaposed." The church, or rather the reforming elements within it, strove to restore the purity of early Christian teaching, and was quite careful that the form—the work of art—should not become the object of reverence, that the metaphoric character should remain intact, and that only what was sacred—relics and the Host—were honored. Nevertheless, as the history of the altar shows, particularly since the fourth century the objects in the service of the cult became increasingly fraught with their own magic and were revered above all by those peoples of more recent arrival, hitherto familiar with only magic images and still given to animistic sentiments. A reversion from the second stage to the earlier can thus be seen in the latter days of early Christianity. A sort of intermediate stage is thus attained, one that in Vischer's phrase is *vorbehaltend*—that is, "a decision is reserved," "no conclusions are reached," or "only a conditional commitment is made"—a stage characteristic of the Middle Ages, where both options are kept open and both being *and* meaning are included. Compare also Schauerte (1950:319ff.).

16. It would seem that the inclination toward a more didactic manifestation that brought the forms into visibility—thereby imprinting them with their specific and recognizable characteristics—was more clearly felt in France than in Germany, at least in the twelfth century. Hence in French cathedrals, the representations of *Caritas* are placed on the pediment zone and shown in action, offering a cloak or bread or suckling a child. The German formulations show *Caritas* without attributes—identified only by an inscription—either as an attending figure standing beside saints or, as she appears on the gable

end of the Shrine of the Three Kings in Cologne, as a half-figure above the Adoration of the Kings, in a location and setting recalling the great rose window of a church facade.

17. Hartlaub (1938:1) cites Goethe's (1989) remarks on the obelisk of Monte Citorio recorded in his *Italian Journey*: "Here we have a case where the religious function of art is not calculated on any effect that is to be made on human sight" (323). Naturally, in the Middle Ages there were also established concepts of quality and formal mastery, primarily among the artists themselves and cultivated patrons. These concepts, however, do not represent the highest demands made on the work of art. Clear indications of such a development toward concepts of formal mastery actually becoming the highest demands can be observed in the thirteenth century in efforts directed toward making the Church-as-Heavenly-Jerusalem visible to the senses, in the display of the Host, and in the function of the crypt in the exhibition of relics. That this intention is fundamental, however, is acknowledged only after the fifteenth century (see the work of Sedlmayr; Wallrath 1940:283).

18. Compare also the blunt formulation of Evers (1942): "Stylistic explanations are given if one no longer knows the facts" (391).

19. Three citations from the extensive literature on this problem will be offered (cf. Töwe 1939:passim): "The strong emphasis on artistic independence and complete originality is only the consequence of false and unworkable theories. Art always stands in historical contexts: there is no creation *ex nihilo*; rather everywhere it proceeds from given conditions. It is true for architecture above all, however, that the best works are not those in which artistic individuality intrudes" (Schnaase 1866–1879, 5:411). "One of the reasons for the insecurity and confusion that reigns in the judgment of works of art of earlier periods (that have arisen under other general historical conditions than creations of contemporary art) is a belief in enduring fundamentals of art; a belief that rests on the supposition that with all changes of art-historical goals and artistic knowledge, indeed, with the changes in the concept of the work of art, something can be seen that, in principle, is lasting and unchanging" (Dvorák 1924). "Those who undertake to expound upon the essence and meaning of artistic activity usually proceed from the effect of the work of art on man's spiritual condition or sensory perceptions. This starting point is manifestly false" (Konrad Fiedler).

20. A letter from the one of the Fuggers demonstrates the characteristic distinction between form and content of this position: "I want the altarpiece to be devotional and not just a demonstration that the painter only wants to show off his art" or "I would gladly have a good copyist, even if he were not endowed with the arts of painting, if he were only a master of copying" (quoted in Lill 1908:31).

21. Compare also Weisbach (1945): "At the moment when the What was taken for granted and the How came to the fore, he [the artist] began to act within an autonomous region of art" (3).

22. This is not the place to decide from which point of view form and content are always to be regarded as composing a unity (Albiker 1944). This view, which in the final analysis makes the presentation of the history of art possible, does not contradict the fact—demonstrable in the literature of all periods—that artistic form and content are conceived as two separable factors that are often in conflict. Consensus rapidly follows if

we differentiate between purpose—the content that calls the work of art into existence and compels it to service—and the value ascribed to the work of art; it is this ascribed value that makes up the true quality of the work of *art* as such. Discussion of the latter necessarily has no place here. This distinction between a priori substance and the meaning brought into existence by the work of art is already found in Vitruvius when he distinguishes between "what a master-builder should both spatially and visually evoke" and what "he should by artifice cause to perceived in the appearance" (*De architectura*, 1.1, quoted in Schumacher 1947:12). [Vitruvius (1970, 1.6–7) gives "quod significatur et quod significat" (what signifies and what is signified) (*sic*).]

23. Bernard of Clairvaux to William of Cluny (Bernard of Clairvaux 1690). This phrase also appears in his *De modo bene vivendi*, chap. 9.

24. For comparable problems in Antiquity, see Geffcken (1918:287), Müller (1931:494), Kaschnitz-Weinberg (1944:58), Meyer (1884–1902, 2:134ff.), and Reinach (1928).

25. Compare the claims of Bernard of Clairvaux, quoted earlier, and the position of St. Augustine, which confirms the latent danger:

> I feel that when the sacred words are chanted well, our souls are moved and are more religiously and with a warmer devotion kindled to piety than if they are not so sung. . . . Nevertheless, when I remember the tears I poured out at the time I was first recovering my faith, and that now I am moved not by the chant but by the words being sung, when they are sung with a clear voice and entirely appropriate modulation, then I recognize the great utility of music in worship. . . . Yet when it happens to me that the music moves me more than the subject of the song, I confess myself to commit a sin deserving punishment, and then I would prefer to not have heard the singer. (*Confessions*, 10.33, quoted in Schlosser 1914, 1:27; English translation: Augustine 1991:207–8).

Similar thoughts can be found in Plotinus:

> For he who contemplates physical beauty must not lose himself therein, but he must recognize that it is an image and a vestige and a shadow, and he must flee to that of which it is a likeness. For if one were to rush forth and to grasp for truth that which is only a beautiful reflection in the water, then the same thing will happen to him that happened to the one about whom a meaningful myth tells how he, wanting to grasp a mirrored reflection, vanished in the depths of the waters; in the same way, he who holds on to physical beauty and will not let go of it, will sink, not with the body but with his soul, into the dark abysses, horrible for the mind to behold, where he will languish blindly in Orcus, consorting with shadows there as he did here. (*Ennead* 1.6.8, quoted in Panofsky 1929; English translation: Panofsky 1968:31).

This puts a new visage on the Golden Madonna of Essen. She carried relics within her and, although she resembled a cult image, was worthy of adoration not as an image, but rather for what was enclosed within her and radiated outward through the gold. This sculpture—uncommon for this time and in this size—should be seen as connected in

these aspects to the magnificent golden images of Antiquity. (Another morphological piece of evidence could be the prehistoric face-urns, whose Gothic name, *manleika*, means "human likeness" [Kauffmann 1913, 1:190n.2].) In the view of the medieval religious reformers, St. Foy of Conques—a figure quite similar to that of the Essen Madonna—had no claims to reverence as a cult image. The image of St. Foy was to be rejected because the finely modeled appearance decorated with gems incited adoration (Mâle 1924, 1:200). See also Bandmann (1949b:128).

26. This process, which represents a relapse, so to speak, to the earlier, presymbolic stage (the worshiping of the thing-in-itself without reference to the meaning that the thing pointed to), is primarily to be observed when emerging peoples—who have not yet participated in the development of structure toward form—enter into the historical record. In this manner, the Eucharistic table becomes an altar, the spiritual *ecclesia* becomes a *templum*, and the indicating, illustrating, or edifying image becomes a dispenser of grace. In the treatment of the problem of stylization in medieval art, these thoughts have yet to be teased apart.

27. "Without a doubt, the infiltration of images must be judged as the result of ethnic conditioning" (Elliger 1930:95).

28. "Although it is needful that this be visibly celebrated, yet it must be spiritually understood" (Augustine n.d., 37:1267; English translation: Augustine 1917:486).

29. Elliger (1930:viff.) lists the following arguments against images:

1. Because of the identity of image and god among the pagans, the danger arose that the Christ depicted in the image could be conceived as one god among other gods; all the more so since the early Christians initially believed that the pagan images of gods were animated by demons (Borinski 1914–1924, 1:14; Michel 1902:3ff.).
2. The Mosaic prohibition (Exodus 20:4).
3. For Christians, union with God proceeded solely through the spirit. Only with Neoplatonism did the physical image also offer possibilities for union.
4. The supernatural conception of the divine.
5. The absence of any authentic pictures of Christ.

The following grounds operated in favor of images:

1. The pictures of historical biblical events in the catacomb paintings as "pictorial expressions of the historical demonstrations of the effective power of God" and as pledge and earnest for the believers whose faith was jeopardized by the delay of the Second Coming (Michel 1902:16).
2. The reification of the Last Supper and baptism and their associated objects and gestures.
3. The Hellenizing of piety (Borinski 1914–1924, 1:9).
4. The connections with the imperial cult and classical traditions.
5. The religious necessity for graphic representation.
6. Pedagogical and didactic grounds.

The polemic between the defenders of either tendency cannot be discussed here.

30. The beginnings are reported by Paulinus of Nola (Elliger 1930:84). For him, tolerating images for didactic reasons does not ascribe importance to the concrete object, but rather to the connection to the spiritual Plan of Salvation in which the biblical events are only parables and expressions, not justifications or reasons.

31. In the fourth century, in order to make the Plan of Salvation visible, art was permitted in combination with the word. In the Renaissance and the Baroque eras, it freed itself from the word. In Western art, the great artists are held to be those who led in this direction and imparted their own personal power of expression to colors and forms—Giotto, Rembrandt, Kandinsky.

32. Compare the medieval examples of the meaning of this word cited by Frey (1946b:117).

33. This belief in the word as a means to bring about a thing or a transaction on a higher spiritual plane has its parallels (and more) in the high value placed on perspective in the thought of the Quattrocento. By means of perspective—a rational medium, born of the intellect—the actual world, beset with shortcomings, was re-created and re-presented in new and better form: "Painted gold is worth more than real gold."

34. The first concept is based on Plato; the second, on Aristotle. The degree to which the second is more recent since it requires a more formless conception of god than Plato cannot be discussed here. Compare Schweitzer (1925).

35. On the genesis of these categories, see Stockmeyer (1939) and Termehr (1950).

36. The resuscitation of the taste for medieval architecture at the end of the eighteenth century and the beginning of the nineteenth is strongly characterized by the discovery of its value for contemplation, one that was atmospherically conceived and religiously interpreted. The old buildings filled the soul with reverence, awe, and melancholy. Agincourt (1813) emphasizes the unwilled emotion: "An involuntary thrill catches the senses unawares and inclines the soul to contemplation and reverence" (Un saisissement involontaire surprend les sens, et dispose l'âme à la contemplation et au respect) (68) (Termehr 1950:74).

37. Schinkel and Semper (1878, 2:447) wrestled with these artistic challenges to assemble their insights into the "meaningful" character of early architecture (Grisebach 1924:152, 156, 160; Stockmeyer 1939:4).

38. Unlike painting, architecture could never fulfill Schelling's (1807) principle of beauty; that is, it could never be what resides in the transparent manifestation of absolutes that are completely without content. This also corresponds to the Kantian definition of the artistically beautiful as having no "concept" and hence should be directly and clearly graspable as an object of general pleasure; that is, it should generally please even without having a concept associated with it. On this basis architecture has been arranged under the heading of applied or "not-liberal" arts even by the most "up-to-date" theorists of art. This is clearest in Benedetto Croce. Compare Frey (1946c:93ff.).

39. The beginnings of this lie in the Romantic period.

It would not be astonishing if in the present universal tendency to imitation, some genius, conscious of its powers, should break forth into a longing desire for absolute originality. If such a genius were penetrated with a true idea of his art, justly esteeming that symbolic expression and revelation of divine mysteries

which is its sole appropriate object, and regarding all besides merely as the means, the working members, or characters which, duly combined, produce a correct expression, his compositions would probably be the foundation of a new style: genuine hieroglyphic symbols, the simple offspring of nature and natural feelings, but drawn from individual conceptions, and arbitrarily thrown together in accordance with the ancient methods of an earlier world. . . . The question now to be considered is whether a painter ought to trust thus implicitly to his own genius for the creation of his allegories, or confine himself to the adoption of those old symbols, which have been handed down to us, hallowed by tradition. . . . The first method is unquestionably the most dangerous. . . . There seems to be more safety in clinging to the old masters. (Schlegel 1860:146–47)

40. Concerning the representations on coins of the Middle Ages, Lange (1942) is of the opinion that the people of the Middle Ages "found their visual pleasure in concepts portrayed in shapes, in the illumination of an exalted emblem that stood before the inner eye" (6).

41. According to Sedlmayr (1939), the hallmark of Gothic architecture is a "sensibilizing" of the spiritual relations and meanings and a "spiritualizing" of the physical material.

42. This necessity of addressing the inner self is shown in the modern phenomenon of the enjoyment of nature, in the delight in landscape, and, above all, in the unconquered mountains and seas, for example, that eventually brought about a transformation in the design of fountains and gardens.

43. This conception of the artistic—the intellectual pleasure in the work of art—strongly marks the Quattrocento as well (Kauffmann 1941; Wittkower 1949).

44. In another context but with the same import, Luther (1883–) wrote, "Face to face with God . . . all will be the same, clergy and laity alike" (51:240), or "All Christians truly partake of the spiritual condition; there is no distinction among them on the basis of office alone" (6:407).

45. This agrees with the generally subordinate position of iconography in art history's orientation toward stylistic criticism (Bandmann 1951).

46. The most extreme analogies from the natural sciences are to be found in Wetter (1835:48ff.), where the step from the Romanesque to the Gothic is compared to the development from the elephant to the horse and from the owl to the swan. The "unorganic" Romanesque massiveness is a preliminary step to the thoroughly articulated "organic" Gothic.

47. Although the root of this concept lies with Plato, it is primarily Aristotle's, for whom the form as sign, as designation entered into the material due to the *eidos*, born within the artist, which allows him to form the formless substance according to an interior conception of the idea (*Metaphysics*, Z 7 1032a 12–13; Schweitzer 1925:76ff.).

48. This is also the view of Agincourt (1813), who applies Winckelmann's categories to medieval architecture.

49. These ideas, first applied to works of literature in the *Sturm und Drang*, were taken up again by the Romantics (e.g., Herder).

50. Andrae (1930) is completely within Semper's tradition.

51. The root of this idealistic view of art obviously lies in Platonic philosophy, in which the idea can appear and become visible only in matter; however, that materiality detracts from the pure idea. Similarly with Plotinus, for whom the beauty of the work of art "depends upon the 'injection' of an ideal form into matter, overcoming the latter's inertia and inspiriting, spiritualizing, enlivening it" (Panofsky 1929:12; English translation: Panofsky 1968:27).

52. "Our priesthood is joy, our temple nature" (J. C. F. Hölderlin, "Hymne an die Liebe," quoted in Flasche 1949:17).

53. "The highest purpose of humanity is the artistic" (Richard Wagner).

54. "The accomplishment of the man who creates a machine is like the act of a god" (Sedlmayr 1948b:107).

55. An approach developed by Lehmann (1940:75ff.).

56. "The inherent tendency in the form toward multiplication and hence dilution and dissolution is thus stronger than the will to continued reimprinting and hence conservation of meaning and the maintaining of religious symbolism" (Weigert 1938:108). From the Renaissance onward, it can be clearly observed how pediments crowning windows and doorways, originally confined to sacred architecture, came also to be applied to profane buildings. This was even more the case in the nineteenth century, when railway station waiting rooms and bathing establishments were erected with the apparatus of forms drawn from the Hagia Sophia. We might conclude from statements by the Cistercians, to whom these things appeared only as signs of extravagance and pomp, that the status and the meaning of these forms may already have been forgotten by the twelfth century.

57. We know, for example, that relics were displayed from the dwarf gallery of St. Servaas in Maastricht.

58. A morphological investigation of the vaulting of the nave of Speyer produces similar results. Its reception is not due to any perfecting of construction techniques now capable of building such a vault, nor does it bear witness to any parallels of artistic growth that might correspond to a situation like that in the Basilica of Maxentius in Rome. Vaulting a church building *means* something, it expresses something, and it makes a claim, as will be explained.

59. Sedlmayr's (1935–1936) article on the baldachin is a typical example of the combination of the morphological with the structural-analytic approach. The baldachin and its symbolic abbreviation in a single plane—represented by the arch—are discussed. The archaeological work of Hamberg (1945) also tends in this direction. This method has become particularly developed in recent decades, and the methods of stylistic criticism have been brought to bear on questions of meaning. For example, Schrade (1939–1940a) challenges us to once again recognize the work of art as a "shape imbued with reason, arising out of specific realities." The definition of Lipps (1906) also tends in this direction: "Artistic form is nothing other than the content's mode of existence" (2:32). Jünger (1942) speaks of the gargoyles of Laon Cathedral as the "petrification of an extinct experience" (153). The goal of research is less the history of the gaze than the history of mankind that lies behind it. Compare Lützeler (1934): "Art is uniquely fitted to have the most subtle and comprehensive understanding of form as the bearer of reason" (26). The prediction of Tietze (1924:191) that the formalistic method is an inescapable intermediate step for a "new

iconography from the ground up" has proved true. Schrade (1928a) has identified the limits and dangers of this course: "If the study of the psychological symbolism of forms (today more or less universally acknowledged) proceeds as if it were dealing with absolutes, if it neglects to align its standards for judging spiritual and intellectual movements to the conditions of imagination of the period under consideration, it must err" (568).

2. The Symbolic Meaning of the Building According to Written and Visual Sources

1. Suger's report about Saint-Denis will suffice as an example (Panofsky 1946:105).

2. These testimonies are assembled by Sauer (1924).

3. Sources of this kind are found principally in the literature of late Antiquity and Byzantium—for example, the poem of Paul the Silentiary on Hagia Sophia (Salzenberg 1854:iiff.).

4. This attitude made little impact on Suger's report, however. He began the new building in 1144 because of insufficient space in the old church and was tormented that he might not live to see the completion of the undertaking: "We, however, exhilarated by so great and festive a laying of so holy a foundation, but anxious for what was still to be done and fearful of the changes of time, the diminution of persons and my own passing away, ordained . . . an annual revenue for the completing of this work" (quoted in Panofsky 1946:103).

5. Of course, the extent to which a literary expression of the intention to copy is actually reflected in formal results is another question.

6. In any event, the patron and the actual "architect" are only rarely identical. Thus Benno of Osnabrück: "Praecipuus architectus, cementarii operus . . . solertissimus dispositur" (Eminent architect, most expert at masonry work, is laid here) (Pevsner 1942:234; cf. Hindenberg 1921). The participation of Bernward of Hildesheim in the construction of St. Michael's also seems to have extended to practical matters.

7. The emergence of the artist in the later Middle Ages notwithstanding, the primacy of the patron is still evident in this citation concerning the building of the Cistercian abbey of Baumgartenberg in Upper Austria: "Rinhardus vita fecit pius hoc opus abba, per manus artificiis Liebhardi Passaviensis" (Reinhard, the pious abbot, made this work during his lifetime, by the hands of the craftsman Liebhard of Passau) (Kletzl 1935:20). In the fourth and fifth centuries, we find inscriptions incised in church buildings of Syria giving the names of patrons as well as architects (Lassus 1947:249). The situation is similar to that cited for Baumgartenberg. It must be remarked, however, that the naming of the artist on the Syrian church should be understood as a survival from late Antiquity, but in Baumgartenberg we see the beginnings of the modern appreciation of the individual artist.

8. This problem in Egyptian art has been discussed by Wolf (1935), Scharff (1939), and Spiegel (1940). Roeder (1947:198ff.) unconvincingly argues the opposite position.

9. Thus St. Peter's in Bebenhausen stands in relation to St. Peter's in Rome (Krautheimer 1942b:15). In this conviction, we encounter a very ancient stratum, one that increasingly came to the fore in the course of the Middle Ages: "When a new person en-

tered the family, the ancient natives of the North said expressly: our kin has been born again, such-and-so has come back. And they reinforced the statement in their gift of the old name to the young arrival" (Grønbech 1937–1942, 1:230).

10. As an example of a historicizing copy from a later period, it is reported that when in 1530 Emperor Charles V was to be crowned in Bologna instead of in St. Peter's in Rome, the specific local features of St. Peter's were to be copied as faithfully as possible (Eichmann 1942, 2:5).

11. "The architect of a medieval copy did not intend to imitate the prototype as it looked in reality; he intended to reproduce it 'typice' and 'figuraliter' as a memento of a venerated site and simultaneously as a symbol of promised salvation" (Krautheimer 1942b:17; Spörl 1930:50; Evers 1939:205ff.).

12. For Panofsky (1944), consciousness of the temporal distance between Antiquity and the present is the principal criterion that distinguishes the Italian Renaissance from all the medieval renewal movements: "The pre-Gothic Middle Ages had left Antiquity unburied and alternately galvanized and exorcized its body. The Renaissance stood weeping at its grave and tried to resurrect its soul" (228).

13. On the whole question, compare Beenken (1938:27ff.), Keller (1940:672), and Körte (1930).

14. For example, Diocletian wished that his transformation of the life of the empire be understood as a "restoration of the old forms" (Vogt 1949:123). See also Burdach (1926).

15. Thus Pliny the Elder (Burdach 1926:57); later also Vasari, Herder, and Goethe. Compare Töwe (1939:17).

16. Hrabanus Maurus was proud of his literal agreement with the church fathers (Spörl 1930:307). According to the Council of Nicaea in 787, the form of the picture was not to be left to the invention of the painter but to the decrees of the church, based on transmitted traditions (Labbé 1759–1798, 7:831). At any rate, in the Middle Ages there were already intimations of the modern concept of the artist. See also the Anonymous Bernensis on the coloring of initials: "If within his own practice and through his own understanding, the honest artist makes no experiments, if he uses nothing of his own discovery, but only what he has learnt from others, he must declare himself unworthy" (Theophilus 1874:390). In what we call modern times, the limits to the play of fantasy formerly set by dogma were replaced by those of the academies, where the boundless possibilities of artistic imagination were restricted to the limits set by the models of tradition.

17. Compare the hymns describing Hagia Sophia or the contemporary descriptions of Cluny III or Saint-Denis.

18. Until the time of Augustus, the belief that the *oikumene*—the *imperium*—was coterminous with the *orbis terrarum* had been founded on official statement and popular opinion. All else outside was barbarian territory and no-man's-land (Vogt 1949:12ff.). The collectivity that the great family of the *oikumene* represented was a community of blood ties. This had far-reaching consequences when Constantine bound Christianity (originally a universal religion unconnected to that concept) to the *oikumene,* and it became, so to speak, a folk religion (Mensching 1947).

19. "The [Greek] empire flourished there until it succumbed to Rome and Julius Cae-

sar became emperor. To this day Rome controls the temporal sword and on behalf of St. Peter the spiritual one also" (Dobozy 1999:126).

20. Otto of Freising (1912a:256), for example, begins no new series with Charlemagne; rather, he continues on in the old sequence of Roman emperors.

21. Otto of Freising (1912b) charged that Arnold of Brescia was "enamored of the unique, greedy for the new" (singularitatis amator, novitatis cupidus) (2:28, 106). "Unheard-of innovation" was also the charge exchanged by popes and emperors during the Investiture Controversy and brought by the popes against the reforming monastic orders (Spörl 1930:303).

22. Nevertheless, the opinion that the Roman Empire had come to an end after Charlemagne was not unknown among medieval German historiographers (Spörl 1930:520; Kampers 1890:62–63).

23. In his chronicle for the year 1250, Matthew Paris (1888) reported the words of Frederick II on his deathbed: "The Empire, which from long before Christ has flourished until now, fades and sinks into fatal oblivion" (303).

24. *Codex Theodosianus*, chap. 16:8 (quoted in Unger 1878:27; see also Hartmann 1897, 1:429). Late Antiquity also knew a romantic, historicizing relationship with the buildings of the ancients. In his thirty-first speech to the Rhodians, Dio Chrysostom (1932–1951) says: "For you must not take it for granted, Rhodians, that you hold first place in Hellas, nay, you must not. . . . Nay, it is rather the stones which reveal the greatness of Hellas, and the ruins of the buildings" (quoted in Schrade 1939–1940b:197ff.). Compare also Pliny the Younger (*Epistolae* 8:24), who urges Maximus to "cherish sentiments of respect for their antiquity, their colossal achievements" (quoted in Birt 1909:159).

25. On the ancient categories of judging a building, see Schlikker (1940) and Gerkan (1941:619ff.).

26. *Ordinatio*, as used by Vitruvius (*De architectura*, 1.2). *Ordinare* and *designare*, in the sense of a sketched drawing, are revived only in the Renaissance.

27. *Eurhythmia* and *symmetria* (Vitruvius, *De architectura*, 1.2).

28. *Ichnographia,* according to Vitruvius and Cetus (Mortet 1907:452); *dispositio,* according to Isidore of Seville (1911, 19.9).

29. *Distributio* or *constructio*.

30. *Decor,* according to Vitruvius; *venustas,* according to Isidore of Seville; *dispositio, constructio*, and *venustas* also, according to Hrabanus Maurus (*De universo*, 1.21, chaps. 1–4).

31. For criticism of this position, see Feulner (1942:90). Even for the Baroque period, such a position is one-sided, to say the least.

32. For an extensive discussion of the question of the purpose of architecture, see Frey (1946c:93ff.).

33. With the possible exception of the impost (Deichmann 1950a).

34. To mention the most important ones of general significance: the provision of the interior with supports, the central-plan building with interior ambulatory, the pillar, the groin vault, the dome, the apsidal ambulatory, and the tower (Vincent 1937; Krautheimer 1939). On regional styles up to about the eighth century, see Deichmann (1937).

35. Proclaimed as a medieval invention by Sedlmayr (1933, 1935:55), the Colossal order was traced to its roots in Antiquity by Weigand (1934:414).

36. Liesenberg (1928) also makes the observation that "the liturgical demands were neither the definitive nor the most forceful basis for the development of the basilica and the peculiarities of its realization" (36). See also Wulff (1914–1918, 1:202).

37. These rooms acquired additional functions as well.

38. The Severan Basilica in Leptis Magna was a pagan basilica with chambers near the tribunal much like pastophories (Apollonj 1936:fasc. 8–9) (see figure 2.36). The ambulatory in St. John Lateran was added later, probably by Leo I in the fifth century (Lauer 1911:51). The ambulatory of the Carolingian cathedral of Cologne is similar to that on the Plan of St. Gall (Doppelfeld 1948a, 1948c). St. Michael's in Hildesheim is somewhat divergent in having a western entrance (Beseler 1946). Another source for the important medieval type of the apse-with-an-ambulatory is uncovered here, one that evolved independently both from the choir ambulatory (which arose from the crypt) and from imitations of the Church of the Holy Sepulchre.

39. As burial place, as place for the altar of a second dedicatory patron saint, as choir for an enclosed congregation, and so on.

40. Behind the westwork (as will be seen) lies a type of the central-plan building that is demonstrably detachable from the church to which it is joined, but the western choir is and always has been an inseparable part of the church.

41. The same goals can be met by the westwork, the western choir, and the Cluniacs' forechurch (e.g., Cluny III).

42. This observation can be confirmed in the development of Protestant church architecture, where with the rejection of the symbolic interpretation of the church building the demand for a centrally standing pulpit can be satisfied, while the basilican or hall-like construction of the room fades, and the altar retreats to one of the long sides (Gause 1901:70; Hasak 1893). Similarly, the rejection of transepts, which emphatically reappear with the Counter-Reformation (e.g., Kollegienkirche in Salzburg, Weingarten, Ottobeuren). See Sedlmayr (1938).

43. Certainly such changes are not lacking in medieval architecture—for example, in the Christian interpretation applied to the pagan sepulcher with its cruciform ground plan or in the "purposeless" application to later buildings of the arcade motif from the Palatine Chapel in Aachen, which had been an integral component of classical architecture (Bogner 1906:21). Many survivals of insignia and attributes of rank can be ascribed to this turning of something that was once purposeful into something symbolically meaningful. Technau (1939) has followed the course of some ancient cult objects in their transformation from useful objects to signs of power and importance, how they became works of art in a higher sense, but also how the world of ideas became divided into sacred and profane spheres. A lovely example of how vestiges of the functional goal of the form are left behind while the meaningfulness of the type lives on in the now predominant work of art is the armor of the Mannerist period (Klapsia 1937–1938). The armor's function had caused variations in its form that were not, however, expressed artistically. When the practical use disappeared, a meaningful function superseded the practical one and armor became a badge of rank that expressed the strength, knightly rank, and elite status of the bearer. From now on, people who never actually fought but who wished to express the conditions of nobility and status that they had been granted could participate in that status by commissioning a suit of armor.

In this way, armor shifts into a new sphere of consciousness, for the chosen bearer of the armor-as-sign can now choose it as an act of will. It depends on neither necessity nor unconscious custom. Frey (1946b) expressed it most clearly: "This objectifying of subjective reality—the detaching of self from the subject, and the assumption of the object's independence from the self—is the fundamental phenomenon of all creativity" (107–8).

44. So it is with dwarf galleries, which have nothing to do with the vaulting of the apses that lie behind them, and rib vaulting, which only in a later stage was actually a functional part of the construction (Gall 1915, 1925).

45. His critical judgment of the creative power of symbolism is strengthened by the observation that with the appearance of new metaphors, symbolism is capable of changing.

46. For example, the importance of the individual stones in the church building as symbols of individual people held together by the mortar of love (church building and congregation having had the same name, *ecclesia*, from the second century on) (Sauer 1924:112) or the interpretation, first seen in the twelfth century, of the central-plan church as a crown of heaven (Sauer 1924:291) or the equation of the tower with the Virgin Mary (Sauer 1924:142).

47. Sauer (1924:291ff.) rightly rejects this overrating of allegorical texts by French theorists such as Émile Mâle. It is possible, however, that the attachment of subjective, *post facto* allegorical interpretations to the orientation and cruciform ground plan of the Constantinian basilicas ensured their eventual proliferation. Orientation and cruciform ground plans were not constructional requirements when the Constantinian basilicas were built. The cruciform ground plans of the Constantinian basilicas nevertheless do require explanation. Medieval Christian allegories *are* valid, however, as primary sources for the programs of wall fresco cycles (e.g., Schwarzrheindorf) and figural portal sculpture.

48. Before we can speak of reception, we must demonstrate the possibility that the form could possibly have been discontinued. Naturally we must also consider the possibility that the combinations of building parts to which Christendom applied its new meaning had already in Antiquity lost the meaning of their structural origins and been reduced to clichés or set pieces. Although that might apply in a few individual cases, in general we must say that the most important phenomena of early Christian church architecture show receptions that cannot be explained from self-evident customs and do not arise from the eschatological character of the primitive church, which originally shunned forms.

49. The works of Sedlmayr (1936, 1939, 1948a) and Kitschelt (1938) bring nothing really new to this basic idea; they merely draw our attention to some facts overlooked in the more recent literature of art history.

50. The attempt of Gruber (1936) to show the concept of the Heavenly City of Dionysius Areopagitica as the root and intellectual framework of the westwork is completely wrong. Although the westwork metaphorically does represent the Heavenly City—and a great many other things as well—it does not arise *from* it. If any correspondence between the literary allegory regarding the concept of the Heavenly City and this monumental building-type measures up at all, then it is perhaps only to the degree that providing altars dedicated to the angels in the westwork was inspired by Dionysius's text, even though

it is nowhere the same as in that text. But even that, as Sauer's (1924:283) convincing exposition demonstrates, is extremely questionable.

51. In a similar sense, Sauer (1924) quotes Hrabanus Maurus: "Parietes enim templi dei fideles sunt ex utroque populo, h. e. judaico et gentili, ex quibus Christus aedificavit Ecclesiam suam" (The walls of this temple are the faithful of both peoples, that is of the Jews and the Gentiles, with which Christ has built his church) (116). In the Palatine Chapel in Aachen, the following inscription runs around the octagon under the cornice at the gallery level: "Cum lapides vivi pacis conpage ligantur Inque pares numeros omnia conveniunt, Claret opus domini, totam qui construit aulam. Effectusque piis dat studiis hominum. Quorum perpetui decoris structura manebit, Si perfecta auctor protegat atque regat: Sic deus hoc totum stabili fundamine templum, Quod Karolus princeps condidit, esse velit" (When the living stones are linked in peaceful harmony and in even numbers all stand together, the work of the lord who built the whole hall shines brightly and the pious labor of mortal men is crowned with success. Their structure of perpetual beauty will abide if the *auctor* [i.e., God] protects it in its perfection and holds sway over it. Thus may it be God's will that this entire temple, which the Emperor Charles built, may rest upon a stable foundation) ("Versus in aula ecclesiae" 1880–1881)

52. This is the early Christian interpretation, and even then it contrasted with the pagan actualization of the cult. This is why Islam, which retained many older Christian concepts, could, unlike Christianity and Judaism, feel that the whole world is a mosque (i.e., a place of prayer), as Muhammad said (Kühnel 1949:5).

53. "Dispositio autem materialis ecclesiae modum humani corporis tenet" (The material arrangement of the church follows the disposition of the human body) (Durandus, quoted in Sauer 1924:111n.1). "Erat (ergo) suo tempore in tantum de novo augmentata huius veteris ecclesie fabrica, ut de ipsa sicut de bene consummatis ecclesiis congrue secundum doctores diceretur, quod ad *staturam humani corporis* esset formata. Nam habebat et adhuc habere cernitur, cancellum, qui et sanctuarium, pro capite et collo, chorum stallatum pro pectorialibus, crucem, ad utraque latera ipsius chori duabus manicis seu alis protensam, pro brachiis et manibus, navim vero monasterii pro utero, et crucem inferiorem eque duabus alis versus meridiem et septentrionem expansam, pro coxis et crurubus" (At that time [i.e., the time of Adelhard (1055–1082)], there was such an extensive renovation of the structure of this ancient church, that it could be said of it, as the doctors say of well-constructed churches, that it was fashioned according to *the stature of the human body*. For it had, and is seen to have to this day, a chancel that, together with the sanctuary, represents the head and neck; a choir with its stalls represents the breast; a crossing extending outward on both sides of the choir like two cuffs or wings represents the arms and hands; the nave of the monastery represents the belly; and the lower crossing, likewise with two wings extending south and north, represents the haunches and limbs) ("Gesta abbatum Trudonensium," quoted in Schlosser 1896:242; Bandmann's emphasis). Vitruvius already mentioned the idea that the ground plan of a temple looks like the figure of a person stretched out on a cross (Flasche 1949:87).

54. Thus in 382, Ambrose wrote concerning the connection of cruciform ground plan and the Christian cross: "Forma Crucis templum est templum victoria Christi, sacra, triumphalis, signat imago locum" (The temple in the form of the Cross is the tem-

ple of the victory of Christ, the holy, triumphant image indicates the place) (quoted in Lassus 1947:115).

55. For evidence of the meaning of columns as apostles, see Schlosser (1892:13), Sauer (1924:134), Kitschelt (1938:60), Haftmann (1939:59), and Hempel (1942:107). Eusebius (d. 340), describing the consecration of the Basilica of Tyre, says that the twelve columns holding up the dome represent the twelve apostles (Schlesinger 1910:82).

56. It cannot be determined whether the structural necessity for the ambulatory appeared first in the crypt or at the presbytery level.

57. Why the change took place in that century has yet to be explained. One symptom is the extension of the word *ecclesia,* hitherto used for only the spiritual community but now also applied to the church building (Sauer 1924:100; Wulff 1914–1918, 1:20; Dölger 1950:172ff.).

58. The equivalence of the church with the Heavenly City can already be seen in the third century in the contemporary ritual for the consecration of a church (Kitschelt 1938:14; Stiefenhofer 1909).

59. For example, in Alberti (1988, 7.11) we find the recommendation that barrel vaulting be used for naves because the rounded shape looks like the spherical heavens (Borinski 1914–1924, 63).

60. In Egypt in the Amarna period, we find the custom of depicting the worlds of plant and animal on the floor (Andrae 1930:31).

61. The use of the word *templum* for the Christian church is also characteristic in the writings of Lactantius, Eusebius, and Ambrose.

62. The cosmic interpretation survives throughout the whole of Christian church architecture and has been described in the literature of art history for the early Christian period by Lehmann (1945), for the Gothic by Sedlmayr (1948a), for the Byzantine by Andreades (1931), and for the post-Byzantine by Alpatov and Brunov (1932:206–7).

63. Unless one were to understand the baldachin-like vault at the crossing as the image of a tent.

64. Egyptian and Babylonian temples were flat-roofed and nevertheless symbolized heaven (Schäfer 1928:88, 98). The rafter roof of Old St. Peter's in Rome was painted with stars, thus indicating the same meaning.

65. Hence the rosettes representing stars in Mycenaean *tholos*-tombs and the plant forms on columns or the people standing for columns in Gothic portals.

66. Compare the portal inscription from Saint-Denis on pp. 78–79.

67. The brilliant analysis of space by Jantzen (1928), in which he explores the concept of the diaphanous, stops short of an investigation of the origins of the phenomenon.

68. These words, probably written between A.D. 92 and 101, naturally do not relate to a keystone, but they do reveal that a functional achievement can be allegorized. The Gothic keystone can be seen as a similar demonstration of this meaning (Ignatius 1968:78). [Bandmann attributes this quote to Clement of Rome. The supplement to Sauer (1924:393) correctly attributes this text to Ignatius of Antioch.]

69. Küas (1937:63ff.) shows a picture of the Chapel of Mary Magdalen in Meissen Cathedral, a chapel from the second half of the thirteenth century consisting of three bays. On the boss of the middle keystone is a representation of Christ; on the boss nearest the

altar, the dove of the Holy Spirit; and on that in the bay nearest the entry, a circular garland. The ribs of the vault spring from four consoles carrying symbols of the Evangelists. The *Psalter of Robert de Lisle* (British Museum MS Arundel 83, f. 126b, reproduced in Warner 1910:3, pl. 24), in which Christ is portrayed as a keystone among symbols of salvation, should also be mentioned.

70. By admitting light, the windowed crossing lantern—which is crowned by a keystone—becomes part of another group of symbols that can be traced back to pre-Christian light and sun cults. According to Plotinus, whose thoughts found wide acceptance in Christian theology, light "comes from God and is God himself. And then man may believe in his presence when it enters like a god into the house of him who prays, and illuminates it" (quoted in Vogt 1949:71ff.).

71. This is most clearly seen in house urns and reliquary shrines. Miniature forms show characteristic features most clearly, since all possible practical use or purpose is removed. Hence we find shrines that look like churches, circular chandeliers that represent the City of God (being assembled out of little houses), or the tabernacle covering the holy of holies. This identification is important for the evaluation of architectural description in Middle High German poetry. Trier (1929:11ff.) advances the thesis that descriptions of the vaulting of a monumental structure as a baldachin or of the whole church as a tabernacle in poetry derive from the difficulty of rendering the monumental in words. This, he claims, gave rise to a metaphorical approach using miniature forms that can be more easily visualized. In reality, of course, the relationship is the reverse, and it is the miniature colonnette, the tiny gable, and the like on the tabernacle that are derived from the monumental form. Because the use, function, and transmission of the original monumental form set practical bounds on any copying of the whole in a miniature, any attempt to use a miniature form to reconstruct what a building originally looked like is inevitably muddied.

72. The Christian interpretation of the church as the City of God also includes the concept of the cosmos, in which God is at home. Apart from allegorical representations of the four walls as the four elements (which has had no formal consequences), it is in ceiling painting that this concept is most visible.

73. This should not be discounted: the ground plan can represent the human body (see n. 53); the keystone can depict activity; a door can represent a mouth; a window, an eye (Brzóska 1931:68ff.).

74. The ancient Egyptians envisaged something similar. For them, the heavens were carried by four forked supports like columns at the farthest ends of the earth, supports that resembled the ones carrying the roof-of-heaven over the throne (Schäfer 1928:87).

75. To damage a column was a grave crime (*Lex Baiuvariorum*, 10.7–11, cited in Knögel 1936:178). In addition to the freestanding columns-of-judgment—the column-as-placemarker—there were functional columns with magical power ascribed to them in matters of judgment (e.g., the miracle-working column of St. Gereon in Cologne [Clemen 1916–1929, 2:26ff.]).

76. According to Andrae (1930:54), all three orders represent forms originally occurring in dwellings. Doric is Mediterranean, comes from building in stone, and represents a support carrying a heavy load, thickening toward the top. Ionic represents a

wooden tree trunk carrying a wooden saddle (Durm 1910:fig. 5). Corinthian, as a bundle of reeds with leaf fronds at the top, harks back to Mesopotamia and Egypt (Andrae 1933b).

77. The Romantic theory, which can perhaps be traced to Raphael's fancy that the Gothic church represents a forest, should be completely rejected (cf. Lützeler 1948:197; Schlosser 1927e:278). The idea that a remnant of prehistoric worshiping in an open area covered by treetops had been carried along, so to speak, into the Egyptian temple is likewise to be rejected (Scheffer 1935:123). The process is exactly the opposite: because of their symbolism—that is, because of their meaningful function within the structure—the otherwise meaningless pillars were decorated with visual forms and depictions. Naturally there are in architecture many features and functions recalling techniques from building with wood, reed, or wattle. These forms are, however, to be understood as representative, as recollections of the meaning of the house.

78. In illustrations of ancient Babylon, we see two gigantic watchmen holding staves as big as columns on either side of a gate (Andrae 1930:37, 55).

79. Representing the four supports upholding the roof of heaven as figures was common in ancient Egypt. It would be useful to investigate the history of *atlantes*. In Egypt, the sun was also portrayed as resting on a column, which could be replaced by a figure (Schäfer 1928:93ff.).

80. The paired obelisks in front of the temple of Heliopolis in Egypt were originally independent divinities (Röder 1949:77).

81. Thus a menhir could be set up as a cult image in a Gallo-Roman peripteral temple (Röder 1949:80).

82. A connection first made by Haftmann (1939:5ff.).

83. The menhirs of the South Sea islanders carry the names of their donors. Since the name is part of the person, the menhirs are not only memorials but also the seat of the soul. On occasion, they are given human features (Röder 1949:55).

84. Menhirs can have numerous other meanings as well (Röder 1949).

85. In this sense, Pliny the Elder writes: "Columnarum ratio erat attolli super ceteros mortales quod et arcus significare novicio invento" (The purport of placing statues of men on columns was to elevate them above all other mortals) (*Naturalis historia*, 34.27).

86. According to Kaschnitz-Weinberg (1944), this connection of the column-as-figure with the column-as-support lies in the Megalithic period as wandering people settled down and funerary architecture with a higher meaning developed: "The emergence of the images from the structures, the sacral-daemonic character of the houses of the dead (as well as those of the gods and the kings), strikes our awareness particularly clearly. Monument and architecture of the Megalithic cultures were, wherever possible, saturated with powers of a daemonic and psychic nature" (37).

87. The insertion of relics is also found in Japanese Buddhism: "Holy objects are also walled up or sealed in figures of gods or the saints in order to make them ritually valid and usable. In that way things acquire mana" (Zeller 1911:212). Orthodox Buddhism must have undergone a similar transformation in the popular mind when the proper furnishing and decoration of the temple took on prime importance (Gundert 1935:71ff.). In keeping with its nature, popular belief holds that the holy is close by and

omnipresent, everywhere enveloping earthly forms with a sacred inviolability (Mensching 1947:139ff.).

88. Georg Dehio's observation that the column-flanked portal resembles "a concave mirror that projects a miniature reflection of the interior perspective outward" is not as formalistic as Evers (1939:169) implies. The Egyptian idea that the sun appears at the portals of the world and vanishes when the world's doors close could also be mentioned (Schäfer 1928:101ff., figs. 22–24). The sun is often pictured on the front of a temple that embodied the cosmos. The symbolism of the church portal has numerous analogies, such as the rose window on the west front and the winged altarpiece.

89. Inscription on the portal of Saint-Denis:

> *Portarum quisquis attolere quaeris honorem,*
> *Aurum nec sumptus operas mirare laborem.*
> *Nobile claret opus, sed opus quod nobile claret,*
> *Clarificet mentes, ut eant per lumina vera,*
> Quale sit intus in his determinat aurea porta.
> Mens hebes ad verum per materialia surgit,
> Et demersa prius hac visa luce resurgit. (Suger, quoted in
> Panofsky 1946:47–49; Bandmann's emphasis)

90. Also Santa Maria la Real in San Guesa (Navarre) (Hauttmann 1929:507–8, fig. 472).

91. In Italy, this achievement is connected with Giovanni Pisano. In his chancel, the columns (which were still made as columns by his father, Nicola) were replaced by figures. The image appears as the complement of the Word proclaimed from the chancel. It is not the completion of the Christological cycle that is the achievement of Giovanni, but rather his drive to convert everything into images, with nothing left out. The meaning of the rood-screen-as-bearer-of-images in the thirteenth century is surely connected with this symbolizing drive evident on chancels, portals, and altars (Braunfels 1949:321ff.).

92. Something similar can be observed in the history of music. When the *cantus firmus* emerges from early medieval monophonic music and as the principal voice attains primacy, the other voices then act as ground and harmony. It would be foolish to regard the *cantus firmus* as a "fossil" of monophony and the accompanying voices as "anticipating" a more advanced polyphony.

93. Examples are interior columns that support the vaults and separate the nave from the aisles.

94. In his *Meditations*, Marcus Aurelius, like St. Augustine, saw the idea of the City of God in the order of the cosmos (Vogt 1949:61).

95. For the symbolic character of the Hellenistic-Roman city plan with its rectangular layout and inscribed coordinate system, compare Bulić (1929:73), Gerkan (1924:134), Tritsch (1928:16ff.), Lehmann-Hartleben (1929), and Kantorowicz (1944). The cross made by the intersection of *cardo* and *decumanus* pointing to the four cardinal directions was also interpreted by St. Jerome as the cross of Christ (Kitschelt 1938:79). This symbolism appears in the same fashion in Diocletian's palace in Split and in Palmyra, which were both cities and military camps.

96. Found until well into the fourth century in Poreč, Noricum, Aquileia (Egger 1926), and even Germany (Bader 1946–1947:5ff.). Even in Ottonian times, churches of the highest rank might still have had only a single aisle—for example, St. Pantaleon in Cologne (Tholen 1936) and St. Patroklus in Soest (Thümmler 1948:161ff.).

97. For example, San Martino ai Monti (Kirsch 1933:18).

98. For example, the Basilica of Emmaus (Kirsch 1933:25).

99. Westworks (e.g., Werden), although occasionally called *turris*, are always attached to a basilica even if they were conceived as proprietary churches. Because they are central-plan structures, they sometimes are built as towers. Thus the Church of St. Mary in Hexham is reported as having been "built in the fashion of a tower" (*in modum turris erecta*), and Bishop Agricolus had a parish church built inside the city walls of Avignon *quasi munitissimam turrim* (Knögel 1936:32, 466, source nos. 1003, 1004, 1006). St. Mary's Church in Hexham was a round building (*opere rotundo*) constructed to the east of the main church and connected to it by an atrium. It had "four entrances corresponding to the four cardinal directions" (*quatuor portices, quatuor respicientes mundi climata, ambiebant*). In this way, the symbolic meanings are better expressed than in the cathedral of Trier, where the biblical description of the square Heavenly City is brought into play in the Roman "core" (Kempf 1947:129ff.). Whatever the implications are of a parish church built like a fortress within the city walls (*intra muros*) in Avignon, it is worth thinking about why parish churches were built throughout the Middle Ages as single rooms without any particular allegorical expression in the structure, but rarely were they built without a mighty west tower. Perhaps an urban community wished to imply a symbolic manifestation, much as the French kings did in the royal galleries of their cathedrals. Whether the emergence of the central-plan structure in the East around the turn of the sixth century implies a departure from the ancient idea of city (Kitschelt 1938:85) or a poetic intensification of this idea, with the church no longer representing the actual city, cannot be decided here.

100. We can surely assume, though, a similarity with Hellenistic city elements—from *via triumphalis* to royal palace—if we can see the arrangement in the whole complex of which the actual church building is only a part. For example, an orientated approach route leads to Speyer Cathedral, and the arrangement is even clearer at Lorsch, where the three-aisled *via triumphalis* is constructed like an atrium and leads to the tomb of Louis the German [Bandmann has Louis the Pious (who was buried in Metz)], thus recalling the layout that Emperor Galerius chose in Thessaloniki. There, a covered way leads from a triumphal arch to Hagios Georgios, the former imperial mausoleum, where Galerius's audience chamber was located (Gerke 1947:24). Here, Galerius probably follows the great model of Diocletian in Split (Vogt 1949:153).

101. "Basilicae prius vocabantur regum habitacula, unde et nomen habent; nam basileus rex et basilicae regiae habitationes. Nunc autem ideo divina templa basilicae nominantur, quia ibi regi omnium Deo cultus et sacrificia offeruntur" (The dwelling places of kings were at first called basilicas, whence the word is derived, for *basileus* means "king" and "basilicas" mean "royal dwellings." But now the divine temples are called basilicas because there worship and sacrifice are offered to God, the king of all) (Isidore of Seville 1911, 15.4).

102. Not to mention the effect of its arrangement as a Roman military camp (Wulff 1936:259ff.).

103. In addition to the basis of this relationship in the identity of city and state in the ancient world (explored earlier) and the great antiquity of the symbolic meaning of the city, we could also adduce that the city as metaphor corresponded to the fellowship of the Christian community. While the pagan temple as house-of-god could, through its symbolic enhancement, represent the basic planes of the cosmos (i.e., earth and heaven), in the Christian church building the representation of the city is inserted as a mediating level.

104. This is clear, above all, in the arrangement of a monastic complex that truly does represent a city. However, the sequence of portal (city gate), atrium (*via triumphalis*), and basilica (royal palace) could also be seen as an echo of the core of the Hellenistic city.

105. Painted scenes of the Last Judgment could usually be found in the interior on the west wall.

106. This type with frontally portrayed, double-towered city gate can already be found on coins from the Spanish colony of Augusta Emerita (Mérida) and from Bizya (Schultze 1909:304, fig. 6, 325, fig. 9).

107. We do find this building motif in the ancient Near East, however—in the Hittite *hilani* that lived on in Syrian church building. As elements of the palace, the *hilani* had nothing to do with the Hellenistic-Roman city gate (Schaefer 1945:98). The double towers of Persian palace buildings—those of the palaces of the kings Cyrus (Pasargadae, sixth century B.C.) and Darius (Persepolis)—are like city gates. Here the bodyguards were stationed. Assyrian temples had great military buildings on the western side to guard the holy precinct (Andrae 1933a:114). The Hellenistic city and the Near Eastern palace have several points in common; both are dwellings of god-kings (Bissing 1923:40ff.). This type, which goes back to the great doorways guarding the Egyptian royal temples of the dead (Oelmann 1922a:191), already possessed a symbolic meaning (Dombart 1933:87–98). The pre–Indo-European world of Asia Minor also knew the city gate with flanking towers (Schenck 1947:176ff.), and we find the double-gate portal in the prehistoric hill forts of the Hallstatt era (1500–500 B.C.) in the Rhineland (J. H. Schmidt 1938).

108. Adamnan (the biographer of St. Columban) reports that Irish monks went to Syria in order to learn how to build a monastery (Baum 1935:223; Knögel 1936:2ff.; Pirenne 1941:78).

109. Schultze (1917:18) is of the opinion that the spread of the Roman city gate as a type is primarily due to the form of city gate developed in the Augustan period and that it spread mainly in the provinces (Syria, Spain, southern France, the Rhineland) where its later appearance in church buildings is to be observed, while in Italy the basilican facade persisted (cf. Kitschelt 1938:34n.82).

110. The form of two massive, round, flanking towers—standing so close to each other that there is only space enough for a narrow doorway in the middle—is very common in civic architecture and only very rarely appears in church architecture, as at Origny (Schultze 1917:39).

111. The church is seen as a castle by Sidonius Apollinaris, referring to a church built in Lyons in 472: "Aedes celsa nitet nec in sinistrum aut dextrum trahitur, sed arce frontis prospicit aequinoctialem" (The lofty edifice shines out, nor is it extended to left or right,

but faces the equinoctial circle [i.e., faces east–west] with the stronghold of its brow) (*Epistolae*, 2.10.4, quoted in Weigand 1927:156). The frequently encountered reference to the westwork as *castellum* comes from this tradition.

112. Like the baldachin that was later compressed into a system of arches, the placement of corner pilasters on a single plane so they frame the two figures and the turning of the gable into a flat surface crowning the frontal portrait of the emperor signify an important medieval stylistic principle: the reduced presence of illusionistic pictorial elements—perspective—and the increased presence of forms whose function is to indicate and represent. Compare Charles the Bald in the Codex Aureus of St. Emmeram (Munich, Staatsbibliothek, Clm. 14 000, Cim. 55, f. 5r, reproduced in Schramm 1935–1936:fig. 29a) and its copy in the Sacramentary of Henry II (Munich, Staatsbibliothek, Clm. 4456, Cim. 60, f. 11v, reproduced in Schramm 1935–1936:fig. 85b). See also Sedlmayr (1935–1936).

113. The cross not only was a symbol of the church, but signified the empire to an even greater extent insofar as any separation of these two realms can be allowed. Alföldi (1939:18ff.) shows that the emperor can appear on a coin with the symbol of the cross while under the protection of the sun god. In Byzantium, the emperor opened the games commemorating the foundation of the city by making the sign of the cross over the crowds, and the leaders of the factions lifted up crosses wound around with roses (*The Book of Ceremonies*, quoted in Dietrich 1912:78).

114. Also seen as a city gate by Morey (1942:140, 219n.291).

115. Kantorowicz (1944:222) derives the composition and individual differentiating elements from representations of acclamations on antique consular diptychs and coins. Delbrück (1949:215–17) raised objections to Kantorowicz's interpretation in some particulars. He takes the transverse building to be an oratory in front of the city where the emperor received the representatives of the people.

116. Royal palace and city gate are also the main elements of the poetic representation of the Heavenly Jerusalem in the twelfth century (Lichtenberg 1931:18, 23ff.). St. Augustine (n.d.) already knew the concept of church as royal palace: "Templum Regis ipsa Ecclesia" (The church itself is the temple of the king) (37:39).

117. We can also infer that the "lay" or "secular" western transept of the church also is a royal hall, provided for the earthly ruler to use both as throne and as a judgment hall, as the transmitted symbolism shows this part of the edifice to be. Since the continuous transept of the east end is the throne hall of Christ and his representative, so the western one is for the earthly *vicarius*. That this western solution became possible only at a specific moment, after the coronation of Charlemagne, and was not already used in Byzantium will be discussed later (see pp. 111–12). For similar meanings of this building part, compare Lehmann (1938:91) and Frey (1938:42).

118. Compare Schaefer (1945:88) in opposition to Reinhardt (1935).

119. Also on a bracteate of Frederick I (Suhle 1936:93), where the palace building appears as an abbreviation, like a baldachin above three arches, beneath the middle and highest of which the king sits with crown and orb.

120. Here a wall already surrounded the multitowered complex. Four towers stand in the corners and are overshadowed by a domed temple-like structure in the center.

121. Occasionally monasteries were surrounded by a wall, as in Jumièges (Knögel

1936:source no. 587) and Mettlach (Knögel 1936:23), where the walls were referred to as city walls (*muro civitatis*). The fortified churches of Siebenbürgen (Romania), encircled as they are by walls, are not discussed here, for they were built that way from practical necessity, rather than from any inclination to reflect a city.

122. In their capitularies, Childebert I and Clothar I affirm that it is forbidden to take a criminal by force out of the atrium in which he has sought refuge (Knögel 1936:29, source no. 833).

123. In a review of Beyer's (1925) book on Syrian church architecture, Weigand (1927:149ff.) indicated that the possibilities of deriving the double-tower facade from Hittite palace architecture were quite limited and advanced the possibility of its derivation from the Hellenistic *propylon*, the gate facade of the atrium, as a more likely candidate for investigation. Examples of this may be found in the Constantinian Church of St. Paulinus in Tyre, the Church of the Holy Sepulchre in Jerusalem, St. Stephen in Gaza, and Old St. Peter's in Rome. Predecessors of the form are to be found, for example, in the Heliopolitanum in Baalbek.

124. "The pride of thine heart hath deceived thee, thou that dwellest in the clefts of the rock, whose habitation is high; that saith in his heart, Who shall bring me down to the ground? Though thou exalt thyself as the eagle, and though thou set thy nest among the stars, thence will I bring thee down, saith the Lord" (Obadiah, 1:3–4).

125. [Epiphanies were "the appearances of a god or beneficent manifestations of the divine in a human context" and were "a staple of late antique paganism in both religious and state imperial cults" (Carr 1991:713). The ceremonial appearance of Queen Elizabeth on the balcony of Buckingham Palace is a contemporary manifestation of this. The pope's blessing *urbi et orbi*, currently given from the gallery above the entrance to St. Peter's Basilica, was formerly often given from the balcony of one of his palaces. That ritual could also be seen in this light.]

126. Transversally placed, two-storied. Compare the bracteate of Frederick I, mentioned in n. 119.

127. In the western portal of Chartres, while the miniature buildings comprising the individual baldachins over the column-figures group themselves heraldically—in the symbolic three-tower group—the cityscape above the scenes in the capital zone unrolls as a continuous frieze. This evident contrast is evoked by the impulse toward monumentality. The same contrast manifests itself in book illustration as well.

128. Doubtless here the flexibility of the intellectual outlook, the poetic vision, prepared the ground for it (Lichtenberg 1931:30, 35, 46, 51; Sedlmayr 1939).

129. This transformation stands within a larger process of individualizing and stripping the magic from earthly things. As part of this process, divine service and religion became special duties and activities of human beings. Autonomous, independent thinking installs rational perception in the place of myth. The real world becomes emptied of divinity, the latter becoming a "remote and exalted Godhead whose presence is only dimly sensed" (Mensching 1947:79ff.).

130. Hence the judgment of Haevernick (1935): "If we glance at the whole series of images on coins, there is no doubt that no attempt whatever is made here to create a picture of the building as it really is. Rather, the series of building representations develops

slowly, always with the same forms (gate, wall, tower, battlements, gables, banners) in very symmetrical manner, almost as an ornament. The idea of producing a realistic representation was far from the die-cutter's mind" (9). Nevertheless, Haevernick overlooks the striking parallels between the three-tower group on coins and seals and on contemporary church buildings.

131. As examples of the depiction of a church on a city seal that is almost like a portrait, the city seal of Bonn may be mentioned as well as that of Strasbourg. Typically enough, both date from the thirteenth century.

132. The westernmost example is Verdun (Schaefer 1945:88ff.).

133. It is also typical that the first coin demonstrably of this kind carries the inscription "Colonia urbs"; thus the meaning is even closer to the portrait of the city.

134. For the time being, we can present this picture as a possibility only as long as the question of the westwork, which also serves as a possible ancestor of the triple group, is not discussed. As the western part of the Palatine Chapel in Aachen shows, the three-tower group can also occur independently from and parallel to the westwork (Sommerfeld 1906, reviewed in Rahtgens 1907:51ff.). From the double-towered city gate, there are numerous transitions to the single-towered gate, the fortified gatehouse, and the three-towered group (J. H. Schmidt 1938:9).

135. These city symbols are very similar to the pair of mosaics (also identified by inscriptions as Jerusalem and Bethlehem) on the sides of the apse in the Chapel of St. Venantius (seventh century) in the Lateran baptistery. Individual houses, stacked one above the other, rise up like towers from behind a city wall, which includes a great portal shaped like a niche and is flanked by small stair towers (Berchem and Clouzot 1924:200–201, figs. 252–255).

136. On the question of portrait and type, the situation here appears not dissimilar to that observed in the thirteenth century, in that the uniqueness of the object being portrayed—what is proper to the individual, the realistic, the *portrait*-like—remains recognizable even though it subordinates itself to the force of the "heraldic," becoming a codified symbol, a model representing a *type*. This is a development that reaches its peak in the eleventh and twelfth centuries, and whose termination in the thirteenth century returns the act of representing to a phase comparable to that prevailing in the sixth century. The city seal of Haguenau conveys "What once was, is back again"; the mosaic in Ravenna says "What once was, lingers still."

137. Compare Hager's (1939:46) remarks about the Bayeux Tapestry. Theodoric was following classical practices of the cult of personality in his use of narrative images (e.g., Trajan's Column), which survived in Byzantium (e.g., frescoes in the narthex of Justinian's palace) and later in the pictures with which the Germanic rulers outfitted their palaces (e.g., the pictures that Theodelinda, queen of the Lombards, had placed in her palace in Monza at the end of the sixth century and the frescoes in the palaces of Aachen and Ingelheim) (Hager 1939:36ff.).

138. As in the Codex Sinopensis (Goldschmidt 1926:34, fig. 32).

139. Effmann (1899:310ff.) cites the niche-gate between towers in Teilenhofen (Eidam 1895). A Roman niche-gate between towers has also been documented in Fréjus (Schultze 1909:292).

140. The flanking stair-towers, however, are lacking (Oelmann 1922a:189ff.; Erdmann 1943:19ff.).

141. [The *Sendgericht,* or *synodus parochialis,* was a customary court for cases dealing with the laity in episcopal jurisdictions and flourished in the Holy Roman Empire from the ninth to the sixteenth century (cf. Zapp 1995).]

142. The typical Cluniac plan can be understood in this context as a final consequence of the divorce of these realms: an atrium introduced by double towers and a church without an accented, western structure resembling a tower.

143. There were similar loggias in Trier, Werden, and St. Peter's in Rome. In the atrium of Aachen, Louis the Pious received the homage of the people, and from there the clergy conducted the emperor into the church (Faymonville 1909:100ff.).

144. With the Investiture Controversy, this separation becomes obvious; with the Concordat of Worms, the forms were only partially restored. Already the *vitae* of the first half of the twelfth century speculate whether indeed it is possible to unite *pontificum* and *imperium* entirely in a single person. The unity of the regal and sacerdotal was perceived as a sort of lost paradise (Köhler 1934:99). Bühler (1934) commented on the tendency of the papacy toward independence: "Thus the papacy, in league with separatist powers, had destroyed the universalism carried by the Empire, and in the process it had indirectly and unintentionally created a large part of the spiritual, moral, and political preconditions for the eruption and spread of the Reformation of the sixteenth century."

145. A similar usage could be proposed for the stepped portal in the western transversal structures resembling palaces of Speyer and Goslar.

146. Indeed, in the reconstructions there is no obvious entrance at all (Krencker 1929:148, fig. 183a–c) (see figure 2.37).

147. It could be found already on a *denarius* of Charlemagne dating from the end of the eighth century (Lange 1942:53ff.; Schaefer 1945:88n.37). For variations on this type, see Dannenberg (1876:355ff., pl. 41, figs. 934–942).

148. The reader is once again referred to Sedlmayr (1935–1936), who documents this motif in its various forms throughout the Middle Ages.

149. This group of three arches was first understood as a portal by Oelmann (1922b: 130ff.), who traced its origins to Parthian-Sassanid palace architecture (cf. Swoboda 1919:151ff.).

150. Regarding the particular form at Aachen, see Bogner (1906).

151. The *Testamentum Domini nostri Jesu Christi* (Rahmani 1899:chap. 19), probably from the fifth century, can be seen as the earliest written evidence for the requirement that the church ought to have three entrances on the western side.

152. Henry III is also found in this spatial association in a Gospel Book (Cod. Berlin Kupferstichkabinett 78 A 2 f, 1 a, reproduced in Schramm 1935–1936:fig. 102), as is St. Mark on a folio from the Codex Rossanensis (Goldschmidt 1926:fig. 33).

153. In the westwork of Corvey, under the window of the throne niche on the west gallery, an inscription tablet from the time of the church's foundation (873–885) can be seen: "Civitatem istam tu circumda Domine et angeli tui custodiant muros eius" (Surround, O Lord, this city and may thine angels watch over its walls).

154. On the roots of fortress architecture in the North, see Schuchardt (1931). The

Roman fortress (see pp. 152–53), like the residential tower and the villa, influenced the Germanic north, whereby Roman-Frankish tradition confronted an old Germanic-Saxon tradition. On the vision of the Heavenly City as fortress, see Lichtenberg (1931: 11ff., 73ff., 87, 95). Fortress and city were not equated or identified with each other in Antiquity, but a combination was possible. Flavius Josephus (37–100), in the fifth book of his *History of the Jewish War,* describes the Temple and the Antonian fortress in Jerusalem. The fortress stood in the corner of the temple and was connected to it through entrances: "[It was] distributed into apartments of every description and for every use. [Its] various conveniences gave it the semblance of a town, its magnificence that of a palace. The general appearance of the whole was that of a tower, with other towers at each of the corners" (Josephus 1858:409).

155. Although the westwork is occasionally designated as a separate *ecclesia*, it is structurally coherent with the adjoining basilica.

156. Other references are equally appropriate for towers above the crossing and choir and, above all, for the concept of the funerary tower (Forsyth 1950).

3. Historical Meaning

1. This interpretation is most commonly presented within "genetic" art history. It conceives of the work of art as a living organism and stresses the differentiation of individual monuments in order to grasp what is unique.

2. Hence the manifold "dependencies" in Strzygowski's work (e.g., St. Maria im Kapitol on M'shatta, St. Peter's in Rome on Armenian domed churches) are often untenable. Indeed, the unity of the Mediterranean—still intact at least until the incursions of Islam in Merovingian times—makes such structural combinations possible and would render the modern idea of regarding something as "Near Eastern" absurd.

3. Haupt (1909) takes Santa María de Naranco to be an ancient Germanic royal hall; Krencker (1929:167) considers it to be a descendant of the *frigidarium* in the Roman bath with its flanking pools.

4. Although this approach *would* be appropriate for a history of German architecture in the Middle Ages.

5. On the problem of pre-Christian renaissances, compare Garger (1934) and Rodenwaldt (1931).

6. On the meaning of reception in more recent times, compare Ladendorf (1949:98–101).

7. Historical meaning not only conserves, receives, and sustains but also can destroy. The destruction of Saint-Denis by the Jacobins is comparable to the razing of the enemy's fortress.

8. In an address to the Freiburger Kunstwissenschaftliche Gesellschaft concerning the formation of style and tradition in the Middle Ages, Jantzen (1939), for whom the unique and incomparable is what is worthy of research, argued that tradition has a retarding, subordinating impulse that, in the formation of style, is opposed to the creative.

9. Kömstedt (1936) attempted to redirect the appraisal of early medieval book illumination through a new appreciation of reception.

10. The concept of reception—this new sense of reiteration—had always been at home in the circle of the Warburg Institute—that group took as its goal the investigation of the survival of the classical world in the Middle Ages—and in the so-called Vienna School as well, with particular reference to the history of architecture and Christian archaeology (Schlosser 1934). Because modern art history and literary criticism are particularly dedicated to the concept of originality, those aspects of the literary or artistic work forming part of the larger cultural stream—as opposed to the creative aspects—are only now beginning to be taken into consideration. In philology, the work of Curtius (1953), which arranges the sources according to this new line of vision, deserves to be singled out. This vision no longer concentrates on the divisions within European culture, on which all the comparative sciences had focused their attention since the nineteenth century; instead, it looks at the unique and unchanging common ground of Western culture that through reception *"aufhebt"* the classical and the medieval, the pagan and the Christian, the Mediterranean and the northern.

11. Blauensteiner (1932:17) demonstrates that art forms that are fixed due to an inherent meaningfulness of their contents—such as memorial or funerary monuments—are very often fixed in their formal development as well and are characterized by stylization, triple structures, and symmetry. See also Focillon (1934:86ff.).

12. Rodenwaldt (1921) had this "historicity" in mind when he wrote, "Artistic creation in monumental size and enduring material is first undertaken by peoples at the moment when their historical self-confidence first awakens. The absence of monumental buildings and the absence of past history of a people are basic qualities that essentially and necessarily belong together" (2).

13. Even before the realpolitik events of the present age, a spiritual aversion to the phenomena of Western history can be observed ("Happy the people whose annals are tiresome," according to Montesquieu) and was given a veneer of scientific respectability, for example, in the writings of Strzygowski (1941) and Marti (1947). The disreputable nature of worldly power, a weariness regarding change, and the slackening attraction for the things that belong to this historical complex are grave symptoms for the end of this "history." O. Spengler, H. G. Wells (1920), and A. Weber (1946) see the approach of an epoch without history. This would seem to be confirmed by the attitude of new world powers that make no attempt to use received symbols to legitimize themselves within Western history.

14. On the cooperative social forms of the Inca state, see Baudin (1947:36ff.).

15. Semper (1884), for example, holds that human society built on family, clan, and race is the "most rational and natural" (352). He concedes, however, that the achievements of the great civilizations are connected with dynastic control and hierarchic or oligarchic forms of government. According to Strzygowski (e.g., 1936), this was the case with the Indo-Europeans who lived a natural life, without recourse to force, until they became involved with the Mediterranean cultures that had been "corrupted" by the influence of the Persians. According to Marti (1947), however, the Indo-Europeans forced themselves on the original peaceful inhabitants, like the Ligurians and Wends, as despots. On the prehistoric situation, see Menghin (1910), Franz, (1937), and Quiring (1948:54ff.).

16. Religions of nature are mostly built on the clan and the imagined extended family, which is held together through relationships of a natural sort. The ancestor of the clan,

often an animal totem, is the divine father whose procreative and creative power is honored. Outside the clan religion, the divinities of other communities can easily be imagined and, according to circumstances, can be worthy of honor. Religions of nature have no inherent missionary drives (Dworak 1938:1, 12–14; Mensching 1947:27).

17. Hence, for example, the growing canon of social obligations of people without history becomes anchored to the divinity as creator and is made into a divine commandment in order to lend power to the law's validity. In the case of the Germanic peoples, before their contacts with the peoples of the Mediterranean, moral laws and other legal matters were not traced to the gods. The control of interaction rested more in the person and on the hierarchy of objects and less in a fear of the beyond (Vogt 1939:246). Until the tenth century, the Germans had no kingdom of the dead. The items accompanying them in burial were not intended for use in the beyond but were their personal earthly possessions (Redlich 1948:171).

18. Justinian, for example, published his codification of the laws as a divine commission (Dworak 1938:58).

19. The father deity of the nature religion becomes the ruler deity and takes on the attributes of the earthly king, who in his turn bases his rulership on his divine counterpart (Dworak 1938:15ff.). The relationship of man to god changes from that of a child to that of a subject. Man brings himself nearer to the god with signs of inferiority, such as kneeling and offering tribute. *Zeus pater* becomes *Zeus basileus*. Countless old Roman gods of field, forest, and house became satellites of the new gods of power (Burck 1942:10; Mensching 1947:45ff., 79ff.).

20. It is symptomatic, for example, that after Aurelian the legitimacy of the emperor no longer rested on the confirmation of the senate and army but on divine mandate from the *Sol invictus*. The independence of the emperor from common earthly society was heightened by his figure being seen surrounded by a numinous light. The worldly powers' overlapping and competing areas of jurisdiction were thus separated from this supreme sacral court. The emperor's place in the divine hierarchy placed him on a wholly different plane from the rest of the mortals.

21. For the significance for the history of religion, see Leeuw (1933:96ff., 196ff.) and Mensching (1947:22ff.).

22. Amenhotep III was the first ruler who had a temple erected to himself. He was both object of worship and highest priest (Jeremias 1919:23).

23. This picture of the development of the Hellenistic cult of the ruler is extremely simplified. Fixed conceptions and imprinted forms can be observed from the second Ptolemy on. Compare Kaerst (1927:476ff.) and Ensslin (1943).

24. From Augustus onward, there are decisive efforts to reunite the principate and the superior pontificate, an ancient unity that had been preserved in the Near East. The later emperors are supreme judges, and, thanks to their charisma, their decisions are divine revelations. As commander of the armies, the emperor acts as *deo imperante*. Only in later history do these combined functions intersect with human abilities. Instead of the magic-charismatic kingship, the king manifests the highest moral qualities: he is just, virtuous, and pious and therefore is the best ruler. Instead of the spontaneously recognized charisma, we find the sanctity of tradition and the justification in history (Mensching 1947:54ff.).

25. By approximately A.D. 400, the audience chamber had become the cult place of the palace and was termed *sacra nostra secreta*. Here the emperor's subjects fell on their knees before him (Alföldi 1934:32); Pliny the Younger addresses Trajan as *sanctissime imperator*. Not only the palace was sacred, but the city as well; Rome and later Constantinople were called *urbs sacra* (Ensslin 1943:50).

26. Some of the Roman emperor's titles included *rector generis humani*, *rector orbis*, *pacator orbis*, *invictus*, and *deus et dominus natus* (Ensslin 1943:40; Vogt 1949:280).

27. The idea that the production of documentary and representative forms, particularly in the early times, owes its origins merely to the requirements of power reveals a thoroughly secularized, materialist way of thinking (e.g., Strzygowski 1941:52, 74, 244). In reality, the records are "full of god" and are not calculated merely to make an impression on people, as would be the case with a concept of pure power. Thus the inscriptions and pictures about national events that are chiseled into the rocks in Iran serve not so much as documents and representations. Instead, they capture an event for the deity by means of an image (Erdmann 1943:47). This conduct still bears traces of the older animistic concept that the spirit living within the stone makes the name or picture carved on its surface lasting and holy (Kaschnitz-Weinberg 1944:35).

28. In a still wider sense, we might observe here that many self-confident rulers had collections of an encyclopedic nature compiled—for example, Charlemagne, Henry the Lion, and Louis XIV (Philippi 1923:61; Fegers 1943). The dogmatic and liturgical codifications of the church and the legal codifications of Justinian and Napoleon can be seen in much the same way.

29. Regarding the penetration of this kind of governmental structure into Germanic community forms before Charlemagne, particularly concerning the continuity of Germanic forms, Mitteis (1941:53, 1944:171) sees the historicity of the state as already prepared in the installation of a tribal monarchy within Germanic forms of community structure. The nobility stands in parallel to the monarchy—and, for him, is not derivable from it—and corresponds to forms rooted in the structure of clans in the prehistoric period. Compare also Naumann (1940) and Jankuhn (1938:271ff.).

30. Thus in Rome, for example, numerous prehistoric social rules were integrated into the legal apparatus of the state (Burck 1942). Similarly, the feudal practice of the Indo-Europeans, which installed itself in place of the autocratic and theocratic despotisms of the original Mediterranean population, represents the structures of prehistoric clan relationships elevated to historicity (Schenk 1947:204ff.).

31. For the religious changes brought about by settlement, see Mensching (1947:66).

32. The architectural forms of tombs (Glück 1933:49) and the ruler's palace (Frey 1942:155) were often carried over from the forms' particular prehistoric conditions.

33. The emperor's picture also appears with the army, as its actual leader, and on the coins as guarantor of their genuineness.

34. The caliphs' relationships with their predecessors were often similar in that they simply substituted their own names for those of their predecessors in inscriptions (Berchem 1910:134).

35. It is significant that in the foundation of the Norman states—above all, in Sicily—a secular civil law developed rather than a spiritual or an ecclesiastical one. Burckhardt

saw the first embodiment of the modern type of state, the princely-bureaucratic territorial state, in the Sicilian monarchy. Clearly the appearance of such a state rests on the older Germanic conception of law as grounded in the functional relationships of human society rather than as linked to a divine order (Schmidt 1915:42).

36. As representative of the imperial position, Otto of Freising (1912a:267, 301) had a strong aversion to the Normans' concern for their own national law. He termed them a *gens inquietissima* (a most restless people).

37. One might interpret the unprecedented concept of power in the Italian Renaissance (Burckhardt 1934:57) in this light.

38. We should also understand the architectural style practiced by the Normans in this way. For example, in the pictorial images of the conquest of England in the Bayeux Tapestry, they adopted the forms of the West—building in stone, the basilica, the patterns formed by columns—but enlivened them with a unique spirit that allowed the roots of the architectural elements in the developments of late Antiquity to be completely forgotten (Gall 1925:1915).

39. For example, Louis the Pious in the palace of Ingelheim and Henry II in Merseburg (Schramm 1935–1936:36; Hager 1939:37ff.). Theodelinda, queen of the Lombards, had pictures of the history of her people erected in her palace at Monza: "Ibi etiam praefata regina sibi palatium condidit in quo aliquid et de Langobardorum gestis depingi fecit. In qua pictura manifeste ostenditur quomodo Langobardi eo tempore comanu capitis tondebant vel qualis illis vestitus qualis habitus erat" (There the aforementioned queen built herself a palace in which she caused some of the heroic deeds of the Lombards to be painted. In this picture it was plainly depicted how the Lombards of that age cut their hair and what their costumes and postures were like) (Clemen 1889:222n.1). Even before this, Christendom could produce such pictures, as the arrangement and content of the Joshua *rotulus* shows.

40. With the meaning "cross-beam" the word *templum* was applied to the sacred precinct, where the worshipers waited for divine signs, and finally to the house of the god: "Templum significat et aedificium deo sacratum et tignum quod in aedificio transversum ponitur" ("Temple" signifies both a building dedicated to God and the beam that is placed across the building) (Festus, quoted in Weinstock 1932; Flasche 1949). The same was also true for *tabernaculum*, meaning "beam," which later signified "booth" and still later "shrine."

41. The "forest" (Ger. *Forst*) originally designated an enclosed area of the royal estate (Trier 1947:9).

42. Menhirs were often arranged so that they formed a circle (Röder 1949:6, 22). One could also derive the open place in the ancient city, the agora, from the sacred meaning of the area set apart. From this meaning could be derived the early Christian basilica as a community assembly place, but this interpretation applies above all to the mosque. The mosque was originally a quadrangular, walled place set aside for assembly, the administration of justice, and the imparting of lessons. It was only slowly, through the physical requirements of the cult—the installation of the Mecca-wall and the erection of a *mihrab*—and primarily through the type of the funerary mosque that the mosque became a space set aside for the cult (Kühnel 1949).

43. In later architecture, for example, in the garland of columns in the Greek temple and in the choir columns of the Gothic cathedral standing around the altar-grave and referred to as apostles.

44. Such as *Reich* and *Ding* (Trier 1947:11ff.). [The German word *Reich* means "empire," cognate to the English "reach," as in "outer reaches," and the German word *Ding* means "object," cognate to the Old English *Þing,* meaning "legislative assembly."]

45. "By being tied to the soil, the meaning of what it is to be lasting, permanent, and unchanging first enters mankind's worldview and with it a concept of the destructive nature of time. Hand in hand with that goes a consciousness of past and future, for until that time consciousness had been more or less like a point in time, existing only in the present" (Kaschnitz-Weinberg 1944:37).

46. In the ancient cemetery in Merimde in Lower Egypt, the dead frequently were buried so that their gaze was directed toward the place of the former hearth (Scharff 1944–1946:14).

47. In Assyria, the practice was for the living to leave their house and give it over to the dead one (Andrae 1930). Initially, the tomb house even had a bath and a toilet for the dead (Scharff 1944–1946:18).

48. This is still clearly visible in the written Babylonian symbol for tomb (Andrae 1930:11).

49. This conception is also interwoven with that of the Babylonian throne hall (Wachtsmuth 1929–1935, 1:18ff.) (see figure 3.8).

50. The ground plan of this long temple has a certain similarity with the basilica, although it should be observed that nave and aisles do not communicate, for freestanding pillars in the inner space were absolutely unknown in the Mesopotamian temple. A connection between this Assyrian epiphany-temple and the old Babylonian ziggurat is represented by the temple of Assur at Kar-Tukulti-Ninurta, where the niche for the appearance of the god is set into the attached ziggurat, which represented the true, albeit inaccessible, dwelling of the god (see figure 3.6). The god descended from his temple and showed himself.

51. Although the hieroglyph for "temple" still shows its origins in the windbreak constructed out of mats (Andrae 1930:64ff.), it is doubtful whether the Egyptian–Mesopotamian *aedicula* of the god could really still have been understood as such, for their builders had long ago gone over to construction in brick, and the reed hut survived only in buildings of lower status. It is similarly doubtful that when they looked at temples made of stone, the Greeks saw connections with their own temporally distant wood buildings in them.

52. This kidnapping of the gods and tokens of a conquered land has found its imitators well into the present. Napoleon had the columns from the chapel of Aachen taken to Paris. To our secularized way of thinking, from which practical magic has been completely excluded, this action appears as "art theft," expressible in units of currency and illegal material enrichment. Thus deprived of its deeper meaning, it finds its place among the articles of the Geneva Convention.

53. The tendency of the nomadic people of Upper Egypt to construct rectangular,

walled-up pit-graves first appeared when they became acquainted with the concept of the grave-as-house of the settled people of Lower Egypt (Scharff 1944–1946:n.36).

54. It should be noted that in the prehistoric Nordic tradition of building in wood, stone—which was not yet turned to building purposes—possessed a status of particular holiness for quite a long time. After the ridgepole and the hearth, the holy stone was a center of magic power (Saeftel 1935:115). In the Hebrew Bible, accounts of Absalom setting up a stone because he was childless, of Jacob setting up a stone in Bethel because God appeared to him there, and Moses setting up twelve stones for the twelve tribes all point to the powers residing in stone (Röder 1949:76; Mensching 1947:59).

55. The use of *rustica* blocks in castle and city walls reappears in Hohenstaufen times (Roth 1917).

56. When the Anglo-Saxons first settled in England, they continued their tradition of building in wood. After the triumph of the Roman over the Celtic church at the Council of Whitby (664), building in stone "after the Roman fashion" (*more romano*) became the rule. The contrasting term *more scottorum* indicated the practice of building in wood (Pfeilstücker 1934:72ff.).

57. For the use of stone in Speyer, see Weigert and Hege (1933:147ff., 153).

58. In Germany: Cologne, Augsburg, Mainz, Trier, and Aachen. At the end of the sixth century, Gregory the Great wrote to Bishop Mellitus that he should convert the pagan temples into Christian churches, "for if the shrines are well built, it is essential that they should be changed from the worship of devils to the service of the true God. When this people see that their shrines are not destroyed, they will be able to banish error from their hearts and be more ready to come to places they are familiar with, but now recognizing and worshipping the true God" (Bede 1969:107, quoted in Mensching 1947:148). In this statement, one senses the reserve of "higher" piety in the face of the popular religious predilection for the materiality of the holy and of tradition.

59. After the Franks overran the great Roman cities of the Rhineland, they generally refrained from rebuilding the destroyed cities since these had no place in the Franks' feudal state organization, but they converted the Roman legate's palaces into royal or ducal castles. The regional dukes and the archbishops resided there, as would the bishops as representatives of the king in Ottonian times—for example, in Cologne and Trier.

60. For the theft of spolia in Antiquity, see Kitschelt (1938:16) and Deichmann (1940:115ff.).

61. Parts of the buildings from Antiquity can be conceived of as relics in a double sense; they can possess magical powers (as later in the miracle-working column of St. Gereon in Cologne [Clemen 1916–1929, 1:26ff.]), or they can be irreproducible vehicles of a vanished era and its art. Examples of the latter are Petrarch's appraisal of the ruins of Rome as relics (Heckscher 1936:27) and the fact that Pope Nicholas V allowed the buildings of Antiquity to be dismembered to ennoble his own (Heckscher 1936:20n.17).

62. The "profaning of once-sacred materials" plays a subsidiary role in the theft of spolia from pagan temples (Deichmann 1940:116).

63. One example among many: in San Paolo fuori le mura in Rome, many of the capitals are ancient spolia, but only the columns upholding the triumphal arch have antique shafts as well (Deichmann and Tschira 1939; Deichmann 1940:124).

64. Such "theft" is also evident in Antiquity. Two looted columns were set up in the tenth century B.C. in Assur as the "royal steles" in a row of steles, columns until then being unknown in Assyria (Andrae 1930:41).

65. Wachtsmuth (1929–1935, 1:45, 2:11ff.) already discussed this development in its particulars. He explored the rise to prominence of the antechamber, main hall, and holy of holies along a single axis; the attachment of towers; the combination of axial and transversal buildings; and so on in Near Eastern pre-Christian architecture.

66. It is characteristic that Krencker (1929:161), in his investigation of the "green" phase of Trier—by which time the Roman bath was no longer used as such—could draw on palaces, temples, *praetoria*, army camps, early Christian church structures, and fora for comparison in his interpretation but was unable to ascertain the use of that structure as a *praetorium* with any certainty.

67. It is pointless to try to see something like the Forum of Trajan as influenced by military architecture because it was more austere, or to quarrel whether Split should be called a palace, a military camp, or a city. It is the fundamental unity of the idea underlying all of them that is decisive.

68. This unofficial, "clumsy" architecture was what Witting (1902) had in mind when he excluded the great received "official" buildings—the ones that were received as "representative" buildings—from the development of ancient Christian architecture.

69. For example, Baghdad—the circular city of al-Mansur (Sarre and Herzfeld 1920, 2:129ff.; Wachtsmuth 1929–1935, 1:217, fig. 132). Compare also the hypothetical reconstruction of the palace of Attila (see figure 3.15).

70. This would be an argument—but only one—for the assumption that the Greeks were unacquainted with the courtyard house.

71. Compare Weigand (1933:458ff., fig. 29) and the Roman fora. In contrast to the orderly Fora Julii, Augusti, and, above all, that of Trajan (see figure 3.9), the Roman Forum was still irregular. Observe the relationship of the layout of the imperial fora to the early Christian basilica (e.g., the Lateran basilica). The entire layout had to be traversed from Trajan's Forum through the Basilica Ulpia (which took the place of the later Christian transept, transversally placed behind the forum, opening into it through three portals), past Trajan's Column (flanked by libraries, as in the Plan of St. Gall), eventually to the *presbyterium* of the temple of Divus Trajanus (Rodenwaldt 1942b:357, 1942b:372). Compare also Boehringer and Krauss (1937:35ff.).

72. The overall plan of Hatra, for example, shows an irregular city wall enclosing a rectangular palace compound in whose western part the actual palace stood (Andrae 1908–1912, 1, pl. 1).

73. Examples are the "Imperial Baths" in Trier and the Palazzo d'Oro of Hadrian's Villa in Tivoli (Krencker 1929:figs. 129a, 220).

74. Comparable with the three-winged *porticus* villa and the Baroque *cour d'honneur* and, to a certain extent, with the imperial palace in Lyons (Krencker 1929:fig. 222).

75. Two extreme examples of such layouts are the Hittite temple I in Boghazköy (fifteenth to twelfth century B.C.) (Puchstein 1912:pl. 33, 95, fig. 70) and (in Roman times) the Flavian Palace on the Palatine (Krencker 1929:fig. 219).

76. For example, military camps, forts, and the later Islamic caravanserai and *madrasa*,

because of the size of the open area and the relatively weak accent on the buildings arrayed against the inside surface of the wall (Krencker 1929:figs. 226–228; Krönig 1950; Wachtsmuth 1929–1935, 1:156ff., 182ff.). In the caravanserai inside a city, this open space could also be covered over (Wachtsmuth 1929–1935, 1:173ff.).

77. For example, the arrangement of spaces in the throne hall of Nebuchadnezzar's palace in Babylon (see figure 3.8) perfectly illustrates the solution for connecting a greater room or an area containing the crowd to a smaller room sheltering the holy of holies. Its origins in the Babylonian courtyard house are obvious. This was the usual solution until the adoption of the transept by the Christian church.

78. By the third century, the *Apostolic Constitutions* already called for an oblong, oriented room (Funk 1905:1.57.2–7). Compare Liesenberg (1928:45ff.) and Paulus (1944:3).

79. El-Anderin (Butler 1929:pl. 8) and Tebessa (Gsell 1900). Here a small plaza was set in front of the great court of the fifth-century monastery, from which a great temple stairway led to an atrium. This forecourt, probably laid out as a garden and transected by paths in the form of a cross, is an early form of the cloister that preserves the ancient function and arrangement to this day.

80. The intention of making these early monasteries look like fortresses can be traced to the circumstances of founding (e.g., Bénian was erected at the time of the Vandal invasions) but, above all, to the fact that in its planned and centralized organization, with the absolute ruler at its apex, the monastic community resembled the ideal of the Hellenistic city community. Another reason that explains the concentration of this type in Syria and Africa is that these buildings were located in the immediate neighborhood of military camps and desert palaces in the combat zones of the Roman Empire.

81. For example, the monasteries of Id-Der, Il-Uber, and Dêr-Nawa in Syria (Butler 1929:88, 90, figs. 91, 93, 112). In Dêr-Nawa, the relationship to the Hellenistic garrison-palace layout (Split) is still very clear.

82. Even this reduced form still follows the overall Hellenistic pattern and some scholars have attempted to see close analogies to the cult of Adonis in the arrangement of *propylaeum*, atrium, and church-hall (Heisenberg 1908:197ff.; Schwarz 1913:340ff.).

83. For example, Etchmiadzin in Armenia (Bachmann 1930), Fontenelle (Schlosser 1889; Fendel 1927), Centula (Effmann 1912), and Lorsch (Behn 1934). In Lorsch, the idea of the *via triumphalis*—in addition to the concept of the forum—might have resulted in the development of the atrium.

84. The reasons for the failure of the attempt to merge the palace with the church are based on the history of the Western *imperium* and will be discussed later.

85. Already under the tetrarchy, the emperor, Diocletian, was no longer committed to a single city as the seat of the imperial court; he carried his gigantic empire with him and ran it from wherever he happened to be (Vogt 1949:97ff.).

86. The satraps of the great Persian kings copied the royal palace in their buildings (Bissing 1923:49); in Hatra, the "official" palace was copied in a neighboring private house (Andrae 1908–1912, 2:69, fig. 75).

87. For the area around the cathedral in Cologne at the time of the Franks and Carolingians, see *Der Dom zu Köln* (1948).

88. The discoveries made in 1942 during excavations for a bunker (Gerster 1948:73ff.) and the excavations in the cathedral since 1945 clearly point in this direction. Compare the publications of Doppelfeld (1948a, 1948b, 1948c) and Vogts (1950:15ff., 45).

89. Compare also Lilienfeld (1902) and Ohr (1902). In the context of earlier statements it would naturally be more correct to speak not of worldly and spiritual—profane and sacral—spheres but of a gradual separation of these domains as a result of the church becoming autonomous.

90. Attempts have been made to trace the lack of a double choir in Speyer to this extraordinary triumphal way. In this, Speyer has a parallel in Saint-Denis, which is also a royal burial site (Röttger 1934:82; Fuchs 1929:52).

91. It is on the basis of this negative aspect that the process of palace building in later Salian and Hohenstaufen times should be understood. The worldly and spiritual spheres having separated themselves, the emperor again built his own palaces. The cathedral was no longer a state church in the older sense. This negative aspect will shed light in particular on the buildings of the Hohenstaufens in Sicily. There, ever since the Normans, emphasis had been placed on the apparatus of the state in opposition to that of the church. Particularly under Frederick II, there was an extensive palace and castle architecture, while church construction supported by the emperor was almost completely lacking.

92. The placement of the baptismal chapel vis-à-vis the main church also remains without a uniform solution.

93. On the rejection of the official cult of the emperor, which entailed the total repudiation of society's existence, compare Mommsen (n.d., 5:520ff.) and Becker (1913:155ff.). Already in the pre-Christian Near Eastern mystery cults the world was held to be evil (Vogt 1949:65; cf. also Fuchs 1938). This was the beginning of a fundamental characteristic of those world religions according to which from the beginning of his existence man was accursed and could be saved only through an active belief in the facts of salvation. According to earlier folk religions, however, man was born into a state of grace from which he could be cast out if he offended against the ritual proscriptions (Mensching 1947:20ff.).

94. In the words of Photios, "the believer is immersed in the sanctuary as if he had actually entered into Heaven" (quoted in Wulff 1929–1930).

95. Further similar testimony can be found in Hippolytus, Arnobius, and Lactantius (Koch 1942:94ff.).

96. The principal obligatory liturgical formulations were fixed by Gregory the Great around 590 (Klauser 1944:4). See also Schermann (1914).

97. Early Christian ascetic ideals would be passed on by monasticism in an "inner emigration," as it were (Vogt 1949:273ff.), partly in reaction to Arian Caesaropapism and partly as a stand against the sacramental hierarchy of the church (Tellenbach 1936:55; Marx 1948).

98. Alföldi, Delbrück, Grabar, Klauser, and Köllwitz have uncovered these relationships. Compare also the more recent work of Kantorowicz (1944) and Lehmann (1945).

99. On this question in general, see Nissen (1906–1910); on orientation in Christian church architecture specifically, see Sauer (1924:87, 393n.117) and Weigand (1922).

100. The imperial god of ancient Egypt was Ra, the sun god (Moret 1902:278ff.; Baethgen 1888:33ff.; Jeremias 1913:174ff.; Kampers 1924:6ff.; Dworak 1938:23ff.).

101. The bishop was later enthroned in the eastern end of the church as a symbol of the cross in the apse above him (Sybel 1925:140ff.). Compare also Nissen (1906–1910:21ff., 322ff.).

102. The account from *The Book of Ceremonies* on the imperial coronation reads: "While the gold-embroidered curtain covers the tribunes, so that their Majesties are not visible, the singers sing the hymn 'Rise Up.' Forthwith the curtains are lifted and all that are in the sacristy hail their Majesties" (Dietrich 1912:27).

103. As the King of Heaven, Sun of Righteousness (Dölger 1918:414ff.; Barthmann 1904; Nissen 1906–1910:417, 391; Schlosser 1927b; Stauffer 1941:41ff.; Lösch 1933; Bousset 1921; Lohmeyer 1919; Herwegen 1920). Leo the Great had to attack the deplorable custom of saluting the rising sun (Sauer 1924:295, 432), and Tertullian fought against the popular rumor that Christians worshipped the sun (Straub 1942:387). The *Sol invictus* no longer appeared on coins after 320; the sun symbol could therefore be appropriated as an attribute of Christ (Vogt 1949:86).

104. The cult of Louis XIV, *le roi soleil*, might be mentioned.

105. Under Theodosius, though, the emperor as "sinner" was already possible.

106. In the Forum of Trajan, even more so than in Leptis Magna, the transversally placed basilica closes off the plaza of the community from the space of higher status, much like a choir screen does. The transversally placed room forces one to stop and face it head on (Brunoff 1927:48).

107. The character of the community meetinghouse as an open plaza is clearest in the *basilica discoperta*, a basilica with an unroofed central nave, attested in literature until the sixth century (Klauser 1942:n.22; Dyggve 1940).

108. This use is first found in the Christian church building (Kitschelt 1938:37ff.).

109. In the small, provincial, pagan basilicas in Kempten and Ladenburg am Neckar, the portico was already interrupted on the narrow side (Schultze 1928).

110. For example, Old St. Peter's and the Shrine of St. Menas in Abu Mina (see figure 3.25), where the type of the Constantinian state basilica was taken up again by Emperor Zeno (474–491) (Liesenberg 1928:87, 91ff.). Schneider (1950) also maintains that it was initially as a judicial apse that the apse found entry into the church and rejects the interpretation that it was originally a sacral niche for the altar (Alföldi 1935:133) or funerary niche (Dyggve 1940). The "acoustic" origins of the apse may be dismissed (Wulff 1914–1918, 1:202).

111. On the different meanings of the word "apse," compare Schneider (1950) and Hager (1901:143ff.).

112. As the *sedes episcopalis* in Augustine and the *Liber pontificalis* (Otte 1883–1885, 1:47; Sauer 1924:132n.5). In the judicial and market basilicas, it served as the seat of the supervisory authority (Langlotz 1950). Apsidal altars can be found in eastern Syria in the fourth century (Klauser 1932:355). In early Christian times, however, the altar generally stood in front of the apse (Sybel 1906:90ff.).

113. "In the east, in the Lord's part, there shall be a presbyterium, in the midst of which, elevated by three steps, the bishop is enthroned. In the west the laity shall sit" (Liesenberg 1928:45ff.).

114. Extensively discussed by Dyggve (1939) and taken up by Kempf (1949:10), but compare Klauser (1942:14).

115. In any event, there were important exceptions in Ottonian times: both St. Pantaleon in Cologne and St. Patroklus in Soest were single-aisled churches that nonetheless had transepts (see p. 276n.96).

116. It is debatable whether the Visigoths thereby linked the indigenous, provincial Roman mausoleum with the early Christian one (Schlunk 1935:1ff.) or whether they had already adopted this as their own manner of building (Glück 1933:169ff.).

117. Naturally, there are rectangular single-naved halls that served as houses of God in early Christian times. They seem to have been very widespread, even in the second and third centuries (Liesenberg 1928:190–96). But they are all without apses.

118. This is implicit in the small rectangular buildings over the graves of martyrs in the Rhineland (Lehner and Bader 1932:43ff.), most recently discussed by Klauser (1947:39, 41 figs.). Compare also the Chapel of St. Benedict at Monte Cassino (Frankl 1927:8, fig. 6).

119. This is the opinion of Witting (1902), however, and most comprehensive theories follow him even today. While it should be granted that some architectural phenomena *can* be causally connected to liturgical changes, the concept of "development" that intrudes into every observation of an architectural component overlooks the historical phenomenon most characteristic of the architecture of the Middle Ages: that the fixed, largely received types initially are sharply delineated and that gradually at first—under the influence of other locally operating factors—changes follow that can lead to new solutions that are often artistically more valuable because they are more disciplined. All of this shows, however, that the original meaning is gradually being lost. The fact that the original meaning is often no longer current with us and can be reconstructed only with difficulty, while the form in its development stands clearly before our eyes, poses particular difficulties for any exposition of this kind.

120. Take, for example, the offertory procession—the *offertorium* that introduced the principal part of the action and communion in the first centuries (Mabillon's [1687] *Ordo romanus I*; cf. also Schreiber 1948:306ff.). Klauser connects it to the beginnings of the Roman transept as a consequence of the classical tribute and gift distribution of the imperial cult. We cannot expect this enlargement of the transepts to have been necessary in the great, spacious state basilicas on purely functional grounds, when in subsequent centuries it is found neither in smaller nor larger buildings.

121. On the adjoining of the *cella trichora*, compare Rossi (1864, 3:495), Kraus (1896), and, most recently, Paulus (1944:4ff., 68ff.); on the choice of the tower-crowned, truly cruciform burial church that originated in Asia Minor, see, most recently, Guyer (1945:73ff.); on the impact of the *heroön*, see Dyggve (1940); on the meaning of the architectural followers of the Church of the Holy Sepulchre in Jerusalem—which is still not fully recognized—see, most recently, Krautheimer (1942b) and Forsyth (1950).

122. For early Christian times, compare Paulus (1944:15ff.), Kitschelt (1938:51ff.), and Kempf (1948); for Byzantine art, see Schneider (1941a); for the later Middle Ages (with particular reference to the westwork), see Rave (1937) and the work of E. Lehmann, Reinhardt, Pinder, and Krautheimer.

123. Compare the remarks on combining the Roman transept with the true cruciform church on pp. 180–84.

124. With the perfect Byzantine cruciform church with a segregated crossing in mind, Guyer (1945) completely misunderstood the meaning of Charlemagne's reception of the archaic Constantinian transept basilica (Krautheimer 1942a) and characterized it as "barbaric incompetence." Due to its excessively narrow scope and the idea of development underlying it, Beenken's (1930:226) judgment remains similarly unsatisfactory.

125. One notes the apologetic remarks of Dietrich (1912) in the introduction to his translation of *The Book of Ceremonies* and the text where Freytag (n.d.) refers to Byzantium as the first European civil-service state, "which knew how to bestow an sense of assiduous servitude on its subjects, an obsession with titles, attachment to exterior trappings, delight in ornate ceremonial" (1:105).

126. The work of Dom Rhabanus Haacke, O.S.B. (1947), completely misunderstands the real status of the emperor.

127. Sometime before 381, the whole complex was replaced by a larger double-church layout that no longer possessed these archaic characteristics; instead, in the southern building an apse opened into the community space (Gnirs 1915:164, fig. 127).

128. This would recall the earliest phases of the Byzantine cruciform domed church (Lassus 1947:124ff.; Bandmann 1950).

129. For a discussion of the relationships in the Baroque period, see Frey (1946b).

130. According to Roman legends, it was as a repentant sinner that Constantine delegated his powers to the pope as his deputy (Vogt 1949:261).

131. The niche dedicated to the cult of the emperor in a transversal building opening into the courtyard of the Baths of Antoninus in Ephesus belongs in this series, as, perhaps, does the audience hall in the Flavian Palace (Domus Augustana) on the Palatine, which served as a dining room and shows a similarity to the transept of Old St. Peter's and to the Shrine of St. Menas primarily in the series of small niches (Lemaire 1911:45).

132. This separation naturally had a liturgical basis. In the Eastern liturgy, the celebrants emerge briefly in front of a *scena* comparable with that of the classical theater, but the entire Western liturgy was celebrated before all eyes (Liesenberg 1928:33). *The Book of Ceremonies* (Dietrich 1912:26ff.) reports that during his coronation the emperor, accompanied by the deacons, entered the enclosed altar area and administered the eucharist to the patriarch. After leaving the altar area, the emperor gave his blessing to the patriarch and exhorted him to carry out his duties.

133. For further substantiation, see Kitschelt (1938:52ff.).

134. This displacement of the altar into the apse, with its accompanying change in meaning, is also connected with the turning of the priest toward the east (Liesenberg 1928:64).

135. Eusebius (*De vita Constantini*, 3.49) reports that in Constantine's palace, the cross was set up in the center of the vaulting as the new insignium of the emperor and of God (cf. Kitschelt 1938:56; Paulus 1944:16). Some examples from Byzantine ceremonial: the emperor carried the cross in his hand at Christmas mass, and from his throne he made the sign of the cross over his people after his return from battle and at official games (Dietrich 1912:42, 56, 78).

136. Concerning the importance of the throne hall in Byzantine times, it is reported that two armchairs stood there. The one on the right was reserved for Christ and remained empty on Sundays and holidays, but on workdays the emperor reigned from there as the deputy of Christ (Schneider 1941a:10).

137. From the consecration inscriptions of Old St. Peter's and San Paolo fuori le mura in Rome.

138. For possible connections of the transept to the throne hall and the other choir structures, such as the three-celled presbyterium and the basilica with an attached central-plan building, see Kitschelt (1938:59ff., 63ff.).

139. Recently, this has been extensively discussed by Kirsch (1939) and by Krautheimer (1942a:2n.9). It concerns the Lateran basilica, Old St. Peter's, San Paolo fuori le mura, Thessaloniki, and probably the Church of the Holy Apostles in Constantinople.

140. On the development of the Constantinian basilica, see Kraus (1896, 1:265), Lietzmann (1923:127ff.), Kirsch (1935), Wulff (1936), Langlotz (1950), and Deichmann (1950b).

141. A similar situation existed in the imperial basilica in Trier, where, as sun god, the emperor was enthroned in the apse with the gods of the week surrounding him (Massow 1948:18ff.).

142. Gratian dropped the title *pontifex maximus* in 382.

143. Only later—probably under the influence of the nearby great martyrs' churches, which gained priority everywhere between the sixth and tenth centuries—did the name of St. John take precedence. In the kingdom of the Franks, funerary and martyrs' churches outfitted with precious relics also enjoyed a far higher regard than the cathedrals. The presence of the robe of St. John the Evangelist beneath the altar was mentioned for the first time during the reign of Gregory the Great (Lauer 1911:77).

144. Some mention should be made of Charlemagne's palace in Aachen, which he referred to as his "Lateran" (Lauer 1911:119; Krautheimer 1942a:35ff.). The she-bear in Aachen (a parallel to the Roman she-wolf in front of the Lateran palace) and the equestrian statue of Theodoric, which Charlemagne had brought to Aachen from Ravenna, were intended to ensure its "Lateran-ness."

145. The Lateran palace is referred to as belonging to the pope in his capacity as deputy of the emperor as early as the *Vita Silvestri*. It also appears thus in the *Liber pontificalis* and according to Gregory of Tours (Lauer 1911:27ff.; Coleman 1914:324.).

146. The Leonine ambulatory, which was renewed by Nicholas IV in 1288, passed above this pavement (Lauer 1911:33ff.).

147. The great *triclinium* was erected under Leo III. The Vatican became the residence of the popes only after the return of Gregory XI from Avignon in 1372.

148. Even in post-Carolingian times, most episcopal palaces also served as royal castles and palaces—for example, in Cologne, Mainz, Worms, and Speyer. The same holds true for the monasteries.

149. A passage, which was destroyed in 1806, led from Speyer Cathedral to the palace.

150. In Goslar and Bamberg, for example. The relationships were fundamentally different after the Investiture Controversy, when the emperors still possessed their own *Eigenkirchen*, but these were no longer the principal churches, and the old relationships continued to be reflected only in castle chapels.

151. The cathedral connected to the bishop's palace in Bosra was also a central-plan building (Butler 1929:125, fig. 124).

152. The divisions of space were determined by the imperial processions (Ebersolt 1910b; Dietrich 1912).

153. See n. 121. Compare also Wulff (1914–1918, 1:18ff.), Rahn (1866:22), Freshfield (1913), Bettini (1946:29ff.), Lassus (1947:116), Grabar (1946), and Guyer (1950).

154. These ideas were first explored extensively by Kraus (1896:262ff.).

155. The cruciform western European passage-graves of pre-Christian times have a genesis different from that of the Mediterranean ones and are not centered (cf. Müller 1905:75, fig. 56; Paulus 1944:103n.16; Glück 1933:257ff.).

156. The St. Mangenkirche in St. Gall is also very similar (Fiechter-Zollikofer 1947:65ff.).

157. In his polemic, Guyer (1950:91ff.) sees the type of Old St. Peter's as an incomplete cruciform church that, because of its reception in Carolingian times, retarded the development of the true cruciform type: "Doubtless, in view of the Greek cruciform church with segregated crossing, the adoption by Charlemagne of the Roman transept basilica represented a step backward to a more primitive level. It is, however, one of the unaccountable caprices of the history of architecture that due to its prestige, this form, unfortunately built above the graves of the holy apostles, exerted such a great influence that it retarded again and again the development of the Romanesque cruciform basilica" (96).

158. The semicircular ambulatory connecting the pastophories to each other outside the apse indicates this. Already found in Leptis Magna, it later became widespread in Egypt (Liesenberg 1928:78ff., 102, 119, 194ff.).

159. In these cases, the transept is usually present as a matter of course.

160. For example, in Werden II (Effmann 1926) and in the stump-transepts surviving on the lower Rhine in Heisterbach, Mönchen-Gladbach, and Neuss. Even Riehen, which looked like a cruciform church from the outside, on the inside had closed off the transept-arms to make them look like chambers (see figure 3.21).

161. How closely the cathedral of Metz follows the early Christian formulation can be seen by comparing it with the church of Teurnia (St. Peter im Holz, Steiermark) (Egger 1926:12, fig. 8).

162. The presence of a baldachin over the baptismal font was required in the early Christian baptistery so that it, like the altar, might remain pure (Rahmani 1899:chap. 19). Imitating the Holy Sepulchre, which was crowned with a central-plan, baldachin-like building, probably also played an important role (Lehmann 1945:26ff.; Smith 1950).

163. Looking at this type of crypt, one could place the ambulatory-crypt of Sant' Apollinare in Classe in Ravenna—an altar with ciborium connected through a *confessio* to an ambulatory ring (Hoferdt 1905:53)—at the beginning, although not chronologically. At the other end of its development stand such formations as the western crypt of St. Othmar in the Stiftskirche of St. Gall; the crypts of St. Georg in Reichenau-Oberzell, Rohr, of San Francesco in Ravenna, and of Saint-Avit in Orléans; the western crypt in the castle of Quedlinburg; and many others (cf. also Hubert 1938:63ff.). The baldachin-like character of the space is particularly obvious if, as in St. Cäcilien in

Cologne and St. Mang in Füssen, the middle part of the room that represents the bal-
dachin is covered with a central-plan vault while the periphery is covered with barrel
vaults (Lang 1932:49ff.).

164. The concept of the baldachin also can be seen in the vaulting of the church of San
Salvatore in Spoleto (Deichmann 1943:106ff.).

165. On the baldachin as vault of heaven, see Lehmann (1945), Navarre (1897–1917),
Rodenwaldt (1925:37ff.), and Smith (1950).

166. St. Babylas in Kaoussié near Antioch also belongs to this type (Lassus 1938,
2:5–44; Guyer 1950:74ff.).

167. It has become doubtful whether the model was indeed Constantine's Church of
the Holy Apostles (Graf 1892), since according to Kaniuth (1941) and Heisenberg (1908),
that church was not cruciform.

168. Glanfeuil, the first daughter house established in Frankish lands, was perhaps
built in this fashion.

169. On this enterprise, connected with the sacred *imperium* and stemming from clas-
sical Antiquity, compare Rodenwaldt (1942b:356ff.) and Weber (1936:185ff.). See also the
reports in Cassiodorus's *Variae* (1894:8.15, 7.5) that Theodoric's favorite relaxation was the
contemplation of the architecture of his ancient predecessors and that he had instructed
the *curator palatii* to make sure that nobody would be able to distinguish the new build-
ings from the old ones (L. Schmidt 1938:359ff.; Schenk 1938:115ff.).

170. The kingdom of Burgundy, which already in pagan times had made the priest-
hood (*sinista*) independent from the monarchy (*hendinos*), constitutes a significant excep-
tion (Naumann 1940:40, 51). This sheds a new light on the powerful Cluniac movement
of the eleventh and twelfth centuries (Naumann 1942:18ff.) as well as on the decision of
the Salian emperor Conrad II to make the feudal system the bearer of the power of the
state again, replacing the Ottonian episcopal administration.

171. Clovis was a Roman consul and styled *novus Constantinus* (new Constantine)
(Spörl 1930:314; Wrackmeyer 1936).

172. Classical Latin reemerges as a learned language only with the emancipation of
the vernacular languages.

173. The results of excavations are insufficient to provide satisfying reconstructions,
and the interpretation of literary sources stands on similarly uncertain ground. Compare
the remarks of Paulus (1944:147) on the expressions *ad instar crucis aedificata* (built like a
cross) and *opus quadrifidum* (four-fold work).

174. This continuity with Antiquity relates to only a thin upper stratum. The bloody
conflicts of the rulers among themselves, the strength of the old Frankish aristocracy, and
the power of the Frankish people's traditional way of life created strong hindrances (Hus-
song 1938:182; Brenner 1912:253ff.).

175. The round crossing tower of Cruas (Puig i Cadafalch 1928:120), dating from the
twelfth century and completely alien to what was common in the North, may be taken as
an example of how the forms of the past lived on in France south of the Loire and were per-
petuated by the Merovingians but not taken up in Romanesque art. It represented a type
that was last known in the Carolingian period (Centula), but, according to written sources,
it must have been more widespread in Merovingian times. Perhaps due to its round form

and recessed gallery, it was originally conceived as a copy of the Anastasis (regarding the tower built by Bishop Apollinaris of Clermont, see Knogel 1936:no. 241; cf. also Forsyth 1950). The same holds for the articulation of the apse by means of engaged columns (e.g., Vaison-la-Romaine), common in France from the fifth until the twelfth century, and for the application of blind galleries. The building schools south of the Loire had transmitted what essentially amounted to a set of building components in high relief, of a kind that would only much later become common in Germany, in part mediated through the paradigmatic building of Speyer and in part as a result of a new *Kunstwollen* (Schippers 1926–1927:77ff.). In this way by the sixth and seventh centuries, the building forms in Merovingian regions had already achieved an often perplexing similarity with those of Romanesque times—that is, the eleventh and twelfth centuries. Michel (1905, 1:941ff.) therefore takes the regions south of the Loire as the lands where the Romanesque originated, since it was only there that Roman vaulted construction survived. In the history of forms, however, these French crossing-towers, blind columns, galleries, and ashlar are not a perplexing anticipation. Rather, they represent a persistence of Merovingian forms that became a local building custom and continued to be practiced. The same appearances in the eleventh and twelfth centuries, particularly on the right bank of the Rhine, represent a conscious reaching back and relate not to the Merovingian, but to the sources of the Merovingian—that is, to Roman provincial construction. It is also typical that the southern French building schools never made the decisive change to the basilica or the segregated crossing.

176. It is worth considering whether the prominence given to St. Gereon by the Merovingian kings and the resulting neglect of the cathedral is due not only to the status of the martyr's relics but also to the potential that this building had with its central-plan layout, not dissimilar to that of the Byzantine court church. It was in St. Gereon that Clovis was elevated to the kingship, Theodoric II received the homage of the Franks, and Theodoric the fratricide was executed. The fact that in Frankish times the church possessed a *Westbau* that, as in Aachen, allowed the ruler to take part in the divine service from an interior gallery and to show himself to those in the atrium outside speaks for the designation of St. Gereon as both a principal church and a coronation church on the Byzantine model. On the Merovingian–Visigothic La Daurade, compare Clemen (1916: 183ff.) and Rey (1930, 1949).

177. In the palace of Diocletian in Split (see figure 2.10), the central-plan mausoleum of the emperor held a status equivalent to that traditionally accorded to a temple (Koethe 1931, 1933).

178. Scholars working under the influence of the notion of the supreme value of originality in artistic creation have made many attempts to trivialize the relationships of Aachen to San Vitale, either by exaggerating their formal differences to the point of negation or by overemphasizing the Germanic elements to underscore the relationships to the Mausoleum of Theodoric. In consideration of the historical situation surrounding the relationship between these two structures, efforts in both these directions should be rejected.

179. The Persian palace also had a great influence on the Syrian basilica, with its pylon towers (Bissing 1923:40ff.).

180. Examples are the church dedicated by Justinian to the archangel Michael on the northern shore of the Bosphorus and the Church of SS. Sergius and Bacchus in Justinian's Hormisdas palace (Wulff 1914–1918, 2:372.).

181. A layout very similar to that in Mainz has now been precisely identified in Trier: the Chapel of St. Stephen adjacent to the cathedral, a two-story episcopal chapel from the middle of the twelfth century, is connected by a corridor on the upper floor to the bishop's palace (Kempf 1949:7).

182. It is unimaginable that the frescoes in Schwarzrheindorf did not have a direct relationship to Byzantium.

183. A Germanic kingdom—an island of the Visigothic kingdom, once the most important after the Frankish and Burgundian ones—remained in Austrias for some time after the Arab conquest in 711 (Schlunk 1947, 2:330ff.).

184. Schlunk (1936) incorrectly derives the type of Santa María de Naranco not from the Germanic royal hall but from the similar Camara Santa in Oviedo, which was built between 792 and 842 as a chapel of St. Michael and plainly belongs in the tradition of the Mediterranean type of the two-story, barrel-vaulted mausoleum. Although very early used as a church, Santa María de Naranco was built as a palace building—there were baths in the lower story—and was sited transversally with a monumental outdoor stairways on the broad side. In contrast, the building of the Camara Santa is built on a long axis (Egger 1936:201–27; Dyggve 1936:228–37).

185. "Aquisgrani palacium mittens et exinde similitudinem sumens, turrim que adhuc superest erexit" (Starting from the palace of Aachen, and taking his model therefrom, he erected the tower which survives to this day) (*Miraculi S. Liutwini* 1887–1888:1265).

186. "Capellam instar Aquensis inceptum" (Originating in the image of the chapel of Aachen) (Schlosser 1892:no. 138).

187. In pre-Carolingian times, the Roman–Gregorian liturgy had already penetrated into the kingdom of the Franks (Liesenberg 1928:24; Baumstark 1923:52).

188. The type was first identified precisely and defined formally by Effmann (1899: 167ff., 1912, 1929). More recent studies are those by Fuchs (1929), Reinhardt and Fels (1933, 1937), Thümmler (1937), Gruber (1936), Rave (1937), Lehmann (1938), and Walbe (1937).

189. Studies by Rave (1937) and Beseler (1946) show very clearly the influence of other solutions to the western ends of churches on the westwork.

190. In Werden, the access is reduced to tiny openings. In the literary sources as well, the westwork is identified as an attached building with its own focus, and in Werden it is referred to as *ecclesia St. Petri*—as distinct from the main church—and in Farfa as *oratorium adjunctum ecclesiae* (an oratory attached to the church) (Fuchs 1947:25).

191. These activities all concern typical proprietary church rights and are concentrated in the westwork (Tellenbach 1936:88n.9, 89; cf. also Hofmeister 1931:452).

192. Reinhardt (1934) would see the westwork as an elevated west choir, designed so as not to impede processions.

193. Lehmann (1938) similarly sees the westwork as the mortising and interpenetration of the western tower and the transept outfitted with galleries (cf. also Paulus 1944:60).

194. Evers (1942) once bluntly criticized this view so widespread in art history thus: "Stylistic explanations are given if one no longer knows the facts" (391).

195. Lay propriclary church lords could alsu be called *abbas* (abbot) (Schreiber 1948:101). Angilbert, Charlemagne's son-in-law and builder of the westwork of Centula, was called abbot (Effmann 1912:1).

196. Schreiber (1948) traces the sources in canon law to strong Byzantine roots as well: "It was the concern of the patron that the Byzantine church and monastery, and the hospital and almshouse as well, should be administered as a legal entity and that the spiritual governor in particular be likewise installed according to the stipulations of the patron" (1ff.). Feine (1941, 1942, 1943) argues along the same lines. In his review of Heiler (1941), Seeberg (1942) notes, "The Byzantine concept of the imperial church is more important for the German kings than the Germanic proprietary church and its permutations, more important even than Augustine's City of God" (3).

197. According to Rave's (1937) corrections, which contrast with Effmann's (1912) reconstruction.

198. See p. 277n.108.

199. Monte Cassino, for example. When Glanfeuil was founded, it was reported that it had a gate with a tower guarded by St. Michael (Knögel 1936:no. 434; Wulff 1914–1918, 2:460; Gruber 1936; Krefting 1937; Vallery-Radot 1929).

200. In the form of a hall in Büraberg (Lehmann 1938:91ff.), in Passau (Lehmann 1937:259ff.), and, in Ottonian times, in St. Pantaleon in Cologne and St. Patroklus in Soest.

201. It was already interpreted in this way by Fuchs (1929:73; see also Berlet 1936:62).

202. See, for example, the astonishing similarity of the *Torhalle* of Lorsch to the town hall of Boos an der Nahe (Behn 1933:434).

203. The arches of Constantine and of Septimius Severus, for example, have a chamber over the archways and therefore are also two-storied.

204. The Roman church was already creating areas of autonomy shortly after Constantine's death. Pope Gelasius I (496) ignored the sacral authority of the *imperium*, for example, and called it simply *potestas* (Tellenbach 1934–1935:41ff.).

205. The pope, now worthy of being styled *kyrios*, acquired the "service" of the emperor as *strator*, and the emperor became *cursor* to the pope (Kantorowicz 1944:231; Ostrogorsky 1935:193ff.; Holtzmann 1918). Representations of an enthroned and crowned pope, however, first appeared in the twelfth century.

206. The clerical privileges of the emperor were as follows: he had the right to enter the choir and the holy of holies during mass, to have a cross precede him (*ius crucis praeferandae*), to have a baldachin, to be liturgically received, to be admitted into the cathedral chapter, and to use liturgical vestments in his functions as ruler (Eichmann 1942:203). Constantine originally granted some of these rights to church officials as part of their civic appointments. By the time of the foundation of the Western *imperium*, they had become specifically ecclesiastical and were now assigned back to the emperor.

207. Among other titles, Charlemagne was styled *gratia Dei rex francorum et langobardorum atque patricius romanorum* (king, by the grace of God, of the Franks and Lombards and patrician of the Romans) and *serenissimus Augustus a Deo coronatus magnus pacificus imperator* (most serene Augustus and great peace-bringing emperor, crowned by God), and Otto II was *Divus Caesar imperator Augustus* (Divine Caesar, Emperor Augustus) (Schramm 1929, 1:12; Wrackmeyer 1937; Stengel 1939).

208. As in the pictorial representations of the deeds of Charlemagne in the palace of In-gelheim (Hager 1939:37ff.), where Alexander (Kampers 1901) and Augustus (Frauenholz 1926:86; Könn 1938; Muller and Gross 1950) were turned into inspiring predecessors. With the rise of the nation-states from the eleventh century on, their own proper heroes acquired a status higher than that of these classical models. Thus the English historians replaced Charlemagne with William the Conqueror, and the French placed the figure of Dagobert above those of Augustus and Charlemagne (Spörl 1935:63ff.; Frauenholz 1926:119).

209. As a political system, the arrangement of the Ottonians—treating the archbish-oprics as units of government and filling the episcopal sees with relatives or chaplains—had classical roots in the office of the Roman provincial archpriest, a practice that worked to counter the growing independence of the regional dukes and other local powers of the empire. Bickel (1928) compares the figure of the archpriest to that of the president of a provincial assembly.

210. The installation of the popes and bishops of the Roman church by Otto III—who took Justinian as his model—should be seen in this light (Unterkirchner 1943:18, 25; Köhler 1935:44).

211. The pope's title of *pontifex maximus*, first claimed by Leo I, was never disputed by the emperor (Köhler 1935:43), however, and even after the Investiture Controversy, the popes recognized the German emperors as heads of the universal Christian state, but some popes exempted France from the emperors' authority.

212. Reinhardt (1934:178) points to the Roman aqueducts as examples.

213. On the meaning of this fusion of the engaged column, see Evers (1939:135).

214. Although a universal community was retained across the borders of states and provinces after the Carolingians through a common Latin language and common Roman law, Otto I was no longer able to fully implement the idea of a universal monarchy.

215. From the time of Richer of Reims, medieval English, French, and Norman his-torians no longer counted the Saxon emperors as part of the Roman succession (Meckert 1905:34): "Since the tenth century, West Frankish historians no longer considered the *im-perium* a historical and metaphysical value by which to guide their work" (Spörl 1935:71; Schunter 1926).

216. Pippin III was therefore called *novus Moyses et David* (new Moses and David) and Charlemagne, *novus David* (Spörl 1930:314).

217. St. Augustine still counted Augustus, Trajan, and Marcus Aurelius among the good rulers, but at the time of the Carolingians, only Constantine and Theodosius were so counted (Krautheimer 1942a:37).

218. For Charlemagne's concept of rulership (Laehr and Erdmann 1933:120ff.), see Hincmar of Reims (1852:842ff.).

219. The problem of the universal style and the imperial style in the Austrian Baroque was discussed by Sedlmayr (1937:418ff., 1938); similarly, on the art of Louis XIV, see Fegers (1943).

220. Argued on good grounds by Krautheimer (1942a:3) and Weise (1919). The most recent publication by Crosby (1942) was not available to the author.

221. Thus Paulus (1944:48, 58) in agreement with Viollet-le-Duc (1854–1868, 9:229ff., 1861).

222. In Cologne Cathedral, this arrangement was visually set forth in art. Pope Sylvester and Emperor Constantine, as the prototypes of the most important members of the chapter, the pope and the emperor, originally stood on the pillars at the beginning of the choir stalls. Biblical kings and bishops were also depicted in the stained-glass windows and painted on the choir partition, as they were in Reims (Hager 1939:54).

223. Arguing the opposing view, Feulner (1942:86ff.) believes that by designating the tendency toward centralization as German, the prehistoric apsidal houses on Malta become "German" and Speyer and Limburg, on the contrary, "un-German."

224. As a curiosity, it could be pointed out that the double choir, so celebrated by Pinder and others, was hardly judged in a positive light in the nineteenth century. Still influenced by the Renaissance conception of the facade, theorists of the nineteenth century believed that with the double-choir layouts, "the churches lost their faces, so to speak" (Adamy 1884:187), the "clear disposition was disturbed," and "a sound formation of the facade became impossible" (Bergner 1905:41). These remarks show that when the basis for judgment is closely tied to the formal appearance of the sources and confined to what can be perceived visually today, it cannot claim either historical or aesthetic objectivity.

225. The old sense of the apse as the place where the throne stood may still have been operative.

226. Abingdon, a monastery with a double-choir arrangement, was established in accordance with Egyptian monastic practices in a lonely part of England in the seventh century. Many bishops of Gaul were trained there (Fendel 1927:11).

227. Fulda, Lorsch, and Ingelheim probably also had antique capitals (Clemen 1890).

228. The survival of the practice of articulation of a surface by means of niches—so characteristic of the lower Rhine and Maas region until the end of the Hohenstaufen period—should also be understood in the same manner (Verbeek 1950).

229. Apart from the influx of northern Italian architectural sculpture in the twelfth century, which will be discussed later.

230. The author thanks Prof. Dr. Walter Paatz (Heidelberg) for letting him read his review of E. Kluckhohn's unpublished *Habilitationsschrift* (n.d.).

231. The *comacini* have their counterparts in the wandering Italian scholars Benzo of Alba, Anselm of Besate, and Petrus Crassus. With their legal and literary knowledge, these secular *literati*, accomplished in all aspects of classical learning, entered the service of the emperor and helped maintain the prestige and dignity of the Roman *imperium*.

232. The German emperors were crowned kings of the Lombards in San Michele in Pavia.

233. A capital from Santi Apostoli in Florence of 1075, for example, belongs to a group including San Miniato and the Baptistery in Florence, dated to between 1059 and 1075 (Paatz and Paatz 1940, 1:427ff.). Indeed, the sculpted capitals in Burgundy cited by Moller-Racke (1942:59ff.)—Cluny, La-Charité-sur-Loire, Vézelay, Avallon—are very similar to those created in the upper regions of the Rhine, and there are more of them, but they date from a later period, and here they are the result of imitation of Cluny III.

234. Simple cubiform capitals can still be found in 1183 in the side aisles in Mainz and in the creations of the school of Worms, although in the meantime—under the influence of the Hohenstaufens—a new classicizing art of decoration was flowering on the lower Rhine (Solms-Laubach 1927).

235. Master Donatus, who was active in Lund after 1106, the year of Henry IV's death, came from Speyer. King Erik Egode and Archbishop Asker wanted Lund to rival Speyer. The eastern part was erected in the years 1135 to 1140 by builders from Mainz. Eventually, Alsatian forms were included in the western part, and influences similar to those in Worms made themselves felt (Wentzel 1935). It is possible that Henry the Lion, who aspired to the imperial throne, also had an effect in addition to the imperial influence. Anderson (1938–1939:85) argues that after 1145 Lund had a double-tower facade. From Lund, this kind of ornamentation spread over all of Denmark and southern Sweden.

236. Much of the new Hohenstaufen architectural sculpture on the lower Rhine, which was diffused from Schwarzrheindorf and Bonn, came from Klosterrath.

237. Just as Speyer was the burial place for the Salians and favored as a place of interment for the Hohenstaufen and the first Habsburgs. Novacovic's (1942) thesis on this subject was not available to the author.

238. Kluckhohn's (1940) objections to the history of the building are not convincing.

239. For example, in the antependium (no longer surviving) of the high altar of St. Peter's in Rome, which probably represented the emperor and the pope on the left and right of St. Peter; in the mosaic in the Triclinium of the Lateran (Schramm 1935–1936:fig. 4a–m), where on one side Leo III and Charlemagne receive the tokens of their rulership from the hand of St. Peter and on the other side Constantine and St. Peter (or Sylvester I, according to Clemen [1889:225]) receive their insignia from the hand of Christ; and in a mosaic in Santa Susanna in Rome (also no longer surviving), where Charlemagne and Leo III are represented. There are also reports of similar representations from later times; for example, Louis the Pious and Pope Stephen IV were shown in the gable of the coronation church in Reims (Schramm 1935–1936:26ff., 42).

240. Pope Gregory (590–604) had a column erected in the Forum as a sign of his power as the supreme head of Christendom (Vasiliev 1932, 1:228). Gregory is supposed to have prayed for the soul of Trajan in front of the Vatican obelisk—which, according to the understanding of the times, covered the caesar's mortal remains (Giacomo da Acqui 1836–1955:1374). This legend is first found in Paulus Diaconus's *Vita S. Gregorii Magni* (1949:chap. 17).

241. Boniface VIII (Burdach 1926:153). Clement VIII's contriving to bring a column from the Arch of Constantine into the Lateran church in 1592 was also perhaps inspired by this concept (Leufkens 1913:191ff.).

242. The institution was called the *curia episcopum lateranense* until the tenth century; from 1046 on, it was called the *palatium* and finally curia (Jordan 1939; Ladner 1936:78ff.; Eichmann 1942, 1:19, 211, 224ff.; Tellenbach 1936:176).

243. In his most recent article, Krautheimer (1942a:28) retracts his earlier opinions (1934) on the influence of Cluny on these buildings. These relationships have been more recently discussed by Schwarz (1942:7ff.).

244. See the articles by Conant (1928a, 1928b, 1929a, 1929b, 1929c, 1929d, 1929e, 1930a, 1930b, 1931a, 1931b), cited in Aubert (1936), as well as Conant (1942, 1954, 1963, 1970). Compare also Weisbach (1945:42) and Evans (1938).

245. The emperor also sought—and, at first, found—confederates in the reform movements that followed (Opladen 1908; Dietrich 1934).

246. In the fifteenth and sixteenth centuries, the medieval *renovatio* became a worldly Renaissance and the medieval *reformatio* became an iconoclastic spiritual Reformation (Burdach 1926:83, 100, 132). For the first time, the unity and connection people felt with Antiquity was no longer a whole and could no longer serve as a model. The Reformation confined itself to the New Testament, and the Renaissance sought to revive Antiquity as an aesthetic whole (Panofsky 1944).

247. The quotation is from the description of the life of Hugh of Cluny compiled by Gilon of Cluny (Mortet 1911:273; cf. also Conant 1939:327ff.).

248. With the new building of Desiderius in Monte Cassino (consecrated in 1090) the westwork, which had been erected in 1011 to 1122, was removed, as were those of Farfa and Reims.

249. When Ivan III, after his marriage to the niece of the last Byzantine emperor, became protector of the Russian Orthodox church, Russia kept the idea of the "third Rome" alive from the fifteenth century on in the concept of "Holy Russia" as the embodiment of the kingdom of God (Lampert 1947:54ff.).

250. Compare the historical picture in the *Chronica de origine civitatis*, as presented by Rubinstein (1943).

251. Which is precisely why "imperial style" *cannot* be used as a chronological label for the period.

252. Strzygowski (1941:308) argues that the whole of Romanesque art represents a renaissance of Mediterranean Antiquity in the "art without power" of the northern peoples. On the strength of Antiquity's survival in Tuscany in the Middle Ages, see Beenken (1926–1927), Horn (1938), Paatz (1940:33ff.), and Paatz and Paatz (1940, 1:427ff.); on southern France, see Dehio (1886) and Horn (1937); on Dalmatia, see Kutschera (1918); on Apulia, see Geymüller (1908).

253. This can be demonstrated in the following sequence: Speyer, Mainz, Maria Laach, Schwarzrheindorf, and Bonn (Bandmann 1942:51, 75). In Hohenstaufen times, several changes occurred when Carolingian architecture, which had sunk from being an imperial style to becoming the local everyday style of the lower Rhine, interacted with Salian imperial architecture of the upper Rhine. Double-shelled, space-enclosing forms replaced the monolithic structures typical of the Salian buildings of the upper Rhine regions, the eastern parts of the church buildings became increasingly ornamented, and galleries and niches were freely employed as exterior and interior wall articulation.

254. Typical of the outlook of Henry the Lion is the codex painted at his commission in Helmarshausen, in which he receives a crown from the hand of God, although the honor of duke had hitherto been characterized by the presentation of a lance from the emperor (Schramm 1935–1936, 1:151, fig. 131).

255. That other factors, such as the development of craft workshops, helped spread Gothic architecture is self-evident.

256. See n. 36.

4. The Decline of Symbolic and Historical Meaning

1. "Reformari statum ecclesiae in eum gradum et similitudinem, in quo fuit tempore apostolorum" (In its ranks and appearance, they would reform the state of the church so that it would be as it was in the time of the apostles) (Spörl 1930:309; Heiler 1941).

2. In the eleventh century, Cluny grew into an important *Eigenkirchenherr* when out of increasing concern for the care for the souls of the dead in the afterlife nobles transferred their lay proprietary church rights to the monastery. Cluny introduced the Feast of All Souls, encouraged the Mass for the Dead, and so on. With the transfer of proprietary church rights, the donor retained for himself the privilege of being buried in the holy place. It was the Cistercians who, on principle, first turned against the Cluniacs' economic expansion and the obligations incurred as a result of the donation of proprietary churches (Schreiber 1948:81ff.).

3. "I am coming to the major abuses, so common nowadays as to seem of lesser moment. I pass over the vertiginous height of churches, their extravagant length, their inordinate width, and costly furnishings. As for the elaborate images that catch the eye and check the devotion of those at prayer within, they put me more in mind of the Jewish rite of old. But let this be, it is all done for the glory of God. . . . What possible bearing can this have in the life of monks, who are poor men and spiritual? . . . Ah, Lord! If the folly of it all does not shame us, surely the expense might stick in our throats?" (Matarasso 1993:55–57; Bernard of Clairvaux 1690, 1:538; cf. Schlosser 1896:485, no. 35).

4. "Therefore in the house of God, in which they reverently serve day and night, they retain nothing that recalls arrogance or abundance or that would impair their freely willed poverty; they want no silver or golden cross, rather only a wooden painted one, no lamp other than an iron one, no mass-clothes other than linen, without golden and silver decoration" (*Nomasticon Cisterciense* 1664:chap. 17.54ff.).

> Art is spurned, for Christ also spurned precious metals. . . . The beautiful paintings, the complicated carving—both with golden decoration—the costly draperies, the gorgeous tapestries with their varied colorful pictures, the wonderful windows with sapphire decorated panes, the covers and containers with golden trappings and tassels, the golden chalices with their precious stones, and finally the golden letters in the books, for the Cistercian all this is a banquet for the eyes, not of needful use. Even the bells are considered a feast for the ears. (*Dialogus inter Cluniacensem et Cisterciensem* 1717:1571–72; cf. Weisbach 1945:18)

5. A similar reform opposition—based originally on spiritual purity—also arose in Islamic architecture. Until the tenth century, the mosque was a flat-roofed, covered area with no physical shrine. Under the Seljuks, the cupola mosque arose; it was often outfitted as a burial mosque and served as the mausoleum that housed the tomb of a holy man.

The primitive Islamic opposition of the Wahhabi turned against these types—comparable to the Christian martyria and memorial churches—as well as against the funerary and tower mosques (cf. Kühnel 1949:9ff.).

6. A prescription for the architecture of the mendicant orders (Jüttner 1933:23)—which was close to that of the Cistercians—was compiled by Bonaventure: "Ecclesiae autem nullo modo fiant testunitate, excepta majori capella. Campanile admodum turris de cetero nusquam fiat. Item fenestrae vitre ystorriate vel picturate de cetere nusquam fiant, excepto quod in principali vitrea post majus altaro chori haberi possint imagines crucifixi, B. Virginis, B. Johannis, B. Francisci et B. Antonii Fantum. Et si de cetere facte fuerint, amoveant per visitatores" (Churches, except for large chapels, should never be vaulted. A bell-tower should never be built. Likewise, there should be no historiated or representational windows, except that in the main window behind the high altar of the choir, they may have the images of the Crucified, the Blessed Virgin, St. John, St. Francis, and St. Anthony of Padua. And if any others are made, let them be removed by the order's visitors) (quoted in Krautheimer 1925:n.8).

7. Weisbach's (1945) attempts to bring the sculpture of the twelfth century into connection with the reform movements are flawed. The whole question of his book can be sensibly and fruitfully posed only if the reform movements are seen as antithetical to the other powers. When Cluny III is spoken of as reforming in the same way as Cluny II, the whole picture becomes blurred.

8. See p. 261n.24.

9. On the idea of abstraction within the context of a spiritually centered intellectual position, compare Feulner (1942:154, 172).

10. One example among many: in a woodcut accompanying the anatomy text of Johannes of Ketham, the *Facsiculus medicinae* of 1493 (Schrade 1939–1940c:6off.), a teaching physician is enthroned under a baldachin. This is a sign that science is to be seen as a power that lays claim to transmitted forms.

11. The triumphal arch, a repetition of the portal to the holy of holies in the interior, also became a preferred location for inscriptions and pictorial representations.

12. Whether the column itself was originally joined to the cult building as a likeness of an idol or whether it survived as an element of the construction in wood that lingered on in stone is discussed on pp. 74–75. What *is* certain is that the higher symbolic status it enjoyed was due to the role that it played as a formal set piece in all stylistic schools of thought that professed any connection to Antiquity (Evers 1939:93ff.).

13. At the first conference of German art historians in Brühl in 1948, opinions rejecting the universal applicability of this concept were presented mainly by connoisseurs of manuscript illumination and the goldsmith's art (Paatz 1950). For a balanced evaluation of the question, see Panofsky (1944)

Bibliography

Mittelalterliche Architektur als Bedeutungsträger was completed in 1950. The entries marked with an asterisk (*) appeared in the author's original bibliography but were accessible to him only after the work was completed. The translator's sources are in square brackets.

Adamek, J. 1939. *Vom römischen Endreich der mittelalterlichen Bibelerklärung.* Munich.

Adamy, R. 1884. *Architektonik der altchristlichen Zeit.* Hanover.

Adenauer, Hanna, et al., eds. 1943. *Die Kunstdenkmäler des Kreises Mayen.* Die Kunstdenkmäler der Rheinprovinz, vol. 17, pt. 2. Düsseldorf.

Adhémar, J. 1937. *Influences antiques dans l'art du moyen âge français.* Studies of the Warburg Institute, no. 7. London.

Agincourt, S. d'. 1813. *Histoire de l'art par les monuments.* Paris.

Ahlhaus, J. 1928. Civitas und Diözese. In *Aus Politik und Geschichte: Gedächtnisschrift für G. v. Below,* 1–16. Berlin.

[Alberti, L. B. 1988. *On the Art of Building in Ten Books.* Translated by J. Rykwert, N. Leach, and R. Tavernor. Cambridge, Mass.]

Albiker, K. 1944. Form und Inhalt im Kunstwerk. *Marburger Jahrbuch für Kunstwissenschaft* 13:1–5.

Alföldi, A. 1934. Die Ausgestaltung des monarchischen Zeremoniells. *Mitteilungen des Deutschen Archäologischen Instituts, Römische Abteilung* 49:1–118.

Alföldi, A. 1935. Insignien und Tracht der römischen Kaiser. *Mitteilungen des Deutschen Archäologischen Instituts, Römische Abteilung* 50:1–171.

Alföldi, A. 1939. Hoc signo victor eris: Beiträge zur Geschichte der Bekehrung Konstantins des Grossen. In *Pisciculi: Studien zur Religion und Kultur des Altertums, F. J. Dölger zum 60. Geburtstage dargeboten,* edited by T. Klauser and A. Rücker, 1–18. Münster.

Alpatov, M. V., and N. I. Brunov. 1932. *Geschichte der altrussischen Kunst.* Augsburg.

Anderson, W. 1938–1939. Schonen, Helmarshausen, und der Kunstkreis Heinrichs des Löwen. *Marburger Jahrbuch für Kunstwissenschaft* 11–12:81–102.

Andrae, W. 1908–1912. *Hatra*. 2 vols. Leipzig.

Andrae, W. 1927. Haus–Grab–Tempel in Alt-Mesopotamien. *Orientalistische Literaturzeitung* 30:1033–43.

Andrae, W. 1930. *Das Gotteshaus und die Urformen des Bauens im alten Orient*. Berlin.

Andrae, W. 1933a. Einige altorientalische Zuflüsse zur Kunst des Westens. In *Actes du XIIIe Congrès international d'histoire de l'art*, 112–17. Stockholm.

Andrae, W. 1933b. *Die jonische Säule: Bauform oder Symbol*. Berlin.

André, G. 1939. Architektur und Kunstgewerbe als Gegenstand der Ikonographie. In *Festschrift R. Hamann zum 60. Geburtstag*, 3–11. Burg.

Andreades, G. A. 1931. Die Sophienkathedrale von Konstantinopel. *Kunstwissenschaftliche Forschungen* 1:33–94.

Apollonj, B. M. 1936. *Il Foro e la basilica severiana di Leptis Magna*. Monumenti italiani, rilievi raccolti a cura della reale accademia d'Italia, fasc. 8–9. Rome.

Aristotle. n.d. *Metaphysics*. Many editions.

Aubert, M. 1936. Église abbatiale de Cluny. *Congrès archéologique de France* 1935:503–22.

Aubert, M. 1941. *L'Architecture française à la fin de l'epoque romane*. Paris.

Augustine. n.d. *Enarratio in psalmum XCIX (XCVIII)*. In *Patrologiae cursus completus. Series latina*. Vol. 37. Paris.

[Augustine. 1917. *Ennaratio in psalmum*. Select Library of the Nicene and Post-Nicene Fathers of the Christian Church. New York.]

[Augustine. 1991. *Confessions*. Translated by Henry Chadwick. Oxford.]

Bachmann, E. 1941. Kunstlandschaften im romanischen Kirchenbau Deutschlands. *Zeitschrift des deutschen Vereins für Kunstwissenschaft* 8:159–72.

Bachmann, W. 1930. *Kirchen und Moscheen in Armenien und Kurdistan*. Leipzig.

Bader, W. 1946–1947. Die christliche Archäologie in Deutschland nach den jüngsten Entdeckungen an Rhein und Mosel. *Annalen des historischen Vereins für den Niederrhein* 144–145:5–31.

Baethgen, F. 1888. *Beiträge zur semitischen Religionsgeschichte*. Berlin.

Bandmann, G. 1942. Die Werdener Abteikirche, 1256–75: Studie zum Ausgang der staufischen Baukunst am Niederrhein. Ph.D. diss., Cologne.

Bandmann, G. 1949a. *Die Bauformen des Mittelalters*. Bonn.

Bandmann, G. 1949b. Zweiter deutscher Kunsthistorikertag in Schloss Nymphenburg. *Der Cicerone* 3:126–29.

Bandmann, G. 1950. Das Kunstwerk als Geschichtsquelle: Das Problem der Eigenkirche. *Deutsche Vierteljahreschrift für Literaturwissenschaft und Geistesgeschichte* 4:454–69.

Bandmann, G. 1951. Ikonologie der Architektur. *Jahrbuch für Ästhetik und allgemeine Kunstwissenschaft* 1:65–109.

Bandmann, G. 1964. Ein ästhetisch verachtete Epoche. *Rheinische Post*, 19 December. [Reprinted in *Deutsche Wissenschaft heute*, edited by Paul Hübner, 95–101. Munich, 1966]

Bandmann, G. 1966. Die Galleria Vittorio Emanuele II. Zu Mailand. *Zeitschrift für Kunstgeschichte* 29: 81–110.

Barthmann, D. 1904. *Das Himmelsreich und sein König nach den Synoptikern*. Paderborn.

Bastgen, H. 1911. Das Capitulare Karls des Grossen über die Bilder und die sog. Libri Carolini. *Neues Archiv der Gesellschaft für ältere Geschichtskunde* 36:13–51.

Bau und Kunstdenkmäler des Regierungsbezirks Wiesbaden. 1907. Vol. 3, *Lahngebiet.* Frankfurt am Main.

Bauch, K. 1939. *Über die Herkunft der Gotik.* Freiburger Kunstwissenschaftliche Gesellschaft, vol. 27. Freiburg im Breisgau.

Baudin, L. 1947. *Die Inka von Peru.* Essen.

Baum, J. 1935. Aufgaben der frühchristlichen Kunstforschung in Britannien und Irland. *Forschungen und Fortschritte* 11:222–23.

Baum, J. 1938. *Romanische Baukunst in Frankreich.* Stuttgart.

Baumstark, A. 1906. *Die Messe im Abendland.* Kempten.

Baumstark, A. 1907. Die Ausgrabungen am Menasheiligtum in der Mareotiswüste. *Römische Quartalschrift* 21:7–17.

Baumstark, A. 1923. *Vom geschichtlichen Werden der Liturgie.* Freiburg im Breisgau.

Becker, E. 1913. Protest gegen den Kaiserkult und Verherrlichung des Sieges am Pons Milvius in der altchristlichen Kunst der konstantinischen Zeit. In *Konstantin der Grosse und seine Zeit: Gesammelte Studien,* edited by F. J. Dölger, 155–90. Freiburg im Breisgau.

Bede. 1862. *Collectanea et flores.* In *Patrologiae cursus completus. Series latina.* Vol. 94. Paris.

[Bede. 1969. *Bede's Ecclesiastical History of the English People.* Edited by B. Colgrave and R. A. B. Mynors. Oxford.]

Beenken, H. 1926–1927. Die Florentiner Inkrustationsarchitektur des 11. Jahrhunderts. *Zeitschrift für bildende Kunst* 60:221–30, 245–55.

Beenken, H. 1930. Die ausgeschiedene Vierung: Kritische Bemerkungen zu einigen Rekonstruktionen karolingischer Kirchenbauten. *Repertorium für Kunstwissenschaft* 51:207–31.

Beenken, H. 1938. Der Historismus in der Baukunst. *Historische Zeitschrift* 157:27–68.

Behn, F. 1933. Die Torhalle zu Lorsch. *Forschungen und Fortschritte* 9:433–35.

Behn, F. 1934. *Die karolingische Klosterkirche von Lorsch an der Bergstrasse.* Berlin.

Behn, F. 1948. Lorsch: Das Reichskloster der Karolingerzeit. *Jahrbuch für das Bistum Mainz* 3:321–32.

Behne, A. 1942. Das Problem der Sichtbarkeit. *Das Werk* 29:145–48.

Beissel, S. 1880a. Der Dom von Köln. *Stimmen aus Maria Laach* 19:65–83, 134–43.

Beissel, S. 1880b. Der Dom von Köln. *Stimmen aus Maria Laach* 20:163–83, 388–400.

Berchem, M. van. 1910. *Amida: Materiaux pour l'épigraphie et l'histoire musulmanes du Diyar-bekr.* Heidelberg.

Berchem, M. van, and E. Clouzot. 1924. *Mosaïques chretiennes du IVe au Xe siècle.* Geneva.

Bergner, H. 1905. *Handbuch der kirchlichen Kunstaltertümer in Deutschland.* Leipzig.

Berlet, E. 1936. Die Lorscher Königshalle in ihrer Abhängigkeit von der Ideenwelt des Germanentums. *Der Wormsgau* 2:62–65.

Bernard of Clairvaux. 1690. Apologia ad Guilelmum abb. Obb. S. Bern. In *Opera Omnia,* edited by J. Mabillon. 2 vols. Paris.

Bernard of Clairvaux. n.d. De modo bene vivendi. In *Patrologiae cursus completus. Series latina.* Vol. 204. Paris.

Berve, H., ed. 1942. *Das neue Bild der Antike.* 2 vols. Leipzig.

Beseler, H. 1946. St. Michael in Hildesheim: Untersuchungen zur Geschichte des Bernwardsbaues. Ph.D. diss., Munich.

Bettini, S. 1946. *L'architettura di San Marco*. Padua.

Beumann, H. 1948. Widukind von Korvey als Geschichtsschreiber und seine politische Gedankenwelt. *Westfalen* 27:161–76.

Beurlier, E. 1891. *Le Culte impérial*. Paris.

Beutler, E. 1934. *Von deutscher Baukunst: Goethes Hymnus auf Erwin von Steinbach, seine Entstehung und Wirkung*. Munich.

Beyer, S. 1925. *Der syrische Kirchenbau*. Berlin.

Bezold, G. von. 1936. Zur Geschichte der romanischen Baukunst in der Erzdiözese Mainz. *Marburger Jahrbuch für Kunstwissenschaft* 8–9:1–88.

Bickel, E. 1928. Die politische und religiöse Bedeutung des Provinzialoberpriesters im römischen Westen. *Bonner Jahrbücher* 133:1–27.

Bickermann, E. 1929. Die römische Kaiserapotheose. *Archiv für Religionswissenschaft* 27:1–34.

Biehl, L. 1937. *Das liturgische Gebet für Kaiser und Reich: Ein Beitrag zur Geschichte des Verhältnisses von Kirche und Staat*. Paderborn.

Bierbach, K. 1939. *Kurie und nationale Staaten im frühen Mittelalter (bis 1245)*. Leipzig.

[Binchy, D. A. 1946. The Diplomacy of the Vatican. *International Affairs* 22:47–56.]

Birt, T. 1909. *Zur Kulturgeschichte Roms*. Leipzig.

Bissing, F. W. von. 1923. Der persische Palast und die Turmbasilika. In *Studien zur Kunst des Ostens: J. Strzygowski zum 60. Geburtstag*, 40–57. Vienna.

Blanckenhagen, P. H. 1942. Elemente der römischen Kunst am Beispiel des flavischen Stils. In *Das neue Bild der Antike*, edited by H. Berve, 2:310–41. Rome.

Blauensteiner, K. 1932. Die Beziehungen gegenständlicher Bindungen zur Stilbildungen. In *Josef Strzygowski-Festschrift, zum 70. Geburtstag*, 17–20. Klagenfurt.

Boehringer, E., and F. Krauss. 1937. *Das Temenos für den Herrscherkult: Prinzessinnen-Palais*. Altertümer von Pergamon, vol. 9. Berlin.

Bögl, O. 1932. *Die Auffassung des Königtums und Staats im Zeitalter der sächsischen Kaiser und Könige*. Erlangen.

Bogner, H. 1906. *Das Arkadenmotiv im Obergeschoss des Aachener Münsters und seine Vorgänger*. Strasbourg.

Borch, A. von. 1934. *Das Gottesgnadentum: Historisch-soziologischer Versuch über die religiöse Herrschaftslegitimation*. Berlin.

Borinski, K. 1914–1924. *Die Antike in Poetik und Kunsttheorie: Von Ausgang des klassischen Altertums bis auf Goethe und Wilhelm von Humboldt*. 2 vols. Leipzig.

Bötticher, K. 1856. *Der Baumkultus der Hellenen*. Berlin.

Bousset, W. 1921. *Kyrios Christos*. Göttingen.

Brackmann, A. 1916. Die Erneuerung der Kaiserwürde im Jahre 800. In *Geschichtliche Studien für Albert Hauck zum 70. Geburtstage dargebracht*, 121–34. Leipzig.

Brackmann, A. 1934. Die Ursachen der geistigen und politischen Wandlung Europas im 11. und 12. Jahrhundert. *Historische Zeitschrift* 149:229–39.

Brackmann, A. 1937. *Magdeburg als Hauptstadt des deutschen Ostens*. Leipzig.

Braun, J. 1934. *Der christliche Altar in seiner geschichtlichen Entwicklung*. 2 vols. Munich.

Braunfels, W. 1949. Zur Gestalt-Ikonographie der Kanzeln des Nicola und Giovanni Pisano. *Das Münster* 2:321–49.

Braunfels, W. 1950. Italienische Stadtbaukunst im Mittelalter und der Begriff *Civitas*. In *Beiträge zur Kunst des Mittelalters: Vorträge der Ersten Deutschen Kunsthistorikertagung auf Schloss Brühl, 1948*, 39–45. Berlin.

Brenner, E. 1912. Der Stand der Forschung über die Kultur der Merowinger. *Bericht der römisch-germanischen Kommission* 7:253–351.

Brieger, T. 1880. *Constantin der Grosse als Religionspolitiker*. Gotha.

Brunoff, N. 1927. Über den Breitraum in der christlich-orientalischen und der altrussischen Baukunst. *Münchner Jahrbuch der bildenden Kunst*, n.s., 4:35–58.

Brutails, I. A. 1900. *L'Archéologie du moyen âge et ses méthodes*. Paris.

Brzóska, M. 1931. *Anthropomorphe Auffassung des Gebäudes und seiner Teile: Sprachlich untersucht an Quellen aus der Zeit 1525–1750*. Jena.

Buchkremer, J. 1947. Untersuchungen zum karolingischen Bau der Aachener Pfalzkapelle. *Zeitschrift für Kunstwissenschaft* 1:1–22.

Bühler, J. 1934. Weltanschauung und Politik im Mittelmeer. *Geistige Arbeit* 1:1.

Bulić, F. 1929. *Kaiser Diokletians Palast in Split*. Zagreb.

Bullough, E. 1914. Ein Beitrag zur genetischen Ästhetik. In *1. Kongress für Ästhetik und allgemeine Kunstwissenschaft, Berlin, 1913* (*Zeitschrift für Ästhetik und allgemeine Kunstwissenschaft. Beiheft*). Stuttgart.

Burck, E. 1942. Die altrömische Familie. In *Das neue Bild der Antike*, edited by H. Berve, 2:5–52. Rome.

Burckhardt, J. 1929. *Weltgeschichtliche Betrachtungen*. Berlin.

Burckhardt, J. 1934. *Kultur der Renaissance in Italien*. Vienna.

Burdach, K. 1926. *Reformation, Renaissance, Humanismus: Zwei Abhandlungen über die Grundlage moderner Bildung und Sprachkunst*. 2d ed. Berlin.

Butler, H. C. 1929. *Early Churches in Syria: Fourth to Seventh Centuries*. Princeton, N.J.

Cabrol, E., and H. Leclercq. 1907– . *Dictionnaire d'archéologie chrétienne et de liturgie*. Paris.

Cagiano de Azevedo, M. 1940. La Chiesa di Santa Maria della Libera in Aquino. *Rivista del Reale istituto d'archeologia e storia dell'arte* 8:189–200.

Candidus. 1887. *Vita Eigilis*. In *Monumenta germaniae historica. Scriptores*. Vol. 15. Hanover.

[Carr, A. W. 1991. Epiphanies. In *The Oxford Dictionary of Byzantium*, 1:713. New York.]

Caspar, E. 1930–1933. *Geschichte des Papsttums von den Anfängen bis zur Höhe der Weltherrschaft*. 2 vols. Tübingen.

Caspar, E. 1935. Das Papsttum unter fränkischer Herrschaft. *Zeitschrift für Kirchengeschichte* 54:132–266.

Cassiodorus Senator. 1894. *Variae*. In *Monumenta germaniae historica. Auctores antiquissimi*. Vol. 12. Berlin.

Cassirer, E. 1923–1931. *Philosophie der symbolischen Formen*. 4 vols. Berlin.

Cassirer, E. 1927. Das Symbolproblem und seine Stellung im System der Philosophie. *Zeitschrift für Ästhetik und allgemeine Kunstwissenschaft* 21:295–312.

Christ, H. 1935. Zur Erklärung des T-förmigen Grundrisses der konstantinischen Peterskirche. *Rivista di archeologia cristiana* 12:293–311.

[Christ I. 1982. In *Anglo-Saxon Poetry*, edited by S. A. J. Bradley, 205–7. London.]

Clasen, K. H. 1943. Die Überwindung des Bösen: Ein Beitrag zur Ikonographie des frühen Mittelalters. In *Neue Beiträge deutscher Forschung: Wilhelm Worringer zum 60. Geburtstag*, edited by E. Fidder, 13–36. Kaliningrad/Königsberg.

Clemen, P. 1889. Die Porträtdarstellungen Karls des Grossen. *Zeitschrift des Aachener Geschichtsvereins* 12:44–147.

Clemen, P. 1890. Der karolingische Kaiserpalast zu Ingelheim. *Westdeutsche Zeitschrift* 9:54.

Clemen, P. 1906. *Die Kunstdenkmäler der Stadt und des Kreises Bonn*. Die Kunstdenkmäler der Rheinprovinz, vol. 5. Düsseldorf.

Clemen, P. 1916. *Die romanische Monumentalmalerei in den Rheinlanden*. Düsseldorf.

Clemen, P. 1916–1929. *Die Kunstdenkmäler der Stadt Köln*. 3 vols. Die Kunstdenkmäler der Rheinprovinz, vol. 7, pt. 1. Düsseldorf.

[Clement of Alexandria.1925. *Stromata*. The Ante-Nicene Fathers, vol. 2. New York.]

Coleman, C. B. 1914. *Constantine the Great and Christianity*. New York.

Conant, K. J. 1928a. La Chapelle Saint-Gabriel à Cluny. *Bulletin monumental* 87:55–64.

Conant, K. J. 1928b. Five Old Prints of the Abbey Church of Cluny. *Speculum* 3:401–4.

Conant, K. J. 1929a. Les Fouilles de Cluny. *Bulletin monumental* 88:109–23.

Conant, K. J. 1929b. Mediaeval Academy Excavations at Cluny: The Season of 1928. *Speculum* 4:3–26.

Conant, K. J. 1929c. Mediaeval Academy Excavations at Cluny: Preliminary Restoration Drawings of the Abbey Church. *Speculum* 4:168–76.

Conant, K. J. 1929d. Mediaeval Academy Excavations at Cluny: Drawings and Photographs of the Transept. *Speculum* 4:291–302.

Conant, K. J. 1929e. Mediaeval Academy Excavations at Cluny: The Significance of the Abbey Church. *Speculum* 4:443–50.

Conant, K. J. 1930a. La Date des chapiteaux du choeur de l'abbaye de Cluny. *Bulletin monumental* 89:381–85.

Conant, K. J. 1930b. Mediaeval Academy Excavations at Cluny: The Date of the Ambulatory Capitals. *Speculum* 5:77–94.

Conant, K. J. 1931a. Mediaeval Academy Excavations at Cluny: The Season of 1929. *Speculum* 6:3–14.

Conant, K. J. 1931b. Le Problème de Cluny d'après les fouilles recentes. *Revue de l'art* 2:141–54, 189–204.

Conant, K. J. 1939. The Third Church at Cluny. In *Medieval Studies in Memory of Arthur Kingsley Porter*, edited by W. R. W. Koehler, 2:327–57. Cambridge, Mass.

Conant, K. J. 1942. Mediaeval Academy Excavations at Cluny: Two New Books About Cluny. *Speculum* 17:563–65.

Conant, K. J. 1954. Mediaeval Academy Excavations at Cluny: Final Stages for the Project. *Speculum* 29:1–43.

Conant, K. J. 1963. Mediaeval Academy Excavations at Cluny: Systematic Dimentions in the Buildings. *Speculum* 38:1–45.

Conant, K. J. 1970. Mediaeval Academy Excavations at Cluny. *Speculum* 45:1–35.

Corsten, K. 1936. Neue Studien zum alten Dom zu Köln. *Annalen des historischen Vereins für den Niederrhein* 129:1–50.

*Crosby, S. McK. 1942. *The Abbey of St. Denis, 475–1122*. New Haven, Conn.

Curtius, E. R. 1943. Schrift- und Buchmetaphorik in der Weltliteratur. In *Neue Beiträge*

deutscher Forschung: Wilhelm Worringer zum 60. Geburtstag, edited by E. Fidder, 61–100. Kaliningrad/Königsberg.

[Curtius, E. R. 1953. *European Literature and the Latin Middle Ages*. London.]

Curtius, L. 1913. *Die Antike Kunst*. Handbuch der Kunstwissenschaft, vol. 1. Berlin.

Dalman, G. 1922. *Das Grab Christi in Deutschland*. Leipzig.

Dannenberg, H. 1876. *Die deutschen Münzen der sächsischen und fränkischen Kaiserzeit*. Berlin.

Dehio, G. 1886. Romanische Renaissance. *Jahrbuch der preussischen Kunstsammlungen* 7:129–40.

Dehio, G., and G. von Bezold. 1884–1901. *Die kirchliche Baukunst des Abendlandes*. Stuttgart.

Deichmann, F. W. 1937. *Versuch einer Darstellung der Grundrisstypen im Morgenlande*. Halle.

Deichmann, F. W. 1940. Säule und Ordnung in der frühchristlichen Architektur. *Mitteilungen des Deutschen Archäologischen Instituts, Römische Abteilung* 55:114–30.

Deichmann, F. W. 1941. S. Agnese fuori le mura und die byzantinische Frage in der frühchristlichen Architektur Roms. *Byzantinische Zeitschrift* 41:70–81.

Deichmann, F. W. 1943. Die Entstehungszeit von Salvatorkirche und Clitumnustempel bei Spoleto. *Mitteilungen des Deutschen Archäologischen Instituts, Römische Abteilung* 58:106–48.

Deichmann, F. W. 1948. *Frühchristliche Kirchen in Rom*. Basel.

Deichmann, F. W. 1950a. Architektur. In *Reallexikon für Antike und Christentum*, 1:604–13. Stuttgart.

*Deichmann, F. W. 1950b. Basilika (christlich). In *Reallexikon für Antike und Christentum*, 1:1249–59. Stuttgart.

Deichmann, F. W., and A. Tschira. 1939. Die frühchristlichen Basen und Kapitelle von S. Paolo fuori le mura. *Mitteilungen des Deutschen Archäologischen Instituts, Römische Abteilung* 54:99–111.

Deissmann, G. A. 1923. *Licht vom Osten, das Neue Testament, und die neuentdeckten Texte der hellenistisch-römischen Welt*. 4th ed. Tübingen.

Delbrück, H. 1893. Die gute alte Zeit. *Preussische Jahrbücher* 71:1–28.

Delbrück, R. 1932a. Der spätantike Kaiserornat. *Die Antike* 8:1–21.

Delbrück, R. 1932b. *Spätantike Kaiserporträts von Constantinus Magnus bis zum Ende des Westreiches*. Studien zur spätantiken Kunstgeschichte, vol. 8. Berlin.

Delbrück, R. 1949. The Acclamation on the Doors of Santa Sabina. *Art Bulletin* 31:215–17.

Delinger, A. 1936. *Die Ordensgesetzgebung der Benediktiner und ihre Auswirkung auf die Grundrissgestaltung*. Dresden.

Delius, W. 1928. *Die Bilderfrage im Karolingerreich*. Halle.

Dellemann, O. 1937. *Der mittelalterliche Bautypus der einräumigen Dorfkirchen Ostfrieslands*. Würzburg.

Dempf, A. 1929. *Sacrum Imperium*. Munich.

Deshoulières, F. 1932. *Les Églises de France: Cher*. Paris.

Deubner, L. 1934. Die Tracht des römischen Triumphators. *Hermes* 69:316–23.

Dialogus inter Cluniacensem et Cisterciensem auct. anonymo de diversis utriusque ordinis observantis. 1717. In *Thesaurus novus anecdotorum*, edited by E. Martène. Paris.

Diepen, J. 1926. *Die romanische Plastik in Klosterrath*. Würzburg.

Dietrich, K. 1912. *Hofleben in Byzanz*. Leipzig.

Dietrich, M. 1934. *Die Zisterzienser und ihre Stellung zum mittelalterlichen Reichsgedanken bis zur Mitte des 14. Jahrhunderts*. Munich.

Diez, E. 1915. *Die Kunst der islamischen Völker*. Handbuch der Kunstwissenschaft, vol. 4. Berlin.

Diez, E. 1944. *Iranische Kunst*. Vienna.

[Dio Chrysostom. 1932–1951. *Works*. 5 vols. Cambridge, Mass.]

[Diodorus. 1933. *Diodorus of Sicily*. Edited and translated by H. C. Oldfather. Loeb Classical Library. London.]

Dionysius Aeropagitica. n.d. *Opera*. In *Patrologiae cursus completus. Series graeca*. Vols. 3 and 4. Paris.

[Dobozy, M., ed. 1999. *Saxon Mirror: A Sachsenspiegel of the Fourteenth Century*. Philadelphia.]

Dobschütz, E. von. 1921. Vom vierfachen Schriftsinn. In *Harnack-Ehrung*, 1–13. Leipzig.

Dölger, F. J. 1906. *Sakrament der Firmung, historisch-dogmatisch dargestellt*. Vienna.

Dölger, F. J. 1911. *Sphragis: Eine altchristliche Taufbezeichnung in ihren Beziehungen zur profanen und religiösen Kultur des Altertums*. Paderborn.

Dölger, F. J. 1918. *Die Sonne der Gerechtigkeit und der Schwarze: Eine religionsgeschichtliche Studie zum Taufgelöbnis*. Münster.

Dölger, F. J. 1929–1950. *Antike und Christentum*. 6 vols. Münster.

Dölger, F. J. 1930. Die Heiligkeit des Altars und ihre Begründung im christlichen Altertum. In *Antike und Christentum*, 2:161–240. Münster.

Dölger, F. J. 1932. Zur antiken und frühchristlichen Auffassung der Herrschergewalt von Gottes Gnaden. In *Antike und Christentum*, 3:117–27. Münster.

Dölger, F. J. 1934. Zur Symbolik des altchristlichen Taufhauses. In *Antike und Christentum*, 4:153–87. Münster.

Dölger, F. J. 1937. Rom in der Gedankenwelt der Byzantiner. *Zeitschrift für Kirchengeschichte* 56:1–42.

Dölger, F. J. 1940. Die Familie der Könige im Mittelalter. *Historisches Jahrbuch der Görres-Gesellschaft* 60:397–420.

Dölger, F. J. 1950. "Kirche" als Name für den christlichen Kultbau. In *Antike und Christentum*, 6:161–95. Münster.

Der Dom zu Köln. 1948. Euskirchen.

Dombart, T. 1933. Der zwei-türmige Tempel-Pylon in der altägyptischen Baukunst und seine religiöse Symbolik. *Egyptian Religion* 1:87–98.

Doppelfeld, O. 1948a. Der alte Dom zu Köln und der Bauriss von S. Gallen. *Das Münster* 2:1–12.

Doppelfeld, O. 1948b. Ein Schnitt durch den Untergrund des Kölner Doms. *Forschungen und Fortschritte* 24:97, 101.

Doppelfeld, O. 1948c. *Der unterirdische Dom*. Cologne.

Dopsch, A. 1926. Vom Altertum zum Mittelalter: Das Kontinuitätsproblem. *Archiv für Kulturgeschichte* 16:159–82.

Drexler, W. 1916. Kaiserkultus. In *Ausführliches Lexikon der griechischen und römischen Mythologie*, edited by W. H. Roscher, 2/1:901–19. Leipzig. [Reprint, Hildesheim, 1965]

[Durandus, W. 1843. *The Symbolism of Churches and Church Ornaments: A Translation of the First Book of the "Rationale divinorum officiorum."* Leeds.]

Durm, J. 1910. *Die Baukunst der Griechen.* 3d ed. 2 vols. Handbuch der Architektur, vol. 2. Leipzig.

Düsterwald, F. 1890. *Die Weltreiche und das Gottesreich.* Freiburg im Breisgau.

Dvorák, M. 1924. *Kunstgeschichte als Geistesgeschichte.* Munich.

Dworak, P. 1938. *Gott und König.* Bonn.

Dyggve, E. 1936. Das Mausoleum von Marusinac und sein Fortleben. *Bulletin de l'Institut archéologique bulgare* 10:228–37.

Dyggve, E. 1939. *Der altchristliche Friedhof Marusinac.* Forschungen in Salona, vol. 3. Baden.

Dyggve, E. 1940. Probleme des altchristlichen Kultbaus: Einige archäologisch begründete Gesichtspunkte zu Grabkult und Kirchenbau. *Zeitschrift für Kirchengeschichte*, 3d ser., 59:103–13.

Dyggve, E. 1941. *Ravennatum Palatium sacrum: La basilica ipetrale per ceremonie.* Copenhagen.

Ebersolt, J. 1910a. *Le Grand Palais de Constantinople et le Livre de cérémonies.* Paris.

Ebersolt, J. 1910b. *Sainte-Sophie de Constantinople: Étude de topographie d'après les cérémonies.* Paris.

Ebrard, J. 1873. *Die iro-schottische Missionskirche des 6., 7., und 8. Jahrhunderts.* Gütersloh.

Effmann, W. 1890. *Heiligkreuz und Pfälzel: Beiträge zur Baugeschichte Triers.* Fribourg.

Effmann, W. 1899. *Die karolingisch-ottonischen Bauten von Essen-Werden.* Strasbourg.

Effmann, W. 1912. *Centula.* Münster.

Effmann, W. 1926. *Die karolingisch-ottonischen Bauten zu Werden.* Vol. 2 of *Die karolingisch-ottonischen Bauten von Essen-Werden.* Strasbourg.

Effmann, W. 1929. *Die Kirchen der Abtei Corvey.* Edited by A. Fuchs. Paderborn.

Eger, H. 1939. Kaiser und Kirche in der Geschichtstheologie Eusebs von Caesarea. *Zeitschrift für neutestamentliche Wissenschaft* 38:97–115.

Egger, R. 1926. *Frühchristliche Kirchenbauten im südlichen Noricum.* Vienna.

Egger, R. 1936. Das Mausoleum von Marusinac und seine Herkunft. *Bulletin de l'Institut archéologique bulgare* 10:201–27.

Eichmann, E. 1942. *Die Kaiserkrönung im Abendland.* 2 vols. Würzburg.

Eidam, H. 1895. Theilenhofen [Kastell]. *Limesblatt* 15:421–24.

Einem, H. von. 1948. Die Monumentalplastik des Mittelalters und ihr Verhältnis zur Antike. *Antike und Abendland* 3:120–51.

Einem, H. von. 1950. *Rembrandt, Segen Jacobs.* Bonn.

Einhard. 1829. *Vita Karoli Magni.* In *Monumenta germaniae historica. Scriptores.* Vol. 2. Hanover.

Eisenhofer, L. 1932. *Handbuch der katholischen Liturgik.* 2 vols. Freiburg im Breisgau.

Elliger, W. 1930. *Die Stellung der alten Christen zu den Bildern in den ersten vier Jahrhunderten.* Leipzig.

Elliger, W. 1934. *Zur Entstehung und frühen Entwicklung der altchristlichen Bildkunst.* Leipzig.

Ensslin, W. 1943. *Gottkaiser und Kaiser von Gottes Gnaden*. Sitzungsberichte der bayerischen Akademie der Wissenschaften, philosophisch-historische Abteilung, vol. 6. Munich.

Erben, W. 1931. *Rombilder auf kaiserlichen und päpstlichen Siegeln des Mittelalters*. Graz.

Erdmann, C. 1932. Über Endkaiserglaube und Kreuzzugsgedanke im 11. Jahrhundert. *Zeitschrift für Kirchengeschichte* 51:384–414.

Erdmann, K. 1943. *Die Kunst Irans zur Zeit der Sassaniden*. Berlin.

Eusebius. n.d. *De vita Constantini*. In *Patrologiae cursus completus. Series graeca*. Vol. 20. Paris.

Eusebius. n.d. *Historia Ecclesiastica*. In *Patrologiae cursus completus. Series graeca*. Vol. 20. Paris.

Evans, A. J. 1901. Mycenaean Tree and Pillar Cult and Its Mediterranean Relations. *Journal of Hellenic Studies* 21:99–204.

Evans, J. 1938. *The Romanesque Architecture of the Order of Cluny*. Cambridge, Mass.

Evers, H. G. 1939. *Tod, Macht, und Raum als Bereich der Architektur*. Munich.

Evers, H. G. 1942. *P. P. Rubens*. Munich.

Faymonville, K. 1909. *Der Dom zu Aachen*. Munich.

Fegers, H. 1943. *Das Politische Bewusstsein in der französischen Kunstlehre des 17. Jahrhunderts*. Mainz.

Feine, H. E. 1939. Ursprung und Wesen des Eigenkirchentums. *Zeitschrift der Akademie für deutsches Recht* 6:120.

Feine, H. E. 1941. Studien zum langobardisch-italienischen Eigenkirchenrecht. *Zeitschrift der Savigny-Stiftung für Rechtsgeschichte, Kanonistische Abteilung* 30:1–95.

Feine, H. E. 1942. Studien zum langobardisch-italienischen Eigenkirchenrecht. *Zeitschrift der Savigny-Stiftung für Rechtsgeschichte, Kanonistische Abteilung* 31:1–105.

Feine, H. E. 1943. Studien zum langobardisch-italienischen Eigenkirchenrecht. *Zeitschrift der Savigny-Stiftung für Rechtsgeschichte, Kanonistische Abteilung* 32:64–190.

Fendel, J. 1927. *Der Ursprung der christlichen Klosteranlage*. Bonn.

Feulner, A. 1942. *Kunst und Geschichte*. Leipzig.

Fiechter-Zollikofer, E. 1947. Untersuchungen in der St. Mangenkirche in St. Gallen. *Zeitschrift für schweizerische Archäologie und Kunstgeschichte* 9:65–79 .

Fiedler, H. S. 1937. *Dome und Politik*. Bremen.

Flasche, H. 1949. Similitudo Templi: Zur Geschichte einer Metapher. *Deutsche Vierteljahresschrift für Literaturwissenschaft und Geistesgeschichte* 23:81–125.

Focillon, H. 1934. *Vie des formes*. Paris.

Formigé, J. 1928. Les Églises primitives et l'adaptation à cet usage des maisons antiques. *Bulletin de la Société nationale des antiquaires de France* 1928:310–17.

Förster, O. H. 1943. Von Speyer bis Chartres. In *Neue Beiträge deutscher Forschung: Wilhelm Worringer zum 60. Geburtstag*, edited by E. Fidder, 106–42. Kaliningrad/Königsberg.

*Forsyth, G. H., Jr. 1950. St. Martin's at Angers and the Evolution of Early Medieval Church Towers. *Art Bulletin* 32:308–18.

Frankl, P. 1918. *Die Baukunst des Mittelalters*. Handbuch der Kunstwissenschaft. Berlin.

Frankl, P. 1927. Die Rolle der Ästhetik in der Methode der Geisteswissenschaften. *Zeitschrift für Ästhetik und allgemeine Kunstwissenschaft* 21:145–50.

Franz, L. 1937. *Religion und Kunst der Vorzeit*. Prague.

Frauenholz, E. von. 1926. Imperator Oktavianus in der Geschichte und Sage des Mittelalters. *Historisches Jahrbuch* 46:86–122.

Freshfield, E. H. 1913. *Cellae trichorae and Other Christian Antiquities of Sicily with Calabria and North Africa Including Sardinia*. Vol. 1. London.

Frey, D. 1938. Die Entwicklung nationaler Stile in der mittelalterlichen Kunst des Abendlandes. *Deutsche Vierteljahresschrift für Literaturwissenschaft und Geistesgeschichte* 16:1–74.

Frey, D. 1942. *Englisches Wesen im Spiegel der Kunst*. Stuttgart.

Frey, D. 1946a. Das Kunstwerk als Willensproblem. In *Kunstwissenschaftliche Grundfragen*, 80–92. Vienna.

Frey, D. 1946b. Der Realitätscharakter des Kunstwerks. In *Kunstwissenschaftliche Grundfragen*, 107–49. Vienna.

Frey, D. 1946c. Wesensbestimmung der Architektur. In *Kunstwissenschaftliche Grundfragen*, 93–106. Vienna.

Frey, D. 1946d. Zur Grundlegung. In *Kunstwissenschaftliche Grundfragen*, 11–22. Vienna.

Frey, D. 1946e. Zur wissenschaftlichen Lage der Kunstgeschichte. In *Kunstwissenschaftliche Grundfragen*, 23–79. Vienna.

Frey, D. 1946f. Zuschauer und Bühne. In *Kunstwissenschaftliche Grundfragen*, 151–223. Vienna.

*Frey, D. 1949. *Grundlegung zur einer vergleichenden Kunstwissenschaft*. Innsbruck.

Freytag, G. n.d. *Bilder aus der deutschen Vergangenheit*. Many editions.

Frick, R. 1928. *Die Geschichte des Reich-Gottes-Gedanken in der alten Kirche bis zu Origenes und Augustin*. Giessen.

Fuchs, A. 1929. *Die karolingischen Westwerke*. Paderborn.

Fuchs, A. 1938. *Der geistige Widerstand gegen Rom in der antiken Welt*. Berlin.

Fuchs, A. 1947. Zur Frage der Bautätigkeit des Bischofs Badurad am Paderborner Dom. *Westfälische Zeitschrift* 97, pt. 2:3–34.

Funk, F. X., ed. 1905. *Didascalia et constitutiones Apostolorum*. 2 vols. Paderborn.

Gall, E. 1915. *Niederrheinische und normännische Architektur im Zeitalter der Frühgotik*. Pt. 1, *Die niederrheinischen Apsidengliederungen nach normännischem Vorbilde*. Berlin.

Gall, E. 1925. *Die gotische Baukunst in Frankreich und Deutschland*. Pt. 1, *Die Vorstufen in Nordfrankreich von der Mitte des elften bis gegen Ende des zwölften Jahrhunderts*. Handbücher der Kunstgeschichte, vol. 2. Leipzig.

Galling, K. 1927–1932a. Altar: I Religionsgeschichtlich. In *Religion in Geschichte und Gegenwart: Handwörterbuch für Theologie und Religionswissenschaft*, 1:229–32. 2d ed. Tübingen.

Galling, K. 1927–1932b. Altar: II Israelitisch. In *Religion in Geschichte und Gegenwart: Handwörterbuch für Theologie und Religionswissenschaft*, 1:232–4. 2d ed. Tübingen.

Garger, E. von. 1934. Zur spätantiken Renaissance. *Jahrbuch der kunsthistorischen Sammlungen in Wien*, n.s., 8:1–28.

Gasquet, A. 1888. *L'Empire byzantin et la monarchie franque*. Paris.

Gaul, O. 1932. *Romanische Baukunst und Bauornamentik in Sachsen*. Cologne.

Gause, E. 1901. *Der Einfluss des christlichen Kultus auf den Kirchenbau, besonderes auf die Anlage des Kirchengebäudes*. Jena.

Geffcken, J. 1918. Der Bilderstreit des heidnischen Altertums. *Archiv für Religionswissenschaft* 19:286–315.

Gerber, W. 1911. *Untersuchungen und Rekonstruktionen an altchristlichen Kultbauten in Salona*. Vienna.

Gerber, W. 1912. *Altchristliche Kultbauten Istriens und Dalmatiens*. Dresden.

Gerkan, A. von 1924. *Griechische Städteanlagen*. Berlin.

Gerkan, A. von. 1941. Review of *Hellenistische Vorstellungen von der Schönheit des Bauwerks nach Vitruv*, by F. W. Schlikker. *Zentralblatt der Bauverwaltung* 61:619–20.

Gerke, F. 1940. Ideengeschichte der ältesten christlichen Kunst. *Zeitschrift für Kirchengeschichte*, 3d ser., 59:1–102.

Gerke, F. 1947. Die europäische Kultureinheit zur Zeit Karls des Grossen und Ottos des Grossen. In *Der Rhein und Europa: Kölner Kulturtage vom 18. bis 27. Oktober 1946*. Cologne.

Gerke, F. 1948. *Christus in der spätantiken Plastik*. 3d ed. Mainz.

Gerster, E. 1948. Römischer Palast und Dionysos-Mosaik in Köln. *Forschungen und Fortschritte* 24:73–76.

Geymüller, H. von. 1908. *Friedrich II. und die Anfänge der Renaissance in Italien*. Munich.

Giacomo da Acqui. 1836–1955. *Chronicon imagini mundi*. In *Scriptorum. Historiae patriae monumenta*. Vols. 3–5. Turin.

Glück, H. 1926. Die Herkunft des Querschiffes in der römischen Basilika und der Trikonchos. In *Festschrift zum 60. Geburtstag von Paul Clemen*, 200–207. Bonn.

Glück, H. 1933. *Der Ursprung des römischen und abendländischen Wölbungsbaues*. Vienna.

Gnirs, A. 1915. Die christliche Kultanlage aus konstantinischer Zeit am Platz des Domes in Aquileja. *Jahrbuch des Kunsthistorischen Institutes der KK. Zentral-Kommission für Denkmalpflege* 9:140.

[Goethe, J. W. von. 1971. *Elective Affinities*. Translated by R. J. Hollingdale. Harmondsworth.]

[Goethe, J. W. von. 1989. *Italian Journey*. Edited by T. P. Saine and J. L. Sammons. Translated by R. R. Heitner. New York.]

Goldschmidt, A. 1926. *Die Elfenbeinskulptur aus der romanischen Zeit (XI.–XII. Jahrhundert)*. 4 vols. Berlin.

Götze, A. 1933. *Kleinasien*. Vol. 1, pt. 3 of *Kulturgeschichte des alten Orients*. Handbuch der Altertumswissenschaft, vol. 3. Munich.

Grabar, A. 1936. *L'Empereur dans l'art byzantin*. Paris.

*Grabar, A. 1945. Plotin et les origines de l'esthétique médiévale. *Cahiers archéologiques* 1:15–34. [Reprinted in *L'Art de la fin de l'antiquité et du moyen âge*. Paris, 1968]

*Grabar, A. 1946. *Martyrium: Recherches sur le culte des reliques et l'art chrétien antique*. Paris.

*Grabar, A. 1947. Le Témoignage d'une hymne syriaque sur l'architecture de la cathédrale d'Edesse au VIe siècle et sur la symbolique de l'édifice chrétien. *Cahiers archéologiques* 2:41–68.

Graf, H. 1892. Neue Beiträge zur Entstehungsgeschichte der kreuzförmigen Basilika. *Repertorium für Kunstwissenschaft* 15:1–18, 94–109, 306–31, 447–71.

Graff, P. 1937–1939. *Geschichte der Auflösung der alten gottesdienstlichen Formen in der evangelischen Kirche Deutschlands*. Göttingen.

Grasser, A. 1946. Wie die britische Commonwealth entstand. *Neue Auslese* 1:12.

Grisebach, A. 1924. *Carl Friedrich Schinkel*. Leipzig.

Grønbech, V. 1937–1942. *Kultur und Religion der Germanen*. 2 vols. Hamburg.

Gruber, O. 1936. Das Westwerk: Symbol und Baugestaltung germanischen Christentums. *Zeitschrift des deutschen Vereins für Kunstwissenschaft* 3:149–73.

Gsell, S. 1900. *Les Monuments antiques d'Algerie*. Paris.

Gundert, W. 1935. *Japanische Religionsgeschichte*. Tokyo.

Günter, H. 1916. Das evangelische Kaisertum. *Historisches Jahrbuch der Görres-Gesellschaft* 37:376–93.

Günter, H. 1933. Die Reichsidee im Wandel der Zeit. *Historisches Jahrbuch der Görres-Gesellschaft* 53:409–28.

Guth, A. 1932. *Die Stiftskirche zu Hamersleben*. Giessen.

Guyer, S. 1934. Zur kunstgeschichtlichen Stellung der Wallfahrtskirche Kalat Siman. *Jahrbuch des deutschen Archäologischen Instituts* 49:90–96.

Guyer, S. 1945. Beiträge zur Frage nach dem Ursprung des kreuzförmig-basilikalen Kirchenbaus des Abendlandes. *Zeitschrift für schweizerische Archäologie und Kunstgeschichte* 7:73–104.

*Guyer, S. 1950. *Grundlagen mittelalterlicher abendländlicher Baukunst: Beiträge zu der vom antiken Tempel zur kreuzförmigen Basilika des abendländischen Mittelalters führenden Entwicklung*. Einsiedeln.

Haacke, R. 1947. *Rom und die Cäsaren*. Düsseldorf.

Haevernick, W. 1935. *Die Münzen von Köln*. Die Münzen und Medaillen von Köln, vol. 1. Cologne.

Haftmann, W. 1939. *Das italienische Säulenmonument*. Leipzig.

Hager, G. 1901. Zur Geschichte der abendländischen Klösteranlage. *Zeitschrift für christliche Kunst* 14:97–106, 135–46, 167–86, 193–204.

Hager, W. 1939. *Das geschichtliche Ereignisbild*. Munich.

Hahn, L. 1913. *Das Kaisertum*. Leipzig.

Haller, J. 1913. *Die Epochen der deutschen Geschichte*. Stuttgart.

Hallmann, H. 1943. *Das Mittelmeer als Schicksalsraum für die germanische Frühzeit und das alte deutsche Reich*. Kriegsvorträge der Rheinischen Friedrich-Wilhelms-Universität, vol. 108. Bonn.

Hamann, R., and F. Rosenfeld. 1910. *Der Magdeburger Dom*. Berlin.

Hamberg, P. G. 1945. *Studies in Roman Imperial Art with Special Reference to the State Reliefs of the Second Century*. Copenhagen.

Hampe, K. 1931. Der Kulturwandel um die Mitte des 12. Jahrhunderts. *Archiv für Kulturgeschichte* 21:129–50.

Harnack, A. 1902. *Das Wesen des Christentums*. Leipzig.

Harnack, A. 1908. *Die Mission und Ausbreitung des Christentums in den ersten Jahrhunderten*. Leipzig.

Harnack, A. 1925. *Lehrbuch für Dogmengeschichte*. 3d ed. Berlin.

Hartlaub, G. F. 1938. Unsichtbare Kunst. *Geistige Arbeit* 5:1.

Hartmann, L. M. 1897. *Geschichte Italiens im Mittelalter*. 4 vols. in 6. Leipzig.

Hartmann, N. 1933. *Das Problem des geistigen Seins*. Berlin.

Hasak, M. 1893. Die Predigtkirche im Mittelalter. *Zeitschrift für Bauwesen* 43:399–422.

Hashagen, J. 1930. Über die Anfänge der christlichen Staats- und Gesellschaftsordnung. *Zeitschrift für Kirchengeschichte* 49:131–58.

Hashagen, J. 1931. Über die ideengeschichtliche Stellung des staufischen Zeitalters. *Deutsche Vierteljahrsschrift für Literaturwissenschaft und Geistesgeschichte* 9:350–62.

Hashagen, J. 1937. Die staufische Renaissance. *Geistige Arbeit* 4:7.

Haskins, C. H. 1927. *The Renaissance of the Twelfth Century*. Cambridge, Mass.

Hauck, A. 1905–1920. *Kirchengeschichte Deutschlands*. 5 vols. Leipzig.

Haupt, A. 1909. *Die älteste Kunst, insbesondere die Baukunst der Germanen*. Leipzig.

Haupt zu Preetz, R. 1925. Die Säule bei den nördlichen Germanen. *Repertorium für Kunstwissenschaft* 45:23–35.

Hauttmann, M. 1929. *Die Kunst des frühen Mittelalters*. Berlin.

Heckscher, W. S. 1936. *Die Romruinen: Die geistige Voraussetzungen ihrer Wertungen im Mittelalter und in der Renaissance*. Würzburg.

Heer, F. 1938. Reich und Gottesreich. Ph.D. diss., Vienna.

Heer, F. 1949. Die "Renaissance"-Ideologie im frühen Mittelalter. *Mitteilungen des Österreichischen Instituts für Geschichtsforschung* 57:23–81.

Heiler, F. 1941. *Altkirchliche Autonomie und päpstlicher Zentralismus*. Munich.

Heisenberg, A. 1908. *Grabeskirche und Apostelkirche*. 2 vols. Leipzig.

Heldmann, K. 1928. *Das Kaisertum Karls des Grossen*. Weimar.

Hempel, E. 1942. Der Realitätscharakter des kirchlichen Wandbildes im Mittelalter. In *Kunstgeschichtliche Studien: Festschrift für D. Frey*, 106–20. Wrocław/Breslau.

Hermanin, F. 1934–43. *Gli artisti in Germania*. L'opera del genio italiano in estero, vol. 1. Rome.

Herwegen, I. 1920. *Das Königtum Christi in der Liturgie*. Düsseldorf.

Herwegen, I. 1932. *Antike, Germanentum, und Christentum*. Salzburg.

Herzog-Hauser, G. 1924. Kaiserkult. In *Realenzyklopädie der classischen Altertumswissenschaft*, edited by W. Pauly and G. Wissowa, supp. 4:806–53. Stuttgart.

Heussi, K. 1927–1932. Columba. In *Religion in Geschichte und Gegenwart: Handwörterbuch für Theologie und Religionswissenschaft*, 1:1709. 2d ed. Tübingen.

Heyne, M. 1899. *Das deutsche Wohnungswesen von den ältesten geschichtlichen Zeiten bis zum 16. Jahrhundert*. Leipzig.

Hincmar of Reims. 1852. *De regis persona et regio ministerio*. In *Patrologiae cursus completus. Series latina*. Vols. 125 and 126. Paris

Hindenberg, J. 1921. *Benno II., Bischof von Osnabrück, als Architekt*. Strasbourg.

Hirschfeld, O. 1888. Zur Geschichte des römischen Kaiserkultes. *Sitzungsberichte der königlichen preussischen Akademie der Wissenschaften* 1888:833–62.

Hoechstedter, M. 1934. *Karl der Grosse, Könige, Patricius und Kaiser als Rector Ecclesiae*. Munich.

Hoernes, M., and O. Menghin. 1925. *Urgeschichte der bildenden Kunst in Europa*. Vienna.

Hoferdt, E. 1905. *Ursprung und Entwicklung der Chorcrypta*. Wrocław/Breslau.

Hoffmann, H. 1919. *Karl der Grosse im Bild der Geschichtsschreibung des frühen Mittelalters, 800–1250*. Berlin.

*Hoffmann W. 1950. *Hirsau und die "Hirsauer Bauschule."* Munich.

Hofmeister, P. 1931. Das Gotteshaus als Begräbnisstätte. *Archiv für katholisches Kirchenrecht* 111:450–87.

Holl, K. 1906. Die Entstehung der Bilderwand in der griechischen Kirche. *Archiv für Religionswissenschaft* 9:365–84.

Holtzinger, H. 1899. *Die altchristliche und byzantinische Baukunst*. Handbuch der Architektur, vol. 3, pt. 1. 2d ed. Stuttgart.

Holtzmann, R. 1918. *Der Kaiser als Marschall des Papstes*. Schriften der Strassburger wissenschaftlichen Gesellschaft, n.s., vol. 8. Strasbourg.

Horn, W. 1937. *Die Fassade von St. Gilles*. Hamburg.

Horn, W. 1938. Das Florentiner Baptisterium. *Mitteilungen des kunsthistorischen Institutes in Florenz* 5:99–151.

Hrabanus Maurus.1851. *De Universo*. In *Patrologiae cursus completus. Series latina*. Vol. 111. Paris.

Hubert, J. 1938. *L'Art préroman*. Paris.

Hübsch, H. 1828. *In welchem Stil sollten wir bauen?* Karlsruhe.

Hübsch, H. 1862–1863. *Die altchristlichen Kirchen nach den Baudenkmalen und älteren Beschreibungen und der Einfluss des altchristlichen Baustils auf den Kirchenbau aller späteren Perioden*. Karlsruhe.

Huelsen, C. 1903. Zu den römischen Ehrenbögen. In *Festschrift zu Otto Hirschfelds 60. Geburtstage*, 423–30. Berlin.

Huelsen, C. 1933. Bramante und Palestrina. In *Hermann Egger: Festschrift zum 60. Geburtstag*, 57. Graz.

Huizinga, J. 1930. Aus der Vorgeschichte des niederländischen Nationalbewusstseins. Part 1: Mittelalterliches Nationalbewusstsein. In *Wege der Kulturgeschichte*, 208–22. Munich.

Humann, G. 1918. Der Zentralbau zu Mettlach und die von der Aachener Pfalzkapelle beeinflussten Bauten. *Zeitschrift für christliche Kunst* 31:81–94.

Hürlimann, M. 1948. *Englische Kathedralen*. Zurich.

Hussong, L. 1938. Über die Möglichkeiten, die die frühgeschichtliche Bodenforschung der mittelalterlichen Kunstgeschichte bietet bei Herausstellung des germanischen Erbes in den westlichen Nachbarländern. *Rheinische Vierteljahrsblätter* 8:182–85.

[Ignatius of Antioch. 1968. Epistle to the Ephesians. In *Early Christian Writings*, translated by M. Staniforth, 73–84. Harmondsworth.]

Illert, F. M. 1942. Der Königschor der Wormser Domes. *Der Wormsgau* 2:337–44, 390.

Immich, O. 1919. *Das Nachleben der Antike*. Leipzig.

Isidore of Seville. 1911. *Etymologiae*. Oxford.

Jakobsohn, H. 1939. *Die dogmatische Stellung des Königs in der Theologie der alten Ägypter*. Munich.

Jankuhn, H. 1938. Gemeinschaftsform und Herrschaftsbildung in frühgermanischer Zeit. *Kieler Blätter*, n.s., 1:270–81.

Jantzen, H. 1928. *Über den gotischen Kirchenraum*. Vortrag der Freiburger Kunstwissenschaftlichen Gesellschaft, vol. 15. Freiburg im Breisgau.

Jantzen, H. 1938. *Über den kunstgeschichtlichen Raumbegriff*. Munich.

Jantzen, H. 1939. Report of an Address to the Freiburger Kunstwissenschaftliche Gesellschaft, Jan. 31, 1936. *Oberrheinische Kunst* 8:186.

Jastrow, M. 1905. *Die Religion Babylons und Assyriens*. 3 vols. Giessen.

Jedin, H. 1935. Die Entstehung und Tragweite des Trienter Dekrets über die Bilderverehrung (1563). *Tübinger theologische Quartalschrift* 160:143–88.

Jeremias, A. 1913. *Handbuch der altorientalischen Geisteskultur*. Leipzig.

Jeremias, A. 1919. *Die Vergötterung der babylonisch-assyrischen Könige*. Leipzig.

Joachim, H. 1935. *Die Stiftskirche zu Königslutter*. Göttingen.

Jordan, K. 1938. Streitschriften des Investiturstreites. *Geistige Arbeit* 5:7.

Jordan, K. 1939. Die Anfänge der römischen Kurie im 11. und 12. Jahrhundert. *Geistige Arbeit* 6:3.

[Josephus. 1858. *The Jewish War*. Translated by R. Traill. Boston.]

Joutz, L. 1936 *Der mittelalterliche Kirchenvorhof in Deutschland*. Berlin.

Jung, E. 1939. *Germanische Götter und Helden in christlicher Zeit*. 2d ed. Munich.

Jünger, E. 1942. *Garten und Strassen*. Berlin.

*Jungmann, J. A. 1948. *Missarum solemnia*. Vienna.

Justi, F. 1879. *Geschichte des alten Persiens*. Berlin.

Jüttner, W. 1933. *Ein Beitrag zur Geschichte der Bauhütte und des Bauwesens im Mittelalter*. Bonn.

Kaerst, J. 1927. *Geschichte des Hellenismus*. 3d ed. 2 vols. Leipzig.

Kahl, G. 1939. *Die Zwerggalerie*. Würzburg.

Kähler, H. 1939. *Die römischen Kapitelle des Rheingebiets*. Römisch-germanische Forschungen, vol. 13. Berlin.

Kampers, F. 1890. *Die deutsche Kaiseridee in Prophetie und Sage*. Munich.

Kampers, F. 1901. *Alexander der Grosse und die Idee des Weltimperiums in Prophetie und Sage*. Freiburg im Breisgau.

Kampers, F. 1924. *Vom Werdegang der abendländischen Kaisermystik*. Berlin.

Kampers, F. 1925. Rex et Sacerdos. *Historisches Jahrbuch der Görres-Gesellschaft* 45:495–515.

Kaniuth, A. 1941. *Die Beisetzung Konstantins des Grossen*. Breslauer historische Forschungen, vol. 18. Wrocław/Breslau.

Kantorowicz, E. 1944. The "King's Advent" and the Enigmatic Panels in the Door of Santa Sabina. *Art Bulletin* 26:207–31.

Kaschnitz-Weinberg, G. von. 1943. Von der zweifachen Wurzel der statuarischen Form im Altertum. In *Neue Beiträge deutscher Forschung, Wilhelm Worringer zum 60. Geburtstag*, edited by E. Fidder, 177–90. Kaliningrad/Königsberg.

Kaschnitz-Weinberg, G. von. 1944. Über den Begriff des Mittelmeerischen in den vorchristlichen Kunst. *Marburger Jahrbuch für Kunstwissenschaft* [Festschrift for R. Hamann] 13:23–68.

Kauffmann, F. 1913. *Deutsche Altertumskunde*. 2 vols. Munich.

Kauffmann, H. 1941. Über "rinascere," "rinascita," und einige Stilmerkmale der Quattrocento-Baukunst. In *Concordia decennalis: Deutsche Italienforschungen. Festschrift der Universität Köln zum 10-jährigen Bestehen des deutsch-italienischen Kulturinstitutes Petrarcahaus in Köln*. Cologne.

Kaufmann, K. M. 1910. *Die Menasstadt und das Nationalheiligtum der altchristlichen Ägypter in der westalexandrinischen Wüste*. Leipzig.

Kautzsch, R. 1919. Der Ostbau des Doms. *Zeitschrift für Geschichte der Architektur* 7:77–99.

Kautzsch, R. 1921. Der Dom zu Speyer. *Städel-Jahrbuch* 1:75–108.

Kautzsch, R. 1932. Review of *Denkmäler der früh- und hochromanischen Baukunst in Österreich*, by R. Pühringer. *Zeitschrift für Kunstgeschichte* 1:52–54.

Kautzsch, R. 1934. Der Meister des Westchores am Dom zu Worms. *Zeitschrift des deutschen Vereins für Kunstwissenschaft* 1:4–15.

Kautzsch, R. 1936. Die Gothardkapelle am Dom zu Mainz und Kasr ibn Wardan. In *Beiträge zur Kunst und Geschichte des Mainzer Lebensraumes: Festschrift für Ernst Neeb*, 41–46. Mainz.

Kautzsch, R. 1943. "Mainz." In *Handbuch der deutschen Kunstdenkmäler*. Vol. 4, *Rhein-franken*. Edited by G. Dehio and E. Gall. Berlin.

Keller, H. 1939. Die Entstehung des Bildnisses am Ende des Hochmittelalters. *Römisches Jahrbuch für Kunstgeschichte* 3:227–356.

Keller, H. 1940. Das Geschichtsbewusstsein des deutschen Humanismus und die bildende Kunst. *Historisches Jahrbuch* 60:664–84.

Kempf, T. K. 1947. Die Deutung des römischen Kerns im Trierer Dom nach den Aus-grabungen von 1943–46. *Das Münster* 1:129–40.

Kempf, T. K. 1948. *Die altchristliche Bischofskirche Triers*. Trier. [Enlarged reprint from *Trierer theologische Zeitschrift* 56:2–9, 33–37, 118–23, 182–89]

Kempf, T. K. 1949. Das Heiligtum des Erzmartyrs Stephanus bei Liebfrauen. *Trierische Landeszeitung* 75:46.

*Kempf, T. K. 1950. Die Erforschung einer altchristlichen Bischofskirche auf deutschem Boden. *Forschungen und Fortschritte* 26:244–47.

Kiekebusch, A. 1912. Eine germanische Ansiedlung aus der späteren römischen Kaiserzeit bei Paulinaue. *Praehistorische Zeitschrift* 4:152–65.

Kirsch, J. P. 1933. Die vorkonstantinischen christlichen Kultusgebäude im Lichte der neuesten Entdeckungen im Osten. *Römische Quartalschrift* 41:15–28.

Kirsch, J. P. 1935. Die Entwicklung des Bautypus der altchristlichen und römischen Basi-lika. *Römische Quartalschrift* 43:1–22.

Kirsch, J. P. 1939. Das Querschiff in den stadtrömischen christlichen Basiliken des Alter-tums. In *Pisciculi: Studien zur Religion und Kultur des Altertums, F. J. Dölger zum 60. Geburtstag*, edited by T. Klauser and A. Rücker, 148–56. Münster.

Kitschelt, L. 1938. *Die frühchristliche Basilika als Darstellung des himmlischen Jerusalem*. Munich.

Klapsia, H. 1937–1938. Der Prunkharnisch des Manierismus: Geschichtliche Sinndeutung und geistliche Grundlagen. *Sitzungsberichte der Kunstgeschichtlichen Gesellschaft Berlin*.

Klauser, T. 1927. *Die Cathedra im Totenkult der heidnischen und christlichen Antike*. Liturgiegeschichtliche Forschungen, vol. 9. Münster.

Klauser, T. 1932. Beziehungen zur christlichen Archäologie. *Jahrbuch für Liturgiewis-senschaft* 12:346–62.

Klauser, T. 1937. Das Querschiff der römischen Prachtbasiliken des 4. Jahrhunderts. *Forschungen und Fortschritte* 13:57–58.

Klauser, T. 1942. *Vom Heroön zur Märtyrerbasilika*. Kriegsvorträge der Rheinischen Friedrich-Wilhelms-Universität, vol. 62. Bonn.

Klauser, T. 1944. Abendländische Liturgiegeschichte: Forschungsbericht und Besinnung. *Eleuteria: Bonner theologische Blätter für kriegsgefangene Studenten* 1:3–30.

Klauser, T. 1947. Bemerkungen zur Geschichte der Bonner Märtyrergräber. *Bonner Geschichtsblätter* [*Bonn und sein Münster: Festschrift J. Hinsenkamp*] 3:35–41.

Kletzl, O. 1935. *Titel und Namen von Baumeistern deutscher Gotik*. Munich.

Klewitz, H. W. 1939a. Die Festkrönung der deutschen Könige. *Zeitschrift der Savigny-Stiftung für Rechtsgeschichte, kanonistische Abteilung* 59:48–96.

Klewitz, H. W. 1939b. Königtum, Hofkapelle, und Domkapitel im 10. und 11. Jahrhun-dert. *Archiv für Urkundenforschung* 16:102–56.

Klewitz, H. W. 1940. Das salische Erbe im Bewusstsein Friedrich Barbarossas. *Geistige Arbeit* 7:1.

Kluckhohn, E. 1940. *Die Kapitelornamentik der Stiftskirche zu Königslutter; Studien über Herkunft, Form und Ausbreitung*. Marburg. [Reprint from *Marburger Jahrbuch für Kunstwissenschaft* 11–12 (1938–1939)]

Knögel, E. 1936. *Schriftquellen zur Kunstgeschichte der Merowingerzeit*. Bonn.

Knopf, R. 1914. *Die Himmelsstadt*. Leipzig.

Koch, C. 1942. Gottheit und Mensch im Wandel der römischen Staatsform. In *Das neue Bild der Antike*, edited by H. Berve, 2:133–54. Rome.

Koch, H. 1917. *Die altchristliche Bilderfrage nach den literarischen Quellen*. Göttingen.

Koch, K. 1940. Die erste Kirche zu Werden an der Ruhr. *Annalen des historischen Vereins für den Niederrhein* 137:154–59.

Koethe, H. 1931. Zum Mausoleum der weströmischen Dynastie bei alt-Sankt-Peter. *Mitteilungen des Deutschen archäologischen Instituts, Römische Abteilung* 46:9–26.

Koethe, H. 1933. Das Konstantinsmausoleum und verwandte Denkmäler. *Jahrbuch des archäologischen Instituts* 48:185–203.

Koethe, H. 1937. Die Trierer Basilika. *Trierer Zeitschrift* 12:151–79.

Köhler, O. 1935. *Das Bild des geistlichen Fürsten im 10.–12. Jahrhundert*. Messkirch (Baden).

Köhler, W. 1934. Die deutsche Kaiseridee am Anfang des 16. Jahrhunderts. *Historische Zeitschrift* 149:35–56.

Kollwitz, J. 1943. Review of *Die frühchristliche Basilika als Darstellung des himmlischen Jerusalem*, by L. Kitschelt. *Byzantinische Zeitschrift* 42:273–75.

Kömstedt, R. 1935. Nationale Charaktere in der romanischen Baukunst nördlich der Alpen. In *Festschrift Heinrich Wölfflin zum 70. Geburtstag*, 111–26. Dresden.

Kömstedt, R. 1936. Zur Beurteilung der frühmittelalterlichen Buchmalerei. *Westdeutsches Jahrbuch für Kunstgeschichte* 9:31–58.

Könn, K. 1938. *Augustus im Wandel zweier Jahrtausende*. Leipzig.

Kornemann, E. 1901. Über den hellenistischen und römischen Herrscherkult. *Beiträge zur alten Geschichte* 1:51–146.

Körte. W. 1930. *Die Wiederaufnahme romanischer Bauformen in der niederländischen Malerei des 15. und 16. Jahrhunderts*. Leipzig.

Krahe, H. 1938a. Probleme der ägäischen Wanderung in sprachwissenschaftlicher Beleuchtung. *Geistige Arbeit* 5:1.

Krahe, H. 1938b. Der frühesten Indogermanen im vorderen Orient. *Geistige Arbeit* 5:10.

Krahe, H. 1939. Vorgeschichte des Griechentums nach Zeugnis der Sprache. *Antike* 15:175–94.

Kratz, J. M. 1876. *Wozu dienten die Doppelchöre in den alten deutschen Cathedralen, Stifts-, und Klosterkirchen?* Hildesheim.

Kraus, F. X. 1896. *Geschichte der christlichen Kunst*. 2 vols. in 3. Freiburg im Breisgau.

Krautheimer, R. 1925. *Die Kirchen der Bettelorden in Deutschland*. Cologne.

Krautheimer, R. 1934. San Nicola in Bari und die apulische Architektur des 12. Jahrhunderts. *Wiener Jahrbuch für Kunstgeschichte* 9:5–42.

Krautheimer, R. 1939. The Beginnings of Christian Architecture. *Review of Religion* 4:127–48.

Krautheimer, R. 1942a. The Carolingian Revival of Early Christian Architecture. *Art Bulletin* 24:1–38. [Reprinted in *Studies in Early Christian, Medieval, and Renaissance Art*, 203–56. London, 1971]

Krautheimer, R. 1942b. Introduction to an Iconography of Medieval Architecture. *Journal of the Warburg and Courtauld Institutes* 5:1–34. [Reprinted in *Studies in Early Christian, Medieval and Renaissance Art*, 115–50. London, 1971]

Krefting, A. 1937. *St. Michael und St. Georg in ihrer geistesgeschichtlichen Beziehung.* Jena.

Krencker, D. 1929. *Die Trierer Kaiserthermen.* Augsburg.

Krencker, D. 1939. *Die Wallfahrtskirche des Simeon Stylites in Kalat Siman.* Abhandlungen der preussischen Akademie der Wissenschaften, philosophisch-historische Klasse, 1938, vol. 4. Berlin.

Krönig, W. 1934. Review of "S. Nicola in Bari und die apulische Architektur des 12. Jahrhunderts," by R. Krautheimer. *Zeitschrift für Kunstgeschichte* 3:297–98.

Krönig, W. 1950. Staufische Baukunst in Unteritalien. In *Beiträge zur Kunst des Mittelalters: Vorträge der Ersten Deutschen Kunsthistorikertagung auf Schloss Brühl, 1948*, 28–38. Berlin.

Kruse, H. 1934. *Studien zur öffentlichen Geltung des Kaiserbildes im römischen Reiche.* Paderborn.

Küas, H. 1937. Ein unbekannter Zyklus der Naumburger Werkstatt. *Zeitschrift des deutschen Vereins für Kunstwissenschaft* 4:63–75.

Kubach, H. E. 1934. *Rheinische Baukunst der Stauferzeit: Das Triforium und seine Parallelen in Frankreich.* Forschungen zur Kunstgeschichte Westeuropas, vol. 12. Cologne.

Kubach, H. E. 1936. Das Triforium: Ein Beitrag zur kunstgeschichtlichen Raumkunde Europas im Mittelalter. *Zeitschrift für Kunstgeschichte* 5:275–88.

Kubach, H. E. 1938. Die deutsche Westgrenze und die Baukunst des Mittelalters. *Deutsches Archiv für Landes- und Volksforschung* 2:326–51.

Kuhn, H. 1949. Zur Deutung der künstlerischen Form des Mittelalters. *Studium Generale* 2:114–21.

Kühnel, E. 1949. *Die Moschee.* Berlin.

Kunze, H. 1925. Die kirchliche Reformbewegung des 12. Jahrhunderts im Gebiet der mittleren Elbe und ihr Einfluss auf die Baukunst. *Jahrbuch der Historischen Kommission für die Provinz Sachsen und für Anhalt* 1:388–476.

Kunze, H. 1925–1926. Der Dom des Willigis in Mainz. *Mainzer Zeitschrift* 20–21:39–44.

Kunze, H. 1937. Dome und Politik. Review of *Dome und Politik*, by H. S. Fiedler. *Sachsen und Anhalt* 13:1–27.

Kutschera, O. von. 1918. Das Giovannino-Relief des Spalatiner Vorgebirges. *Jahrbuch der kunsthistorischen Sammlungen* 12.

Labbé, P. 1759–1798. *Sacrorum conciliorum nova et amplissima collectio.* 34 vols. Florence.

Ladendorf, H. 1949. Wiederaufnahme von Stilformen in der bildenden Kunst des 15. bis 19. Jahrhunderts. *Forschungen und Fortschritte* 25:98–101.

Ladner, G. 1931. Der Bilderstreit und die Kunstlehren der byzantinischen und abendländischen Theologie. *Zeitschrift für Kirchengeschichte* 50:1–23.

Ladner, G. 1936. *Theologie und Politik vor dem Investitutstreit.* Brünn/Brno.

Laehr, G. 1926. *Die konstantinische Schenkung in der abendländischen Literatur des Mittelalters.* Historische Studien, vol. 166. Berlin.

Laehr, G., and C. Erdmann. 1933. Ein karolingischer Konzilsbrief und der Fürstenspiegel Hincmar von Reims. *Neues Archiv* 50:106–34.

Lampert, E. 1947. Kirche und Volk in Russland. *Neue Auslese* 2:54.

Landers, E. 1938. *Die deutschen Klöster vom Ausgang Karls des Grossen bis zum Wormser Konkordat und ihr Verhältnis zu den Reformen*. Berlin.

Lang, E. 1932. *Ottonische und frühromanische Kirchen in Köln*. Koblenz.

Lange, K. 1942. *Münzkunst des Mittelalters*. Leipzig.

*Langlotz, E. 1950. Basilika (nichtchristlich). In *Reallexikon für Antike und Christentum*, 1:1225–49. Stuttgart.

Laqueur, R. 1909. Das Wesen des römischen Triumphes. *Hermes* 44:215–36.

Lassus, J. 1938. L'Église cruciforme de Antioch-Kaoussie. In *Antioch on the Orontes*, edited by R. Stillwell, 2:5–44. Princeton, N.J.

Lassus, J. 1947. *Sanctuaires chrétiens de Syrie*. Paris.

Lasteyrie, R. de. 1912. *L'Architecture religieuse en France à l'époque romane*. Paris.

Latte, K. 1920. *Heiliges Recht*. Tübingen.

Lauer, P. 1911. *Le Palais de Lateran*. Paris.

Lauffer, O. 1936. *Die Begriffe "Mittelalter" und "Neuzeit" im Verhältnis zur deutschen Altertumskunde*. Berlin.

Laugier, N.-A. 1755. *Essays sur l'architecture*. Paris.

Laur-Belart, R., and H. Reinhardt. 1943. Die Kirche von Riehen: Baugeschichte und Untersuchung. *Zeitschrift für schweizerische Archäologie und Kunstgeschichte* 5:129–48.

Leclercq, H. 1907. Confirmation. In *Dictionnaire d'archéologie chrétienne et de liturgie*, 3, pt. 2:2515–51. Paris.

Leeuw, G. van der. 1933. *Phänomenologie der Religion*. Tübingen.

Lehmann, E. 1937. Karolingische Architektur: Literaturbericht. *Zeitschrift für Kunstgeschichte* 6:257–60.

Lehmann, E. 1938. *Der frühe deutsche Kirchenbau*. Berlin.

Lehmann, E. 1940. Über die Bedeutung des Investiturstreites für die deutsche hochromanische Architektur. *Zeitschrift des deutschen Vereins für Kunstwissenschaft* 7:75–88.

Lehmann, K. 1945. The Dome of Heaven. *Art Bulletin* 27:1–27.

Lehmann-Hartleben, K. 1929. Städtebau. In *Realenzyklopädie der classischen Altertumswissenschaft*, edited by W. Pauly and G. Wissowa, 2d ser., 6:2024–2124. Munich.

Lehner, H., and W. Bader. 1932. Baugeschichtliche Untersuchungen am Bonner Münster. *Bonner Jahrbücher* 136–137:1–216.

Leisegang, H. 1926. Der Ursprung der Lehre Augustins von der *Civitas Dei*. *Archiv für Kulturgeschichte* 16:127–58.

Lemaire, R. 1911. *L'Origine de la basilique latine*. Paris.

Lenoir, M. A. 1852. *Architecture monastique*. Paris.

Leufkens, J. 1913. Der Triumphbogen Konstantins. In *Konstantin der Grosse und seine Zeit*, edited by F. J. Dölger, 191–216. Freiburg im Breisgau.

Levison, W. 1898. Zur Geschichte des Frankenkönigs Chlodowech. *Bonner Jahrbücher* 103:42–86.

Levison, W. 1912. Die Iren und die fränkische Kirche. *Historische Zeitschrift* 109:1–22.

Lichtenberg, H. 1931. *Die Architekturdarstellungen in der mittelhochdeutschen Dichtung*. Münster.

Liegle, J. 1936. Architektur Bilder auf antiken Münzen. *Die Antike* 12:202–28.

Liesenberg, K. 1928. *Der Einfluss der Liturgie auf die frühchristliche Basilika*. Freiburg im Breisgau.

Lietzmann, H. 1923. Die Basilika als Schöpfung konstantinischer Baumeister: Report of an Address to the Archäologische Gesellschaft zu Berlin, 6 November 1923. *Archäologischer Anzeiger*, supplement to *Jahrbuch des Deutschen Archäologischen Instituts* 38–39:125–29.

Lietzemann, H. 1937–1944 *Geschichte der alten Kirche*. 2d ed. 4 vols. Berlin.

Lilienfeld, H. 1902. *Die Anschauung von Staat und Kirche im Reich der Karolinger*. Heidelberg.

Lill, G. 1908. *Hans Fugger und die Kunst*. Leipzig.

Lipps, T. 1906. *Grundlegung der Ästhetik*. Hamburg.

Løffler, J. B. 1883. *Udsigt over Danmarks kirkebygninger fra den tidligere middelalder*. Copenhagen.

Lohmeyer, E. 1919. *Christuskult und Kaiserkult*. Tübingen.

L'Orange, H. P. 1935. *Sol invictus imperator: Ein Beitrag zur Apotheose*. Symbolae osloenses, vol. 14. Oslo.

Lösch, S. 1933. *Deitas Jesu und antike Theologie*. Rottenburg.

Lotze, H. 1868. *Geschichte der Ästhetik*. Munich.

Löwy, E. 1930. *Ursprünge der bildenden Kunst*. Sonderdruck aus dem Almanach der Akademie der Wissenschaften. Vienna.

Lozoya, J., Marqués de. 1931. *Historia de arte hispánico*. Barcelona.

Luther, M. n.d. *Tischreden*. Many editions.

Luther, M. 1883– . *D. Luther Werke: Kritische Gesamtausgabe*. Weimar.

Lützeler, H. 1934. *Einführung in die Philosophie der Kunst*. Bonn.

Lützeler, H. 1948. Der Kölner Dom in der deutschen Geistesgeschichte. In *Der Kölner Dom: Festschrift zur Siebenhundertjahrfeier 1248–1948*, 195–250. Cologne.

Maass, E. 1902. *Die Tagesgötter*. Berlin.

Mabillon, J. 1687. *Museum italicum*. 2 vols. Paris.

Mâle, E. 1924. *L'Art religieux du 12e siècle en France*. Paris.

Marti, O. 1947. *Die Völker West- und Mitteleuropas im Altertum*. Baden-Baden.

Martin, A. von. 1929. Antike, Germanentum, Christentum, und Orient als Aufbaufaktoren der geistigen Welt des Mittelalters. *Archiv für Kulturgeschichte* 19:301–45.

Marx, W. 1948. Brüdergemeine (Herrenhütter). In *Reallexikon zur deutschen Kunstgeschichte*, 2:1265–73. Stuttgart.

Massow, W. von. 1948. *Die Basilika in Trier*. Simmern.

[Matarasso, P., ed. 1993. *The Cistercian World: Monastic Writings of the Twelfth Century*. Harmondsworth.]

Matthew Paris. 1888. *Chronica majora*. In *Monumenta germaniae historica. Scriptores*. Vol. 28. Hanover.

Maurenbrecher, W. 1929. *Die Form der Stütze*. Munich.

Meckert, P. 1905. *Kirche und Staat im Zeitalter der Ottonen*. Wrocław/Breslau.

Meier, P. J. 1900–1901. Der Meister von Königslutter und Italien. *Kunstchronik* 12.

Meier, P. J. 1905. Der Meister von Königslutter und Italien. *Kunstchronik* 16.

Meissner, B. 1920. *Babylon und Assyrien*. Heidelberg.

Melicher, T. 1930. *Der Kampf zwischen Gesetz und Gewohnheitsrecht*. Weimar.

Menghin, O. 1910. *Weltgeschichte der Steinzeit*. 2d ed. Vienna.

Mensching, G. 1938. *Volksreligion und Weltreligion*. Leipzig.

Mensching, G. 1947. *Die Soziologie der Religion*. Bonn.

Merzarío, G. 1893. *I maestri comacini*. Milan.

Mettler, A. 1909. Die zweite Kirche von Cluni und die Kirchen in Hirsau nach den "Gewohnheiten" des 11. Jahrhunderts. *Zeitschrift für Geschichte der Architektur* 3:273–86.

Mettler, A. 1910. Die zweite Kirche von Cluni und die Kirchen in Hirsau nach den "Gewohnheiten" des 11. Jahrhunderts. *Zeitschrift für Geschichte der Architektur* 4:1–16.

Meyer, E. 1884–1902. *Geschichte des Altertums*. Stuttgart.

Meyer, H. 1937. Volkstum, Rasse, und Recht. *Forschungen und Fortschritte* 13:1–3.

Meyer-Barkhausen, W. 1929–1930. Karolingische Kapitelle in Hersfeld, Höchst a. M., und Fulda. *Zeitschrift für bildende Kunst* 63:126–37.

Meyer-Barkhausen, W. 1939. Die Akanthuskapitelle in Werden und Helmstedt als Nachklang der karolingisch-ottonischen Ornamententwicklung in Essen. *Wallraf-Richartz Jahrbuch* 11:9–25.

Michel, A. 1905. *L'Histoire de l'art*. Paris.

Michel, V. 1902. *Gebet und Bild in frühchristlicher Zeit*. Leipzig.

Miraculi S. Liutwini. 1887–1888. In *Monumenta germaniae historica. Scriptores*. Vol. 15. Hanover.

Miraculi S. Wandregisili. 1887–1888. In *Monumenta germaniae historica. Scriptores*. Vol. 15. Hanover.

Mitteis, H. 1941. Staatliche Konzentrationsbewegungen im grossgermanischen Raum. In *Abhandlungen zur Rechts- und Wirtschaftsgeschichte: Festschrift für Adolf Zycha*, 53–86. Weimar.

Mitteis, H. 1944. Die Staatsnatur des alten deutschen Reiches. *Forschungen und Fortschritte* 20:171.

Möbius, F. 1944. Review of *Recherches sur le symbolisme funeraire des Romains*, by F. Cumont. *Deutsche Literaturzeitung* 65:264–68.

Moddermann, W. 1875. *Die Rezeption des römischen Rechtes*. Jena.

Mogk, E. 1911–1919. Heiligtümer, heiliger Ort. In *Reallexikon der germanischen Altertumkunde*. Strasbourg.

Moller-Racke, R. 1942. Studien zur Bauskulptur um 1100 am Ober- und Mittelrhein. *Oberrheinische Kunst* 10:39–70.

Mommsen, T. n.d. *Römische Geschichte*. Many editions.

Moret, A. 1902. *Du charactère religieux de la royauté pharaonique*. Paris.

Morey, C. R. 1942. *Early Christian Art*. Princeton, N.J.

Mortet, V. 1896. La Mesure des colonnes à la fin de l'epoque romaine d'après un très ancien formulaire. *Bibliothèque de l'École des chartes* 57:277–324.

Mortet, V. 1898. La Mesure des colonnes à la fin de l'epoque romaine d'après un très ancien formulaire. *Bibliothèque de l'École des chartes* 59:56–72.

Mortet, V. 1907. Un Formulaire du VIII siècle pour les fondations d'édifices et de ponts d'après des sources d'origine antique. *Bulletin monumental* 71:442–65.

Mortet, V. 1911. *Recueil de textes relatifs à l'histoire de l'architecture et à la condition des architectres en France au moyen âge*. Paris.

Muller, F., and K. Gross. 1950. Augustus. In *Reallexikon für Antike und Christentum*, 1:993–1004. Stuttgart.

Müller, H. W. 1949. Review of *Bemerkungen zur ägyptischen Baukunst des alten Reiches*, by H. Ricke. *Deutsche Literaturzeitung* 70:551–63.

Müller, K. F. 1936. *Das assyrische Königsritual*. Leipzig.

Müller, O. 1937. Die Einhardsbasilika zu Seligenstadt am Main. *Forschungen und Fortschritte* 13:373.

Müller, S. 1905. *Urgeschichte Europas*. Strasbourg.

Müller, V. 1931. Cultbild. In *Realenzyklopädie der classischen Altertumswissenschaft*, edited by L. Pauly and G. Wissowa, supp. 5:472–511. Stuttgart.

Müller, W. 1937. Birnstab. In *Reallexikon zur deutschen Kunstgeschichte*, 2:68–77. Stuttgart.

Naumann, H. 1933. Karolingische und ottonische Renaissance. In *Wandlung und Erfüllung*. Stuttgart.

Naumann, H. 1940. *Altdeutsches Volkskönigtum*. Stuttgart.

Naumann, H. 1942. *Kaiser und Ritter*. Bonn.

Navarre, O. 1897–1917. Velum. In *Dictionnaire des antiquités grecs et romains*, edited by C. Daremberg and E. Saglio, 5:677–80. Paris.

Netzer, H. 1910. *L'Introduction de la messe romaine en France sous les carolingiens*. Paris.

Neuss, W. 1922. *Die katalanische Bibelillustration um die Wende des ersten Jahrtausends und die altspanische Buchmalerei*. Bonn.

Neuss, W. 1946. *Die Kirche des Mittelalters*. Bonn.

Niemann, G. 1910. *Der Palast Diokletians in Spalato*. Vienna.

Nissen, H. 1906–1910. *Orientation*. 3 vols. Berlin.

Nomasticon Cisterciense. 1664. Paris.

Nottarp, H. 1916. Das Ludgersche Eigenkloster in Werden im 9. Jahrhundert. *Historisches Jahrbuch der Görres-Gesellschaft* 37:80–98.

Novacovic, T. 1942. Kaiseridee und Kaisergrab. Ph.D. diss., Vienna.

Oelmann, F. 1922a. Hilani und Liwanhaus. *Bonner Jahrbücher* 127:189–236.

Oelmann, F. 1922b. Zur Deutung des römischen Kernes im Trierer Dom. *Bonner Jahrbücher* 127:130–88.

Oelmann, F. 1927. *Haus und Hof im Altertum*. Berlin.

Ohr, W. 1902. *Der karolingische Gottesstaat in Theorie und Praxis*. Leipzig.

Omont, H. 1929. *Miniatures des plus anciens manuscrits grecs de VIIe au XIVe siècles*. Paris.

Opladen, P. 1908. *Die Stellung der deutschen Könige zu den Orden des 13. Jahrhunderts*. Bonn.

Ostrogorsky, G. 1935. Zum Stratordienst des Herrschers in der byzantinisch-slawischen Welt. *Seminarium Kondakovianum* 7:187–204.

Otte, H. 1883–1885. *Handbuch der kirchlichen Kunstarchäologie des deutschen Mittelalters*. Leipzig.

Otto of Freising. 1912a. *Chronica*. In *Monumenta germaniae historica. Scriptores*. Vol. 45. Hanover.

Otto of Freising. 1912b. *Gesta*. In *Monumenta germaniae historica. Scriptores*. Vol. 46. Hanover.

Overbeck, F. 1919. *Christentum und Kultur*. Basel.

Paatz, W. 1940. Die Hauptströmungen in der Florentiner Baukunst des frühen und hohen Mittelalters und ihr geschichtlicher Hintergrund. *Mitteilungen des kunsthistorischen Institutes in Florenz* 6:33–72.

Paatz, W. 1950. Renaissance oder Renovatio. In *Beiträge zur Kunst des Mittelalters: Vorträge der Ersten Deutschen Kunsthistorikertagung auf Schloss Brühl, 1948*, 16–27. Berlin.

Paatz, W., and E. Paatz. 1940. *Die Kirchen von Florenz*. Frankfurt.

Panofsky, E. 1927. *Die Perspektive als "symbolische Form."* Vorträge der Bibliothek Warburg, vol. 1924–1925. Leipzig.

Panofsky, E. 1929. *Idea*. Leipzig.

Panofsky, E. 1944. Renaissance and Renascences. *Kenyon Review* 6:201–36.

*Panofsky, E. 1946. *Abbot Suger on the Abbey Church of St. Denis and Its Treasures*. Princeton, N. J.

[Panofsky, E. 1968. *Idea: A Concept in Art Theory*. Columbia, S.C.]

Pantoni, A. 1939. Problemi archeologici Cassinesi: La basilica pre-desideriana. *Rivista di archeologia cristiana* 16:271–88.

Patzelt, E. 1924. *Die karolingische Renaissance*. Vienna.

Paulus, H. 1944. *Der Gesinnungscharakter des merowingisch-westfränkischen Basilikenbaues*. Würzburg.

Paulus Diaconus. 1849. *Vita S. Gregorii Magni*. In *Patrologiae cursus completus. Series latina*. Vol. 75. Paris.

Peterson, E. 1930. Die Einholung des Kyrios. *Zeitschrift für systematische Theologie* 7:682–702.

Pevsner, N. 1942. Terms of Architectural Planning in the Middle Ages. *Journal of the Warburg and Courtauld Institutes* 5:232–37.

Pfeilstücker, S. 1934. *Spätantikes und germanisches Königsgut in der frühangelsächsischen Kunst*. Bonn.

Pfister, F. 1924. Epiphanie. In *Realenzyklopädie der classischen Altertumswissenschaft*, edited by W. Pauly and G. Wissowa, supp. 4:277–323. Stuttgart.

Philippi, F. 1923. Heinrich der Löwe als Beförderer von Kunst und Wissenschaft. *Historische Zeitschrift* 127:50–65.

Pieper, P. 1936. *Kunstgeschichte*. Berlin.

Piper, F. 1847–1851. *Mythologie und Symbolik*. 2 vols. Weimar.

Pirenne, H. 1941. *Geburt des Abendlandes*. 2d ed. Frankfurt am Main.

Pliny the Elder. n.d. *Naturalis historia*. Many editions.

Pliny the Younger. n.d. *Epistolae*. Many editions.

Pomtow, M. 1885. *Über den Einfluss der altrömischen Vorstellungen vom Staat auf die Politik Kaiser Friedrichs I. und die Anschauung seiner Zeit*. Halle.

Posse, O. 1909–1913. *Die Siegel der deutschen Kaiser und Könige von 751 bis 1806*. 5 vols. Dresden.

Preger, T. 1901a. Konstantinos Helios. *Hermes* 36:457–69.

Preger, T., ed. 1901b. *Scriptores originum Constantinopolitanum*. Leipzig.

Primer, P. 1886. Stimmen gegen die Überschätzung der Kunst. In *Programm des kgl. Gymnasiums zu Weilburg für das Schuljahr 1886*. Weilburg.

Puchstein, O. 1912. *Boghazkoi*. Leipzig.

Pühringer, R. 1931. *Denkmäler der früh- und hochromanischen Baukunst in Österreich*. Vienna.

Puig i Cadafalch, J. 1928. *Le Premier Art roman*. Paris.

Quast, A. F. von. 1872. Verhandlungen der II. Sektion der Generalversammlung der

deutschen Geschichts- und Alterthumsvereine Naumburg. *Correspondenzblatt des Gesamtvereins der deutschen Geschichts- und Altertumsvereine* 20:17–20.

Quiring, H. 1948. Steinzeitende und Weltanschauungswandel. *Forschungen und Fortschritte* 24:54.

Rahmani, Ignatius Ephraim II, ed. 1899. *Testamentum Domini nostri Jesu Christi*. Mainz.

Rahn, I. R. 1866. *Über den Ursprung und die Entwicklung des christlichen Central- und Kuppelbaus*. Leipzig.

Rahtgens, H. 1907. Review of "Der Westbau der Palastkapelle Karls des Grossen und seine Einwirkung auf den romanischen Turmbau in Deutschland," by E. von Sommerfeld. *Westdeutsche Zeitschrift für Geschichte und Kunst* 26:51.

*Rapp, U. 1950. Kultbild und Mysterienbild im Abendland. Ph.D. diss., Würzburg.

Rassow, P., 1932. *Die Kaiser-Idee Karls V*. Berlin.

Ratzinger, G. 1898. Lombardische Bauinnungen in Bayern. In *Forschungen zur bayerischen Geschichte*. Kempten.

Rave, W. 1937. Sint Servaas und die Westwerkfrage. *Westfalen* 22:49–75.

Redlich, C. 1948. Erbrecht und Grabbeilagen bei den Germanen. *Forschungen und Fortschritte* 24:171.

Regling, K. 1924. *Die antike Münze als Kunstwerk*. Berlin.

Reiff, E. 1937. *Anachronistische Elemente in der deutschen Baukunst aus der Zeit von ca. 1650 bis ca. 1680*. Emsdetten.

Reinach, S. 1928. L'Art et la magie. In *Cultes, mythes, et religions*. 3d ed. Paris.

Reinhardt, H. 1934. Die deutschen Kaiserdome des 11. Jahrhunderts. *Basler Zeitschrift für Geschichte und Altertumskunde* 33:175–94.

Reinhardt, H. 1935. Das erste Münster zu Schaffhausen und die Frage der Doppelturmfassade. *Anzeiger für schweizerische Altertumskunde*, n.s., 37:241–57.

Reinhardt, H. 1941. Von Minaretten, Säulenheiligen, und Totenleuchten. *Schweizerisches Archiv für Volkskunde* 39:40–63.

Reinhardt, H., and E. Fels. 1933. Études sur les églises-porches carolingiennes et leurs survivance dans l'art roman. *Bulletin monumental* 92:331–65.

Reinhardt, H., and E. Fels. 1937. Études sur les églises-porches carolingiennes et leurs survivance dans l'art roman. *Bulletin monumental* 96:425–69.

Reissmann, K. 1937. *Romanische Portalarchitektur in Deutschland*. Munich.

Review of "Die Entstehung und Tragweite des Trienter Dekrets über die Bilderverehrung (1563)," by H. Jedin. 1937. *Zeitschrift für Kunstgeschichte* 6:256.

Rey, R. 1930. Notre Dame de la Daurade. *Congrès archeologique de France* 1929:105–8.

Rey, R. 1949. Le Sanctuaire paléo-chrétien de la Daurade à Toulouse et ses origines orientales. *Annales du Midi* 61:249–73.

Richter, G. 1900. *Die ersten Anfänge der Bau- und Kunsttätigkeit des Klosters Fulda*. Fulda.

Richter, J. P. 1897 *Quellen der byzantinischen Kunstgeschichte*. Vienna.

Ricke, H. 1944. *Bemerkungen zur ägyptischen Baukunst des alten Reiches*. Zurich.

Riegl, A. 1893. *Stilfragen: Grundlegungen zu einer Geschichte der Ornamentik*. Berlin.

Rieker, K. 1914. Die Entstehung und geschichtliche Bedeutung des Kirchenbegriffs. In *Festgabe für Rudolf Sohm dargebracht zum goldenen Doktorjubiläum*, 1–22. Munich.

Robb, D. M. 1945. The Capitals of the Panteón de los Reyes, San Isidoro de León. *Art Bulletin* 27:195–74.

Rodenwaldt, G. 1921. *Der Fries des Megaron von Mykenai*. Halle.

Rodenwaldt, G. 1925. Cortinae. *Nachrichten der Gesellschaft der Wissenschaften zu Göttingen, philosophisch-historische Klasse* 1925:33–49.

Rodenwaldt, G. 1927. *Die Kunst der Antike*. Berlin.

Rodenwaldt, G. 1931. Das Problem der Renaissancen. *Jahrbuch des Deutschen archäologischen Instituts, Archäologischer Anzeiger* 46:318–38.

Rodenwaldt, G. 1939. Die letzte Blütezeit der römischen Architektur. *Forschungen und Fortschritte* 15:244–45.

Rodenwaldt, G. 1942a. *Kunst um Augustus*. Berlin.

Rodenwaldt, G. 1942b. Römische Staatsarchitektur. In *Das neue Bild der Antike*, edited by H. Berve, 2:356–73. Rome.

Rodenwaldt, G. 1947. Die Leistung Roms für die europäische Kunst. *Forschungen und Fortschritte* 21–23:33–35.

Röder, J. 1949. *Pfahl und Menhir*. Neuwied.

Roeder, G. 1947. Waren die Künstler des Pharonenreiches auch Persönlichkeiten? *Forschungen und Fortschritte* 21–23:198–204.

Rogge, E. 1943. *Einschiffige romanische Kirchen in Friesland und ihre Gestaltung*. Oldenburg.

Rossi, G. B. de. 1864. *Roma sotteranea*. Rome.

Roth, E. 1917. *Die Rustika in der italienischen Renaissance und ihre Vergangenheit*. Vienna.

Rothacker, E. 1937. Schöpfung aus dem Nichts. *Forschungen und Fortschritte* 13:5–6.

Rothacker, E. 1948. *Die Schichten der Persönlichkeit*. 4th ed. Bonn.

Rothkirch, W. Graf von. 1938a. *Architektur und monumentale Darstellung im hohen Mittelalter: 1100 bis 1200*. Leipzig.

Rothkirch, W. Graf von. 1938b. Der figürliche Kirchenschmuck des deutschen Sprachgebiets in karolingischer, ottonischer, und salischer Zeit. In *Festschrift Wilhelm Pinder zum 60. Geburtstag*, 117–39. Leipzig.

Röttger, B. H. 1934. *Die Kunstdenkmäler der Pfalz*. Vol. 3, *Stadt und Bezirksamt Speyer*. Munich.

Rubinstein, N. 1943. The Beginnings of Florentine Political Thought. *Journal of the Warburg and Courtauld Institutes* 5:198–227.

Rudolph, M. V. 1942. *Germanischer Holzbau der Wikingerzeit*. Neumünster.

Ruotger. 1841. *Vita Brunonis*. In *Monumenta germaniae historica. Scriptores*. Vol. 4. Hanover.

Rüttimann, H. 1911. *Der Bau- und Kunstbetrieb der Zisterzienser unter dem Einfluss der Ordensgesetzgebung im 12. und 13. Jahrhundert*. Bregenz.

Sackur, W. 1925. *Vitruv und die Poliorketiker*. Berlin.

Saeftel, F. 1935. Herd- und Hochsäulen im altnordischen Haus als Träger alter germanischer Glaubensvorstellungen. *Germanien* 82–87:111–20.

Sägmüller, J. B. 1898. Die Idee von der Kirche als *imperium romanum* im kanonischen Recht. *Theologische Quartalschrift* 80:50–80.

Salmi, M. 1938–1939. Maestri comacini e maestri Lombardi. *Palladio* 3:49–62.

Salzenberg, V. 1854. *Altchristliche Baudenkmäler von Konstantinopel vom 5.–12. Jahrhundert*. Berlin.

Sarre, F., and E. Herzfeld. 1920. *Archäologische Reise*. Berlin.

Sauer, J. 1913. *Der Zisterzienserorden und die deutsche Kunst des Mittelalters*. Salzburg.

Sauer, J. 1924. *Symbolik des Kirchengebäudes und seiner Ausstattung in der Auffassung des Mittelalters*. 2d ed. Freiburg im Breisgau.

Sauter, C. 1910. Der Neuplatonismus, seine Bedeutung für die antike und mittelalterliche Philosophie. *Philosophisches Jahrbuch* 23:183–95, 367–80, 461–86.

Schaeder, H. 1937. Das Zeitalter des Kalifats und der Kreuzzüge. *Forschungen und Fortschritte* 13:110–11.

Schaefer, H. 1945. The Origin of the Two-Tower Facade in Romanesque Architecture. *Art Bulletin* 27:85–108.

Schäfer, H. 1928. *Weltgebäude der alten Ägypter*. Berlin.

Scharff, A. 1939. Typus und Persönlichkeit in der ägyptischen Kunst. *Archiv für Kulturgeschichte* 29:1–29.

Scharff, A. 1944–1946. *Das Grab als Wohnhaus in der ägyptischen Frühzeit*. Sitzungsberichte der bayerischen Akademie der Wissenschaften, philosophisch-historische Klasse, vol. 6. Munich.

*Schauerte H. 1950. Das Symbol. In *Festgabe für Alois Fuchs zum 70. Geburtstage*, edited by W. Tack, 319–35. Paderborn.

Scheffer, T. von. 1935. *Die Kultur der Griechen*. Vienna.

Schelling, F. W. J. von. 1807. *Über das Verhältnis der bildenden Künste zur Natur: Festrede*. Munich.

Schenk, A., Graf von Stauffenberg. 1938. *Theodorich der Grosse und seine römische Sendung*. Würzburg.

Schenk, A., Graf von Stauffenberg. 1947. Die grossen Wanderungen und das Hethiterreich: Ein Versuch zur vergleichenden Universalgeschichte. In *Das Imperium und die Völkerwanderung*, 176–211. Munich.

Schermann, T. 1914. *Die allgemeine Kirchenordnung, frühchristliche Liturgie, und kirchliche Überlieferung*. Paderborn.

Schippers, A. 1926–1927. Der Umschwung des Stilgefühls in der rheinischen Baukunst des 12. Jahrhunderts. *Zeitschrift für bildende Kunst* 60:77–84.

Schlag, G. 1940. *Die deutschen Kaiserpfalzen*. Frankfurt.

Schlag, G. 1943. Der zentrale Mehreckbau in der Baukunst der deutschen Kaiserzeit. *Elsass-Lothringisches Jahrbuch* 21:62–80.

Schlegel, F. von. 1846a. Gemähldebeschreibungen aus Paris und den Niederlanden in den Jahren 1802–4, 4. Sendung. In *Sämtliche Werke*, vol. 6. Vienna.

Schlegel, F. von. 1846b. *Grundzüge der gotischen Baukunst*. Leipzig.

[Schlegel, F. von. 1860. *The Aesthetic and Miscellaneous Works*. Translated by E. J. Millington. London.]

Schlesinger, M. 1910. Symbolik in der Architektur. *Zeitschrift für Geschichte der Architektur* 4:21–31.

Schlikker, F. W. 1940. *Hellenistische Vorstellungen von der Schönheit des Bauwerks nach Vitruv*. Berlin.

Schlosser, J. von 1889. *Die abendländischen Klosteranlagen des frühen Mittelalters*. Vienna.

Schlosser, J. von 1891. *Beiträge zur Kunstgeschichte aus den Schriftquellen des frühen Mittelalters*. Sitzungsberichte der kaiserlichen Akademie der Wissenschaften in Wien, vol. 123. Vienna.

Schlosser, J. von. 1892. *Schriftquellen zur Geschichte der karolingischen Kunst*. Vienna.

Schlosser, J. von. 1895. Ein veronesisches Bilderbuch und die höfische Kunst des XIV. Jahrhunderts. *Jahrbuch der kunsthistorischen Sammlungen des allerhöchsten Kaiserhauses* 16:144–230.

Schlosser, J. von. 1896. *Quellenbuch zur Kunstgeschichte des Abendländischen Mittelalters.* Vienna.

Schlosser, J. von. 1914. *Materialien zur Quellenkunde der Kunstgeschichte.* Vol. 1: *Mittelalter.* Sitzungsberichte der kaiserlichen Akademie der Wissenschaften in Wien, vol. 177. Vienna.

Schlosser, J. von. 1927a. Die Entwicklung der Medaillen. In *Präludien, Vorträge und Aufsätze,* 44–67. Berlin.

Schlosser, J. von. 1927b. Heidnische Elemente in der christlichen Kunst des Altertums. In *Präludien, Vorträge und Aufsätze.* Berlin.

Schlosser, J. von. 1927c. Zur Genesis der mittelalterlichen Kunstanschauung. In *Präludien, Vorträge und Aufsätze,* 180–212. Berlin.

Schlosser, J. von. 1927d. Zur Geschichte der Kunsthistoriographie. In *Präludien, Vorträge und Aufsätze,* 248–95. Berlin.

Schlosser, J. von. 1927e. *Präludien, Vorträge und Aufsätze.* Berlin.

Schlosser, J. von. 1927f. Randglosse zu einer Stelle Montaignes. In *Präludien, Vorträge und Aufsätze,* 216–26. Berlin.

Schlosser, J. von. 1934. *Die Wiener Schule der Kunstgeschichte.* Mitteilungen des Österreichischen Instituts für Kunstgeschichte, Ergänzungsband, vol. 13. Innsbruck.

Schlunk, H. 1935. Santa Eulalia de Bovedo. In *Das siebente Jahrzehnt: Adolf Goldschmidt zu seinem 70. Geburtstag,* 1–13. Berlin.

Schlunk, H. 1936. Naranco und verwandte Bauten. *Sitzungsberichte der kunstgeschichtlichen Gesellschaft Berlin, Oktober 1935 bis Mai 1936.*

Schlunk, H. 1937. Spanische Architektur aus der Zeit der asturiaschen Monarchie. *Forschungen und Fortschritte* 13:241–43.

Schlunk, H. 1947. Arte visigodo, arte asturiana. In *Ars Hispaniae,* 2:227–441. Madrid.

Schmeidler, F. 1909. *Die italienischen Geschichtsschreiber des 12. und 13. Jahrhunderts.* Leipzig.

Schmidt, A. 1950. Westwerke und Doppelchöre: Höfische und liturgische Einflüsse auf die Kirchenbauten des frühen Mittelalters. Ph.D. diss., Göttingen.

Schmidt, H. 1895. *Handbuch der Symbolik.* 2d ed. Berlin.

Schmidt, J. H. 1938. *Stadttore im Rheinland.* Bonn.

Schmidt, L. 1938. Theodorich: Römischer Patrizius und König der Ostgoten. *Zeitschrift für schweizerische Geschichte* 18:404–14.

Schmidt, R. 1915. Königsrecht, Kirchenrecht, und Stadtrecht beim Aufbau des Inquisitionsprozesses. *Festgabe der LeipzigerJuristenfakultät für Rudolf Sohm,* 4:41–73. Munich.

Schnaase, C. 1866–1879. *Geschichte der bildenden Künste.* 2d ed. 8 vols. Düsseldorf.

Schneider, A. M. 1941a. Die Hagia Sophia in der politisch-religiösen Gedankenwelt der Byzantiner. *Das Werk des Künstlers* 2:4–75.

Schneider, A. M. 1941b. Die Symbolik des Theoderichgrabes in Ravenna. *Byzantinische Zeitschrift* 41:404–5.

Schneider, A. M. 1950. Apsis. In *Reallexikon für Antike und Christentum,* 1:571–73. Stuttgart.

Schneider, F. 1878. Der karolingische Torbau zu Lorsch. *Korrespondenzblatt des Gesamtvereins der deutschen Geschichts- und Altertumsvereine,* 26:1.

Schneider, F. 1886. *Der Dom zu Mainz*. Berlin.

Schneider, F. 1926. *Rom und der Romgedanke im Mittelalter*. Munich.

*Schneider, T., and K. H. Schelkle. 1950. Bauen. In *Reallexikon für Antike und Christentum*, 1:1265–78. Stuttgart.

Schnitger, H. 1939. Die deutschen Bischöfe aus den Königssippen von Otto I. bis Heinrich V. Ph.D. diss., Munich.

*Schnitzler, H. 1950. *Der Dom zu Aachen*. Düsseldorf.

Schnürer, G. 1894. *Die Entstehung des Kirchenstaates*. Cologne.

Schrade, H. 1928a. Frühchristliche und mittelalterliche Kunst. *Deutsche Vierteljahresschrift für Literaturwissenschaft und Geistesgeschichte* 6:548–80.

Schrade, H. 1928b. Frühchristliche und mittelalterliche Kunst. *Deutsche Vierteljahresschrift für Literaturwissenschaft und Geistesgeschichte* 7:348–422.

Schrade, H. 1939–1940a. [Introduction]. *Das Werk des Künstlers* 1.

Schrade, H. 1939–1940b. Dio Chrysostomus über den Zeus des Phidias. *Das Werk des Künstlers* 1:197–214.

Schrade, H. 1939–1940c. Rembrandts Anatomie des Dr. Tulp. *Das Werk des Künstlers* 1:60–100.

Schramm, P. E. 1929. *Kaiser, Rom, und Renovatio*. Leipzig.

Schramm, P. E. 1935–1936. *Die deutschen Kaiser und Könige in Bildern ihrer Zeit, 8.–12. Jahrhundert*. 2 vols. Leipzig.

Schreiber, G. 1948. *Gemeinschaften des Mittelalters*. Münster.

Schubart, W. 1937. Der hellenistische König. *Forschungen und Fortschritte* 13:123–24.

Schuchardt, C. 1935. *Alteuropa*. 3d ed. Berlin.

Schuchardt, K. 1931. *Die Burg im Wandel der Weltgeschichte*. Potsdam.

Schulte, A. 1934. Deutsche Könige, Kaiser, Päpste als Kanoniker an deutschen und römischen Kirchen. *Historisches Jahrbuch der Görres-Gesellschaft* 54:137–77.

Schultze, R. 1909. Die römischen Stadttore. *Bonner Jahrbücher* 118:280–352.

Schultze, R. 1917. Das römische Stadttor in der kirchlichen Baukunst des Mittelalters. *Bonner Jahrbücher* 124:17–52.

Schultze, R. 1928. *Basilika: Untersuchungen zur antiken und frühmittelalterlichen Baukunst*. Römisch-germanische Untersuchungen, vol. 2. Berlin.

Schulz, B., and J. Strzygowski. 1904. Mschatta: Bericht über die Aufnahme der Ruine. *Jahrbuch der königlich preussischen Kunstsammlungen* 25:205–373.

Schumacher, F., ed. 1947. *Lesebuch für Baumeister*. Berlin.

Schunter, A. 1926. *Der weströmische Kaisergedanke ausserhalb des einstigen Karolingerreiches im Hochmittelalter*. Munich.

Schürer, O. 1929. Romanische Doppelkapellen: Eine typengeschichtliche Untersuchung. *Marburger Jahrbuch für Kunstwissenschaft* 5:99–192.

Schwäbl, F. 1919. *Die vorkarolingische Basilika St. Emmeram in Regensburg*. Regensburg.

Schwarz, H. M. 1942. Die Baukunst Kalabriens und Siziliens im Zeitalter der Normannen: 1. Teil, Die lateinischen Kirchengründungen des 11. Jahrhunderts und der Dom in Cefalù. *Römisches Jahrbuch zur Kunstgeschichte* 6:1–112.

Schwarz, M. 1913. Das Stilprinzip der altchristlichen Architektur. In *Konstantin der Grosse und seine Zeit: Gesammelte Studien*, edited by F. J. Dölger, 340–62. Freiburg im Breisgau.

Schwarz, R. 1947. *Vom Bau der Kirche*. Heidelberg.

Schweitzer, B. 1923. Archäologische Funde in den Jahren 1916 bis 1922: Griechenland. *Archäologischer Anzeiger*, supplement to *Jahrbuch des Deutschen Archäologischen Instituts* 37:238–345.

Schweitzer, B. 1925. *Die bildende Kunst und der Begriff des Künstlerischen in der Antike*. Heidelberg.

*Schweitzer, B. 1946. *Spätantike Grundlagen der mittelalterlichen Kunst*. Leipzig.

Sedlmayr, H. 1933. Das erste mittelalterliche Architektursystem. *Kunstwissenschaftliche Forschungen* 2:25–62. [Reprinted in *Epochen und Werke: Gesammelte Schriften zur Kunstgeschichte*, 1:80–139. Vienna, 1959]

Sedlmayr, H. 1935. Zur Geschichte des justinianischen Architektursystems. *Byzantinische Zeitschrift* 35:38–69.

Sedlmayr, H. 1935–1936. Über eine mittelalterliche Art des Abbildens. *Critica d'arte* 6:261–69. [Reprinted in *Epochen und Werke: Gesammelte Schriften zur Kunstgeschichte*, 1:140–54. Vienna, 1959]

Sedlmayr, H. 1936. Die gotische Kathedrale. In *XIVe Congrès internationale d'histoire de l'art: Resumés* 1:86. Laupen.

Sedlmayr, H. 1937. Die Rolle Österreichs in der Geschichte der deutschen Kunst. *Forschungen und Fortschritte* 13:418–19. [Reprinted as part of "Österreichs bildende Kunst," in *Epochen und Werke: Gesammelte Schriften zur Kunstgeschichte*, 2:266–86. Vienna, 1982]

Sedlmayr, H. 1938. Die politische Bedeutung des deutschen Barocks. In *Gesamtdeutsche Vergangenheit: Festschrift für Heinrich Ritter von Srbik*, 126–40. Munich. [Reprinted in *Epochen und Werke: Gesammelte Schriften zur Kunstgeschichte*, 2:140–56. Vienna, 1982]

Sedlmayr, H. 1939. Die dichterische Wurzel der Kathedrale. In *Mitteilungen des österreichischen Instituts für Geschichtsforschung* [Festschrift for Hans Hirsch], supp. 14:275–87. [Reprinted as part of "Die Geburt der Kathedrale," in *Epochen und Werke: Gesammelte Schriften zur Kunstgeschichte*, 1:155–81. Vienna, 1959]

Sedlmayr, H. 1948a. Architektur als abbildende Kunst. *Österreichische Akademie der Wissenschaften, philosophisch-historische Klasse, Sitzungsberichte* 225:1–25. [Reprinted in *Epochen und Werke: Gesammelte Schriften zur Kunstgeschichte*, 2:211–34. Vienna, 1982]

Sedlmayr, H. 1948b. *Verlust der Mitte*. Salzburg.

*Sedlmayr, H. 1950. *Die Entstehung der Kathedrale*. Zurich.

Seeberg, E. 1942. Review of *Altkirchliche Autonomie und päpstlicher Zentralismus*, by F. Heiler. *Deutsche Literaturzeitung* 63:3.

Semper, G. 1869. *Über Baustyle*. Zurich.

Semper, G. 1878. *Der Stil in den technischen und tektonischen Künsten*. 2d ed. Munich.

Semper, G. 1884. *Kleine Schriften*. Berlin.

Seppelt, F. X. 1934. *Das Papsttum im Frühmittelalter*. Leipzig.

Simson, O. von. 1937. *Zur Genealogie der weltlichen Apotheose im Barock, besonders der Medicigalerie des P. P. Rubens*. Strasbourg.

*Smith, E. B. 1950. *The Dome: A Study in the History of Ideas*. Princeton, N.J.

Sohm, R. 1895. *Kirchenrecht*. 2d ed. Leipzig.

Solms-Laubach, E. Graf zu. 1927. Die Wormser Bauschule in Hessen und ihre Grundlagen in Deutschland und Italien. Ph.D. diss., Marburg.

Sommerfeld, E. von. 1906. Der Westbau der Palastkapelle Karls des Grossen und seine

Einwirkung auf den romanischen Turmbau in Deutschland. *Repertorium für Kunstwissenschaft* 29:195–222, 310–25.

Soper, A. C. 1947. The Dome of Heaven in Asia. *Art Bulletin* 29:225–48.

Soteriou, G. A. 1940. Die altchristlichen Basiliken Griechenlands. In *Atti del IV congresso internazionale di archeologia cristiana*, 1:355–80. Rome.

Spangenberg, H. 1923. Die Perioden in der Weltgeschichte. *Historische Zeitschrift* 127:1–49.

Spiegel, J. 1940. Typus und Gestalt in der ägyptischen Kunst. *Mitteilungen des deutschen Instituts für ägyptische Altertumskunde* 9:156–72.

Spörl, J. 1930. Das Alte und das Neue im Mittelalter; Studien zum Problem des mittelalterlichen Fortschrittsbewusstseins. *Historisches Jahrbuch* 50:297–341, 498–524.

Spörl, J. 1935. *Grundformen hochmittelalterlicher Geschichtsbetrachtung*. Munich.

Sprater, F. 1947. *Königspfalz und Gaugrafenburg in Speyer*. Speyer.

Stach, W. 1935. Die geschichtliche Bedeutung der westgotischen Reichsgründung. *Historische Vierteljahresschrift* 30:417–45.

Stange, A. 1935. Arteigene und artfremde Züge im deutschen Kirchengrundriss. *Zeitschrift des deutschen Vereins für Kunstwissenschaft* 2:229–52.

*Stange, A. 1950. *Das frühchristliche Kirchengebäude als Bild des Himmels*. Cologne.

Stauffer, E. 1941. *Theologie des Neuen Testaments*. Stuttgart.

Steinhausen, G. 1923. Verfallsstimmung im kaiserlichen Deutschland. *Preussisches Jahrbuch* 194:153–85.

Stengel, E. E. 1939. Kaisertitel und Souveränitätsidee. *Deutsches Archiv für Geschichte des Mittelalters* 3:1–56.

Stephani, K. G. 1902. *Der älteste deutsche Wohnbau und seine Einrichtung*. Leipzig.

Stiefenhofer, D. 1909. *Die Geschichte der Kirchweihe vom 1. bis 7. Jahrhundert*. Munich.

Stockmeyer, E. 1939. *Gottfried Sempers Kunsttheorie*. Zurich.

Straub, J. A. 1939. *Vom Herrscherideal der Spätantike*. Stuttgart.

Straub, J. A. 1942. Konstantins christliches Sendungsbewusstsein. In *Das neue Bild der Antike*, edited by H. Berve, 2:374–94. Rome.

Strzygowski, J. 1936. *Spuren des indogermanischen Glaubens in der bildenden Kunst*. Heidelberg.

Strzygowski, J. 1941. *Europas Machtkunst im Rahmen des Erdkreises*. Vienna.

Stuhlfauth, G. 1927–1932. Altar: III Christlicher. In *Religion in Geschichte und Gegenwart: Handwörterbuch für Theologie und Religionswissenschaft*, 1:234–31. 2d ed. Tübingen.

Stutz, U. 1895. *Die Eigenkirche als Element des mittelalterlich-germanischen Kirchenrechts*. Berlin.

Suhle, A. 1936. *Die deutschen Münzen des Mittelalters*. Berlin.

Swarzenski, G. 1932. Aus dem Kunstkreis Heinrichs des Löwen. *Städel-Jahrbuch* 7–8:241–397.

Swoboda, K. M. 1919. *Römische und romanische Paläste: Eine architekturgeschichtliche Untersuchung*. Vienna.

Sybel, L. von. 1906. *Christliche Antike*. Marburg.

Sybel, L. von. 1908. *Altchristliche Kunst*. Marburg.

Sybel, L. von. 1925. Das Werden der christlichen Kunst, II. *Repertorium für Kunstwissenschaft* 45:141–47.

Technau, W. 1939. Vom Bedeutungswandel der Dinge. *Geistige Arbeit* 6:1.

Tellenbach, G. 1934–1935. *Römischer und christlicher Reichsgedanke in der Liturgie des frühen Mittelalters.* Sitzungsberichte der Heidelberger Akademie der Wissenschaften, vol. 1934–1935. Heidelberg.

Tellenbach, G. 1936. *Libertas: Kirche und Weltordnung im Zeitalter des Investiturstreits.* Stuttgart.

[Tellenbach, G. 1940. *Church, State, and Christian Society at the Time of the Investiture Contest.* Translated by R. F. Bennett. Oxford.]

Termehr, L. 1950. Romanische Baukunst; ein Beitrag zur Geistesgeschichte des Stilbegriffs. Ph.D. diss., Bonn.

Tertullian. 1890. *De idolatria.* In *Corpus scriptorum ecclesiasticorum satinorum,* 20:30–58. Vienna.

Texier, C. 1839. *Description de l'Asie mineur.* Paris.

Theophilus presbyter. 1874. *Schedula diversarum artium.* Vienna.

Thiersch, H. 1923. Zu den Tempeln und zur Basilika von Baalbek. *Nachrichten der Gesellschaft der Wissenschaften zu Göttingen, philosophisch-historische Klasse* 1923:1–32.

Tholen, P. 1936. Ein ottonischer Grossbau als Saalkirche. *Westdeutscher Beobachter,* February 5, evening edition.

Thümmler, H. 1937. *Die Stiftskirche zu Cappel und die Westwerke Westfalens.* Münster.

Thümmler, H. 1939. Die Baukunst des 11. Jahrhunderts in Italien. *Römisches Jahrbuch für Kunstgeschichte* 3:141–226.

Thümmler, H. 1948. Die frühromanische Baukunst in Westfalen. *Westfalen* 27:177–214.

Tietze, H. 1924. Geisteswissenschaftliche Kunstgeschichte. In *Die Kunstwissenschaft der Gegenwart in Selbstdarstellungen,* edited by J. Jahn, 183–98. Leipzig.

Tietze, H. 1930. Romanische Kunst und Renaissance. *Vorträge der Bibliothek Warburg* 1926–1927:43–57.

Töwe, C. 1939. *Die Formen der entwickelnden Kunstgeschichtsschreibung.* Berlin.

Treitinger, O. 1938. *Die oströmische Kaiser- und Reichsidee nach ihrer Gestaltung im höfischen Zeremoniell.* Jena. [Reprinted in *Die oströmische Kaiser- und Reichsidee. Vom oströmischen Staats- und Reichsgedanken.* Darmstadt, 1956]

Treitinger, O. 1940. *Vom oströmischen Staats- und Reichsgedanken.* Leipziger Vierteljahresschrift für Südosteuropa, vol. 4. Leipzig. [Reprinted in *Die oströmische Kaiser- und Reichsidee. Vom oströmischen Staats- und Reichsgedanken.* Darmstadt, 1956]

*Treitinger, O. 1950. Baldachin. In *Reallexikon für Antike und Christentum,* 1:1150–53. Stuttgart.

Trier, J. 1929. Architekturphantasien in der mittelalterlichen Dichtung. *Germanisch-romanische Monatsschrift* 17:11–24.

Trier, J. 1947. Völkernamen. *Westfälische Zeitschrift* 97:9–37.

Tritsch, F. 1928. Die Stadtbildung des Altertums und die griechische Polis. *Klio* 22:1–83.

Troeltsch, E. 1912. *Die Soziallehren der christlichen Kirchen und Gruppen.* Tübingen.

Unger, F. W. 1878. *Quellen zur byzantinischen Kunstgeschichte.* Vienna.

Unterkirchner, F. 1943. Der Sinn der deutschen Doppelchöre. Ph.D. diss., Vienna.

Vallery-Radot, J. 1929. Note sur les chapelles hautes dédiées à Saint-Michel. *Bulletin monumental* 88:453–78.

Vasari, G. B. n.d. *Vite.* Many editions.

Vasiliev, A. A. 1932. *Histoire de l'empire byzantin.* Paris.

Verbeek, A. 1936. Romanische Westchorhallen an Maas und Rhein: Die Entwicklung einer Bauform in Lüttich, Maastricht, und Xanten im späten 12. Jahrhundert und die Anfänge der rheinischen Zweischalenwandgliederung. *Wallraf-Richartz Jahrbuch* 9:59–87.

Verbeek, A. 1950. Ottonische und Staufische Wandgliederung am Niederrhein. In *Beiträge zur Kunst des Mittelalters: Vorträge der Ersten Deutschen Kunsthistorikertagung auf Schloss Brühl, 1948*, 70–83. Berlin.

Versus in aula ecclesiae in aquis palatio. 1880–1881. In *Monumenta germaniae historica. Poetae latini aevii carolini*. Vol. 1. Berlin.

Vincent, L. H. 1937. Deux origines de l'architecture chrétienne. In *Quantulacumque: Studies Presented to Kirsopp Lake*, edited by R. P. Casey. London.

Vincent, L. H., and F. M. Abel. 1932. *Emmaüs*. Paris.

Viollet-le-Duc, E. 1854–1868. *Dictionnaire raisonné de l'architecture française*. 10 vols. Paris.

Viollet-le-Duc, E. 1861. L'Église imperiale de Saint-Denis. *Revue archéologique* 3:301–10, 345–53.

Vischer, F. T. 1887. Das Symbol. In *Philosophische Aufsätze: Eduard Zeller zu seinem fünfzigjährigen Doktor-Jubiläum gewidmet*, 151–93. Leipzig.

Vischer, F. T. 1898. *Das Schöne und die Kunst*. 2d ed. Stuttgart.

Vita Henrici imp. 1856. In *Monumenta germaniae historica. Scriptores*. Vol. 12. Hanover.

[Vitruvius. 1970. *Vitruvius on Architecture*. Loeb Classical Library. London.]

Vogelstein, M. 1930. *Kaiseridee, Romidee, und das Verhältnis von Staat und Kirche seit Konstantin*. Wrocław/Breslau.

Vogt, J. 1949. *Constantin der Grosse und sein Jahrhundert*. Munich.

Vogt, W. H. 1939. Altgermanische Religiosität. *Forschungen und Fortschritte* 15:246–47.

*Vogts, H. 1950. *Köln im Spiegel seiner Kunst*. Cologne.

Vogüé, C. de 1865. *Syrie centrale: Architecture réligieuse du Ier au VIIe siècle*. Paris.

Vollmer, H. 1907. *Vom Lesen und Deuten heiliger Schriften: Geschichtliche Betrachtungen*. Tübingen.

Vonderau, J. 1919. *Die Ausgrabungen am Dom zu Fulda, 1908–1913*. Fulda.

Vonderau, J. 1925. *Die Ausgrabungen der Stiftskirche zu Hersfeld in den Jahren 1921 und 1922*. Fulda.

Wachtsmuth, F. 1929–1935. *Der Raum*. 2 vols. Marburg.

Wachtsmuth, F. 1930. Der Ursprung des Querschiffs. *Zeitschrift für Bauwesen* 80:53–58.

Walbe, H. 1937. Vom Kloster Lorsch. *Zeitschrift des deutschen Vereins für Kunstwissenschaft* 4:51–62.

Wallrath, R. 1940. Zur Entstehungsgeschichte der Krypta. *Jahrbuch des kölnischen Geschichtsvereins* 22:273–92.

Walter, J. 1918. Zur kunstgeschichtlichen Bewertung des romanischen Stadtsiegels von Strassburg. *Anzeiger für elsässische Altertumskunde* 3:952–57.

Warner, G. F., ed. 1910. *British Museum: Reproductions from Illuminated Manuscripts*. 2d ed. London.

Weber, A. 1946. *Abschied von der bisherigen Geschichte*. Hamburg.

Weber, M. 1922. *Gesammelte Aufsätze zur Wissenschaftslehre*. Tübingen.

Weber, W. 1936. *Princeps*. Stuttgart.

Weigand, E. 1922. Die Ostung in der frühchristlichen Architektur. In *Festschrift Sebast-ian Merkle zu seinem 60. Geburtstag*, edited by W. Schellberg, J, Hehn, and F. Till-mann, 370–85. Düsseldorf.

Weigand, E. 1927. Review of *Der syrische Kirchenbau*, by H. W. Beyer. *Byzantinische Zeit-schrift* 27:149–57.

Weigand, E. 1928. Propylon und Bogentor in der östlichen Reichskunst, ausgehend vom Mithridatestor in Ephesos. *Wiener Jahrbuch für Kunstgeschichte* 4:71–114.

Weigand, E. 1933. Ist die frühchristliche Kirchenanlage hellenistisch oder römisch? *Forschungen und Fortschritte* 9:458–59.

Weigand, E. 1934. Das spätrömische Architektursystem. *Forschungen und Fortschritte* 10:414–15.

Weigand, E. 1940. Review of "Säule und Ordnung in der frühchristlichen Architektur," by F. W. Deichmann. *Byzantinische Zeitschrift* 40:545–46.

Weigert, H. 1936. Das Kapitell in der deutschen Baukunst des Mittelalters. *Zeitschrift für Kunstgeschichte* 5:7–46, 103–24.

Weigert, H. 1938. Die Bedeutung des germanischen Ornaments. In *Festschrift Wilhelm Pinder zum 60. Geburtstag*, 81–116. Leipzig.

Weigert, H., and W. Hege. 1933. *Die Kaiserdome am Mittelrhein: Speyer, Mainz, und Worms*. Berlin.

Weinel, H. 1908. *Die Stellung des Urchristentums zum Staat*. Tübingen.

Weinstock, S. 1932. Templum. *Mitteilungen des Deutschen Archäologischen Instituts, Römische Abteilung* 47:95–121.

Weisbach, W. 1945. *Religiöse Reform und mittelalterliche Kunst*. Einsiedeln.

Weise, G. 1919. *Studien zur Entwicklungsgeschichte des abendländischen Basilikengrundriss-es in den frühesten Jahrhunderten des Mittelalters*. Sitzungsberichte der heidelberger Akademie der Wissenschaften, philosophisch-historische Klasse, vol. 21. Heidelberg.

Wells, H. G. 1920. *Outline of History*. London.

Wentzel, H. 1935. Der Dom zu Lund und die romanischen Steinmeister in Schonen. *Geistige Arbeit* 6:5.

Werner, H. 1919. *Die Ursprünge der Metapher*. Arbeiten zur Entwicklungspsychologie, vol. 3. Leipzig.

Wersebe, O. von. 1938. *Der Altfrid-Dom zu Hildesheim und die Gründungskirchen von Es-sen und Gandersheim*. Göttingen.

Wetter, J. 1835. *Geschichte und Beschreibung des Domes zu Mainz*. Mainz.

Wiegand, J. 1900. *Das altchristliche Hauptportal an der Kirche der hl. Sabina*. Trier.

Wiegand, T. 1934. *Die Kaiserpaläste in Konstantinopel*. Berlin.

Willard, H. M. 1935. A Project for the Graphic Reconstruction of the Romanesque Abbey of Monte Cassino. *Speculum* 10:144–46.

Wilpert, J. 1916. *Die römischen Mosaiken und Malereien der kirchlichen Bauten vom IV. bis XIII. Jahrhundert, 1*. Freiburg im Breisgau.

Wind, E. 1931. Warburgs Begriff der Kulturwissenschaft und seine Bedeutung für die Ästhetik. *Zeitschrift für Ästhetik und allgemeine Kunstwissenschaft* 25:163–79.

Windisch, H. 1931. *Imperium und Evangelium im Neuen Testament*. Kiel.

Witting, F. 1902. *Die Anfänge christlicher Architektur*. Strasbourg.

*Wittkower, R. 1949. *Architectural Principles in the Age of Humanism*. London.

Wolf, W. 1935. *Individuum und Gemeinschaft in der ägyptischen Kultur*. Glückstadt.

Wrackmeyer, A. 1936. *Studien zu den Beinamen der abendländischen Könige und Fürsten bis zum Ende des 12. Jahrhunderts*. Marburg.

Wulff, O. 1914–1918. *Altchristliche und byzantinische Kunst*. 2 vols. Handbuch der Kunstwissenschaft. Berlin.

Wulff, O. 1929–1930. Das Raumerlebnis des *naos* im Spiegel der *Ekphrasis*. *Byzantinische Zeitschrift* 30:531–39.

Wulff, O. 1936. Entwicklungsläufe der altchristlichen Basilika. *Byzantinisch-neugriechische Jahrbücher* 12:61–96.

Xydis, S. G. 1947. Chancel Barriers, Solea and Ambo of Hagia Sophia. *Art Bulletin* 29:1–24.

[Zapp, H. 1995. Send, -gericht. In *Lexikon des Mittelalters*, 7:1747–48. Munich.]

Zeller, A. 1911. *Die Kunstdenkmäler der Provinz Hannover, II*. Vol. 4, *Stadt Hildesheim*. Hanover.

Zimmer, H. 1937. Zur Symbolik der Hindutempel. *Forschungen und Fortschritte* 13:134–36.

Zwingli, H. 1908. *Zwinglis Schriften [20–29]*. In *Huldreich Zwinglis sämtliche Werke*, edited by E. Egli and G. Finsler. 2d ed. Corpus Reformatorum, vol. 89. Leipzig.

Zwingli, H. 1914. *Zwinglis Schriften [30–50]*. In *Huldreich Zwinglis sämtliche Werke*, edited by E. Egli, G. Finsler, and W. Köhler. 3d ed. Corpus Reformatorum, vol. 90. Leipzig.

Index

Numbers in italics refer to pages on which illustrations appear.